The Theology of Craft and the Craft of Work

An important reconceptualisation is taking place in the way people express creativity, work together, and engage in labour; particularly, suggests Kidwell, a surprising resurgence in recent years of manual and craft work. Noting the wide array of outlets that now market hand-made goods and the array of popular books which advocate "making" as a basis for activism or personal improvement, this book seeks to understand how the micro-politics of craft work might offer insights for a broader theology of work. Why does it matter that we do work which is meaningful, excellent, and beautiful? Through a close reading of Christian scripture, *The Theology of Craft and the Craft of Work* examines the theology and ethics of work in light of original biblical exegesis. Kidwell presents a detailed exegetical study of temple construction accounts in the Hebrew bible and the New Testament. Illuminating a theological account of craft, and employing the ancient vision of "good work" which is preserved in these biblical texts, Kidwell critically interrogates modern forms of industrial manufacture. This includes a variety of contemporary work problems particularly the instrumentalisation and exploitation of the non-human material world and the dehumanisation of workers. Primary themes taken up in the book include agency, aesthetics, sociality, skill, and the material culture of work, culminating with the conclusion that the church (or "new temple") is both the product and the site of moral work. Arguing that Christian worship provides a moral context for work, this book also examines early Christian practices to suggest a theological reconceptualisation of work.

The **Revd Dr Jeremy H. Kidwell** (MCS, Ph.D, Theological Ethics, University of Edinburgh) serves as Post-Doctoral Research Associate in the School of Divinity at the University of Edinburgh. He lectures in Christian Ethics, the Ethics of Work, Technology and Design and Environmental Ethics, and is currently involved in full-time research on an interdisciplinary research project focussed on Christian responses to climate change, titled "Caring For the Future Through Ancestral Time." Dr Kidwell's research is engaged primarily with Christian ethics, the environment and political theology. His most recent work, a co-edited volume *Theology and Economics: A Christian Vision of the Common Good* (2015) brings together constructive reflections from Christian theologians and economists across the UK, USA and Europe and is the result of a two year collaboration. Prior to his academic work, Jeremy worked as a technician and trainer in telecommunications and information technology and he continues to provide consulting services on network security, infrastructure, and the use of information technology in teaching and learning. This experience in the marketplace provided the impetus for this book and motivated the research behind it.

The Theology of Craft and the Craft of Work
From Tabernacle to Eucharist

Jeremy H. Kidwell

LONDON AND NEW YORK

First published 2016
by Routledge
2 Park Square, Milton Park, Abingdon, Oxon OX14 4RN

and by Routledge
711 Third Avenue, New York, NY 10017

Routledge is an imprint of the Taylor & Francis Group, an informa business

© 2016 Jeremy H. Kidwell

The right of Jeremy H. Kidwell to be identified as author of this work has been asserted by him in accordance with sections 77 and 78 of the Copyright, Designs and Patents Act 1988.

All rights reserved. No part of this book may be reprinted or reproduced or utilised in any form or by any electronic, mechanical, or other means, now known or hereafter invented, including photocopying and recording, or in any information storage or retrieval system, without permission in writing from the publishers.

Trademark notice: Product or corporate names may be trademarks or registered trademarks, and are used only for identification and explanation without intent to infringe.

British Library Cataloguing in Publication Data
A catalogue record for this book is available from the British Library

Library of Congress Cataloging-in-Publication Data
Kidwell, Jeremy, 1980–
 The theology of craft and the craft of work : from tabernacle to eucharist / by Jeremy Kidwell.
 pages cm
 Includes bibliographical references and index.
 ISBN 978-1-4724-7651-7 (hardcover) — ISBN 978-1-4724-7652-4 (ebook) — ISBN 978-1-4724-7653-1 (epub) 1. Work—Biblical teaching. 2. Work—Religious aspects—Christianity. 3. Temples—Design and construction—Biblical teaching. 4. Public worship—Biblical teaching. 5. Workmanship—Miscellanea. 6. Handicraft—Miscellanea. I. Title.
 BS680.W75K53 2016
 261.8'5—dc23 2015033028

ISBN: 978-1-4724-7651-7 (hbk)
ISBN: 978-1-315-55233-0 (ebk)

Typeset in Garamond Premier Pro
by Apex CoVantage, LLC

Contents

Acknowledgements — vi
A Note on the Text — viii
Abbreviations — ix

Introduction: Seeking a Theology of Craft — 1

PART I
Moral Making: The Construction of the Place of Worship — 21

1. Building the Tabernacle — 23
2. Building the Temple — 53
3. The Temple Not Made With Hands: Reconceptualising the Temple — 81
4. Jesus the Temple: Temple Construction in the New Testament — 117

PART II
Moral Maintenance: Sustaining Work Ethics in Christian Worship — 147

Introduction to Part II — 149

5. Burnt Offerings: Challenging Modern Work Efficiency — 157
6. Firstfruits and the Consecrating Relation — 178
7. "Eaten" Offerings and Liturgical Sociality — 200

Conclusion: Seeking the Craft of Worship — 212

Bibliography — 216
Index of Biblical References — 231
Index of Authors — 239
Index of Subjects — 241

Acknowledgements

I am in the debt of faculty and friends at the University of Edinburgh who have provided comment on the research and writing presented here, particularly Dr David Reimer, who has ably steered me through the "Scylla" and "Charybdis" churning up the waters of biblical scholarship, and my two examiners Prof. Nick Adams and Prof. Timothy Gorringe, who offered a generous measure of the same type of guidance from a theological perspective. I am also grateful to Prof. Oliver O'Donovan for sharing his wisdom on patristic ethics. Portions of this study in early drafts have been presented at several conferences, including a Society for the Study of Christian Ethics conference, several Society of Biblical Literature sessions (Biblical Theology, Concept Analysis and the Hebrew Bible, and Theology of the Hebrew Scriptures sections), a Kirby Laing Institute for Christian Ethics seminar, the Tyndale House forum on Theology and Social Ethics, and several University of Edinburgh research seminars. I am very grateful to those who have shared insights and critique in the context of those fora. In particular, I want to express my thanks to Brian Brock and Esther Reed, who provided wise input on this project while it was still in the early stages. Special thanks also go to a group of peers, Graham Chernoff, Seth Ehorn, and Joe Rivera, who read drafts of this manuscript. I am also especially grateful to Ben Edsall for commenting on early drafts of several sections of this work. Any persistent faults in this manuscript are mine, as the diligent attention of my manuscript readers cannot be faulted! My research was financially supported by the University of Edinburgh and the School of Divinity at the University, and it has been attended by a regular awareness that I am the beneficiary of an investment by the Scottish public in scholarship. I hope that my study may prove a small but worthy dividend of this generous gift.

It has been a privilege these past three years to be mentored by Prof. Michael Northcott. His personal investment in my professional development and well-being has been extraordinary as he has generously opened up office, home, and garden as spaces for friendship and learning. Perhaps most of all, I am grateful

to Prof. Northcott for allowing me to be an apprentice in the challenging task of prophetic witness in the midst of our ecological crisis. He has left me with the conviction that our efforts to communicate a moral vision for the health of the whole creation must be not merely true but also beautiful. It might have been easier to provide specific footnotes for those insights in this book that have not arisen from and been refined in our conversations, his mentorship, and my reading of his work (including my use of the term "Moral Making" for Part I of this study). Keeping this in mind, I offer my deepest thanks to Prof. Northcott for sharing his insight and scholarship with me so openly.

Final and ultimate thanks go to my wife Katy for her patience, encouragement, and unfailing support. The conviction that lies behind this research – that communities of faith may yet mobilise towards moral action and change society for the better in the midst of our current ecological crisis – is one that I could not have sustained without frequent borrowing from Katy's hope and vision on this subject. Thanks are also due to our sons Noah and Isaac, whose enthusiasm and joy have infused a new level of hope on my part towards the development of an intergenerational ethic.

A Note on the Text

For Greek and Hebrew, I have followed the convention common to biblical scholarship, to transliterate. This has the additional benefit of making my text accessible to both readers and non-readers of biblical languages. When referencing the text of the bible, I shall primarily provide transliterated Hebrew or Greek (and in some cases Latin, when relevant) and, for the sake of those unfamiliar with Hebrew or Greek, for terms that are uncontroversial, I shall include a gloss enclosed in brackets (i.e., *ndava* ["freewill"]). For glosses I shall typically draw on *BDAG* and *HALOT*. Most biblical quotations are drawn from contemporary English translations, the JPS translation for the Hebrew Bible and the ESV for the New Testament; otherwise, unless noted, glosses and translations are my own.

Abbreviations

When referencing classical and patristic literature, I shall make use of the abbreviation system detailed in the Oxford Classical Dictionary, with author names unabbreviated (i.e., "Aristotle, *Pol.*"). I rely upon SBL style for all biblical abbreviations and references.

ANE	Ancient Near East
AYB	Anchor Yale Bible [Commentary Series]
AYBD	*Anchor Yale Bible Dictionary*, edited by David Noel Freedman, 6 vols (New York: Doubleday, 1992)
BDAG	Walter Bauer, *A Greek–English Lexicon of the New Testament and Other Early Christian Literature*, 3rd edn, revised and edited by Frederick William Danker (Chicago, IL: University of Chicago Press, 2000)
BDB	*The New Brown–Driver–Briggs–Gesenius Hebrew and English Lexicon, With an Appendix Containing the Biblical Aramaic*, edited by Francis Brown with the cooperation of S. R. Driver and Charles A. Briggs (Peabody, MA: Hendrickson, 1979)
BEThL	Bibliotheca Ephemeridum Theologicarum Lovaniensium
CBCNT	Cambridge Bible Commentaries: New Testament [Commentary Series]
ESV	English Standard Version
GNT	Greek New Testament
GR	Graeco-Roman
HALOT	Ludwig Koehler *et al.*, *The Hebrew and Aramaic Lexicon of the Old Testament*, 5 vols, translated and edited under the supervision of M. E. J. Richardson (Leiden: Brill, 1994–2000)
HB	Hebrew Bible
ICC	International Critical Commentary
JPS	*Tanakh: The Holy Scriptures: The New JPS Translation According to the Traditional Hebrew Text* [Bible]

JPSTC	Jewish Publication Society Torah Commentary [Commentary Series]
KJV	King James Version
LPGL	G. W. H. Lampe, *A Patristic Greek Lexicon* (Oxford: Clarendon Press, 1961)
LSJ	*A Greek–English Lexicon*, compiled by Henry George Liddell and Robert Scott, revised and augmented throughout by Sir Henry Stuart Jones with the assistance of Roderick McKenzie (Oxford: Clarendon Press, 1996)
LXX	Greek Septuagint
MT	Masoretic Text
NAB	New American Bible
NET	New English Translation
NIBC	New International Bible Commentary
NICNT	New International Commentary on the New Testament
NICOT	New International Commentary on the Old Testament
NIDNTT	Colin Brown, ed., *The New International Dictionary of New Testament Theology*, 3 vols (Exeter: Paternoster Press, 1975)
NIDOTTE	Willem VanGemeren, ed., *New International Dictionary of Old Testament Theology and Exegesis*, 5 vols (Grand Rapids, MI: Zondervan, 1997)
NIGTC	New International Greek Testament Commentary
NJB	New Jerusalem Bible
NRSV	New Revised Standard Version [Bible]
NT	New Testament
REB	Revised English Bible
SBL	Society of Biblical Literature
TDNT	*Theological Dictionary of the New Testament*, edited by G. Kittel and G. Friedrich, translated by G. W. Bromiley, 10 vols (Grand Rapids, MI: Eerdmans, 1964–1976)
TDOT	*Theological Dictionary of the Old Testament*, edited by G. J. Botterweck and H. Ringgren, translated by J. T. Willis, G. W. Bromiley, and D. E. Green, 17 vols (Grand Rapids, MI: Eerdmans, 1974–2006)
TNIV	Today's New International Version
TOTC	Tyndale Old Testament Commentaries
TWOT	*Theological Wordbook of the Old Testament*, edited by R. Laird Harris, Gleason L. Archer, Jr, and Bruce K. Waltke, 2 vols (Chicago, IL: Moody Press, 1980)
WBC	Word Biblical Commentary

Introduction
Seeking a Theology of Craft

> If we hope to see a world in which people are active participants rather than passive consumers and spectators, then somehow we have to rescue the idea of work as something worthwhile, something if not enduring, then deeply humanising. But this implies changes in our attitudes to work and our understanding of its content: what work is and what work could become.[1]

The last few years have seen a surprising resurgence of craft work. This is evident in the success of websites that sell handmade goods, such as etsy.com, and popular books that advocate the crafts as a basis for activism or personal improvement. Perhaps the most visible of these accounts may be found in Matthew Crawford's recent book, where he issues a call for a revalorisation of the trades summed up in the title, *Shop Class as Soulcraft*. This call has been taken up across the world and can be seen in new communities of hobbyists, workers, and hackers. Urban activists have shown resistance by scattering vacant lots with wildflowers and cultivating vegetable plots in acts of "guerrilla gardening." In the last decade, textile artists have begun to compete with graffiti artists by covering street-signs, lamp-posts, and trees with colourful "yarn-bombing." The maker-movement has taken up the cause of DIY and "hacking" and now boasts a magazine (*Make:*), regular workshops (funded by Google, among others), and hobbyist cooperatives ("Hack Labs"). At ifixit.com, you can find complete teardown instructions with images and step-by-step instructions should you wish to repair your own laptop or smartphone.

While some of the recent accounts by "makers" have a pseudo-spiritual dimension, put paradigmatically in Robert M. Pirsig's *Zen and the Art of Motorcycle Maintenance* (1974), there have been few attempts by theologians to engage in a constructive conversation with this new movement or explore possible symmetries with Christian ethics and theology. This may be in part because Christian writers in the theology of work have not emphasised study of craft work. There have been robust and well-noted attempts by Christian scholars, including John Paul II, Miroslav Volf, and John Hughes, to re-engage the philosophy of work

with Christian political economy.[2] This research has done much to advance a Christian account of political economy and place work within a macro-political perspective. Christian writers, such as Esther Reed and Jeff Van Duzer, have also sought to offer theological reflection tailored for both workers and executives within the modern business context. In a similar vein, this kind of work has done much to advance the conversation about ways in which Christian modes of thought can address the more specific context of individual businesses. As the quote from Roger Coleman with which I open this Introduction suggests, this book is part of a long-term project that aims to see how we might take this very productive conversation in the theology of work in some new directions. Towards that end, I highlight the ways in which ancient craft work and the moral world that it upheld is threaded through several narratives in Christian Scripture. Advancing a biblical theology of craft also necessitates the laying of some groundwork and so I bring this account into a theological engagement with recent writing in craft and design theory.

I do not hope to exhaust the possibilities presented by a theology of craft in this book. Instead, I mean to make a start in the same way that much of the historical reflection in the theology of work does, through sustained reflection on Christian Scripture. In framing this book as a conversation between recent conceptions of craft and the Christian theology of work, it is important to highlight my conviction at the outset that there is a uniquely Christian account of work that may stand in its own right as a conversation partner. To this end, I have constructed this book as a reflection on one of the foremost accounts of valorous work in the bible, the crafting of the Tabernacle. As I shall go on to argue, sustained reflection on the account of Tabernacle construction and the succeeding narratives of Temple construction across the bible reveals a peculiar account of work that has many symmetries with an account of craft, but it also carries its own unique theologically formulated emphases and concerns. In short, I want to bring all this recent theory and analysis regarding craft work into conversation in this book with one strand of argument in Scripture regarding why it matters that we do work that is meaningful, excellent, and beautiful.

In explaining the reasons that lie behind this study, it is also important for me to acknowledge that the impetus for this project is not exclusively academic: it also arises out of my own experience in business. Prior to my academic training in theology and ethics, I worked in a variety of capacities in telecommunications and information technology. In one instance of this, I served as the supervisor of a team of technicians in a call centre that provided support for customers of a telecommunications company in the United States. Our team primarily helped users who were owners of small businesses to address issues with their internet services, though we also dealt with a host of other less frequent issues including network security. Our workspace had an open layout that was meant to assist

in making our work collaborative. Every day we served as one another's audience for what were often great feats of communication and imaginative troubleshooting with persons and devices we would never encounter in any physical sense. The lack of civility offered to these technicians was often astonishing to me, and the negative psychological impact of their treatment was compounded by a style of management that tracked technician productivity as if they were part of a mathematical equation. Their performance was assessed based upon metrics such as the number of cases closed each day, call length, trouble recurrence, and hold time, usually at most on a weekly basis. In my experience this is far from exceptional and such an arrangement serves as the style of management for thousands of people who work in support teams such as this. Yet, as a supervisor, I always found that these stark numbers never managed to grasp at the unique and often impressive level of technical skill that each person cultivated in spite of a work environment that was frequently oppressive (in spite of the best efforts of managers and executives) and where training was at best *ad hoc*.

This was not my first time doing work where the client relationship was almost exclusively "virtual," as I have also – since the very early days of commercial internet use – created and managed virtual worlds for various clients. To this end, I have designed and managed servers and network architectures for clients that included several educational institutions. Here too arose strange quandaries; and as a consultant I have often struggled alongside administrators on the design side to resist the allure of what often proved to be phantom "efficiencies" and on the maintenance side to extricate devices from workplaces when it was discovered that they rendered communication less effective, work less enjoyable, and learning nearly impossible. As many modern philosophers of technology have suggested, the technology I encountered was no inert or morally neutral object: it occupied a phenomenal "cloud" carrying its own culture and allure, which subverted our best intentions to make judgements about its wise use or avoidance. Yet throughout my work in these industries, I have continued to stumble upon a prejudice by entrepreneurs, workers, and managers that the form and content of work does not constitute a moral concern.

I turned to the academic study of ethics and theology out of a desire to develop resources for alienated workers, those who developed skill and offered care in spite of infrastructures and industries that undermined their best work. It was also my hope that I might identify resources that might provide a better basis upon which to empower frustrated managers who were forced to manage these work-environments rather than improve or alleviate them. The moral quandaries that I experienced seemed to me to be at least in part a failure of imagination and it was my hope that I might be able to illuminate alternative ways of managing and performing work that might prove more edifying. Yet I soon discovered that what I thought to be mere procedural issues were

embedded in more substantial problems in Western political economy. It was quickly apparent that attempts to fine-tune existing structures or to offer workers a therapeutic balm, though helpful, could not provide a truly substantial basis for improvement. These issues of worker dissatisfaction were rooted in a deeper malaise revealing far broader consequences that were not merely human but, in a more encompassing sense, disastrous for the whole created order. Too often, in terms of moral reflection, our industries seem to be a hard-driving engine with no one at the wheel. I arrived at the conclusion that these problems were rooted, to some extent, in the attempt to organise and conduct work "scientifically."

In developing this scientific vision of work, over a century ago, late-Enlightenment thinkers distilled a new vision for what was thought to be a rapidly post-Christian culture. Science was to overtake religion in instilling coherence and order into daily work. Human labour, which had been given a moral shape by religion up until this point, was freed from these fetters and given a new organising principle. Into this brave new world, the science of business and management was formalised in the founding of business schools and trade-oriented colleges. Perhaps the most (in)famous expression of the new science of the management of human labour was developed by Frederick Taylor. It is hard to overestimate the impact of Taylor on current work culture, as Robert Kanigel suggests: "'Scientific management,' as well as its near synonym, 'Taylorism,' have been absorbed into the living tissue of American life."[3] It is important to note that Taylor envisioned this bringing of science into business (like Henry Ford) not as a way to increase the wealth of a few, but as a way of improving the lives of all. In this way, the Taylorist renaissance provided not merely a new procedural basis for organising work, but it also deliberately sought to reconceptualise the basis for moral judgement and the enhancement of human flourishing as a science.

Now, well on our way into the twenty-first century, workers and managers, particularly those concerned with ethics, find themselves back at the drawing board. There is a shared sense of disillusionment among scholars in business and the social sciences with the negative impact of modern labour on human well-being and the loss incurred by the transformations in the constitution of work towards industrialisation and – over the course of the twentieth century – towards an "information economy." A number of writers offer biting critique of contemporary work from a variety of perspectives: chronicling worker mistreatment; criticising media and the psychological science of marketing deception; surveying ecological destruction and social injustice; bemoaning wasteful obsolescence; and noting the steady evaporation of function in our products.[4] As these critical accounts suggest, it is easy to find symptoms attesting that the way we make things is ailing from a moral perspective. Given the Enlightenment

vision described above, it may have been reasonable at the very least to expect an increase in function of the manufactured goods and yet it seems that ethical quandaries and dysfunction only multiply.

In the midst of contemporary political and economic crises, prominent scholars in theological ethics have voiced the conviction that a critical reformulation of modern politics must also involve a reformulation of making, or *poiesis*. The solution cannot just be a fine-tuning of political processes if there is truly something wrong with the very foundations of our conception of work. In fact, as Pope John Paul II put it in *Laborem Exercens*, work may be "the essential key to the whole social question."[5] Yet the reformulation needed is not generic. What is called for, as Michael Northcott suggests, is an ecological reconceptualisation of work that is rooted in Christian political economy precisely because "the perversion of making is at the heart of the ecological crisis and is rooted in Western political economy."[6] In order to argue convincingly that the form and content of our work is a moral endeavour, a reconceptualisation of work is necessary that can restore it to those theological and ecological foundations that had (often cooperatively) provided a moral vision of work for centuries. I believe the Russian Orthodox political economist Sergi Bulgakov is right in his suggestion that this reconceptualisation must redeploy work as a fundamental aspect of both our epistemology and conceptions of political economy.[7]

Scholars have taken a number of different approaches in trying to contribute towards such a reconceptualisation. Even writers coming from a secular perspective have begun to warm to the possible relevance of religious ethics as work theorists, workers, and managers have become disillusioned with their scientific taskmaster and those attempts to order work through the application of value-free "scientific" principles. Given the profusion of corporate scandals over the past decade and the complicity of unscrupulous business practice in the current ecological and economic crises, researchers in business ethics have taken up a new focus on social responsibility in business practice.[8] This new stance also includes an openness to the validity of normative moral frameworks and even towards religious texts.[9] Though these developments are quite recent, they offer some promise for a new *rapprochement*. However, if a conversation between business and theology is to be established, there remains much work to be done. The long tenure of secular disdain among social theorists for religious ethics in the twentieth century has led to a situation where engagement by scholars in business ethics and the sociology of work with religious ethics (with the above examples excepted) are often superficial, leaving few examples of sustained and robust appropriation of what might be considered normative sources for theological scholars.

As I have also hinted above, writing in the theology of work has tended to settle into certain academic siloes. In addition to the examples of strong scholarship

I have mentioned above, there is also a substantial body of non-scholarly literature that represents an effort to rehabilitate work practice based on Christian theological reflection. This exists as something of a self-contained (if substantial) "shadow literature" by Christian writers on business ethics. This is not an insignificant body of writing: there is a 200-page annotated bibliography on the subject, and online storefronts exclusively market written materials and lectures on faith, work, and life integration.[10]

The discourse on the theology of work is not neglected: there is a vast popular literature on the subject that often seeks to appropriate reflection in relation to biblical literature. Yet in spite of the quantity of writing, there are a number of conspicuous gaps that I hope to at least make a start at addressing in this book. First, outside the exemplary accounts in Christian political economy (some of which I have noted above), writers in the theology of work have struggled (as Miroslav Volf has astutely noted) to break away from an unhelpful focus on vocation. This has underwritten a tendency among work theologians to take a therapeutic approach, seeking to offer motivation for "faith" at work. As a study by David Miller suggests, this orientation among Christian theologians may arise as a consequence of the way the "Faith at Work" movement has almost exclusively oriented theological dialogue about work towards apologetic purposes.[11] I do think it is important to remind modern workers that their work matters to God, and yet this therapeutic work is only one piece of a broader task. It is equally crucial to examine the specific inner details of our work from a critical theological perspective. There may be, after all, cases where people are engaged in forms of work towards which God may be less favourably disposed. In seeking to fill in some of these gaps and take the theology of work in new directions, I begin this project in the theology of craft by attempting to set some anchor points in the text of Christian Scripture. Given how craft was a key concern in both early Judaism and Christianity, it is my hope that this will provide the basis for a fruitful reading of Christian Scripture and the early Christian tradition and that this study may also lay down some further planks on a bridge between contemporary writing in the theology of work and Christian political economy.

Work Made Strange: On Using the Bible for an Ethics of Work

At the outset, I suggested that part of the contemporary problem of work is due to a subverted moral imagination. In this way, the decline of meaningful forms of work suffers from the professionalisation of knowledge, which Ivan Illich criticised for "[making] people dependent on having their knowledge produced for them"; this, he argued, "leads to a paralysis of the moral and political imagination."[12] Keeping in mind the widespread nature of the problems with modern

work, I would argue that it may not be most helpful to look in familiar places for resources that might provide a basis for the rehabilitation of work. Instead, it may be the case that modern work needs to be brought into contact with a "strange" world whereby the encounter may awaken us to the true strangeness of what have become all-too-familiar patterns in modern work of destruction, waste, and inhospitality.

The place of craft work *par excellence* in the ancient world was the place of worship. In a text that we often discuss in my teaching on technology, Heidegger hints at this fact in his essay "The Origin of the Work of Art." In commenting on truly authentic work, he describes the significance of a Greek temple:

> It is the temple-work that first fits together and at the same time gathers around itself the unity of those paths and relations in which birth and death, disaster and blessing, victory and disgrace, endurance and decline acquire the shape of destiny for human being. The all-governing expanse of this open relational context is the world of this historical people. Only from and in this expanse does the nation first return to itself for the fulfillment of its vocation. . . . The temple, in its standing there, first gives to things their look and to men their outlook on themselves.[13]

As Heidegger suggests, given its place as a focal point for social and political life, the temple itself served as a paradigmatic work of art, architecture, and building. With this in mind, it seems sensible that the most sustained account of good work to be found in Christian Scripture is in the narration of the construction of the place of worship. For a modern audience, the account of Tabernacle and Temple building that extends across the Hebrew Scriptures and New Testament offers a perfect "strange" moral world, which may offer new insight for contemporary accounts of good work.[14]

I should note at the outset that the approach I am proposing in this book, which respects the strangeness of the moral world of the bible, stands in some tension with some other accounts by modern ethicists who have tended towards a demythologising reaction to the perceived strangeness of the bible. In this way of thinking, strangeness represents either an insurmountable epistemological gap or inferior ancient paradigms. Examples are wide-ranging, but on this topic Miroslav Volf's otherwise very fine and appropriately influential dissertation on work provides just one example of a problematic modern response to the "strange":

> A deep divide separates the world of work in biblical times from work in present industrial and information societies. This ever-widening gap precludes developing a theology of work relevant to our time through the

'concordance method' without placing biblical references within a larger theological framework. *The explicit biblical statements about work are, for instance, more or less irrelevant to fundamental contemporary questions* such as the connection between work or unemployment and human identity, the character of humane work in an information society, and the relationship between work and nature in an age of permanent revolution.[15]

The problem that Volf exemplifies in his approach is the tendency towards a "kerygma" that is abstracted from the actual material circumstances native to the biblical narratives. In this way of thinking, the rich variety of material details preserved in the texts of the bible serves as a distraction from the more important paradigms they adorn. As I shall suggest below, I think it is a mistake both to presume that there is such an "ever-widening gap" and to dismiss an account of work with all its richness and detail simply because it exists in a supposedly primitive agricultural context. In contrast, Brian Brock suggests, rightly I think, "it is not our historical or moral distance from the Bible that renders it foreign to us, nor the gap between time and eternity, but the gap between the ways of God and those of humanity."[16] This gap is insurmountable; and in seeking to mediate the strangeness of the bible, we risk stripping out some of its theological content because it does not come in the expected forms. Instead, in the approach that I take in this book, I propose that one embrace this strange world of goldsmiths, tents, oxen, and land allotments, and see what emerges from that encounter.

One approach to an "alternative world" in which one might seek to inform and reshape contemporary contexts through an encounter with the strange has been commended in the context of biblical study by Mary Douglas with her work *Leviticus as Literature*.[17] In her study of Leviticus, Douglas argues against the liturgical casuistry that has beset other biblical studies that devolve into myopic studies of ritual and item detail, suggesting, "it will not do to reduce the problem by looking for item-by-item meanings."[18] In this way of thinking, the appropriate response to a literary encounter with an alternative world is not to take a mathematical approach, which might result in a catalogue of strange items or a forensic analysis of procedures. Instead, one must seek to grasp at the wider contour of the narrative without bracketing out the material significance of these details. Douglas also warns against looking too quickly for motives behind the practices and eliding the distance between the thought-world of the biblical text and the reader. In her case, this functions with regard to sacrifice, though it also applies more broadly to the themes that I shall examine below.[19] Though Douglas wants to avoid relativising the moral issue at stake behind such a concern, she suggests that our reading ought to simmer longer in the text before proceeding to a crass psychological analysis: "Starting from here no

one is going to understand sacrifice. The assessment of human motives is too immediate, material, and fundamentally secular."[20] Here we come to another potential problem in approaching a "strange" world, as Douglas's approach risks fixing the strangeness of the biblical text in an objective way, as a sort of artefact for sociological analysis. In contrast, I want to commend a reading strategy that borrows from the strengths of this approach especially inasmuch as it can offer an alternative to "kerygma" while focusing more on the biblical text as providing theologically constituted paradigms for practices that themselves can be morally informative.[21]

I shall depart from Douglas in assuming that the field of Christian theology offers a point of continuity between the reader and the text of these Temple-construction narratives. Of course, a huge gap may remain, but some threads of continuity may be grasped in attempting a theologically shaped entrance into the Hebrew thought-world. As I have already noted, in reference to Heidegger above, the centrality of the temple, both in the ancient world and in the Hebrew Bible, suggests that there may be a broader vision or meta-narrative that undergirds these narratives. And, as Margaret Barker argues, we may find that this narrative is woven into the same cloth as the biblical account of creation.[22]

Seen in this way, the practices of worship narrated in the bible provide a means of comprehending these strange texts. On the basis of this conviction, I have structured this study to proceed in Part II with an examination of the interaction between worship and work through a reflection on those practices that sustained the completed Temple (or Tabernacle) building. It is my hope that a closer look at the dynamics at work in these texts may widen our grasp of the moral aspect to the Christian Scriptures that has been greatly neglected by modern Christians.

While I am arguing for a reading of the bible that may bring fresh perspectives to contemporary readers and that celebrates and attends to the alternative world preserved there, it is important that I distinguish my approach here from a reader-response approach such as that commended by Eryl W. Davies in his recent book *The Immoral Bible*.[23] Along with Davies, I suspect that a scientific approach has done nearly as much harm to study of Christian Scripture as it has to the theology of work and consequently I do not intend to interpret the bible in a way such that my conclusions will carry a universal level of normativity in either the liberal or conservative senses. With regard to the latter, I do not think that Christian Scripture is meant to be received as the "command" of God, *if* this has been construed in order to coerce others based on some moral command that I might "discover." Such an instrumentalised approach to Scripture simply does not take into account the pneumatological aspect of bible reading. Neither do I think, however, with regard to a classical liberal approach, that it is

appropriate to attempt to distil the texts of the bible into universal "commands" or paradigms that can have purchase on the wider culture simply by being so generic as to receive wide appeal.

In his book *Singing the Ethos of God* (2007), Brian Brock departs from the "modern obsession with method" and instead approaches exegesis as singing, a metaphor that "draws attention to the way an external word can claim human action and affections and thus be internalized as a way of life."[24] Following Wittgenstein, Brock argues that when we enter "language worlds" they can "orient and shape our lives."[25] This approach construes exegesis as "an ineradicably social 'acoustic space,' within which one learns practical skills of handling and appropriating Scripture."[26] Put in another way, one learns how to handle a text in the midst of reading and re-reading (or singing, as Brock puts it). I find Brock's account compelling, not least because it offers a far more dynamic account of the interaction between reader, text, and the ultimate divine author. In this account, the most indigenously Christian approach to biblical ethics is not to abstract analogical concepts that can be used to distil the biblical materials for moral reflection, but to practise and explicate a faithful form of communal exegesis that can then inform moral deliberation. Along these lines, Brock argues, "A good book is always better than its summary, and, as such, Scripture cannot be summarized. Nor can the exegetical tradition through which we approach it."[27] Brock's strategy is not, then, to avoid analogies altogether, but rather to de-emphasise them as the unifier of Scripture and to redirect attention to the reading by ecclesial community across space and time:

> The metaphor of grammar has the advantage of emphasizing the dynamic and interpretative nature of reading and living. We 'apply' images but 'enact' or 'sing' within a grammar; and 'singing' draws out much more forcefully the recurring return to the text of Scripture and life that the 'application' of 'images' does not so naturally emphasize.[28]

Of some note for my approach in this book, Brock suggests that this reading strategy, which is "attentive to the nuance of Scripture and the way it links with our experience[,] is best understood *as a craft*."[29] This is a way of reading Scripture, I would argue, that has provenance in a more ancient form of exegesis. As I hope to demonstrate by this study, the bible simply has more to offer than some theological exegetes have suggested by the themes they constantly regurgitate with respect to the topic of work. While I cannot fully take up this task here, keeping this ancient connection in mind, I have sought to strengthen my own conclusions in this book with parallel research in patristic moral reflection

and my reflection here will seek to illuminate the text in its ancient and classical contexts.[30]

I follow Brock and part ways with Davies in seeking to read the bible for a believing community, with the aim that it might reacquaint specifically Christian communities with neglected aspects of their Scriptures and the moral implications that these texts may have for contemporary work.[31] This is why I shall mostly use the term "Christian Scripture" in this study. The philosophy and ethics of work have suffered quite long enough under the un-situated "democratized self," which, as Alasdair MacIntyre notes, is infinitely plastic and ultimately empty.[32] My purpose in pursuing an ecclesial reading is, in this way of thinking, not merely a parochial concern, but rather represents intellectual honesty and, following MacIntyre, a form of resistance to those Enlightenment approaches that are so deeply implicated in the contemporary work problems I have already noted. The major consequence of this ecclesial dimension to my reading strategy is my attempt, particularly in Part II of this study, to place the task of exegesis in relation to the complex of practices that also compose a substantive part of the activities of the Christian community.[33] It is also important to note that, in taking up an ecclesially embedded approach, I do not intend for this study to serve exclusively sectarian ends. Quite to the contrary, I shall elaborate below a number of ways in which the moral vision elucidated here is commensurable with insights developed in the contemporary craft theory and business ethics. These insights come from a wholly secular marketplace and share little – at least overtly – of the theological foundation upon which I have sought to construct this account of moral work. However, as several other scholars in Christian ethics have recently argued, this apparent incommensurability on the level of first principles need not necessarily prevent one from expecting points of engagement. In particular, as Luke Bretherton has argued, drawing upon Oliver O'Donovan's moral philosophy, we may yet find some *ad hoc* commensurability at the level of practices with our secular neighbours. As Bretherton notes, "This *ad hoc* commensurability is grounded in the reality not only of Christians sharing the same moral field as their neighbours, but also the work of the Spirit breaking the eschatological reality in among all people everywhere."[34]

Keeping these hermeneutical considerations in mind, in this book, I shall present a partial attempt to rehabilitate resources for a reformulation of the ethics of work through exegesis of Christian Scripture. I shall bring this exploration of the primary sources of Christian faith into contact with contemporary research in craft theory, the sociology of work, and business ethics in order to seek out insights for the moral organisation of human labour that may offer a profound and robust challenge to scientific work-management on its own terms. I shall seek to confront the dichotomies and incoherencies latent in

so-called "scientific" management of labour in order to bring into sharper relief the relevance of the moral vision of work preserved in Scripture.

A Method for Synthesising Ethics and Exegesis

Keeping in mind the basic posture that I have outlined above, some comments are in order as to how this more abstract posture will translate into specific methodological commitments. In this book, I have pursued an approach to reading Christian Scripture that can engage with the text of Christian Scripture on its own terms rather than making this encounter with otherness the basis for a truncated or eclectic reading. More specifically, this represents an attempt to respect the integrity of the canonical text in its received form as it has been authorised by Christian communities over time. This is something of a departure from the positivistic scientific study of the bible that seeks a detached scientifically objective reading. As John Webster has suggested, the approach I am taking here may be expressed as a form of textual attentiveness: "what is involved in reading this text is determined by this text."[35] In the case of this study, attention to the text works out in three practical ways, with my pursuit of a reading that is (1) canonically oriented, (2) ecologically sensitive, and (3) theologically constituted.

As I have already mentioned above, particularly in the theology of work, while the bible is often appropriated in reflection on work ethics, this is often a recitation of the same few texts (i.e., Genesis 1–3, Leviticus 25 – the jubilee texts, or Luke 10:7, "the worker deserves his wages") or a narrow range of themes (sabbath,[36] toil, etc.).[37] Useful and interesting though these appropriations may be, to put it in Brock's terminology, on the subject of the theology of work, we are apparently "singing" a very short song. One of the benefits of tracing Tabernacle- and Temple-construction narratives is that they are scattered in all sorts of places across the bible and sustaining our attention on the same theme across a number of texts offers the possibility that one might let each unique voice further augment the "texture" of a larger moral account. This also provides an opportunity to examine biblical themes and texts that are quite often neglected by ethicists.

With this wider canonical strategy providing the basis for a commitment to a wider scope of Christian Scripture, I take up a second reading strategy – ecological attentiveness – in order to tether my reading to the *real* material details of Scripture. One of the primary concerns that any study of work in Christian Scripture must confront is the apparent distance between the agricultural work context of biblical texts and the contemporary post-agricultural context of many modern businesses. In the former, though this was not exclusively the case, work was predominantly agricultural. In contrast, in the present day, particularly in

light of the industrialisation of agriculture and widespread urbanisation (over 80 per cent of people in Britain and America live in urban contexts), the average person will likely have little first-hand knowledge of agricultural work. In addition to my attempt to provide a textured moral account that draws in several "voices" through an intertextual reading across the canonical text of Christian Scripture, I attend to this substantially agrarian text by performing what might be termed an "agrarian" or "ecological" reading.

Given that my analysis in this book is aimed more at craft work than agricultural work, I need to unpack exactly what I mean by this. In her recently published volume *Scripture, Culture, Agriculture*, Ellen Davis offers an ecological hermeneutical awareness that she describes as an "agrarian" reading.[38] What has not yet perhaps been fully appreciated about Davis's approach is the way in which she – along with several contemporary Christian environmental ethicists including Michael Northcott, David Clough, and Tim Gorringe – offers an approach to Scripture not just with a focus on ecological or agricultural themes but rather with a way of grasping and deploying the unity that lies behind themes of technology, work, and environment as they are already present in the Hebrew Scriptures. Following the prolific American essayist and self-titled Agrarian Wendell Berry, Davis observes how the farmer's perspective provides a more coherent frame for a number of moral issues that modern urban people tend to dichotomise: "It is whether we use natural systems wisely and gratefully, or conversely, disregard and abuse the systems upon which we and other organisms depend. With respect to our use of arable land, the most important question is whether we can learn to practice agriculture that works like ecosystems, in all our various habitats."[39] In this way, Scripture offers an integrated and ecological vision of human moral life as "the conscious part of the ecosystems we necessarily inhabit."[40] In Davis's account, this is the fundamental moral question concerning good agriculture and she argues that this question is a fundamental concern behind the vision of justice narrated in Christian Scripture. For Davis, sustained attention to the particularised visions in the text of Scripture provides a reliable basis for judging and reconstructing particularised visions for our present quandaries. Following this concern, in this book, I shall attempt to attend to the specifically ecological contours of the visions of good work in Christian Scripture in its original agrarian context in order to retrieve some of the moral vision embedded in Scripture for contemporary workers. This includes ancient philosophy of work, which was quite often an agrarian concern. In this way, I acknowledge that craft work in the ANE, in the best instance, functions as part of the ancient agrarian economy and philosophical reflection on work (though this is not always explicitly noted) is part of a broader ancient agrarian enterprise. In order to fully appreciate the account of good work presented there, one must keep in mind this ancient context. Thus this reading offers a

form of retrieval, or of healing what I consider to be a surmountable estrangement between the modern industrial context and the pre-modern agrarian one. I mean to demonstrate that moral reflection on those forms of work that are prevalent in agrarian societies may be relevant to the present-day work problems. This is true not least partly because those agrarian societies had a sharper sense of their ecological limits. The modern conception of work that presumes it is possible to operate outside ecological limits stands in stark contrast to the witness of Scripture. There is a long tradition that defines the act of human labour by the ways in which we distinguish ourselves against nature. Fabrication, in this way of thinking, is a departure from material limitation and contingency and human labour is a phenomenally defining departure from our contingency and relation to the "natural." Quite contrary to this dichotomy, in the account I am providing here, a Christian account of worship and the resonant account of moral work respects God's good act of creation and seeks to operate within material and bioregional limitations rather than transcend them. The account that we find in Scripture, as Northcott suggests, makes regular reference to a balanced and ordered engagement with non-human creation and this dynamic is a purposive and moral one.[41] In this way, a biblical theology of craft, such as the one that I am developing in this book, is enabled by this agrarian/ecological sensibility.

The third dimension to my reading strategy, pursuing a theological reading, brings me into some conflict with biblical-critical studies of the theme of work in Scripture. As I have already implied above, one finds in many contemporary scholarly studies on work in the bible by biblical-critical scholars, a reluctance to draw normative theological or ethical conclusions.[42] Though they come to the deduction in different ways, "theologies of work" and historical-critical studies of work in the bible share in this tendency to conclude that the bible is "ambiguous" on the subject of work. While biblical-critical scholars may be content to rest with this conclusion, some theological scholars build on this supposition to conclude that more conceptual systematics may serve as a substitute or referee for the (supposedly) terse content of Scripture. Along these lines, in his otherwise very fine study *The End of Work*, John Hughes provides a brief survey of the biblical account of work and suggests, "Human work has been viewed as having a profoundly ambiguous nature throughout the Christian tradition. In the Scriptures apparently differing views lie side by side, and cannot easily be separated."[43] I highlight this tendency among the literature in order to explain my stress on a theological reading strategy in spite of my close textual focus. In particular, this theological orientation leads me to presume that there is a theologically construed continuity to be found among the various texts of Scripture. In looking for continuity, I do not mean to suggest that the biblical narrative regarding work is not complex, and to some extent one must acknowledge that it is appropriate

to highlight the complexity of the biblical account on work. However, to appreciate complexity does not require the conclusion that the text is ambiguous and provides no guidance for a moral–theological account of work. This theological focus also dovetails with what I have detailed above as a Canonical reading with its emphasis on the final received form of the text. There are several methodological implications of this theological approach. I shall avoid spending my interpretive energy reconstructing redactive layers, presumed authorial strata, or form-critical units that lie behind the text we have. Similarly, I shall not engage in creative reconstruction of texts, entertain interpretation based on an imagined original author or date for a particular text, or entertain formal divisions that are not supported by broad (and theologically construed) consensus. A theological reading need not make exegesis unhistorical, or even neglectful of redactive dimensions that may be evident in the text, though I shall be less optimistic than some contemporary biblical scholars about this possibility.[44] One benefit of this approach is that it enables me to redirect attention to texts that have been historically neglected without excessive justification in response to Wellhausen's famous disdain for (supposed) "priestly literature" including a considerable portion of worship texts. It is my hope that the reader will see the benefit of the ecologically sensitive theological approach that I shall deploy in this study, particularly in the recovery of attention to worship texts and agrarian themes that have been substantially neglected in modern biblical study.

Content and Structure of This Book

The chapters of this study are divided into two parts. In Part I, I begin with a sustained look at the details of "good work" as narrated in the Tabernacle-construction account in Exod 25–40 and then proceed in subsequent chapters to similar analysis of other biblical Temple-construction accounts. This is a deliberately intertextual study; and as I attend to the transformation of the meaning and significance of the Tabernacle/Temple across the Hebrew Scriptures and NT, I shall fill out and nuance my account of moral making by attending to themes such as agency, sociality, skill and wisdom, and the material culture of work. Of particular interest are the uses of Temple building in eschatological and ecclesial analogy. I conclude this chapter with some examination of the significance of these metaphorical appropriations for work ethics and I provide an account of the coherence of the ethics of work as it is presented in these various texts. As Tim Gorringe has observed in his *Theology of the Built Environment*, Paul's epistles are filled with the language of building, and so this first part overlaps with the second as I note how the church becomes both the product and the site of moral work.[45] This leads me to Part II of the book, where I develop a more detailed account of the relational dynamic between work and

worship as it is delineated in Christian Scripture. As I have already suggested above, I mean for this study to carry some purchase on the contemporary practices of Christian communities, and so my account in this second part is meant to explicate the dynamic between work and worship in order to generate some possible avenues for a rehabilitation of the moral life of Christians *through* worship. The regular recourse in post-Enlightenment studies of ritual and liturgy towards a sacred/profane typology can often produce a dichotomised account of the relationship between work and worship. In this study, I again begin with the Hebrew Scriptures and then pursue explicit intertextual study, plumbing the priestly work-vocation for resonances and distinctions with the notion of work for Jesus, his disciples, and the apostle Paul in the NT. The primary question here is regarding the shape of this relationship between the peculiar contexts brought about in "worship" and the more domestic of one "work." Finally, I conclude with a study of offertory practices. Here I bring my attentiveness to work themes to bear on a sustained reading of offerings, sacrifices, and tithes. As is the case with previous chapters, much hinges on our navigation of the transition between the Hebrew Scriptures and the NT. With this in mind, I shall develop an account of the specific dynamics of the work/worship relationship that arise from a sustained look at non-expiatory offertory rituals. In particular, I shall argue that the notion of consecration may be a suitable theological term for describing the relationship that I have identified in earlier chapters between work and worship. I argue that the proper performance of worship necessarily entangles the ordinary work of the people of God, and that too clean a distinction between these can only survive in the midst of blasphemous worship.

Notes

1 Roger Coleman, *The Art of Work: An Epitaph to Skill* (London: Pluto Press, 1988), 6.
2 See Pope John Paul II, *Laborem Exercens* (London: Catholic Truth Society, 1981); Miroslav Volf, *Work in the Spirit: Toward a Theology of Work* (New York, NY: Oxford University Press, 1991); John Hughes, *The End of Work: Theological Critiques of Capitalism*, Illuminations: Theory & Religion (Malden, MA: Blackwell, 2007).
3 Robert Kanigel, *The One Best Way* (New York, NY: Viking, 1997), 6.
4 Regarding the decline of truthfulness and the increase of manipulation in the marketing of the contemporary products of work, see Naomi Klein, *No Logo: Taking Aim at the Brand Bullies* (New York, NY: Picador, 2000). For the rise of consumerism, see John De Graaf, David Wann, and Thomas H. Naylor, *Affluenza: The All-consuming Epidemic* (San Francisco, CA: Berrett-Koehler, 2005). On ecological destruction and the increasingly poisonous character of modern goods, see the now classic texts Rachel Carson, *Silent Spring* (Boston, MA: Houghton Mifflin, 2002) and Murray Bookchin, *Our Synthetic Environment* (New York, NY: Harper & Row,

1974). On the increasing dissatisfaction with work in the UK context, see Madeleine Bunting, *Willing Slaves: How the Overwork Culture is Ruling Our Lives* (London: Harper Perennial, 2004). On injustice in contemporary industrialised work, see Robert H. Frank and Philip J. Cook, *The Winner-take-all Society: Why the Few at the Top Get So Much More Than the Rest of Us* (New York, NY: Penguin Group USA, 1995). On the problem with modern manufacture, see William McDonough and Michael Braungart, *Cradle to Cradle: Remaking the Way We Make Things* (New York, NY: North Point Press, 2002); Giles Slade, *Made to Break: Technology and Obsolescence in America* (Cambridge, MA: Harvard University Press, 2006); Richard Sennett, *The Craftsman* (New Haven, CT: Yale University Press, 2008).

5 Pope John Paul II, *Laborem Exercens*, §3, "The Question of Work, the Key to the Social Question."

6 Michael S. Northcott, *Moral Climate: The Ethics of Global Warming* (Maryknoll, NY: Orbis Books, 2007), 154.

7 Sergei Bulgakov, "The Significance of the Basic Economic Functions: Consumption," in Catherine Evtuhov (ed. and trans.), *Philosophy of Economy: The World as Household* (New Haven, CT: Yale University Press, 2000 [1912]), 95–122.

8 Cf. S. Brammer, Geoffrey Williams, and John Zinkin, "Religion and Attitudes to Corporate Social Responsibility in a Large Cross-country Sample," *Journal of Business Ethics* 71, no. 3 (2007): 229–43; David Kim, Dan Fisher, and David McCalman, "Modernism, Christianity, and Business Ethics: A Worldview Perspective," *Journal of Business Ethics* 90, no. 1 (2009): 115–21; Edwin M. Epstein, "Religion and Business – the Critical Role of Religious Traditions in Management Education," *Journal of Business Ethics* 38, no. 1 (2002): 91–6. This is also supported by a new wave of empirically based scholarship: along these lines see Martin Calkins, "Recovering Religion's Prophetic Voice for Business Ethics," *Journal of Business Ethics* 23, no. 4 (2000): 339–52; Gary R. Weaver and Bradley R. Agle, "Religiosity and Ethical Behavior in Organizations: A Symbolic Interactionist Perspective," *The Academy of Management Review* 27, no. 1 (2002): 77–97.

9 Cf. Edwin M. Epstein, "Contemporary Jewish Perspectives on Business Ethics: The Contributions of Meir Tamari and Moses L. Pava: A Review Essay," *Business Ethics Quarterly* 10, no. 2 (2000): 523–41; Meir Tamari, "Ethical Issues in Bankruptcy: A Jewish Perspective," *Journal of Business Ethics* 9, no. 10 (1990): 785–9; David Escobar, "Amos & Postmodernity: A Contemporary Critical & Reflective Perspective on the Interdependency of Ethics & Spirituality in the Latino-Hispanic American Reality," *Journal of Business Ethics* 103, no. 1 (2011): 59–72; Jonathan Aitken, "The Market Economy and the Teachings of the Christian Gospel," *Economic Affairs* 24, no. 2 (2004): 19–21; David Molyneaux, "'Blessed Are the Meek, for They Shall Inherit the Earth' – An Aspiration Applicable to Business?," *Journal of Business Ethics* 48, no. 4 (2003): 347–63; Moses L. Pava, "The Path of Moral Growth," *Journal of Business Ethics* 38, no. 1/2 (2002): 43–54. This openness does not preclude a continued hostility towards religiously based moral frameworks in other scholarship.

10 Pete Hammond, R. Paul Stevens, and Todd Svanoe, *The Marketplace Annotated Bibliography: A Christian Guide to Books on Work, Business & Vocation* (Downers Grove, IL: InterVarsity Press, 2002). See also http://www.faithandworkresources.com/ and http://www.allthingsworklife.com/ (accessed 12 April 2010).

11 See David W. Miller, *God at Work: The History and Promise of the Faith at Work Movement* (Oxford: Oxford University Press, 2007).

12 Ivan Illich, *Tools for Conviviality* (London: Calder and Boyars, 1973), 85–6.
13 Martin Heidegger, "The Origin of the Work of Art," trans. Albert Hofstadter, in *Basic Writings*, ed. David Farrell Krell (New York, NY: HarperCollins, 1993), 167–8.
14 For an account of a similar kind of "hermeneutic of strangeness," see Jonathan Morgan, "Land, Rest & Sacrifice: Ecological Reflections on the Book of Leviticus," PhD Diss., University of Exeter (2010), 15–22.
15 Volf, *Work in the Spirit*, 77. *Emphasis* mine.
16 Brian Brock, *Singing the Ethos of God: On the Place of Christian Ethics in Scripture* (Grand Rapids, MI: Eerdmans, 2007), xv.
17 Mary Douglas, *Leviticus as Literature* (Oxford: Oxford University Press, 1999).
18 Douglas, *Leviticus as Literature*, 75.
19 Douglas, *Leviticus as Literature*, 66.
20 Douglas, *Leviticus as Literature*, 66–7.
21 I am synthesising here, in some ways, the approach outlined by Oliver O'Donovan in several monographs, summarised helpfully in Craig G. Bartholomew, *A Royal Priesthood? The Use of the Bible Ethically and Politically: A Dialogue with Oliver O'Donovan* (Carlisle: Paternoster Press, 2002); and the approach commended by Brian Brock in *Singing the Ethos of God*.
22 See Margaret Barker, *Creation: A Biblical Vision for the Environment* (London; New York, NY: T&T Clark, 2010), 20.
23 Eryl W. Davies, *The Immoral Bible* (London: T&T Clark, 2010).
24 Brock, *Singing the Ethos of God*, xvi.
25 Brock, *Singing the Ethos of God*, xvi.
26 Brock, *Singing the Ethos of God*, xiii.
27 Brock, *Singing the Ethos of God*, xiii.
28 Brock, *Singing the Ethos of God*, 251.
29 Brock, *Singing the Ethos of God*, 259. *Emphasis* mine.
30 For more detailed inquiries into the patristic context, see my "Labour," in Karla Pollmann and Willemien Otten (eds), *The Oxford Guide to the Historical Reception of Augustine*, 3 vols (Oxford: Oxford University Press, 2013), 3:1268–73; "Radical or Realist? The Ethics of Work in John Chrysostom," in Jeremy Kidwell and Sean Doherty (eds), *Theology and Economics: A Christian Vision of the Common Good* (New York, NY: Palgrave Macmillan, 2015), 127–42; and "Nature and Culture in Augustine, a Patristic Spiritual Ecology?," in Teresa Delgado, John Doody, and Kim Paffenroth (eds), *Augustine and the Environment* (*forthcoming*, Lanham, MD: Lexington Books, 2016).
31 Along these lines, see Stephen E. Fowl and L. Gregory Jones, *Reading in Communion: Scripture and Ethics in Christian Life* (Eugene, OR: Wipf & Stock, 1998).
32 Alasdair C. MacIntyre, *After Virtue: A Study in Moral Theory*, 3rd edn (Notre Dame, IN: University of Notre Dame Press, 2007), 32.
33 For a resonant account in a slightly different context, see Michael Northcott, "Loving Scripture and Nature," *Journal for the Study of Religion, Nature & Culture* 3, no. 2 (2009): 247–53.
34 Luke Bretherton, *Hospitality as Holiness: Christian Witness amid Moral Diversity* (Aldershot: Ashgate, 2006), 111.
35 John Webster, "Reading Scripture Eschatologically," in David F. Ford and Graham Stanton (eds), *Reading Texts, Seeking Wisdom* (Grand Rapids, MI: Eerdmans,

2003), 245–56, at 246, cited in Murray Rae, "On Reading Scripture Theologically," *Princeton Theological Review* 14.1, no. 38 (2008), 15. As Rae notes, the affirmation that the mode of reading a text should arise out of the object under consideration comes from Karl Barth in his *Romans* commentary. The foundational epistemological claim finds expression later by "the Scottish philosopher John Macmurray, who insisted that the nature of the object must prescribe the mode of knowing" (15).
36 See particularly the classic treatment in Karl Barth's CD III/1.
37 This is lamented at length by John Robert Jackson in his dissertation, "Enjoying the Fruit of One's Labor: Attitudes toward Male Work and Workers in the Hebrew Bible" (PhD Diss., Duke University, 2005), 2.
38 Ellen F. Davis, *Scripture, Culture, and Agriculture: An Agrarian Reading of the Bible* (New York, NY: Cambridge University Press, 2009).
39 Ellen F. Davis, "The Agrarian Perspective of the Bible: A Response to James A. Nash, 'The Bible vs. Biodiversity: The Case against Moral Argument from Scripture,'" *Journal for the Study of Religion, Nature & Culture* 3, no. 2 (2009): 264.
40 Davis, "Agrarian Perspective," 264.
41 Michael S. Northcott, *The Environment and Christian Ethics* (Cambridge: Cambridge University Press, 1966), 164. Cf. also William P. Brown, *The Seven Pillars of Creation: The Bible, Science, and the Ecology of Wonder* (Oxford: Oxford University Press, 2010), 47.
42 Cf. Göran Agrell, *Work, Toil, and Sustenance: An Examination of the View of Work in the New Testament, Taking into Consideration Views Found in the Old Testament, Intertestamental, and Early Rabbinic Writings*, trans. Stephen Westerholm (Lund: Verbum, Håkan Ohlssons, 1976), 92.
43 Hughes, *The End of Work*, 22–4.
44 In particular, I shall attempt to attend to points of difference between the LXX and MT when relevant. I shall, however, following Childs, prioritise the MT in my study of Hebrew Scripture here. Cf. Brevard Childs, *Introduction to the Old Testament as Scripture* (London: SCM, 1979), 69–106; cf. also the discussion on 659–71.
45 Timothy Gorringe, *A Theology of the Built Environment: Justice, Empowerment, Redemption* (Cambridge: Cambridge University Press, 2002), 1.

Part I
Moral Making
The Construction of the Place of Worship

1 Building the Tabernacle

Nearly every book in the past decade on work by a theologian or Christian ethicist has included some brief reference to the Tabernacle account in Exodus.[1] This attention is not unwarranted, as the narrative of Tabernacle construction is one of the most extensive ancient accounts of craft work. For this reason, the Tabernacle forms a crucial starting point for the conversation I mean to set up in this book between ancient conceptions of craft work and modern forms of work. Through a reading of the Tabernacle text, I aim to highlight a series of critical questions that the ancient context raises for the modern worker about the form and content of our work. It is also important to begin with the Tabernacle because the biblical account of the Tabernacle's construction establishes the paradigm by which subsequent worship-construction narratives are morally explicable. In addition to the ethical issues raised by this strange ancient craft context, this final point regarding the paradigmatic nature of the Tabernacle account serves as one of the main biblical-critical arguments I attempt to raise in this book.

Though it may not immediately occur to the reader of Exodus that the latter chapters of the book are useful fodder for contemporary ethical reflection, a moral reading is actually suggested by several features in the text. On a superficial level, the Tabernacle account is the lengthiest account of work in the bible: it spans a third of the whole book of Exodus. On a literary level, this paradigmatic account of human work includes a number of parallels with the construction by YHWH of Eden, a narrative of divine Temple construction.[2] In underlining the relation between these two texts, Joseph Blenkinsopp observes that there are three primary points in the history of Israel where "work conclusion" formulae appear: (1) in Genesis 2:1–2, with the creation of the world; (2) in Exodus 39:32/40:33, with the "construction of the wilderness sanctuary and its appointments"; and (3) in Joshua 19:51, at the point of "dividing the land among the tribes after the setting up of the wilderness sanctuary at Shiloh."[3] Along these lines, it can be said that the events that follow Israel's deliverance from Egyptian slavery narrate a recapitulation of the creation account in

Genesis. The elaborately described construction project presents a re-creation of the people of Israel, marking their first free labour since delivery from Egypt. This final point serves, in my view, as the most compelling reason to think of the crafting of the Tabernacle as a paradigmatic account of valorous work. Though I shall turn later in this chapter to some more in-depth analysis of the correspondence between the human construction described in Exodus and the divine act of creation described in Genesis,[4] I begin with a reading of the Tabernacle as a platform upon which to look forwards through Scripture to later Temple construction accounts and also backwards to the paradigms set in the cosmology of Genesis.

Ellen Davis has recently drawn attention to the Tabernacle account in Exodus as an *ethical text* that speaks with incisive prophetic critique to slothful work. We find this critique in the midst of a worship setting, precisely because, as Davis relates, "It takes some imagination to confess poor work as sin, because 'claiming the truth that reveals this sin requires a wholly revised view of the world.'"[5] In the Tabernacle account, the activity of constructing a worship space serves to create a new, morally ordered world that can offer insight to our present moral approach to work. In a resonant way, in his study of the Tabernacle, Mark K. George argues that space can be discursive (in the sense of discourse detailed by Foucault in "Of Other Spaces") and conveys, among many things, the values and priorities of a society: "in addition to its physical and mental aspects, space is something that has social meanings, values, and significations bound up with it."[6] This description of such a free-floating piece of space carries a moral aspect particularly because "it is infused with social meanings particular to Israel, and includes Israel's understanding of how to relate to its God and the rest of creation."[7]

In spite of its popularity for citation by Christian ethicists, this portion of Exodus has not been a popular candidate for close study. In one of the few modern biblical-critical studies on the Tabernacle, Frank Cross sets the situation in latter Exodus studies:

> The Tabernacle is no longer of interest to Christendom as a whole. Scholars from time to time delve into the tedium of its installations, but by and large theologians and preachers look elsewhere for Biblical insights. In past generations this was not true. Few students of the Bible were without ideas as to how the Tabernacle should be reconstructed from the Biblical data. Its attendant theological concepts were heralded from the pulpit as setting forth the ideal age of Israel, the prototype of the Kingdom of God, and the typology of the New Covenant.[8]

Amidst those twentieth-century studies that do exist, most focus on formal features of the text or offer comparative analysis with other related ANE

documents.[9] Yet, as Cross notes, the twentieth-century dismissal of the latter half of Exodus is peculiar to modern biblical-critical scholarship. There is a great deal of pre-modern literature emphasising the importance of the Tabernacle account. One also finds appeal to the importance of the Tabernacle narrative in Rabbinic materials and in the NT.[10] It is my contention, as I suggested in the Introduction, that some of the modern neglect of this text is due to its strangeness. Ironically, there is good reason to believe that the *strangeness* of the text is actually intended by its authors. While a superficial reading of the Tabernacle text might lead a casual reader, dizzy at the extensive material detail in Exodus, to conclude that the genre of the text is an architectural or building plan, this is not actually quite right. In spite of the substantial amount of detail present, recent critical scholarship on Exodus has noted that – as with the survey lists and ritual instructions I shall discuss in later chapters – the Tabernacle does not readily conform to this genre. As George notes, "objects that are not essential to the practice of Tabernacle space, such as the plates, dishes, flagons, and bowls used with the table for the bread of the Presence, are not described in detail, beyond their being made from pure gold."[11] Similarly, details that would be required to reconstruct the Ark itself are missing.[12] This observation should give some pause to those writers who draw too quickly on the language of design in Exodus and find in Bezalel a revalorisation of architecture and engineering while missing the fact that an architect could not actually reconstruct a Tabernacle from the details provided. Given this feature of the text, it would seem that the Tabernacle narrative is meant to convey something slightly different. George provides the insightful observation that the description provided by the writer is visually oriented. Instead, we find:

> The descriptions of the ark and *kappōret* . . . are from the perspective of someone other than their builder or designer, someone who knows and experiences Tabernacle space by walking through it. They are not blueprints. This choice of perspective is a social action, one resulting in a different social understanding and appropriation of space than space described by means of blueprints.[13]

George's argument is complemented by a recent dissertation by Amy Robertson, who argues in a similar fashion that the latter portion of Exodus offers a liturgical poetics. According to Robertson, the difficulties in reading caused by intentional gaps in detail are meant to commend a visual and liturgically oriented contemplative reading. As she puts it, "The waxing and waning of proximal literary patterns and the significant variety present within those literary patterns creates a veritable literary symphony and, needless to say, facilitates a complex reading experience."[14] Following these scholars, I want to argue for the possibility that the Tabernacle narrative is not written in an arcane architectural

genre only fit for ancient builders, but is intended for a wider audience and is provided precisely for the sort of moral reading I shall undertake in the material that follows. As Propp suggests, "Rather than fault the Priestly Writer for imprecision, we might conclude that we are not meant to understand, lest we make a Tabernacle ourselves."[15] Seen in this way, the task of preserving the details of the Tabernacle is instrumental to a broader purpose, in which an alternative moral universe is offered up in visual detail for our inspection and edification. This descriptive exhaustiveness has turned away other readers, but, as will be demonstrated below, sifting through these details can actually be quite instructive. With this in mind, I shall undertake some "sifting" in this chapter by presenting several broadly consistent refrains of the Exodus Tabernacle text and with explication of potential moral dimensions conveyed there. This will begin with a study of the meaning of the "divine pattern" revealed to Moses, which opens the narrative. I then continue on to examine the role of wisdom, before exploring the sociality of the work exhibited in Exodus.

Agency and Design in Exodus 25: Anthropology and Work

I have suggested above that it may not be quite right to read the Tabernacle instructions narrowly as a faithfully preserved architectural instruction for the reconstruction of the Tabernacle, but the narrative nonetheless begins with an emphasis on design. Exodus 25:9 is important for setting out the sort of instructions that are to follow and, by extension, the sort of theological paradigm that is expressed by the Tabernacle construction. Among early Christian writers, the opening section of the Tabernacle account and particularly Exod 25:9 is seen as establishing a prototype for the Christian church.[16] This is noted by Ephrem the Syrian:

> By saying [to him], 'You shall make everything according to the model of the Tabernacle that I will show you,' he first called it a model and a temporal Tabernacle to indicate that it was transitory and that it would be replaced by the church, the perfect prototype which lasts forever. And so . . . they would esteem it because of its likeness to the heavenly Tabernacle.[17]

In Exodus 25, YHWH's speech to Moses emphasises fidelity to the specific instructions, "*Exactly* as I show you concerning the pattern of the Tabernacle, and of all its furniture, so you shall make it" (*emphasis* mine). Further, given the parallels with Genesis I have already noted, this instruction does not imply mere fidelity to instructions, but also conformity to the pattern set by the *great* architect.[18] One can also note that, rather than narrowly affirming the vocation of engineers and architects, these instructions seem to commend a broader

anthropological affirmation of the human person (and bearer of the *imago Dei*) as a *technical* creature: in some sense, both the divine pattern and the expectation of human conformity to it suggests that humans are *made* for work.

This affirmation is one that must be made carefully, narrowly, and construed in contrast to a number of competing options among ancient work philosophy. There are, in fact, many ways to affirm the human capacity for fabrication and conformity to design. In seeking to refine this suggestion, there are several distinctions that will serve to further elaborate my affirmation here of the *centrality* of work to human existence. First, it is important to note that the technical work on display in the Tabernacle narrative is only one of two opposing approaches to the human proclivity to work in the bible. As most craft workers will know, there is good and bad work. The Hebrew Scriptures, and particularly Exodus in this case, are oriented around exposition and response to good work that glorifies God and edifies God's people, and bad work that destroys human agency and enslaves God's people to foreign purposes. Ellen Davis has developed this suggestion with particular attention to Exodus. As she notes, the book contains dual 13-chapter treatments of absolute contrasts, perverted work and divinely mandated work:

> Exodus is setting before us two lengthy, vivid pictures. In the first thirteen chapters, we see Israel enslaved in Egypt, trapped in 'that iron furnace' (Deut. 4:20), the great industrial killing machine of Pharaonic Egypt. There Israel builds store cities for a king so deluded he thinks he is a god. Then at the other end of the book, thirteen chapters portray Israel's first concerted activity in freedom. Israel's first 'public work' is to build a sanctuary for her God, who is of course the real God. These two long narratives at beginning and end are a sort of unmatched pair, designed to contrast absolutely. They are respectively, perverted work, designed by Pharaoh to destroy God's people, and divinely mandated work, designed to bring together God and God's people, in the closest proximity possible in this life. That is what worship is for.[19]

Davis is right to emphasise this contrast, and I would affirm that the broader structure and particular content of this Exodus narrative emphasises how humans are made for work in a generic way, and that we are made to perform *good* work. In this way, Exodus affirms a moral or normative aspect to this human vocation that undergirds my emphasis on design at the outset of the Tabernacle construction.

Having focused this affirmation, it is also important to resist another tendency in discussions of work and set up an unduly specific account of "good work." In contrast to the robust affirmation of work as an anthropological

category that I offer here, some readers have attempted to find a "naturalist" approach in texts elsewhere thought to express reluctance towards human technical expression such as Exod 20:25 and Deut 27:5. In the Exodus instance, we find the repeated instruction, "if you make me an altar of stone, you shall not build it of hewn stones, for if you wield your tool [*ḥrb*] on it you profane it" (20:25). The implication here seems to be that iron tools are just one step too far along. One way of accommodating this text might be to suggest that there is a tension in Exodus between a naturalist anthropology, wherein human persons are made for non-technical subsistence (i.e., hunting and gathering) and a more technically oriented one wherein we find human identity involving, to a certain extent, craft and manufacture. I am reluctant to go down this road, as it can quickly facilitate a work/leisure dichotomy. Further, the text does not necessarily warrant such a conclusion. The term *ḥrb* may refer to a chisel, or more generically to a tool, but, as Peter Enns notes, "The root חרב is used almost exclusively in the contexts of fighting and warfare."[20] Keeping this in mind, we may read the instruction here as possessing a humanistic dimension. Levenson makes a case to this effect:

> Underlying this humanism is the assumption that the Temple is above the realm of ordinary politics, with its wars and bloodshed. It was, in fact, a place of asylum, and an old law forbids the altar in any shrine to be made of dressed stone, 'For you have struck your sword against it and thus profaned it' (Exod 20.25).[21]

Though the "unhewn altar" example offers an interesting trope for discussion, this interpretation is far from the obvious choice. Earlier accounts of altars also challenge these instructions as unequivocal, as numerous Patriarchs before the Exodus construct altars without knowledge of this sanction.[22] Douglas suggests that the reluctance here is not towards work or tools *per se*, but rather to a restriction that is relevant only in the cultic context.[23] In seeking to further emphasise the distance between such a naturalist interpretation and the text of Exodus, it may also be helpful to note that this approach in terms of polarities is elaborated far more explicitly in another discourse that lies outside this discussion of work in the Hebrew Scriptures. There is a well-worn tradition in Roman Stoic thought, particularly by Seneca, that affirms agricultural labour while denigrating tool-using technical work as degrading. Whereas the work of the agricultural labourer is conceived of as in conformity to nature as the worker raises crops and follows nature's rhythms, the artisan seeks to shape and manipulate the products of nature whether they be wood, wool, or stone.[24] In this way, the Stoic's circumscribed praise of manual labour is actually compatible with a Platonic idealism. Accordingly, Seneca's treatment of wisdom is contingent

upon a dualistic anthropology, as when he suggests, "wisdom does not teach our fingers but our minds."[25] Consequently, in Seneca's Stoic affirmation of the need to model human activity after the supposedly "natural" patterns one finds a new tension created within manual labour between those involved in harvest and those participating in manufacture. This Stoic renaissance does not mark an authentic and conceptually based return to manual labour, but rather – in contrast to the more holistically agrarian account in the Hebrew Scriptures that I am examining here – a romantic and pastoral movement. In this way, Epicureans, Stoics, and many other late-Roman romantics (including Virgil and Horace) exalt a *particular* form of manual labour in a way that even more harshly undermines the work of the non-agricultural artisan. Accordingly, this Roman affirmation of agriculture represents quite the opposite of the integrated affirmation of agrarian work that I shall argue is on display in Exodus.

Finally, there is a third distinction that must be made, against the tendency in contemporary exegesis to assume that this inherent human capacity for work is a post-lapsarian novelty. This poses a potential (though perhaps limited) problem for my argument here, in that what is novel may not be protologically "natural." This leads to the assumption that the state in paradise was one of leisure, and that this might be more natural to human activity. The trajectory of this position is typified in a statement by Proudhon: "Amidst all the problems, so much in the forefront of current attention, about work and compensation, organization of industry and the nationalization of the workplace, it occurred to me that it would help to consider a legislative program based on the theory of rest."[26] There are several problems with this assertion, the most basic being that such a reading cannot be claimed as a straightforward reading of the text of Genesis that describes the first human habitation as a *garden* and not a *forest* (or a beach!). Early interpreters demonstrate awareness of this fact as a survey of early Christian exegesis of Gen 1–3 suggests, where one finds a number of late-patristic authorities, particularly Augustine, who see no trouble with the suggestion that work existed in the pre-lapsarian state.[27] Having noted that we cannot find a consensus regarding pre-lapsarian leisure in early Christian reflection, it may be better to assume the near-antecedent and affirm that this dominant focus on leisure is not a persistent feature of Christian reflection but is more likely a feature of post-Marxist labour theory, with its obsession with the technological transcendence of toil as a part of de-proletarianisation. I do not mean to argue that discussion of leisure should be excluded from a holistic social ethics; rather, my point is that leisure should not function as our starting point in discussing the moral ordering of work.

Another way of approaching this issue is to consider the theological commitment that lies at its heart. This focus on leisure tends to arise out of a tendency to reflect on work from a protologically oriented ethics. But it is not really

appropriate to found a theological anthropology primarily on the account in Genesis. As Oliver O'Donovan suggests, Christian knowledge is eschatologically contingent.[28] When we seek a basis upon which to make normative moral statements, we are better served, then, by using an eschatological frame. Again, O'Donovan is instructive on this point:

> This is what is meant by describing the Christian view of history as 'eschatological' and not merely as 'teleological.' The destined end is not immanently present in the beginning or in the course of movement through time, but is a 'higher grace' which, though it comes from the same God as the first and makes a true whole with the first as its fulfillment, nevertheless has its own integrity and distinctness as an act of divine freedom.[29]

An eschatological approach properly provides for the recapitulation of human nature, and it is this eschatological framing that makes the Genesis account only partially normative for Patristic theologians such as Augustine. With this in mind, I return to a refined version of my original suggestion that Exodus commends a holistically agrarian view of technical work as a normal and intended part of human experience.

This suggestion regarding the normality of work is defended in several surprising places in contemporary research outside religious ethics and biblical studies. In one example, researchers in business psychology have noted the "IKEA Effect." They explain:

> When instant cake mixes were introduced in the 1950s as part of a broader trend to simplify the life of the American housewife by minimizing manual labor, housewives were initially resistant: the mixes made cooking too easy, making their labor and skill seem undervalued. As a result, manufacturers changed the recipe to require adding an egg; while there are likely several reasons why this change led to greater subsequent adoption, infusing the task with labor appeared to be a crucial ingredient. Similarly, Build-a-Bear offers people the 'opportunity' to construct their own teddy bears, charging customers a premium even as production costs are foisted upon them, while farmers offer 'haycations,' in which consumers pay to harvest the food they eat during their stay on a farm.[30]

More specifically, Norton, Mochon, and Ariely argue that the IKEA effect is based upon "a fundamental human need for effectance."[31] The crucial point here, which has been taken up in contemporary design, is that the act of completing tasks provides an intrinsic level of human satisfaction. Amateur-work evangelist Matthew Crawford offers a similar argument in his book *Shop Class*

as Soulcraft that this human need to participate in work ought to inform design paradigms. Against the contemporary tendency towards "black box" design, wherein the physical structure of devices is hidden from the user, as with cars that have concealed dashes and Apple products that use special tamper-proof screws, Crawford argues that device structure and thus avenues to repair should remain conspicuous to the user.[32]

Returning to my original observation regarding the emphasis in Exodus on fidelity to the divine plan, it is important to note that this affirmation of work provides the starting point for work ethics. It is not a sanction *carte blanche*, but precisely because human work is given a place in the moral vision of Exodus, discussion can be had that considers how we might separate out "good" from "bad" work and also consider what paradigms may help us in this task of moral judgement. This task of discernment is a key concern of the Tabernacle narrative. The starting point for such discernment, as I have suggested at the outset, is that work can only be construed as existing coherently when it is produced under divine superintendence. This more moderate approach is summed up well in Ps 127:1: "Unless the LORD builds the house, those who build it labor in vain."[33] In the case of the Tabernacle, this superintendence is particularly close, as emphasised by the remarkably descriptive narrative in Chapters 25–31, followed by the account of the lapse into false worship (Chs. 32–4) that is followed by a complete re-narration of the original instructions with only slight modification (Chs. 35–40).

Turning back to the instructions that drive the Tabernacle narrative, of particular interest for our purposes in seeking to understand the moral shape of artifice involved here is the use of the Hebrew *tbnyt*, often rendered in English as "pattern," "plan," or "design." This statement in Exod 25:9, to which I refer above, reminds us that within the divinely provided pattern there is creative space, but this space is *morally* delimited. Waltke observes that amidst the verbose Tabernacle instructions many details are nonetheless omitted, as is the case with the measurements for the lamp-stand in 25:31.[34] As I have already suggested above, the limited scope of these instructions suggests that this is not technically exclusive literature, but that the writer of Exodus means this text to be applicable to a wider audience. In this way, the absence of detail offers us an affirmation of the agency of the human worker, leaving open a space for creativity as a part of the process of construction, albeit within a constraining plan understood both literally and theologically.

The text of Exod 25:9 and the framing of the narrative remind the reader that humans can be said to be naturally technical, but the expression of this capability runs a near-constant risk of lapsing into sin if it is expressed outside divine superintendence and moral ordering. With this in mind, much of the recent writing on the theology of work has rightly emphasised a negative moral

approach, seeking to identify limits and boundaries that can constrain human labour. This approach has found clearest expression in the twentieth century around the theme of sabbath. Such an approach is entirely commended by Christian Scripture, as the Exodus account is itself structured around sabbath observance. As Kearney notes, the first descriptive account of the Tabernacle is structured around seven instructional speeches (25:1, 30:11, 30:17, 30:22, 30:34, 31:1, 31:12), the last of which (31:12) is concerned with sabbath observance.[35] In this way, the Tabernacle narrative parallels the creation account in Gen 1:1–2:3. Recent works and now-classic studies have provided useful exposition of the sabbath theme in Scripture as a way of providing liturgically conceived boundaries around human work. But there is room to augment this approach, as one cannot hope to fully address the subject of human work by recourse to a liturgical practice that is defined by *cessation* of labour. Further, without careful differentiation, this affirmation of sabbath can collude with the early-twentieth-century dichotomy between leisure (or recreation) and work that resulted from Marxist polemics against leisure (or the false impression thereof) in capitalist societies.[36] I prefer to say with a number of contemporary sociologists of work (such as Doug Harper) that work and leisure are inextricably intertwined.[37] With this in mind, in the next section, I mean to augment the reflection that has been done in exegeting the sabbath command by identifying themes in the Tabernacle account that address work directly from a positive trajectory. I focus here on two different aspects of good work: (1) that it is marked as wise, and (2) that it is conducted socially.

Wisdom and Working Knowledge in Exodus 31

Over the past several decades, American and British work culture has undergone a significant transition towards so-called knowledge work. Further, the governments of many developed economies take pride in the fact that their primary industry is no longer making things (i.e., fabrication) but rather dispensing knowledge, providing services, and manipulating financial markets. This has been accompanied by a turn away from broader notions of knowledge as a part of work and an exaltation of "information."[38] Contemporary businesses demonstrate their participation in such a transition in a number of ways: the deployment of their profits to emphasise technology over personnel, the rapid acquisition of information in favour of the cultivation of skills and skilled communities, and the pursuit of wealth in preference to the accumulation of virtue. This idea surfaces in modern theories of knowledge that have tended (until recently) to construe what we know in terms of what we can cognitively process. Excluded from "knowledge" are things like our aesthetic senses, narratives, and the muscle memory that only a skilled artist, musician, or artisan accrues after

years of hard and improving work. One finds this prioritising also in the exaltation of design rather than craft, where the architect is considered a worker with value added while the builder offers "unskilled" labour. This type of prejudice, which relies on the hierarchical organisation of work categories, is often encapsulated in public policy. The American Social Security Code of Federal Regulations (SSR 82–41) defines "unskilled work" as follows:

> the least complex types of work. Jobs are unskilled when persons can usually learn to do them in 30 days or less. The majority of unskilled jobs are identified in the Department of Labor's Dictionary of Occupational Titles (DOT). It should be obvious that restaurant dishwashers are unskilled. It may not be self-evident that other jobs can be learned in 30 days or less, such as sparkplug assembler, school-crossing guard and carpenter's or baker's helper (laborers). In these cases, occupational reference materials or specialists should be consulted.[39]

A quick survey of the "Job Zone 1" list (being "little or no preparation needed") on O-Net, an American government database of work classifications, reveals the categorisation of unskilled occupations including "Construction Laborers" (47–2061.00) "Fallers" (45–4021.00), "Farmworkers and Laborers, Crop" (45–2092.02), and "Hosts and Hostesses" (35–9031.00).[40] In contrast, occupations affirmed as highly skilled in "Job Zone 5" include "Farm and Home Management Advisors" (25–9021.00), "Materials Scientists" (19–2032.00), and "Architects" (17–1011.00).[41] In this example, one can see management and administration of work process exalted over the materially engaged practice of work.

Jacques Ellul offers a provocative critique of the influence of what he calls *technique* on modern work that is relevant to our discussion here. Ellul suggests that modern societies have gravitated towards a uniformity in method and purpose unknown in so-called "primitive society" that involves an assimilation of the form of work into a technological paradigm. The first characteristic of this subordination is deference towards "the rational":

> This rationality, best exemplified in systematization, division of labor, creation of standards, production norms, and the like, involves two distinct phases: first, the use of 'discourse' in every operation; this excludes spontaneity and personal creativity. Second, there is the reduction of method to its logical dimension alone. Every intervention of technique is, in effect, a reduction of facts, forces, phenomena, means, and instruments to the schema of logic.[42]

This deference towards the rationalisation of work criticised by Ellul (and perhaps most famously by Weber) offers an area of contemporary work that may benefit from the strange context offered by our ancient craft account.

In some contrast with the rational model of management I have noted above, what one finds with the Tabernacle is foremost a space for worship that carries an orientation towards the Creator God. This orientation produces a certain resistance to the reductive trend that Ellul outlines here. While Ellul suggests that this change is somewhat inevitable (in the face of evolutionary pressures), I want to argue that one finds a counter-narrative in these Tabernacle texts that has also been taken up by the new "craftivism." In worship of a God whose character is ineffable, efficiency and rationalistic conceptions of wisdom cannot reign in the same way.

In Exodus, this issue is framed by the description of the craftspeople who construct the place of worship in Chapters 25–40. Traditional approaches to wisdom in the bible typically focus on Solomon and the art of statecraft that is perhaps unaccompanied by physical labour – though even in this case he, or someone taken by tradition to be Solomon, hints otherwise in Eccl 2:5 – but surprisingly, the same wisdom language appears in the Hebrew Scriptures much earlier and in relation to a more obscure worker, Bezalel, and a suite of his co-workers. In describing the people who are to be recruited for the work of building the Tabernacle, one finds quite a striking combination of adjectives. In Exod 31:3 and 35:35, a particular artisan is picked out by name (Bezalel) and the strong language deployed in Exod 31:3–5 makes this status strikingly clear:

> I have filled him with the Spirit of God, with ability and intelligence, with knowledge and all craftsmanship [literally: "all work"], to devise artistic designs,[43] to work in gold, silver, and bronze, in cutting stones for setting, and in carving wood, to work in every craft.[44] (ESV)

Noteworthy here is the bringing together of spirit-filling and a juxtaposing of ability and intelligence that frustrates rationalist epistemologies.

This language of being filled with the spirit of God has a long provenance across the bible. It is used to describe John the Baptist (Luke 1:15), his mother Elizabeth (Luke 1:41), Zechariah when he prophecies (Luke 1:67), the first Christian community after Pentecost (Acts 2:4, Acts 4:31), Peter at his speech (Acts 4:8), and Paul after his blindness is healed by Ananias (Acts 9:17, Acts 13:9). Similar language is used by Paul in Romans 8:9, 8:14, 15:19; 1 Cor 7:40, 12:3; 2 Cor 3:3; Phil 3:3. Pre-monarchical judges are described as being granted the "spirit of the Lord" (Judg 3:10, 11:29, 13:25, 14:6, 14:19, 15:14), Saul is possessed by the spirit (1 Sam 10:6, 11:6) and is enabled to defeat the Ammonites, and this passes to David (16:13) upon his anointing. Remarkably, aside

from Moses (Gen 41:38), Bezalel is the first person after the sad statement in 6:3, "My spirit shall not abide in mortals forever," to be described as "having the spirit."

The language describing Bezalel's attributes is also strong, as translated in the NRSV: "ability, intelligence, and knowledge." This cluster of words used to describe Bezalel's spirit-endowment resonates with spirit statements across the Hebrew Scriptures and the NT. In 2 Chr 2:12, Solomon is described by Huram as "a wise son, endowed with discretion and understanding, who will build a Temple for the LORD, and a royal palace for himself" (NRSV).[45] Similarly, Daniel and his friends are given by God "knowledge" and "skill . . . in every aspect of literature and wisdom" (Dan 1:17). Further emphasising the importance of the Exodus narrative, neither of these other instances is accompanied by the same strong language of spirit-filling. This contrast is especially significant given ANE parallel literature, as Mark George suggests:

> The inclusion of others in the production of Tabernacle social space is not unusual among royal building projects of the ancient near east. What is unusual is the ways in which that work is included. It is divinely inspired, just as is the work of Bezalel and Oholiab. . . . It also is due to an internal response by those who participate. They participate because their hearts are stirred or move them. The implication is that, because they are inspired to participate, they receive divine skills for their work, and this sets their work apart from ordinary work.[46]

This language of ability, intelligence, and understanding of all work in Exod 31 echoes later in Deut 4:6, "You must observe them diligently, for this will show your wisdom and discernment to the peoples, who, when they hear all these statutes, will say, 'Surely this great nation is a wise and discerning people!,'" and in the NT, with Col 1:9–10: "For this reason, since the day we heard it, we have not ceased praying for you and asking that you may be filled with the knowledge [*epignosis*] of God's will in all spiritual wisdom and understanding [*pase sophia kai sonesei pneumatike*], so that you may lead lives worthy of the Lord, fully pleasing to him, as you bear fruit in every good work and as you grow in the knowledge of God" (NRSV). What one finds in the text of Exod 31 is a spirit-empowering of particular attributes that resonates across Scripture. The force of this feature of the Exodus Tabernacle narratives is to trouble modern epistemologies that exclude "working knowledge." The logic on display in this text presumes a unity of the forms of knowledge that lead to wisdom and implicates the activity of mundane work in its expression.

As I have suggested above, verbosity in Exodus is not meant to serve as an architectural instruction, at least not in the modern sense of a blueprint, as it is

lacking crucial measurements. Similarly, missing here are extensive instructions for apprenticeship, though this is tersely invoked in terms of the relationship between Bezalel and Oholiab, who is something of an apprentice (Exod 31:6, 35:34, 36:1–2, 38:23). Though explicit instructions in the art of apprenticeship are lacking, the process is explicitly included as part of the master-artisan's duties: "And he has inspired him to teach, both him and Oholiab son of Ahisamach, of the tribe of Dan" (Exod 35:34 NRSV). As Hostetter notes, the two craftsmen are intended to "[teach] their special skills to a great host of manual laborers engaged in the work on the Tabernacle."[47] I draw attention to the element of craft-pedagogy involved in the narrative as it is instructive in answering a key question of this narrative, namely what does it mean to be "spirit-filled" for the task of skilled labour? The narrative suggests that this sort of pneumatic (spirit) gift does not grant gifts that have not previously existed in the person in question, but rather works in cooperation with natural human abilities that have already been cultivated. John Robert Jackson observes that this sort of spirit-empowerment stands in some contrast to other ANE accounts of spirit-filling that construe it as an overtaking of the person, and thus any attributes gained are in apposition to their normal created ability.[48] The narrative provides us with no details that might trouble the assumption that Bezalel was a craftsman before this spirit-filling. Instead, the text connotes that the consequence of the spirit is that his work is done "with thinking and dexterity divinely enhanced."[49] In other words, this brief mention of Bezalel is not about a chef or a farmer being transformed laterally into another trade of goldsmithing (or in contemporary parlance, a farmer being made a "materials scientist"). Later mention of wisdom in this narrative associates the particular sorts of work assigned to people with their ordinary pre-Tabernacle experience. In Exodus 35:26 there is mention of "women whose hearts moved them to use their skill," a whole crowd similarly moved skilful in 35:35, and a statement by God to Moses in 28:3 – "You shall speak to all the skilful [which includes those weaving women in Exod 35], whom I have filled with a spirit of skill, that they make Aaron's garments to consecrate him for my priesthood." This point places the Hebrew perspective at significant odds with other accounts in the ANE, where the work of the artisans is downplayed and credit is given to the manager or deity who guides the work. In the case of one Mesopotamian Temple described by Jackson, "managerial depiction of the Temple construction . . . is an overriding theme of this text: Gudea is depicted as the artisan who constructed the Temple. . . . Ultimately the Temple is not even the work of the king but is the work of the gods."[50] In contrast, Jackson notes, "unlike some ancient Near Eastern accounts of the work of artisans, the *ruaḥ olhym* never replaces or overshadows the work of the artisan."[51] This model of spirit-filling resonates elsewhere across the text of Scripture. Daniel reminds us, "Blessed be the name of God from age to

age, for wisdom and power are his. He changes times and seasons, deposes kings and sets up kings; he gives wisdom to the wise and knowledge to those who have understanding. He reveals deep and hidden things; he knows what is in the darkness, and light dwells with him" (Dan 2:20–22 NRSV). YHWH does not grant these things by His spirit because they are ecstatic gifts that supplant whatever normal capabilities a person possesses. Instead, this language reminds us that all good things come from God. And the inverse is also true: for those who seek wisdom outside the economy of the creator of wisdom, these things become foolish (1 Cor 1:18–19; Isa 29:14).

It is remarkable that this description of Bezalel being granted wisdom in such strong terms is not for a "spiritual" endeavour as is described in Col 1, but is quite literally for the task of building. There is no suggestion that his empowerment is provided so that he can evangelise others while he does his work with prophetic words, or sing eloquent songs of praise while he works. Successful work on the Tabernacle itself is deemed important enough to require the granting of spirit-filled understanding and wisdom. And this is the broader point with which the narrative confronts the reader: in the text of Exodus, there is a clear suggestion that the physical tasks of ordinary (though excellent beyond measure) work are compatible with what is described as "wisdom," "discernment," and "understanding." Narrow conceptions of wisdom (or understanding) as mere possession of information, or even just the pursuit of knowledge, are insufficient. Wisdom is left as a broad category into which one might place various sorts of epistemic abilities, and there is not a clear hierarchy among these abilities.

Drawing on Pauline texts, but along similar lines, Miroslav Volf argues against a Protestant "addition model" where "the Spirit . . . [gives] 'something' new, a new power, new qualities."[52] Instead he commends an "interaction model," which he elaborates in the following way: "a person who is shaped by her generic heritage and social interaction faces the challenge of a new situation as she lives in the presence of God and learns to respond to it in a new way. This is what it means to acquire a new spiritual gift. No substance or quality has been added to her, but a more or less permanent skill has been learned."[53] I am in basic agreement with Volf's description here, particularly in his pursuit of a holistic account of work against the dichotomies he identifies in the "vocation tradition" and also in his differentiation of the work of the spirit.

Regrettably, Volf's attention to the text is limited to a few lines of glosses, leading him to argue for a democratisation of such pneumatic empowerment that is construed at the expense of attentiveness to the text:

> As they stand, these biblical affirmations of the charismatic nature of human activity cannot serve as the basis for a pneumatological understanding of *all*

work, for they set apart people gifted by the Spirit for various extraordinary tasks from others who do ordinary work. But we can read these passages from the perspective of the new covenant in which *all* God's people are gifted and called to various tasks by the Spirit.... All human work, however complicated or simple, is made possible by the operation of the Spirit of God in the working person; and all work whose nature and results reflect the values of the new creation is accomplished under the instruction and inspiration of the Spirit of God (see Isa. 28:24–29).[54]

Aside from his superficial dismissal of the Hebrew Scriptures, a second related issue with Volf's account of pneumatic work is its unmediated aspect. This individualistically focused pneumatology leads Volf to undue worry over questions such as whether "it is possible to understand the work of non-Christians *pneumatologically*."[55] Such a strange query demonstrates the ways in which Volf's account of work is still theologically located amidst an *ordo salutis*. Volf does offer a response to this issue by recourse to a kind of natural law account, quoting Basil's *De Spiritu Sancto* and concluding, "There is hence an important sense in which all human work is done 'in the power of the Spirit.'"[56] Yet this line of thinking seems to miss the social or, to put it in another way, ecclesial dimension of the spirit's work. This social dimension is – as I shall note below – attested in both the Hebrew and NT Scriptures. Consequently, in Volf's pneumatological account of work, ecclesiality is submerged by eschatology.[57] Rather than lament the circumscribed nature of these pneumatic accounts of work in Scripture as Volf does, I find within this ordering an *ecclesially* mediated ethic that deserves closer examination. There is little to no accounting for the significance of Christian worship and ecclesially particular existence of Christians in the account that follows this pneumatic definition in Volf's book. On my reading, there is more to be drawn from Scripture on this subject, and I shall pick up this argument regarding an ecclesial account of work in later chapters.

The importance of what Volf calls an "interaction model" becomes especially clear when one notes the descriptions of worker specialisation in Exodus. As Jackson notes, the Tabernacle narrative deploys a "rich artisanal vocabulary" and, in this way, the text rhetorically affirms by name the variety of specialised craft-knowledge that is implicated in the making of the Tabernacle. This includes, beyond more basic use of ʿśh as in Exod 31:4 ["to make"], a large variety of Hebrew words that are exclusive to craft work: ḥršt ["carving," 31:5]; ṭwh ["spinning by hand," 35:25–6]; ʾrg ["weaving," 28:32, 26:36]; šbṣ ["brocading," 28:20; "setting gems," 28:11]; rks ["tying," 28:28]; gold thread cutting (39:3); metal casting (25:12); mqšh ["hammered work," 25:31]; rqʿ ["hammering in gold," 39:3]; pṭḥ ["stone engraving," 28:11]; ṣph ["gold overlay," 25:11]; and perfume blending (30:25) (this list is not exhaustive).

However, in the midst of all this terminology, it is also important to note that the text gently troubles a reading that seeks to identify Moses (or even YHWH) as managing a sort of Taylorist division of labour. There are discrete skills on display (as affirmed above) that would require significant specialist cultivation, but the overall work is not managed along strictly divided lines. Instead, the flow of skills and abilities remains dynamic such that various work duties blend together. Bezalel and Oholiab are enabled with particularly wide-ranging abilities: "He [YHWH] has filled them with skill to do every kind of work done by an artisan or by a designer or by an embroiderer in blue, purple, and crimson yarns, and in fine linen, or by a weaver – by any sort of artisan or skilled designer" (Exod 35:35 NRSV). In this age of specialisation, it may be helpful to point out that this sort of artistic poly-practice is not out of the question (William Morris serves as a modern example). What we find here is something closer to a medieval sense of craft, where there are identifiable specialised crafts (weaving, stonecutting, embroidery, etc.), but individual craftspeople are not locked into narrowly construed functions.[58]

Another note is in order, regarding the artisanal vocabulary on display here, along with the wisdom of Bezalel. An incautious reader might extrapolate the trajectory of this vocabulary and suggest that the text effectively consecrates all human occupations. In this way, as I have mentioned above, one might note the language of "design" in this account and appropriate the Tabernacle narrative as a revalorisation of architecture and engineering. Along these lines, theologian Paul Stevens has described Bezalel as his "patron saint."[59] The very strong language of divine wisdom associated with this ordinary artisan (as opposed to priests, or Israelite leadership) and the inclusion of a wide number of other artisans in this divinely commissioned building project has led Stevens, along with several others, to rely on the Tabernacle text therapeutically, to revalorise particular human occupations. A number of problems arise from this sort of incautious deployment of the text in moral reflection. As Davis notes well, the account in Exodus offers a strong counter-example of bad work, and further examples follow throughout the HB. Such a carelessly undifferentiated affirmation fails to provide any moral guidance for the jobseeker. Against bland therapeutic readings, the mere presence of a diverse cast of workers should not be read as a blanket affirmation of any sort of work. Further, the presence of diversity among the workers is a far cry from the overspecialisation that plagues modern work.

Work and Sociality in Exodus 32–6

I have argued above that work is given divine empowerment and blessing, but this theme does not fully encompass the moral shape of labour depicted in the

Tabernacle narrative. There is a second, equally important affirmation that balances the first, namely that this work is an inherently social practice. I have written above about the ways in which particular persons and families are singled out for a certain sort of work, and the dynamism that seems to be expressed with regard to various trade-specialisations. It is of further importance to note the strong egalitarian aspect of the work of Israel that is described in Exodus.

Work and Volition

The willing contribution by Israel to the construction work underlines the egalitarian shape of the Tabernacle-construction narrative. This is emphasised in two related ways, as the raw materials are provided by a voluntary offering (echoing the offerings that will be brought by Israel in the liturgy that occurs after the construction of the Tabernacle) and by voluntary participation in the work. This literary celebration of willingness stands as a strong repudiation of the forced labour that is described at the beginning of the Exodus account. Those who are summoned to undertake the work (Exod 36:2, cf. also 25:21–2, 26) are volunteers: "*kōl ᵃšer nᵉśā᾽ô libbô*" ["all those whose hearts were stirred"]. The LXX is more straightforward, with "*kai pantas tous hekousiōs boulomenous*" ["all those who willingly desired"]. In the Hebrew, the verb *nś'w* (lit: "to lift up") is used figuratively here, thus it may be rendered as Walter C. Kaiser suggests: "the heart 'lifts one up' thus inciting action."[60] As the LXX translator emphasises, with the use of the verb *hekousiōs*, human participation in this enterprise is necessarily free inasmuch as it is communal.

In the offerings of raw materials, described in Exod 25:2–25:7, 35:4–9, 35:20–9, 36:3–7, Moses is instructed to accept offerings from those who "*ydbnw lbw*" [lit: "offer freely"], also used in Exod 25:2, 35:5, 35:29. This part of construction comprises a significant portion of the Tabernacle narrative and several features deserve attention. First, as regards the instance in Exod 25, it is striking that this invitation is the first instruction from YHWH to Moses regarding the Tabernacle construction. Further, the human response to this request elaborated in the second extended narrative in Exod 35 (after apostasy and repentance) is rhetorically remarkable. Everett Fox observes how the "refrainlike pattern of key words (e.g., 'mind,' 'willing,' 'service,' 'work,' 'wise,' 'design,' 'brought'), strongly portrays the people's enthusiasm for and participation in the sacred task," in the way that this regular repetition "push[es] the narrative to a crescendo, with the people actually bringing much more than is needed."[61] This enthusiasm provides a noteworthy contrast to the terse language that describes Israel's action in the parallel narrative prior to the apostasy in Exod 32:3. This episode in Exod 35–6 concludes with Moses halting the bringing because they have sufficient material to complete the design and can

leave the surplus behind.[62] The sense of sufficiency is based upon the craftsmen's understanding of the design, and thus a rule of sufficiency is followed. In this way, the procession is measured against a divinely provided sense of sufficiency:

> And they received from Moses all the contribution that the people of Israel had brought for doing the work on the sanctuary. They still kept bringing him freewill offerings every morning, so that all the craftsmen who were doing every sort of task on the sanctuary came, each from the task that he was doing, and said to Moses, 'The people bring much more than enough for doing the work that the LORD has commanded us to do.' So Moses gave command, and word was proclaimed throughout the camp, 'Let no man or woman do anything more for the contribution for the sanctuary.' So the people were restrained from bringing, for the material they had was sufficient to do all the work, and more. (Exod 36:3–7 ESV)

As the coda in verse 7 relates, exuberance in this new work is tempered by a sense of sufficiency (contrast this with divine superabundant action described in Mal 3:10) in which Israel has been trained during their time in the wilderness living on Manna, resonating with the rhythm of Sabbath rest.[63]

As I began this chapter with a discussion of worker conformity and have now arrived at a defence of the "free" nature of this work, some comments are in order regarding the precise shape of the account of worker agency and volition I am elaborating here. One may, after all, over-construe freedom just as easily as one may underestimate servitude in this text. Given the frequent reference to divine superintendence, particularly conformity to the divine "design" as I have noted at the outset, it is important to note that the freedom on display here is not ultimate. This stands in some contrast to the pre-Christian classical approach that Aristotle expounds. One often finds a reluctance in Greek thought to affirm *any* aspect or form of work that takes away the agency of the worker (at least for freeborn citizens). This includes work that simply lacks a *telos*, being purely "mechanical," or work for which the purpose has been subverted, as in the case of work that is exclusively directed towards "profit-seeking." This is a helpful distinction to make with regard to Greek perspectives on work that have not always been appreciated by scholars. William Westermann provides a more sophisticated reading of this Greek disdain for agency-impacting labour:

> When Aristotle suggested that craftsmen, meaning free artisans, live in a condition of limited slavery, he did not need to amplify the idea for his Greek readers. Expanded, it meant that the artisan, when he made a work contract, disposed of two of the four elements of his free status [freedom

of economic activity and right of unrestricted movement], but by his own volition and for a temporary period.⁶⁴

Hannah Arendt expands on this suggestion, noting that "freedom was then understood to consist of 'status, personal inviolability, freedom of economic activity, right of unrestricted movement.'"⁶⁵ Bringing these two accounts into comparison underlines the significance of the theological subordination afforded in the Hebrew account. Worker freedom is contingent upon their conformity to the divine rule; and in a related way, their activity is contingent upon natural created limits. We find here a celebration of worker freedom that can nonetheless also celebrate the givenness of material contingencies.

Relating Human and Divine Work: An Ecological Account

Another way of describing this more complex bestowal of agency for action that is egalitarian but theologically subordinate is that it is an *ecological* account of work. Seen in this way, the two parallelisms that appear in Exodus, (1) between human and divine work, and (2) between divine creation and re-creation, present an overlapping account of agencies in divine and human work. In this way, Exodus reminds the reader that engagement with the material world, particularly as a worker, brings one into a field of contingency and interrelationship. One of the most noteworthy recent treatments of agency can be found in the work of John Milbank, and it is worthwhile to bring my reflection thus far on this biblical text briefly into conversation with Milbank's account of the Christian ethics of work and a noteworthy response (particularly because it is drawn with reference to Exodus 25–40) by Peter Leithart.

In his article "Making and Mis-making: Poiesis in Exodus 25–40," Peter Leithart presents an assessment of John Milbank's critique of modern conceptions of the secular via an account of *poiesis*, but Leithart makes use of the Tabernacle account to elaborate his alternative to Milbank's approach.⁶⁶ Leithart affirms, even more strongly than I have above, the human status as *homo creator*, because (in his conception) they are made in God's image.⁶⁷ Suffice it to say for our purposes here, drawing on Thomas of Aquinas' view of finite causality, Milbank takes as his starting point the suggestion that only God can be truly said to "create."⁶⁸ If one accepts this premise, the consequence is that any attempt to form a distinction between human productive acts (including the generation of "culture") and divine work are problematic and this in turn renders the category of "secular" unstable. One of Leithart's primary purposes in reading Exodus is to further probe and augment Milbank's suggestion along these lines. Thus he concludes, "in an objective, historical sense, the erection of the Tabernacle was the construction of a new religious and sociological world. In building it, Moses

remade the socio-religious structures of the world by remapping the terrain of sacred and profane space."[69] As I shall note near the end of this book, the anti-Tabernacle account of the golden calf teaches us that all human work relies on sacred authorisation: "To be genuinely creative, then, poiesis must be authorized by the Word and embody a creative performance of the Word."[70]

The particulars of this grounding in divine authorisation and poetic performance is where Leithart launches his critique of Milbank's approach. Following the early modern Italian philosopher Giambattista Vico, Milbank sees idolatry as a linguistic mistake, such that "false factum" can be related to "misuse and deception in language."[71] Leithart is troubled by Milbank's post-structuralism, asking,

> how, in Vico's system, can one identify and so avoid the linguistic errors that give rise to mis-making? On Vico's terms, the 'mis-made' cannot be measured by any 'extra-artificial' standard, for that would undermine the fundamental premise of Vico's system, the convertibility of *verbum* and *factum*. Instead, mis-signifying and the consequent mis-making of culture can be identified only from a different, equally 'fictional,' linguistic–social standpoint. For Vico and Milbank, this standpoint is Christianity.[72]

This is the point on which Leithart's reading of Exodus facilitates his critique of Milbank: "In Exodus, however, making and mis-making are identifiable because there is something outside Israel's practice by which that practice could be measured."[73] Exodus offers a coherent external stance by which worship is judged with the recourse to divine pattern (or *tabnît*) upon which Moses acts in Exod 25:9. Yet, in my view, Leithart's critique is equally problematic in that he seems to presume that the divine pattern is readily available and accessible to human perception. I would prefer to accept Milbank's point, and note that our access to this design is accessed in a mediated way. I join these writers in their affirmation of the interrelation of art and science, making and knowing, and aesthetics and morality in our work (or the good, the true, and the beautiful) and also Leithart's suggestion that the way we construe the ground of that unity is itself important. Leithart also rightly reminds readers of the Tabernacle text that the text brings an epistemology along with its more direct moral and liturgical reflection. This observation carries some troubling implications for George's use of the frameworks offered by Foucault, Lefebvre, and the New Historicism in his aforementioned account, *Israel's Tabernacle as Social Space*, which seeks to provide "analysis of the Tabernacle narratives . . . by using a spatial poetics."[74] In contrast, I shall argue that what is required is a *liturgical* poetics that can perform these narratives. Reading some of the biblical presentations of this poetics is the task that I take up in Part II of this study.

In his most recent book, *Beyond Secular Order*, Milbank consolidates and sharpens the commentary that has been threaded through much of his writing on this problem of relating divine and human creativity. He also provides a useful way of navigating the ambivalence in the Hebrew text about relating divine and human action. Rather than, as many theologians of work have done, either conflate divine and human action or dichotomise them, Milbank argues that the two forms of action are Christologically mediated. We may, Milbank argues, affirm the suggestion that Western notions of creativity (and, by extension, modern science) were founded upon Christian theology, but this is not quite enough:

> The notion of *homo creator* . . . arose as a consequence of reflection upon the nature of miracle, grace and the Incarnation. The very idea of 'creativity' is only supplied by the biblically derived idea of creation *ex nihilo*, but . . . this attribute was initially transferred also to human beings under the aegis of participation, Christologically guaranteed. Only *because* an absolute non-human origination lies at the bottom of all human reality are humans able to a degree to share in this and to themselves originate. But the power to do this is restored to us in the Incarnation and even newly augmented by it.[75]

What Milbank offers is a theologically derived account of human creativity that is significantly at odds with modern accounts of creativity as an expression of absolute (and individualistic) human freedom. Bringing human and divine creativity into this kind of Christologically mediated relationship is significant particularly inasmuch as it inexorably implicates *the body* in the process of human imagination and creativity.[76] This emphasis on the body also implies that human creativity is seriously limited inasmuch as it can guarantee things are made towards designed "ends." Human fabrication is not "a construction performed in an interior mental space upon empirically received sensory material, but rather an outward artefacting, performed by the mind and the body in conjunction and guided, not by any established if hidden rational norms, but rather by the lure of a transcendent *telos* which to a degree only makes itself apparent through our own poetic shaping of the limited end which we seek to bring about."[77] Though he does not go so far as to describe his account as "ecological," Milbank's Augustinian description of the creative process, centred as it is around the incarnation and the good limits implied by human embodiment, strikes quite a helpful balance in describing the way our conception of agency shapes our ethics of work. We should not frame human making as the process of exerting control upon matter and bending it to our own ends, but rather as responding to "the lure of a transcendent *telos*."[78]

This discussion of agency also brings this study back around to the issue of volition and freedom. In addition to the vertical relationship (divine–human), we find that the Tabernacle narrative also emphasises corporate human agency. This can be seen, with particular sharpness, as I shall argue below, when one reads the Tabernacle account alongside the Temple-building account in 1 Kings. In Exodus, divine wisdom is bestowed on the artisan Bezalel and his assistant, and then this wisdom radiates outwards into the people of God as they teach others about the craft involved in Tabernacle construction and, presumably, moral work at the same time. In this way, wisdom can be seen to ripple outwards throughout the people of God as they construct the place of worship.

Work Sociality: Working and Worshipping Together

As I have already hinted just above, in addition to the voluntary nature of the work, both construction and worship are inherently social activities. Exod 25:8 underlines this aspect at the outset: "have *them* make me a sanctuary, so that I may dwell among *them*." Of the instances of the verb *ʿśw* ["to make"] that occur in the two construction narratives, 38 have a plural subject.[79] Several texts particularly emphasise the participatory nature of this enterprise. The priestly garments are to be made by "*all* the skillful, whom I have filled with a spirit of skill" (28:3, *emphasis* mine). Further emphasis, perhaps not accidentally, comes with the second set of instructions in Exod 35–40. This section begins with the invitation, "Let *every skillful craftsman* among you come and make all that the LORD has commanded" (35:10, *emphasis* mine). After these instructions are set in motion, we read that "*all the craftsmen* who were doing every sort of task on the sanctuary came, each from the task that he was doing" (36:4, *emphasis* mine). Finally, the completion formula with which this narrative ends emphasises the social aspect of the work that has been finished:

> Thus all the work of the Tabernacle of the tent of meeting was finished, and the people of Israel did according to all that the LORD had commanded Moses; so they did. According to all that the LORD had commanded Moses, so the people of Israel had done all the work. And Moses saw all the work, and behold, they had done it; as the LORD had commanded, so had they done it. (39:32, 42–3)

Though there are named participants in this enterprise (Moses, Bezalel, and Oholiab) and unnamed persons (i.e., the weavers), it is clear that the overall project is to be one that represents the corporate work of the whole people. As observed previously, even the unique inspiration of Bezalel comes along with his apprentice Oholiab and the text includes a subtle reminder that the two

46 *Moral Making*

craftsmen originate from different Israelite families – Bezalel from the tribe of Judah, and Oholiab from the tribe of Dan.

While the construction of this mobile sanctuary might be considered social, one might suggest that its operation is a rather exclusive affair. Sarna suggests as much: "It is not designed, as are modern places of worship, for communal use."[80] But again, this focuses on the peculiar aspect of the worship complex while missing the inherently social affair that was going on in Israel's work and worship. The offerings (mentioned above) that constitute the raw materials for construction set the tone for the nature of the worship system, which is to be described in greater depth later in the Pentateuch and to which I turn my attention in later chapters. Just as the construction is inaugurated by a great accumulation of raw materials that are to be brought as free gifts by both men and women (35:22–9), so too does the later worship of Israel involve *all* Israel. There is exclusive space in the midst of the Tabernacle in which YHWH is said to reside, but the notion of šākan ["to settle, dwell"] here indicates a unique sort of differentiated divine presence. Sarna suggests the following, with reference to Exod 25:8:

> the text speaks of God dwelling not 'in it,' that is in the sanctuary, but 'among them,' that is, among the people of Israel (v. 2).... Thus, the sanctuary is not meant to be understood literally as God's abode, as are other such institutions in the pagan world. Rather, it functions to make perceptible and tangible the conception of God's immanence, that is, of the indwelling of the Divine Presence in the camp of Israel, to which the people may orient their hearts and minds.[81]

The social purpose behind this worship space is demonstrated both in the various contributions of raw materials and labour drawn in for its construction, and in the universal participation commended for the people of Israel in construction and subsequent worship there. Noting this emphasis becomes especially important when one turns to look at the solipsistic account of worker participation in Solomon's Temple.

I have drawn attention to the particular character of the social aspect of work on display in Exodus in part because the existing literature on the theology of work can tend to wander unwittingly into an affirmation of the autonomous worker. This may be driven by authors' therapeutic concerns, but perhaps also by an implicit influence of the modern liberal tradition that conceives of freedom in terms of single agents. In a similar way, the frequent focus on Bezalel in what are often tragically terse appropriations of the Tabernacle account can endorse the familiar Enlightenment trope of the hero worker crafting art that arises from his own originality.[82] Without this careful elaboration of the character of

this sociality, even a strong account of the justice inherent in "good work" can prop up a schema in which the corporate aspect of work is construed within a consumer–producer framework: i.e., consumers are exhorted to be aware of their responsibility to the person working, which remains a moral relationship between two individuals. Exodus provides us with a particular template of the corporate nature of the act of work itself.

This concern is shared by the sociologist Richard Sennett, who reflects at length on the tension faced by workers between autonomy and authority. In *The Craftsman*, he suggests that "[g]ood work" is best nurtured in a setting that avoids both extremes – the "heroic" individual worker and the automaton that exists in authoritarian settings. Sennett suggests that one criterion for this refocusing of authority in work settings might be skill: "A more satisfying definition of the workshop is: a productive space in which people deal face-to-face with issues of authority. This austere definition focuses not only on who commands and who obeys in work but also on skills as a source of the legitimacy of command or the dignity of obedience."[83] This approach provides for a more egalitarian model, without dispensing with the possible need for structured relationships among workers.[84] It is my contention that the moral account provided with the work on the Tabernacle inherently provides this sort of balance precisely because both construction and worship are inherently social activities and they reside within an account of wisdom that provides space for material engagement and skill. This can be distilled into two dialectics, which undergird my account of ecological work throughout this book: (1) between the agency of individual and collective workers, and (2) between the contingency of materials to worker (i.e., design) and the contingency of worker to their materials (i.e., craft).[85] As I shall go on to argue, a Christian moral account of free work must take into account these two contingencies, i.e., to other workers and to materials. Yet it is also crucial to note that this is not a generically ecological account: rather contingency – in this account – to all other creatures (whether human or tree) is predicated upon the fact of their creation by a Creator. These dialectics are *theologically* constituted. As Exodus demonstrates, the factor that stabilises these dialectics is the theological superstructure undergirding the whole of Exodus' message: specifically it is the doxological purpose of this building project that provides holism to the word performed.

Through the reading of the ancient craft in Exodus that I have undertaken in this chapter, I have laid the basic foundation for an account of good work. This is expressed in its most distilled form as the two dialectics just noted above. However, the moral vision initiated by the Tabernacle account may only be fully appreciated with subsequent analysis of later Temple-construction texts that draw these themes of agency and relationship into sharper relief and add texture to the categories that have been presented in Exodus. With this in mind, I turn

my analysis now to comparative examination of selected Temple-construction narratives that lie outside the Pentateuch. In the next chapter, my inquiry brings me to a set of anti-paradigms that are developed in the monarchical narrative (1 Kgs 5–8). I shall go on to explicate those texts that narrate the inversion of Temple construction, with its dissolution as narrated by the prophets (Jeremiah). In Chapters 3 and 4, I shall turn to the "Temple not made with hands" and seek to understand the implications of the reconstituted visions of Temple construction (Isaiah, Zechariah, Chronicles, and Ezra). These reconstituted visions provide an opportunity to further probe aspects of work ethics in eschatological perspective and prepare for my turn to the NT in the final portion of that chapter. Here my analysis will flow into concluding examination of the language and tropes of the Tabernacle-construction narrative as they are deployed metaphorically in the gospels and epistles of the NT. This intensely metaphorical appropriation of Temple construction (i.e., Jesus and Church *as* the new Temple) does not undermine the kind of moral reading I am attempting here, but rather these texts redeploy such themes in a new moral context for the work of the church.

Notes

1 Timothy Gorringe, *The Common Good and the Global Emergency: God and the Built Environment* (Cambridge: Cambridge University Press, 2011), 12; Brian Brock, *Christian Ethics in a Technological Age* (Grand Rapids, MI: Eerdmans, 2010), 228; Ben Witherington, *Work: A Kingdom Perspective on Labor* (Grand Rapids, MI: Eerdmans, 2011), 50–1. R. Paul Stevens describes Bezalel as "my patron saint" in *Doing God's Business: Meaning and Motivation for the Marketplace* (Grand Rapids, MI: Eerdmans, 2006), 177. Stevens provides somewhat haphazard exegesis of "wisdom," "discernment," and "skill" in Exod 31, 35, but he makes the same conclusion that Bezalel's wisdom carries implications for the status of work and he considers this spirit-filling to be paradigmatic as taken up in the NT. See also his *The Other Six Days: Vocation, Work, and Ministry in Biblical Perspective* (Grand Rapids, MI: Eerdmans, 1999), 34. David Hadley Jensen notes the aspects of generosity and restraint in the Tabernacle narrative in *Responsive Labor: A Theology of Work* (Louisville, KY: Westminster John Knox Press, 2006), 14. Armand Larive devotes a footnote to the same affirmation in *After Sunday: A Theology of Work* (New York, NY: Continuum, 2004), 111, see note 7 on p. 187. Miroslav Volf, in his influential account *Work in the Spirit* (1991), makes passing reference to Exod 35:2–3.

2 There is also a parallel between the re-creation accounts in Genesis and Exodus, which can be observed on a literary level. Just as Noah spends 40 days and nights awaiting re-creation (Gen 7:12) and sets up an altar afterwards (Gen 8:20), Moses spends 40 days and nights listening to God's instructions for the new life that awaits the newly liberated people of Israel (Exod 24:18, 34:28), and then he descends to supervise the construction of the Tabernacle (Exod 25–31, 35–40).

3 Joseph Blenkinsopp, "Structure of P," *Catholic Biblical Quarterly* 38, no. 3 (1976): 275–92. See also Richard E. Averbeck, "The Tabernacle and Creation," in

T. Desmond Alexander and David W. Baker, (eds), *Dictionary of the Old Testament: Pentateuch* (Downers Grove, IL: InterVarsity Press, 2003), 816–18.
4 For analysis on correspondences between the creation story and the Tabernacle account, see Joseph Blenkinsopp, *Prophecy and Canon* (Notre Dame, IN: University of Notre Dame Press, 1977), 59–69. See also Jon D. Levenson, *Sinai and Zion* (Minneapolis, MN: Winston Press, 1985), 142–5; and his further development of this theme in Jon D. Levenson, *Creation and the Persistence of Evil* (Princeton, NJ: Princeton University Press, 1994), 66–99. The recent explosion of temple studies provides a substantial body of academic explication of these resonances. For a current literature survey, see Terje Stordalen, *Echoes of Eden: Genesis 2–3 and Symbolism of the Eden Garden in Biblical Hebrew Literature Contributions to Biblical Exegesis and Theology, 25* (Leuven: Peeters, 2000).
5 Davis, *Scripture, Culture, and Agriculture*, 142.
6 Mark K. George, *Israel's Tabernacle as Social Space* (Atlanta, GA: SBL, 2009), 18.
7 George, *Israel's Tabernacle as Social Space*, 8.
8 Frank M. Cross, "The Tabernacle: A Study from an Archaeological and Historical Approach," *The Biblical Archaeologist* 10, no. 3 (1947): 45–68.
9 Robertson provides a helpful summary of these: see Amy H. C. Robertson, "'He Kept the Measurements in His Memory as a Treasure': The Role of the Tabernacle Text in Religious Experience" (PhD Diss., Emory University, 2010), 15–29.
10 This occurs explicitly in the NT in Hebrews 8:5, but also implicitly in the Temple references that can be found in the gospels, Paul's epistles, and in Revelation, as I shall note later in this chapter.
11 George, *Israel's Tabernacle as Social Space*, 70.
12 George, *Israel's Tabernacle as Social Space*, 70–1.
13 George, *Israel's Tabernacle as Social Space*, 71.
14 Robertson, "'He Kept the Measurements in His Memory as a Treasure,'" 138.
15 William H. C. Propp, *Exodus 19–40: A New Translation with Introduction and Commentary*, AYB 2a (New York, NY: Doubleday, 2006), 497.
16 For more, see Scott M. Langston, *Exodus through the Centuries* (Malden, MA; Oxford: Blackwell, 2006), 221ff.
17 Commentary on Exod 25.1, Fathers of the Church 91:261, cited in Joseph T. Lienhard and Ronnie J. Rombs, *Exodus, Leviticus, Numbers, Deuteronomy*, Ancient Christian Commentary on Scripture OT 3, ed. Thomas C. Oden (Downers Grove, IL: InterVarsity Press, 2001), 122. See also Origen, *On First Principles*, 4.2.2 and Gregory the Great, *Pastoral Care*, 2.11.
18 Cf. Amos 9:6; Ps 104:2–3.
19 Ellen F. Davis, "Slaves or Sabbath-keepers: A Biblical Perspective on Human Work," *Anglican Theological Review* 83, no. 1 (2001): 31.
20 "ברח," *NIDOTTE*, 2:255.
21 Jon D. Levenson, *Sinai and Zion* (Minneapolis, MN: Winston Press, 1985), 96. See also the various options described in Paula M. McNutt, *The Forging of Israel: Iron Technology, Symbolism and Tradition in Ancient Society* (Sheffield: Almond Press, 1990), 219.
22 See Gen 8:20, 12:7–8, 13:8, 13:18, 22:9, 26:25, 35:7.
23 For a more extensive treatment of the various exegetical options on this theme, see also Jackson, "Enjoying the Fruit of One's Labor," 349–51.

24 This critique is substantiated at length in Arthur Turbitt Geoghegan, *The Attitude towards Labor in Early Christianity and Ancient Culture* (Washington, DC: The Catholic University of America Press, 1945), 46–8.
25 Kevin Guinagh and Alfred P. Dorjahn, *Latin Literature in Translation* (London: Longmans, Green and Co., 1942), 498.
26 P. J. Proudhon, *Die Sonntagsfeier, aus dem Gesichtspunkt des öffentlichen Gesundheitswesens, der Moral, der Familien- und bürgerlichen Verhältnisse betrachtet* (Kassel, 1850), vi. Cited in Josef Pieper, *Leisure: The Basis of Culture* (San Francisco, CA: Ignatius Press, 2009), 66.
27 Cf. Augustine, *Gn. adv. Man.* 2.15, *civ.* 14.15 and particularly Augustine's emphasis on the relation between creation and resurrection in *civ.* 22.24.
28 Oliver O'Donovan, *Resurrection and Moral Order: An Outline for Evangelical Ethics*, 2nd edn (Leicester: Apollos, 1994), 55.
29 O'Donovan, *Resurrection and Moral Order*, 64–5.
30 Michael I. Norton, Daniel Mochon, and Dan Ariely, "The IKEA Effect: When Labor Leads to Love," *Journal of Consumer Psychology* 22, no. 3 (2012): 453.
31 Norton, Mochon, and Ariely, "The IKEA Effect," 454.
32 Matthew B. Crawford, *Shop Class as Soulcraft: An Inquiry into the Value of Work* (New York, NY: Penguin Press, 2009). This suggestion is substantiated in sociological perspective by Doug Harper, in *Working Knowledge: Skill and Community in a Small Shop* (Berkeley, CA: University of California Press, 1992).
33 ESV.
34 Bruce Waltke, "*Banah*," *TWOT*, 117.
35 Peter J. Kearney, "Creation and Liturgy: The P Redaction of Ex 25–40," *Zeitschrift für die alttestamentliche Wissenschaft* 89, no. 3 (1977): 375–87.
36 For more, see Chris Rojek, "Did Marx have a Theory of Leisure?," *Leisure Studies* 3, no. 2 (1984): 163–74; Kenneth Roberts, *Leisure in Contemporary Society*, 2nd edn (Wallingford: CABI Publishing, 2006), 195–8.
37 William Harper, "The Future of Leisure: Making Leisure Work," *Leisure Studies* 16, no. 3 (1997): 189–98.
38 In what can now be viewed as a somewhat ironic conclusion, Josef Pieper suggests that this category of "information worker" tends to undermine the separation of society into thinkers and workers, cf. Pieper, *Leisure*, 55.
39 This policy became effective on 26 February 1979; from http://www.socialsecurity.gov/OP_Home/rulings/di/02/SSR82-41-di-02.html (accessed 18 July 2012).
40 From http://www.onetonline.org/find/zone?z=1&g=Go (accessed 18 July 2012).
41 From http://www.onetonline.org/find/zone?z=5&g=Go (accessed 18 July 2012).
42 Jacques Ellul, *The Technological Society* (New York, NY: Vintage, 1967), 79.
43 *lḥšb mḥšbt*, which the JPS has translated as "to make designs for work," is literally "to think thoughts," which is usually translated into English using "plan, think out, devise, invent, or scheme."
44 In subsequent usage, I shall defer to English translation in most cases, highlighting terms in brackets following the latest critical eclectic texts of the bible in Hebrew (Biblia Hebraica Stuttgartensia) and in the parallel texts in the Greek Septuagint, and Latin Vulgate for comparison.
45 For more on the complex issue of Solomon's wisdom, see Chapters 2 and 3 below.
46 George, *Israel's Tabernacle as Social Space*, 64.
47 Edwin C. Hostetter, "Oholiab (Person)," *AYBD*, 6:10. Cf. Exod 35:30–36:7.

48 For an account of this contrasting mode of spirit-engagement in Chronicles, see Schniedewind's extended study of "Spirit Possession" in William M. Schniedewind, *The Word of God in Transition* (Sheffield: Sheffield Academic Press, 1995), Chapter 1.
49 John I. Durham, *Exodus*, WBC 3 (Waco, TX: Word Books, 1992), 385.
50 "Enjoying the Fruit of One's Labor," 297.
51 Jackson, "Enjoying the Fruit of One's Labor," 299.
52 Also noteworthy is Volf's astute observation regarding the resonance of this model with "the commonly accepted Weberian understanding of charisma as an extraordinary quality of leadership that appeals to nonrational motives." Volf, *Work in the Spirit*, 112.
53 Volf, *Work in the Spirit*, 112.
54 Volf, *Work in the Spirit*, 114.
55 Volf, *Work in the Spirit*, 118.
56 Volf, *Work in the Spirit*, 118.
57 See Volf, *Work in the Spirit*, 136–7 for his very brief account of the relation between worship and work. I provide a more in-depth critique of this eschatological approach further below in Chapter 3, "Is Eschatology the Appropriate Site for a Theology of Work?"
58 See Jackson, "Enjoying the Fruit of One's Labor," 87–90, 358–9, 365; Sennett, *The Craftsman*; cf. Exod 31:3, 5 and 35:29, 31, 33, 35.
59 Stevens, *Doing God's Business*, 177.
60 Walter C. Kaiser, "אשׁ," *TWOT*, 2:600.
61 Everett Fox, *Genesis and Exodus: A New English Rendition* (New York, NY: Schoken Books, 1991), 431.
62 Few translations grasp at the ecological impact of the final verb in this verse in both MT and LXX. Both "רתוהו" (which is רתי in hiphil infinitive) and "προσκατέλιπον" connote "leave behind" or "leave over." See "רתי" in BDB, 451 and John William Wevers, *Notes on the Greek Text of Exodus*, Septuagint and Cognate Studies 30 (Atlanta, GA: Scholars Press, 1990), 596.
63 See the extended treatment of this in Davis, *Scripture, Culture, and Agriculture*, Chapter 4.
64 William Linn Westermann, "Between Slavery and Freedom," *The American Historical Review* 50, no. 2 (1945): 219.
65 Hannah Arendt, *The Human Condition* (Chicago, IL: University of Chicago Press, 1998), 12n4. Cf. Aristotle, *Nicomachean Ethics*, 1.5 and *Eudemian Ethics*, 1215a35.
66 Peter J. Leithart, "Making and Mis-making: Poiesis in Exodus 25–40," *International Journal of Systematic Theology* 2, no. 3 (2000): 307–18.
67 In spite of her emphasis on practices, one finds that Ellen Davis's unity of art and action resonates with Milbank's preference for Plato (as Milbank puts it): "he does not divide 'ethical' from 'artistic' activity, but rather sees both as proceeding from our determinations of the truth in the light of the Good." John Milbank, *Theology and Social Theory: Beyond Secular Reason* (Oxford: Blackwell, 2006), 356. With this in mind, John Ruskin serves as exemplar for Milbank because "he sought to restore questions of virtue both to theoria, our looking at nature, and to the practice of the artisan – in a way that did not subordinate either our looking at nature, or our imaginative construction, to an initial 'timeless' vision, but instead worked towards the latter by means of the first two." Milbank, *Theology and Social Theory*, 357.

68 "[F]inite causes can give new shapes to things, they cannot bring things into being in any deeply creative sense." Leithart, "Making and Mis-making," 310.
69 Leithart, "Making and Mis-making," 315.
70 Leithart, "Making and Mis-making," 316.
71 Cf. John Milbank, *The Religious Dimension in the Thought of Giambattista Vico, Part 2, Language, Law and History*, Studies in the History of Philosophy 32 (Lewiston, ME: Mellen, 1992), 38–54. Citation from Leithart's summary in Leithart, "Making and Mis-making," 317.
72 Leithart, "Making and Mis-making," 317. For more on Radical Orthodoxy and Post-structuralism see Lars Albinus, "Radical Orthodoxy and Post-structuralism: An Unholy Alliance," *Neue Zeitschrift für Systematische Theologie und Religionsphilosophie* 51, no. 3 (2009): 340–54.
73 Leithart, "Making and Mis-making," 317.
74 George, *Israel's Tabernacle as Social Space*, 41.
75 John Milbank, *Beyond Secular Order: The Representation of Being and the Representation of the People* (Oxford: Wiley Blackwell, 2013), 198.
76 Milbank, *Beyond Secular Order*, 208.
77 Milbank, *Beyond Secular Order*, 209.
78 Milbank, *Beyond Secular Order*, 209.
79 Occurrences with a singular subject are complementary, as they function within the address to Moses, indicating instructions for him to delegate. Affirmed by Jackson, "Enjoying the Fruit of One's Labor," 298. See also Robert E. Longacre, "Building for the Worship of God: Exodus 25:1–30:10," in Walter R. Bodine (ed.), *Discourse Analysis of Biblical Literature: What It Is and What It Offers*, Semeia Studies (Atlanta, GA: Scholars Press, 1995), 21–39.
80 Nahum M. Sarna, *Exodus*, JPSTC 2 (Philadelphia, PA: Jewish Publication Society, 1991), 155.
81 Sarna, *Exodus*, 158.
82 Cf. Sennett, *The Craftsman*, Chapters 2–3.
83 Sennett, *The Craftsman*, 54.
84 While one can be glad for Sennett's revalorisation of labour, his recourse to pragmatism for work ethics leaves much to be desired. I shall address this and highlight the difference in this account in later chapters.
85 In addition to Sennett, this second dialectic is also taken up in a now-classic way by Bruno Latour. Using the "fetish" as a starting point, Latour troubles too simple a resolution of the tension between the mastery exerted by the maker of an idol and its remaking of them in turn. Bruno Latour, *On the Modern Cult of the Factish Gods* (Durham, NC: Duke University Press, 2010), 22, 56.

2 Building the Temple

In reading the latter portion of the Hebrew Scriptures and, especially, any apocalyptic literature, it is hard to avoid the conclusion that the Tabernacle and Temple take on a densely metaphorical function. However, for a time in the biblical narrative they are also nonetheless *real physical* constructions that could have been seen and felt, required active-duty personnel, and had a moral force in the midst of Israel as a physical fixture. By the time one arrives at the end of the NT, the Temple has taken on (permanently, it might seem) a more abstract eschatological meaning. This final meaning is nevertheless reliant on a thick understanding of the actual Temple through which the creation-garden metaphor is built. As I suggested in the Introduction, the approach that I shall take in this book is a canonical one and thus in reading these later construction accounts I shall proceed *through*, and not above, the narrative journey that describes the construction of the Temple. The Temple has a physical history and a narrative in which our final theological understanding must be situated. In keeping with this conviction, in the previous section I attended to the ways in which the narrative and physical details of the Tabernacle might prove morally informative. Though I shall conclude this chapter with attention to the ways in which theological themes introduced and developed across the biblical narrative are given unique final shape in eschatological visions of Temples that are "not built with human hands," first I intend to demonstrate that there is much to be made of the middle.

In particular, here we find an elaboration on the material details of construction that may begin to add further texture to this account of work. In the broadest sense, the account of the building of the permanent Temple and its destruction narrates a rending of a practical moral fabric in which work and worship are intimately woven together. This is where missing threads cause the fabric to fray; and the peculiar worship economy that Israel was given, in which work was to be morally ordered, disintegrates. This unstitching is underlined with particular force (and hindsight) by Israel's prophets. I shall argue that the eschatological reformulation of the Temple can be more thickly understood in

a moral sense as a *response to* this disintegration. My narration of the ways in which worship provides ethics for the people of God will attend to the shape of chaos that ensues when it is (at least temporarily) destroyed by those very persons for whom this moral order is intended to promote flourishing moral community. Over the course of this chapter I shall suggest that providing a fresh witness to the unstitching of the moral order of work narrated by the Tabernacle and maintained by Israel's worship may help to highlight the dynamics behind similar subversions (or "unstitchings") of moral work that have become commonplace in many contemporary places of work. I turn first to an examination of 1 Kgs 1–12 set against a Pentateuchal backdrop before turning to several brief examinations of work ethics and the Temple theme in later prophetic literature.

Setting a Context for Reading the "King's" Temple

It is helpful to set 1 Kings against the backdrop of the biblical literature that precedes it, particularly Deuteronomy and Samuel, and so I begin with a brief summary of relevant Deuteronomic law. It is here that one finds a straightforward forewarning of the unstitching of the fabric of Hebrew moral economy in the so-called Deuteronomists critique.[1] In the account in 1 Samuel, we find a foreboding warning that the sort of work illustrated in Exodus, which I unpacked in Chapter 1, with its dynamic economy of freely offered labour and spirit-filled wisdom may come apart:

> These will be the ways of the king who will reign over you: he will take your sons and appoint them to his chariots and to be his horsemen and to run before his chariots. And he will appoint for himself commanders of thousands and commanders of fifties, and some to plow his ground and to reap his harvest, and to make his implements of war and the equipment of his chariots. He will take your daughters to be perfumers and cooks and bakers. He will take the best of your fields and vineyards and olive orchards and give them to his servants. He will take the tenth of your grain and of your vineyards and give it to his officers and to his servants. He will take your male servants and female servants and the best of your young men and your donkeys, and put them to his work. He will take the tenth of your flocks, and you shall be his slaves ($'bd$). And in that day you will cry out ($z'q$) because of your king, whom you have chosen for yourselves, but the LORD will not answer you in that day.[2]

The final line of the prophet's passage offers a particularly compelling inversion of Exodus 2:23, where the people of Israel cry out for rescue from their slavery. The differences in this text serve to intensify the urgency of the situation; the

king here is not a foreign one and while in Exodus we read, "God heard their groaning," Samuel warns Israel that "the LORD will not answer you in that day." Jackson summarises the all-encompassing subversion of the work of Israel that the text envisions:

> The demands of a king will involve confiscation of labor power, lands, and wealth (1 Sam 8:11–17). The king will demand their labor power through conscription into a standing military force (with its various levels of officers), conscription to agricultural labor (*ḥrš* and *qṣr*, plowing and harvesting royal lands), conscription of smiths (those who would make chariots and weapons), and conscription to palace service or service in state industries ('perfumers,' 'cooks,' and 'bakers').[3]

Much can be made of the themes introduced in the 1 Samuel text, but I shall defer my explication of "bad work" for my reading of the subsequent narrative in 1–2 Kings, to which I now turn.

This suggestion that the reader is to measure Solomon's kingship against the Deuteronomic law provided by Moses is also indicated in the text of 1 Kings. As Leithart suggests, "The allusions to Deut. 28 provide a further indication that the Solomonic order of things is built on the Deuteronomic order."[4] A natural extension of this suggestion is that Solomon's conduct can be measured by comparing his building project to the protological Israelite building, the Tabernacle.[5] Read specifically for the details of the Temple-construction account, particularly against the backdrop of the Tabernacle-construction account and the Deuteronomic literature, a shadow hangs over the Temple-construction account in 1 Kings. One finds an uneasiness in the text concerning the admixture of worship and work in constructing Solomon's place of worship. The account of Solomon's resort to forced labour, plundered materials, and collusion with "the nations" in his Temple construction not only fails to represent the distinctive theology that I have elaborated in relation to the Tabernacle, but it also demonstrates a direct subversion of the relationship that I have detailed above. As I shall repeatedly affirm, however, by their violation, the basic contours of work on display in Exodus are reaffirmed even more forcefully in this narrative.

Early in the narrative of 1 Kings, the reader is set up to expect resonances with the parallel literature in the Pentateuch by David's charge to his son Solomon:

> When David's time to die drew near, he commanded Solomon his son, saying, 'I am about to go the way of all the earth. Be strong, and show yourself a man, and keep the charge of the LORD your God, walking in his ways and keeping his statutes, his commandments, his rules, and his testimonies,

56 *Moral Making*

> as it is written in the Law of Moses, that you may prosper in all that you do and wherever you turn, that the LORD may establish his word that he spoke concerning me, saying, "If your sons pay close attention to their way, to walk before me in faithfulness with all their heart and with all their soul, you shall not lack a man on the throne of Israel."' (1 Kgs 2:1–4 ESV)

As David's exhortation suggests here, the persistence of the monarchy depends on fidelity to the Law of Moses, a term that refers not narrowly to what might be considered juridical literature, but rather to the whole of the Pentateuch and the moral instruction narrated there. In addition, as Provan notes, there is a good deal of direct literary correspondence to the Deuteronomic law:

> [Deuteronomy] is the text to which the language of verses 3–4 taken cumulatively points us (e.g., observe what the Lord your God requires, cf. Deut 11:1; walk in his ways, cf. Deut. 8:6; keep his decrees and commands, cf. Deut. 6:2; that you may prosper in all you do, cf. Deut. 29:9; that the Lord may keep his promise, cf. Deut. 9:5; with all their heart and soul, cf. Deut. 4:29).[6]

In addition to David's charge, two of the initial details narrated with regard to the beginning of Solomon's career as monarch set up an ambiguous tension with the details of kingship narrated in the Pentateuch: (1) Solomon's "marriage alliance with Pharaoh king of Egypt," and (2) worship by the people "at the high places . . . because no house had yet been built for the name of the LORD."[7] I use the term "ambiguous" here because this description of the start of Solomon's career does not represent a bald-faced or deliberate violation of Pentateuchal standards, but rather a sinister ambiguity. The reader is left initially to wonder whether Solomon can pull off his ambitious plan. Keeping this ambiguity in mind, one can read the pursuit of a relationship here with the King of Egypt in two different ways. Reflecting the experience of Joseph (and to a more limited extent, Abraham) in the Genesis account, this could reflect a relationship as outreach to foreign kings and a welcome sign of Israel's cultural ascendancy. Or, read against the Exodus narrative, this new relationship could invoke a dark recollection of Egypt and the oppression of Israel under Pharaoh there. The problem presented of worship at the "high places" can also be read in two contrasting ways. In light of the later development of this practice with respect to syncretistic devotion to other deities, worship at high places can ring as a warning. However, up until this point, the phrase has been used in the previous narratives in the Hebrew Scriptures with a more benign connotation, a place where YHWH was being worshipped.[8] One need not decide either way, as it may well be the writer's intention to leave this question open at the

start of the narrative, so that later details accelerate the transformation of ambiguity into apostasy. Further emphasising this ambiguity, the specific location of this high place at Gibeon potentially implicates Tabernacle worship as the Chronicler recounts this as the place where it was located during David's Reign[9] and, as Arnold notes, Gibeon is included in Joshua's list of Levitical cities (Josh 21:17). In some contrast, the Deuteronomic narrative emphasises the degree to which Gibeon is geographically removed from the Jerusalem tent-shrine.[10] The conjunction *rq* in the subsequent passage further underlines this ambiguity: "Solomon loved the LORD, walking in the statutes of David his father, only [*raq*] he sacrificed and made offerings at the high places. And the king went to Gibeon to sacrifice there, for that was the great high place. Solomon used to offer a thousand burnt offerings on that altar" (1 Kgs 3:3–4 ESV). The text begins with the straightforward suggestion that Solomon loves YHWH and follows his law. However, as these early verses unfold, the status of this "high place" worship is opaque. What is clear from the text of 1 Kgs 3 is that the task of developing the worship of Israel is identified as a task that this king will take up. Whether one identifies the crucial issues as one of centralisation or idolatry, the problem is nevertheless one of conformity and fidelity in worship and thus the pattern is set for a juxtaposition of the construction work on the Tabernacle and Temple.

Working Wisdom and Solomon

I begin this comparison with a focus on the topic of "working" wisdom. In order to demonstrate the urgent need for a reappraisal of biblical wisdom for a Christian ethic of work, it may be helpful to begin with a brief survey of the frequent and superficial use of Solomon in business literature. Demonstrating that the trope has purchase outside explicitly religious discussions, in one study of Kantian capitalism Chryssides and Kaler suggest that business culture can generate something like the "wisdom of Solomon" and go on to use the wisdom of Solomon as a metaphor for impartiality. They suggest, "The task of management in today's corporation is akin to that of King Solomon. The stakeholder theory does not give primacy to one stakeholder group over another, though there will surely be times when one group will benefit at the expense of others. In general, however, management must keep the relationships among stakeholders in balance."[11] They suggest, in Corporate Law, "a body of case law will emerge to give meaning to 'the proper claims of stakeholders' and in effect . . . the 'wisdom of Solomon' necessary to make the stakeholder theory work will emerge naturally through the joint action of the courts, stakeholders, and management."[12] Whatever one might make of their business theory, it is interesting to note the appearance of Solomon as a type

58 *Moral Making*

for the "wise manager" and his wisdom deployed uncritically as a metaphor for exemplary building of social capital. In another example, Myron D. Rush suggests in his book *Management: A Biblical Approach* that the visit of the queen of Sheba to King Solomon (1 Kgs 10:1) should serve as an example of "How a Christian's faithfulness can bring praise to God even from a non-Christian."[13] He concludes that this can serve as a metaphor for the task of being a biblical manager: "People are watching your life – how you conduct your daily business activities – and they are either praising God like the queen of Sheba or they are shocked because you are no different from the rest of society."[14] Adding to the previous metaphorical usage, here Solomon functions as an ideal for cultural engagement and business-based apologetics. In my assessment below, this reading is not only inaccurate but a seriously misleading application of this text. In other instances, Solomon serves as a generic metaphor for exemplary wisdom in business. In *The Top Line*, Tom Despard suggests, "Business ethics is about exercising good judgement and making the right moral choices. It's about striving for a great *Top Line* and about connecting *virtues with vocations*."[15] In affirming this conviction, he provides "a few choice words from King Solomon as he asks the Lord for wisdom" and cites 1 Kgs 3:9: "So give your servant a discerning heart to govern your people and to distinguish between right and wrong."[16] In another similar appropriation of Solomonic wisdom, the entire text of *Street-smart Ethics: Succeeding in Business Without Selling Your Soul* by Clinton W. McLemore is focused on the author's "best attempt to unpack fifty of the most pithy and strategic sayings in the book of Proverbs," based on the assumption that they are wise sayings of Solomon. He adds, "They are pithy in the sense of being highly substantive and strategic in that they embody definite strategies for survival and success."[17] Popular Christian business writer John C. Maxwell provides several appropriations of Solomon in his pithy business advice books. In *The 21 Most Powerful Minutes in a Leader's Day: Revitalize Your Spirit and Empower Your Leadership (2000)*, Maxwell reflects on the important role played by "The Big-Mo" or momentum in business leadership. He concludes:

> Solomon took a good kingdom, and he turned it into a great kingdom. He built an impressive administration that relied on the talents of twelve governors. He made numerous alliances with neighboring powers. He secured trade and shipping routes that made Israel the crossroads of the world. He engaged in an extensive building campaign that made a marvel of Jerusalem. His projects included the Temple of the Lord, an elaborate new palace, the House of the Forests of Lebanon, the Hall of Pillars, the Hall of Judgment, and extensive defensive fortifications for the city. And he accumulated incredible wealth.

Building the Temple 59

To sum up Solomon's reign . . . Solomon took the momentum his father had given him and created the most powerful and prosperous nation in the world.[18]

Maxwell narratives this comprehensive summary of Solomon's reign uncritically as a list of achievements that "his son Rehoboam destroyed in a matter of days."[19] This quick sampling of business literature, particularly the use of the "wisdom of Solomon," demonstrates that the text of 1 Kings is regularly deployed in reflecting on business management both in explicitly Christian literature and elsewhere. Among all these various readings one finds that Solomon is often commended as an ideal type for managerial conduct and as a success story. Through such superficial appropriations of the bible, it is not surprising that one finds a diverse range of applications with biblical paradigms being used merely to prop up an author's suggestion. Perhaps the most distressing outcome is that business writers freely appropriate Solomon's as the ideal type of wisdom at the expense of the robust and contrasting account of working wisdom in Exodus, which I explicated in Chapter 1. Along these lines, Kessler and Bailey note, "Over the years, we have come to associate wisdom with strong judgement and being prudent or astute like King Solomon. In other words, practical wisdom can be thought of as the ability to link the other two forms of wisdom: knowledge and practice."[20] As I shall note here, reading the Solomonic narrative in its wider canonical context seems to suggest the exact opposite, that Solomon's wisdom becomes distorted and functions at the expense of practice. These appropriations of Solomon in business literature function as tragically truncated accounts of working wisdom that do not provide answers for, but rather perpetuate, the quandaries of modern work. In this section, I shall provide a close reading of Solomon's role in the construction narratives and attempt to provide a canonically encompassing reading of the meaning of wisdom in the text of Scripture as it pertains to work. What emerges is a far more complicated account of this king who functions as a stereotype of wisdom and success.

In some contrast to Exodus, where wisdom appears in the midst of work, wisdom comes as a prologue to Temple construction in 1 Kgs (3:5–4:34), where the writer brings the subject of wisdom to the fore with Solomon's famous request, "Give your servant therefore an understanding mind to govern your people, that I may discern between good and evil, for who is able to govern this your great people?" (1 Kgs 3:9 ESV). There are resonances here with the bestowal of wisdom in Exodus. As de Vries notes, "This structure is dramatic in its simplicity: God offers, Solomon responds; God replies, Solomon worships."[21] Though Solomon's wisdom has a different aspect, nonetheless, it goes far beyond the mere managerialism expected by contemporary readers. As Leithart notes, the wisdom of Solomon does not consist merely in issuing commands and settling disputes, but has an aspect of *poiesis*, drawing in the design and execution of the building of the Temple.[22] To this end, one can read

Solomon's making of the gold artefacts of the Temple and planting of his own gardens as an affirmation that a full exhibition of wisdom involves hands-on activity, even for a monarch.

There are, however, tensions with this portrait of Solomonic wisdom as exemplary. Again, de Vries is helpful here in his observation that, by the end of 1 Kgs 3, "the portrait of Solomon . . . differs significantly from the vengeful opportunist in chap. 2 and the political pragmatist of 3:1."[23] Right from the start, the text confronts the reader with a mixed presentation of "wise" Solomon. Within the structure of the text, the first exhibition of wisdom by Solomon in settling a dispute between two prostitutes is not an *ultimate* exhibition of wisdom by Solomon but rather his *first* act. Solomon's request for wisdom is preceded by his brutal consolidation of power, which results in the killing of his brother Adonijah (2:24) and David's general Joab (2:28–34) along with an ambiguous episode describing Solomon's marriage diplomacy with Egypt. Solomon is indeed bestowed unequivocally with divine wisdom, but an assessment of Solomon's execution of wise judgement need not be similarly unequivocal. There are indicators here that Solomon is an immature king who displays promise but who may nonetheless fail to measure up to the Deuteronomic demands of a just monarch.

As I shall suggest below, one finds a more mature (and yet still incomplete) expression of Solomonic wisdom in the building of the Temple. There is, as Gary Knoppers observes, an anti-Temple aspect to the Deuteronomistic narrative as it draws to its anti-climactic close, but I agree with him in suggesting that the negative evaluation of the Temple must not be "confused with the Deuteronomistic stance toward this downfall."[24] He argues:

> the Deuteronomistic analysis of history is profoundly concerned with cultic orthopraxis and cultic heteropraxis. By devoting so much attention to the central sanctuary, the history of the monarchy underscores the Temple's importance. Both the divine election to build and the divine election to destroy affirm the shrine's unique status.[25]

As I shall note further below, the structure of the text highlights the Temple construction as a climax of the narrative before the rapid descent towards the narrative of later monarchical anti-climax. It is entirely reasonable to assume that the Temple-construction narrative is provided for careful critical assessment by the reader – or perhaps more accurately, the worshipping community who reads this text together – as to whether it is an exhibition of Godly wisdom and of what sort it is. Further, this structuring seems to suggest that the primary subject of this narrative is not Solomon, but the Temple. If this is true, appropriation of 1 Kings in moral discourse (especially of the variety noted above)

may benefit from a shift of focus that may be enabled through a canonically refocused study of Solomon.

Unbalanced Human Work-relationships: Workers in 1 Kings

While I have presented a more measured posture towards Solomon above, as the Solomonic narrative proceeds to the new King's work at Temple construction, we find a transition from ambiguity to dissonance, as the character of work on display in Chapters 5–12 rings harshly against the setting provided by Exodus. The first dissonant note that rings in Chapter 5 comes with the volition of workers and status of materials narrated there. In dramatic contrast to the freely offered labour and lavish provision that provides the materials for the Tabernacle, 1 Kgs 5 provides a detailed narration of Solomon's enlisting of slave labourers and collusion with the King of Tyre in expropriating materials. We read in 1 Kgs 5:13 a chilling fulfilment of the warning offered in 1 Samuel, mentioned above: "King Solomon drafted forced labor out of all Israel, and the draft numbered 30,000 men" (1 Kgs 5:13 ESV). Discussions of slavery in the ANE are complex, and it is not my intention to enter fully into the debate over the peculiar form of the slavery represented here, particularly as to whether (as ch. 9 later suggests) the conscripts are Israelites.[26] Regardless of the magnitude of this transgression, Solomon's use of conscripted labour fails to establish the same conclusive break with slavery that is so clear in Exodus. The absence of explicitly demonstrated free agency here stands out particularly as the command that the people be mindful of their experience and deliverance from captivity features as a regular refrain throughout the Hebrew Scriptures – "you shall remember that you were a slave in (the land of) Egypt."[27] A close reading of the text of 1 Kgs 5 reveals elements of tension that prevent an unequivocal denunciation of Solomon, but nevertheless affirm my conclusion here. First, verse 13 is directly preceded by a text that seems to present Solomon's work with Hiram as a validation of his wisdom: "And the Lord gave Solomon wisdom, as he promised him. And there was peace between Hiram and Solomon, and the two of them made a treaty" (5:12). The progeny of wisdom and peace seems to be a relationship that supplies the Temple materials, and yet the later clarification offered with respect to Hiram of Tyre in 1 Kgs 9 shows an awareness of the tension latent in the earlier text, suggesting that this relationship is not such an unambiguous site for "wisdom and peace" after all, and perhaps also not a text to be read as lacking nuance. A proposed structure for the text of 1 Kgs 1–12 by Amos Frisch is helpful here, as he suggests that the Temple construction functions as the climax of the account, which is then surrounded by the collaboration with Hiram, structuring the narrative as follows:[28]

A.	The Beginning of Solomon's Reign: From Adonijah's Proclamation of Himself as King until the Establishment of Solomon's Reign	1.1–2.46
B.	Solomon and the Lord: Loyalty and the Promise of Reward	3.1–15
C.	The Glory of Solomon's Reign: Wisdom, Rule, Riches, and Honour	3.16–4:34
D.	Towards Building the Temple: Collaboration with Hiram, and the Corvée for the Temple	5.1–18
E.	The Building and Dedication of the Temple	6.1–9.9
D'.	In the Wake of Building the Temple: Trade with Hiram, and the Corvée for Building Projects	9.10–25
C'.	The Glory of Solomon's Reign: Trade, Riches, Wisdom, and Honour	9.26–10.29
B'.	Solomon and the Lord: Disloyalty and the Announcement of Punishment	11.1–13
A'.	The End of Solomon's Reign: Rebellions against Solomon and the Division of the Kingdom	11.14–12.24

Seen in the light of this structure, the initial report on Solomon's relationship with Hiram – which comes across as largely positive – must be read in apposition to the later revisiting of this relationship in the chiastically related text of 9:10–25, which notes the complexities of trans-national and trans-religious political relationships and their impact on the liturgy of Israel. Picking up this tension in Chapter 9, Provan suggests, "Themes from Chapters 4–5 are picked up now in a way that hints, not of wisdom, but of foolishness (Solomon's dealings with Hiram, 9:10–14 etc.; his use of forced labor, 9:15–23; foreigners coming to listen to his wisdom, 10:1–13). Other material (e.g., 9:24; 10:26) reminds us of foolishness already revealed in 1 Kings 1–8."[29] Though some scholars have noted that the identity of these labourers is left unclear, even if one affirms the later clarification in 1 Kgs 9 that these are conscripted Canaanites (and not Israelites, which would be a clear violation of Deuteronomic law), their involvement offers a sinister anticipation of the collusion with the nations, like Solomon's taking a wife from Egypt, which is to dominate the latter part of the narrative in 1–2 Kings.

A second crucial difference between the Tabernacle account and the Temple in 1 Kings that rings dissonantly can be found with regard to agency. In 1 Kings, we find what seems by comparison with the Tabernacle a solipsistic account of agency in the building process. While the narrative in Exodus begins with an interaction between Moses and YHWH and then draws an increasingly wide cast of Israel into the production of the Tabernacle, 1 Kings begins in Chapter 5 with a conversation between two monarchs, Solomon and Hiram of Tyre,[30] and

when a wider cast is drawn into the narrative their participation in Temple construction lacks the clear sense of agency presented in Exodus.

While in some contrast to those workers described in Chapter 5, those involved in Chapter 6 are not said to be conscripts, what stands out in this chapter is the dramatically reduced cast of participants. In Exodus, divine wisdom is bestowed on the artisan Bezalel and his assistant, and then this wisdom radiates outwards among the people of God as they teach others about the craft involved in Tabernacle construction and, by extension, Hebrew "work ethics" at the same time. In this way, working wisdom can be seen to ripple outwards throughout the people of God as they construct the place of worship. In contrast, the Temple is a rather solitary affair. The text opens, as I have suggested above, with two monarchs; and it is clear that this narrative provides more detail about their management of the building process than of the experience of the remainder of Israel. Even the artisan Hiram, displaying obvious resonances with Bezalel,[31] is nonetheless constrained only to the making of Bronze implements (1 Kgs 7:40, 45); Solomon reserves the goldsmithing for himself.[32] Further, the lack of narrative verbosity describing the nature of the work performed provides a rhetorical emphasis on their diminished work participation. While we can presume that others were involved in the work because we read the details of their conscription and recruitment, we read nothing about the content of their work, while in contrast Exodus exults in the details of the labour of all the people involved. Even when all the people of Israel make a showing after construction to join in the great celebration in Chapter 8, this is hosted and provided for by Solomon, further emphasising the divestment of the people. That they are invited guests demonstrates the benevolence of the monarch and not the participation of the people in this liturgical celebration.

Jackson reads this lonely cast of characters in 1 Kings as an instance of managerialism.[33] I have attempted a more moderate reading here – keeping open an initial hope for the ambiguous promise of Solomonic kingship – as universalising too stark a portrait of Solomon can undermine our reading elsewhere in the Hebrew Scriptures, as shown particularly with my study below of Chronicles where the depiction of Solomon is reframed in subtle but significant ways. This is the case, I think, with Jackson's reading, as he assumes that any text lacking narrative attention to the details of manufacture bears marks of the influence of a managerial redactor. This inhibits Jackson's reading of other texts, such as Hosea, where the concern is not on the particulars of the building process, but on the theological importance of the Temple. Given this possibility, I have attempted to demonstrate particular features of the text here that make it stand as conspicuous, and, to be fair to Jackson, one can also read in his observation a hint at a theological distinction being made here. While Exodus suggests that neither worship nor work is meant to function with a narcissistic focus on the leader, 1 Kings shows us the all-encompassing consequences of such an approach. Just as the account of wisdom in Exodus did not overwhelm the agency of the

workers, so too the bestowal of wisdom on Solomon does not prevent him from what is ultimately rebellion, fall, and disgrace. This concern over agency and participation comes to the fore, as I shall note further below, in the post-exilic rebuilding narratives including Haggai 1–2 and Ezra 3–6, where one finds a renewed emphasis, harkening back to the Tabernacle, on the free and willing participation of all Israel, where foreign contractors are not co-opted for temporary work, but are invited into the doxological procession as full participants.

The Taylorist emphasis on the scientific design of work process and organisational management has cultivated a deep separation – most pointedly on an epistemological level – between management and work in contemporary firms. In this way of thinking, exemplified in many of the appropriations of Solomonic "wisdom" in the business literature I surveyed above, wisdom is reserved for a design process that is abstracted from the work of making. In contemporary practice, this separation works out not merely on a procedural level, but also on the level of personnel, such that designers quite often have little (or nothing) to do with the actual fabrication of their products. Instead, whether this be the design of a carefully ordered industrial division of labour or the design of specific objects, the actual fabrication is performed by workers who are co-opted for their physical capacities but not for their mental abilities; and this abstraction is intensified by the process of outsourcing whereby manufacturing can happen thousands of miles from the design of a prototype. It is important to note how the recent advent of inexpensive 3D printing is similarly ambiguous, as it enables makers to literally produce a material prototype of their design without involving their hands in a direct way in manufacturing. Part of the justification behind this transformation was the conviction that with advances in industrial technology human involvement in physically involving occupations would decrease as machines became increasingly able to perform and automate these tasks, leading to the so-called "end of work."[34] Yet more than a century later, the end of work appears to be nowhere in sight and instead the human experience of work has been dramatically subordinated to the dreary management of machines that mass-produce bagels, car tyres, clothing, and bandages.[35] One consequence of this change is a sort of design narcissism. Citing Donald Kuspit, Michael Northcott suggests that this vision has also influenced contemporary Neo-*avant garde* artistic production: "Neo-avant garde art is in effect a celebrity cult, sustained by charismatic individuals and their moneyed backers. The object of veneration is not the real experiences that artistic representation may evoke but the primordiality of heroic experience and insight resident in the presentation of art itself. . . . This is truly 'art for art's sake' and nothing more; it points nowhere but narcissistically back on the ego of its creator who claims a privileged experience of reality which he wishes to share through his creative acts with those who encounter them."[36] This narcissism points to a deeply embedded dysfunction latent in making culture, as Northcott observes: "it may

be no coincidence that postmodern art installations often rely upon technological devices and competences more associated with industrial manufacture than with the traditional skills and crafts of aesthetic making."[37]

As an affirmation that the dichotomisation of design and management makes for less satisfactory work, many contemporary manufacturing firms, particularly in the automotive industry, have begun to reshape their production towards a model pioneered in Japan by Toyota, called Lean Production. In the first major study on Lean Production, Womack sets up the contrast with mass-production:

> The mass-producer uses narrowly skilled professionals to design products made by unskilled or semiskilled workers tending expensive, single-purpose machines ... the lean producer, by contrast, combines the advantages of craft and mass production, while avoiding the high cost of the former and the rigidity of the latter. Towards this end, lean producers employ teams of multiskilled workers at all levels of the organization and use highly flexible, increasingly automated machines to produce volumes of products in enormous variety.[38]

This step back towards craft work, according to Womack, also has implications for the way people work:

> most people – including so-called blue-collar workers – will find their jobs more challenging as lean production spreads. And they will certainly become more productive. At the same time, they may find their work more stressful, because a key objective of lean production is to push responsibility far down the organizational ladder. ... Lean production calls for learning far more professional skills and applying these creatively in a team setting rather than in a rigid hierarchy.[39]

Because it is less structured and more nimble, Womack argues, the lean-producing manufacturer is able to focus towards excellence rather than just "good enough." While it may represent a positive move back towards craft, lean manufacturing is not without its problems, and subsequent studies since Womack's enthusiastic report in 1990 have noted how, in spite of the stated contrasts with mass-production, lean production is hardly a reconceptualisation of work design. There is, as Jones, Latham, and Betta observe, a large critical qualitative literature that substantiates the "distance between managerial rhetoric and reality, emphasising the exploitative rather than emancipatory aspects of lean systems."[40] In one example, a study by Graham of the Subaru-Isuzu plant in Lafayette, Indiana, found, "the concept of industrial citizenship carried no connotations of industrial democracy. The only issue on which workers had ever voted was 'whether to have pizza' as their snack of choice."[41] In a

66 *Moral Making*

UK-based study of the lean Vauxhall-GM and Rover-BMW plants, Stewart *et al.* found, "only 31% of respondents felt that they exerted either a great deal or a fair amount of influence over the way they carried out their work; only 34% indicated the same for control over sorting out problems that prevented them from doing their jobs; 62% felt that they could vary the pace of their work very little or none at all; and 73% found it difficult to change the things they did not like about their jobs."[42]

Richard Sennett argues that a turn back to the craft workshop might offer one way of reprioritising worker agency. This turn back towards craft, according to Sennett, comes at the expense of "art." His account of the contrast between the two serves to demonstrate some of the trouble with too easy a recourse to "art" in modern theological accounts of work as *poiesis*, which I have sought to problematise in this book. As Sennett notes,

> The two are distinguished, first, by agency: art has one guiding or dominant agent, craft has a collective agent. They are, next, distinguished by time: the sudden versus the slow. Last, they are indeed distinguished by autonomy, but surprisingly so: the lone, original artist may have had less autonomy, be more dependent on uncomprehending or willful power, and so be more vulnerable, than were the body of craftsmen.[43]

On the basis of this contrast, Sennett argues for a renewed emphasis on the workshop as a social space: "Workshops present and past have glued people together through work rituals, whether these be a shared cup of tea or the urban parade; through mentoring, whether the formal surrogate parenting of medieval times or informal advising on the worksite; through face-to-face sharing of information."[44] In some sense, Sennett's argument is that a true affirmation of the sociality of work will result in a revalorisation of craft. I find this account of agency and the way Sennett sets up this tension to be highly compelling, and his to be a modern account of craft that resonates quite significantly with the ancient account I am focused primarily on in this book.

As an alternative to the account of Solomonic wisdom in 1 Kings, which I have problematised above, I want to commend a textually de-centred account of biblical wisdom that abandons this narrow focus on Solomon and may capture the exhibition of wisdom elsewhere in the bible. This more broadly founded account of wisdom may also provide a complementary insight for the ethics of work. In addition to the thick account of the divine gift of wisdom in Exodus, already surveyed above, the book of Proverbs seems to grant a similar kind of egalitarian *availability* for the gift of wisdom. In Proverbs 9, Lady Wisdom offers a broad invitation: "Whoever is simple . . . Leave your simple ways, and live, and walk in the way of insight" (Prov 9:1–6 ESV).

Textually de-centring an account of wisdom in Scripture frees one from the need, expressed so consistently in the business books above, to sanitise or even valorise Solomon, as his gift of wisdom does not exhaust the possibilities on offer elsewhere in the Hebrew Scriptures. As Ellen Davis has pointed out, the book of Proverbs concludes with an account of a wise craftswoman and wife. The ominous warning that hangs over Proverbs is inverted with a surprisingly positive answer to the rhetorical question, "An excellent wife who can find?" So wisdom is not purely the province of Kings; and further, craft-wisdom seems to be freely available to all Israel, by Solomon's own admission.[45] These occurrences serve well to de-centre the account of wisdom in the Hebrew Scriptures. Indeed, one must deny that wisdom is something to be granted exclusively to Israelite Kings or to be exercised in the service of statecraft, but a careful reader also cannot assert that wisdom is reserved exclusively for a proletariat. Instead, biblical wisdom represents something far wider. It is broadly available and broadly encompassing. A de-centred reading of wisdom, in aggregate, commends caution in focusing "wisdom" on wise management (as may be the case with appropriations of Solomonic wisdom in work ethics) at the expense of wise work. Indeed, in this way Solomon serves as an example of an imbalance in the dialectics I identified in the previous chapter. He is one who masters materials and workers without being "mastered" by them in turn.

Unbalanced Material Work-relationships: Material Culture in 1 Kings

A close study of the material culture of Solomon's Temple building sounds an additional dissonant note with respect to Solomon's exercise of wisdom and the account of work on display in Kings. While much is made by scholars of the presence of conscripts in Chapter 5, many seem to miss the impact of the material details in the narrative in these chapters. In one example, Provan dismisses these details outright and fails to note the comparison: "Much is obscure to us as readers who stand at such a distance from the authors of the text, and we shall not pause at any length to puzzle over the architectural detail or marvel at all the glitter and the gold. Little that is important for interpreting the book of Kings hangs on any such detail."[46] In fact, as I have suggested repeatedly above, the material culture of worship does carry a theological payload and these details carry great significance in enabling the reader to appreciate the subtle critique at work here.

For this final point of contrast, I note the significance connoted by the use of materials in the two narratives. As I have suggested above, the Tabernacle is constructed in the midst of an economy that maintains a memory of the constrained wilderness manna-economy such that even overwhelming generosity

is met with prudential reserve. In contrast, Solomon's use of materials is lavish without mitigation (contrast 1 Kgs 4:22–3). Materials for the Tabernacle are gathered from among the people (presumably in part from their plunder of the Egyptians), while materials for the Temple are expropriated in a contract with Hiram, the King of Tyre, as noted above. Later, those same materials are re-appropriated after 1 Kgs 9, "serving mainly as a source for gold and silver for Davidic kings to pay off invading Gentiles."[47] In some contrast to the status of the materials used in Exodus, in 1 Kings a shadow hangs over the precious materials, particularly gold, that mysteriously appear for Solomon's appropriation in the Temple construction. Not only are we unclear about the source, but the text marks a significant transition in the displays of prosperity and the meaning of value that lies behind them. Provan suggests:

> Why, indeed, is there no mention of gold at all in the description of Solomon's glory in Chapters 4–5, where prosperity is described rather in terms of *food*? And why does gold appear in such abundance here, after the solemn warning of 9:6–9 about 'turning away from God,' and in company with other material that leads us to expect just this 'turning away' of Solomon? These are interesting questions, particularly in view of texts like Proverbs 30:8 and Deuteronomy 17:17. Excessive wealth brings with it the danger of apostasy.[48]

Further commending attention to the brevity of the mention of gold in 1 Kings is a later reference in Ezra 7:15–16, which, in spite of other allusions to 1 Kings in that book, seems in this case to skip past the Solomonic episode and return to the Exodus for its form with the free offering of the people as a source for materials (cf. Exod 35:5, 35:21–2 etc.): "and also to carry the silver and gold that the king and his counselors have freely offered to the God of Israel, whose dwelling is in Jerusalem, with all the silver and gold that you shall find in the whole province of Babylonia, and with the freewill offerings of the people and the priests, vowed willingly for the house of their God that is in Jerusalem" (ESV). Ezra matches the strong emphasis in Exodus on the freewill nature of the offering and the extended dialogue about its provenance. This arrival of gold in 1 Kings also seems to carry with it a change in attitude. Provan summarises: "The influx of food described in Chapters 4–5 has been replaced by an influx of luxury goods (vv. 2, 10–12, 22, 25), and Solomon's use of all this wealth is entirely self-indulgent (vv. 14–29)."[49] The materials that constituted the Tabernacle carried in its finest materials a persistent memory of the freedom of God's people and their absolute deliverance from slavery, while Solomon's enterprise draws in materials with a decidedly more ambiguous status.

Turning from the fate of the Temple materials seen generically to some specific analysis, another important contrast between the work of Solomon and that of Moses is revealed upon close inspection of their use of timber. In Exodus, there is a regular repetition that the wood to be used in construction is to be a native timber, acacia,[50] whereas the timber used overwhelmingly in Solomon's construction is imported Lebanese cedar,[51] to the extent that one of the buildings in his palace complex is termed in 1 Kgs 7:2 *byt yʿr hlbnwn* ["Lebanon Forest House"] and Hiram receives 20 towns in Galilee in exchange for the vast amount of imported Lebanese cedar he has shipped in (1 Kgs 9:11).[52] It is also interesting to note that the "forest house" is the location of the royal armoury, indicated by mention of *nšq byt hyʿr* ["weapons of the house of the forest"] in Isa 22:8. The judgement proclaimed in Jer 21:14 of "kindling a fire in her forest" may be a reference to the destruction of this building. Some caveats with regard to my negative reading of the presence of cedar in 1 Kings need to be noted, particularly in light of my later explication of cedar in eschatological perspective.[53] First, Solomon does also use cypress, which is native to Israel and still grows there in abundance.[54] Similarly, while timber to be used in the sacrifices mentioned in Leviticus is in large part described generically,[55] presumably with whatever is at hand, there are occasional references to the use of cedar.[56] Keeping this in mind, what we can nevertheless conclude from this discussion is that the preciousness of cedar was well known by Israel and this knowledge is narrated well before the time of Solomon. More to the point, along with the use of gold and other rare and precious minerals and stones (which were not available at hand or native to the area), the trouble with Solomon is not simply that he uses cedar but moreover his impulse towards extravagance and excess that generates this expropriation and the culture that surrounds it. This is affirmed even more powerfully by the fact that cypress, a native timber, is also included in Solomon's imports via Hiram of Tyre (cf. 1 Kgs 5:8). The narrator's point is clear: either the local Israelite stock was so exhausted by this project that Solomon had to augment available timber or, even worse, Solomon was so keen to expropriate resources that, in spite of its native, and presumably available status, Solomon chose to use the forests of other nations in the building of his Temple and palace complex. This was a profoundly anti-ecological undertaking. Even the logistics involved provide an ancient account of international shipping. Irene and Walter Jacob note the process involved in such importation: "The large timbers were floated 200 miles down the coast to Jaffa and hauled another 25 miles across land to Jerusalem."[57] To sum up the contrast: in Exodus, we find the consecration of available materials, while in the Solomonic Temple (and in Jeremiah, as I shall note below) one finds the unbounded importation of non-indigenous materials.

70 *Moral Making*

Just as modern readers have often ignored the rich and suggestive material details scattered across Christian Scripture, so too have writers on work tended to neglect the material dimension of work, whether this be the raw materials used by workers or the phenomenology of finished products. Bruno Latour suggests that this neglect is symptomatic of a broader lacuna:

> Much like sex during the Victorian period, objects are nowhere to be said and everywhere to be felt. They exist, naturally, but they are never to be given a thought, a social thought. Like humble servants, they live on the margins of the social doing most of the work but never allowed to be represented as such.[58]

In response, Latour argues that the narration of a robust account of work requires that we expand our conception of the types of work actors and agency to include objects. This expansion offers a way of taking into account a subtler version of the way things act upon workers, as Latour explains it: "In addition to 'determining' and serving as a 'back-drop for human action,' things might authorize, allow, afford, encourage, permit, suggest, influence, block, render possible, forbid, and so on."[59] Because the ANE work context was an overwhelmingly agrarian one, this immediacy of the materiality of work and the contingency of workers upon "things" was likely not as difficult to recapture. As the abstraction of human agency and the denial of limits is a firmly embedded feature of the modern age, reconceptualising work to take a fuller account of materiality for modern workers is a more complicated task. To take seriously the impact of things upon our attempts to perform work that is coherent and moral also involves something of a break with what are traditional modern theoretical conceptions of work.[60]

Yet the consequences are substantial, as contemporary work offers a stunning example of Solomonic expropriation writ large. In a now classic 1972 report, *The Limits to Growth*, a team of MIT analysts used computer modelling to map human consumption patterns against measurable limits of non-renewable resources among several other factors including food production, population growth, and pollution.[61] While the most publicised resource limit in recent discussions is petroleum (with conversations concerning peak oil), there are a number of other resources whose global capacity is also being tested, including phosphate (used in fertiliser), coal, aluminium, iron, and chromium, such that the situation on the horizon may best be described in Richard Heinberg's words as "peak everything."[62] The authors of *Limits to Growth* concluded that, if a "standard-run" scenario persisted, unchecked growth would lead to a condition of global overshoot that in turn would likely lead to societal and economic collapse late in the twenty-first century. More recent studies have vindicated

the authors' suggestions[63] and in some cases observed that we may already be in a situation of overshoot on a number of resources, particularly with regard to petroleum usage and the nitrogen cycle.[64]

These twin analyses of Solomon and contemporary resource crises demonstrate that neither modern industrial societies nor ANE agrarian societies are *necessarily* virtuous moral environments for work. Even though we in the modern context have access to tools that can measure resource availability and quantify pollution, whereas those in the pre-modern context had a more immediate experience of their relation to material, we find that people in both contexts are at risk – as I have suggested with this reading of the building of the place of worship – of "overreach." Yet the account in Christian Scripture preserves an ancient sensibility that can nurture more moral forms of work that may acknowledge and work within limits set by the Creator.

Several recent studies, situated within the space of ecological design, have proposed a reconceptualisation of the worker's relationship to material that is resonant with this ancient account. In one example, in their book *Cradle to Cradle*, Braungart and McDonough note how early industrial approaches to manufacturing betray an ignorance or disinterest in natural limits: "Resources seemed immeasurably vast. Nature itself was perceived as a 'mother earth' who, perpetually regenerative, would absorb all things and continue to grow."[65] This led to the development of a design paradigm that persists to the present day, which they call "Cradle-to-Grave," where "more than 90 percent of material extracted to make durable goods in the United States becomes waste almost immediately."[66] In the most insidious example, products are designed with "built-in obsolescence" such that they last for a limited time and consumers are encouraged to replace the deprecated product rather than repair it when broken or remain satisfied with it while it is functional if "unfashionable."[67] In contrast to the tendency by late-twentieth-century designers to merely fine-tune existing design towards "eco-efficiency," Braungart and McDonough propose a new paradigm for design, which they call "Cradle-to-Cradle." In this conception, they suggest, designers should work first to eliminate waste, which they argue may be accomplished by designing products to be composed exclusively of biological and "technical nutrients." The former is designed to be composted so that biological nutrients avoid landfills and can be used productively in food production, while the latter include non-organic technical components that are engineered to be disassembled and reused for new products, thus reducing the need to continually extract raw materials as the old ones are deposited in waste dumps.

While Cradle-to-Cradle design takes into account the industrial designer's perspective, a similar emphasis on reconceptualising work to avoid waste has

been offered recently by Matthew Crawford. Taking the discussion in a slightly different direction, Crawford advocates for product repairability, so that consumers can also re-engage with product maintenance and limit arbitrary obsolescence. In Crawford's analysis, repair provides not only the grounds for less waste, but also a repair of the relationship between persons and things:

> A decline in tool use would seem to betoken a shift in our relationship to our own stuff: more passive and more dependent. And indeed, there are fewer occasions for the kind of spiritedness that is called forth when we take things in hand for ourselves, whether to fix them or to make them. What ordinary people once made, they buy; and what they once fixed for themselves, they replace entirely or hire an expert to repair, whose expert fix often involves replacing an entire system because some minute component has failed.[68]

In this way, repair work emphasises an aspect of craftsmanship, which Sennett terms "objectification," in that it forces the worker back towards consideration of objects.[69] In a substantial scholarly study of repair work, sociologist Doug Harper goes so far as to argue that the work of repair has preserved these ancient craft sensibilities even while design and manufacture have become rationalised with the rise of mass production and ever-increasingly divided labour, which promote de-skilling. Repair work, according to Harper, preserves a unique tacit epistemological dimension: "fixing, in a general sense, extends a yet earlier mind and method, that of the original fashioner."[70] In this way, the making of repairable objects may also offer a means by which persons can recapture a form of edifying work that has in many contexts been lost.

Moving from the first emphasis in "Cradle-to-Cradle design" on eliminating waste, Braungart and McDonough's second design principle is an emphasis on locality. In this way, they argue that designers should,

> connect them [human systems and industries] to local material and energy flows, and to local customs, needs, and tastes, from the level of the molecule to the level of the region itself.... We consider how the chemicals we use affect local water and soil – rather than contaminate, how might they nourish? – what the product is made from, the surroundings in which it is made, how our processes interact with what is happening upstream and downstream, how we can create meaningful occupations, enhance the region's economic and physical health, accrue biological and technical wealth for the future.[71]

Work that seeks to operate within this kind of sensibility seeks to make use of locally grown and harvested materials and design, and in a corresponding way

it also may rely, as Gorringe has argued, upon vernacular design that is adapted to local bioregional realities. In his account of the built environment, Gorringe notes, "The vernacular, however, represents response not just to climate and materials, but to social form and tradition. . . . Vernacular architecture manifested no *'libido dominandi,'* none of the desire to dominate which Augustine believed characterised the earthly city."[72] Ecological design is, in this appraisal, a proper response to the theology of creation.[73] In my reading, Christian Scripture also possesses this sensibility of "things"; and if one takes this into account, we may see how, in transcending limits, Solomon's construction process demonstrates an unbalance with regard to the second (material) dialectic I outlined in the previous chapter. Solomon's attitude towards materiality resonates with the modern designer's supposed transcendence of bioregional limits and the related neglect of the contingency of worker to material. We can see that this neglect by Solomon expresses a denial of contingency in two related but slightly different ways eschewing both region (by expropriating from Tyre) and the proper limits of material.

In this chapter thus far, I have established several of the key ways in which Solomon's building project evinces the dissolution of a moral relation between work and worship and how this in turn is marked by the unbalancing of two dialectics: among workers and between the worker and materiality. While the text of Exodus provided paradigms for positive moral reflection, Kings offers the inverse of this message, expressed in 1 Kgs 9:6–7:

> But if you turn aside from following me, you or your children, and do not keep my commandments and my statutes that I have set before you, but go and serve other gods and worship them, then I will cut off Israel from the land that I have given them, and the house that I have consecrated for my name I will cast out of my sight, and Israel will become a proverb and a byword among all peoples.

Here one finds an intrinsic connection between the land, representative of the whole economy of Israel and the house of worship, such that when sin pervades the political economy of Israel, their place of worship will (in this case literally) disintegrate.

The Legacy of Solomon: From Unrighteous Temple to "Homes" in Jeremiah

I turn now to Jeremiah to vindicate my suggestion that, with the abandonment of moral work on the Temple, a broader moral relationship has been broken. Particularly we find this exhibited with Jeremiah's attention to the work of

Solomon's descendant, the king Jehoiachim in "house-building." In this case, we find the same immorality that was directly problematised in the Temple-construction account in 1 Kings appearing with regard to more domestic building projects. While Solomon's palace in 1–2 Kings is indirectly problematised, Jeremiah's critique of Jehoiachim is direct and brutal.[74] Similarly, where the relation of work and the place of worship was ambiguous (at best) with Solomon's project, we find a straightforward condemnation in Jeremiah. This is a consequence of the dissolution of the moral relationship that I have identified in the material above: where sin has destroyed the building of worship, other sorts of work appear disordered as well.

While my study will focus on the royal construction critique presented in Jer 22:1–7, some brief background is appropriate to set this text in its narrative context. Fulfilling the violation noted above, a consistent theme in Jeremiah is the relinquishment of the freedom gained in Exodus from Egypt and by extension the relinquishment of free labour, as a consequence for sinful practice. This is put paradigmatically early in Jer 2:20: "For long ago I broke your yoke and burst your bonds; but you said, 'I will not serve.' Yes, on every high hill and under every green tree you bowed down like a whore."[75] Lest the reader underestimate the sinful acts that have led to this fate, it is important to note the narrative progression that has led up to Jeremiah's proclamation in Chapter 22. This text is set narratively at the Temple (19:14–20:18) after Jeremiah has returned from a visit to Topheth, the high place where child sacrifices were likely being practised.[76] Against the backdrop of manifest evil occurring in the high places, Jeremiah pronounces judgement against Israel: Jer 19:14–15 echoes the earlier judgement oracles in 19:3–9 and Chapters 11–13[77] and he is immediately subjected to violent retribution by Pashhur the priest (20:1–2). Jeremiah responds to this demonstration of priestly complicity in the evil of Jerusalem with an oracle of judgement specifically against Pashhur (20:3–6), which intimates the broader judgement to which Israel is to be subjected at the hands of Babylon; and the confident tone of this judgement is juxtaposed with the subsequent confession and lament by Jeremiah (20:7–18).

Jeremiah 22, then, is set amidst a volley of oracles against the evil kings of Judah and arriving at this chapter we find that Jeremiah offers words of judgement specifically against Jehoiachim, a king who appears near the degenerative end of the downwards spiral of the narrative of the Deuteronomist's tale (cf. 2 Kgs 23:34–24:16). Jeremiah has a great dislike for Jehoiachim, as he is, according to Jeremiah, responsible for the undoing of the (albeit temporary) righteousness of the people of Israel under his father Josiah. He has no regard for the scriptures (rediscovered and celebrated by his father, cf. Jer 36:21–6) and foreign cults reappear during his reign (cf. Jer 7:9, 18, 31; 11:9–13). In many

ways, Jehoiachim might be considered Jeremiah's archenemy. This prophetic critique offered by Jeremiah in Chapter 22 focuses on two very concrete aspects of building, which are emblematic of Jehoiachim's unrighteousness and resonate with the aspects of the Solomonic building project portrayed above.

The text opens with Jeremiah's exhortation, "Woe to him who builds his house by unrighteousness, and his upper rooms by injustice" (Jer 22:13a ESV). This is followed by two explications of unrighteous building: slavery and excess. We find the condemnation of slavery in the latter half of verse 13, "who makes his neighbor serve him for nothing and does not give him his wages." Even more so than in 1 Kings, with the direct ascription of this practice to "his neighbor," the unrighteousness of this practice stands out in sharp relief against its clear allusion to Deut 24:14–15.[78] The second condemnation, of excess, is less direct, but nonetheless present in this text. Thompson notes the implicit message here:

> One wonders where the king obtained funds to build his spacious buildings, since he was required to pay heavy tribute to his Egyptian overlord (2 K. 23:33–5). At least the labor cost him nothing, because his fellows worked for *nothing* (*ḥinnām*) and did not receive a *wage* (*pō'al*) for their work. Jehoiakim, who was only twenty-five years old when he began to reign and only thirty-six when he died (2 K. 23:36), was evidently a thoroughly spoiled and self-indulgent young despot.[79]

The directness of Jeremiah's statement leaves no doubt that excess is as central to Jeremiah's critique as slavery: "who says, 'I will build myself a great house with spacious upper rooms,' who cuts out windows for it, paneling it with cedar and painting it with vermilion. Do you think you are a king because you compete in cedar?" (Jer 22:14–15a ESV). In both aspects, excess and slavery, we find that the moral relationship between work and worship – previously cultivated in the construction of the place of worship and now shown to be broken even in the building of "homes" – has dissolved and God's people are left to face the consequences of this moral chaos.

As the account of the Prophet Jeremiah draws to a close, the Temple – intended, like the Tabernacle, to function as a place where the people of Israel could regularly engage in practices that promoted a moral synthesis of worship and labour – is dismantled. The narrative provides a slow account of this final foreclosure:

> In the fifth month, on the tenth day of the month – that was the nineteenth year of King Nebuchadnezzar, king of Babylon – Nebuzaradan the captain of the bodyguard, who served the king of Babylon, entered Jerusalem. And

he burned the house of the LORD, and the king's house and all the houses of Jerusalem; every great house he burned down. (Jer 52:12–13 ESV)

The intimate attention to detail in its dismantling can leave no doubt about the centrality of the Temple and the impact that accompanied its destruction. The painstaking deconstructive detail provided in verses 17–23 offers a rhetorical inversion of the narrative of Exodus, replete with constructive detail, and this narrative is completed with an account of the execution of the leaders of Israel and the Temple personnel (Jer 52:24–7) and the enslavement of the people of Israel (Jer 52:28–30). The reader is left with a spotlight on a lonely King Jehoiachim, exiled and allowed to dine at the King's table, like a favourite pet.

Given the painful and complete fall that Jeremiah narrates for the Temple and its builder, one might expect for the Temple to gradually disappear from the memory of Israel; and some twentieth-century biblical scholarship tends to affirm such an expectation with its dismissal of later Temple themes. But, as a growing group of biblical scholars – including Margaret Barker, Crispin Fletcher-Louis, Greg Beale, and Nick Perrin – have begun to observe over the past several decades, the Temple actually gains strength over the remaining course of the canonical text of the bible as a metaphor for the restoration of the people of God. Here one finds that the relation of work and worship is preserved and even intensified in some cases. With this transformation in mind, in the material that follows, I shall attempt to examine the significance of eschatology for the theology of work. My analysis turns now to the continued, if complex, persistence of the Temple in the moral life of Israel as type and metaphor. In the next chapter, I proceed to examine the way in which biblical texts continue to narrate a moral relation between worship and work using a metaphorical understanding of the Temple that provides a new context in which to narrate the paradigms I have elucidated above.

Notes

1 Cf. Jackson, "Enjoying the Fruit of One's Labor," 241; referencing Deut 17:14–17; Judg 8:22–3, 9:1–57; and 1 Sam 8:10–18.
2 1 Samuel 8:11–18 ESV.
3 Jackson, "Enjoying the Fruit of One's Labor," 241.
4 Peter J. Leithart, *1 & 2 Kings*, Brazos Theological Commentary on the Bible (Grand Rapids, MI: Brazos Press, 2006), 69.
5 This is of course preceded by another protological structure made by YHWH: Eden.
6 Iain William Provan, *1 and 2 Kings*, NIBC 7 (Peabody, MA: Paternoster Press, 1999), 31. This recourse to Deuteronomy is a well-noted feature of 1 Kings by commentators, including more recent work by Brueggeman and Leithart.
7 1 Kings 3:2, ESV.

8 Cf. Martin J. Selman, "הַמָּב," *NIDOTTE*, 1:659. *TDOT* provides a similar reading, 2:143.
9 1 Chr 16:39, 21:29; and 2 Chr 1:3, 1:13. See also Patrick M. Arnold, "Gibeon," *AYBD*, 2:1011–12.
10 To this effect, de Vries writes, "it is noteworthy that the parallel passage in 2 Chr 1:3–13 paraphrases this in such a way as to bring Gibeon inside the Jerusalem city-precincts (something that now has in fact been accomplished in the outward extension of Jerusalem's city limits)." Simon J. de Vries, *1 and 2 Chronicles* (Grand Rapids, MI: Eerdmans, 1989), 51. See also the mention of the Ark residing at Jerusalem in 1 Kgs 3:15.
11 George D. Chryssides, *An Introduction to Business Ethics*, ed. John H. Kaler (London: Chapman & Hall, 1993), 262.
12 Chryssides, *An Introduction to Business Ethics*, 265.
13 Myron Rush, *Management: A Biblical Approach* (Colorado Springs, CO: Victor, 2002), 227.
14 Rush, *Management*, 227–8.
15 Tom Despard, *The Top Line: Virtuous Companies Finish First* (Fairfax, VA: Xulon Press, 2002), 114.
16 Despard, *The Top Line*, 114.
17 Clinton W. McLemore, *Street-smart Ethics: Succeeding in Business Without Selling Your Soul* (Louisville, KY: Westminster John Knox Press, 2003), 59.
18 John C. Maxwell, *The 21 Most Powerful Minutes in a Leader's Day: Revitalize Your Spirit and Empower Your Leadership* (Nashville, TN: Thomas Nelson, 2007), 245. To his credit, Maxwell does acknowledge in another book, "by the end of his reign, this brilliant king somehow forgot the first principle of wisdom," in *A Leader's Heart: A 365-day Devotional* (Nashville, TN: Thomas Nelson, 2010), 301.
19 Maxwell, *The 21 Most Powerful Minutes in a Leader's Day*, 245.
20 *Handbook of Organizational and Managerial Wisdom*, ed. Eric H Kessler and James Russell Bailey (Los Angles, CA: Sage Publications, 2007), 460.
21 De Vries, *1 and 2 Chronicles*, 55.
22 Leithart, *1 & 2 Kings*, 73.
23 De Vries, *1 and 2 Chronicles*, 55.
24 Gary N. Knoppers, "Yhwh's Rejection of the House Built for His Name: On the Significance of Anti-temple Rhetoric in the Deuteronomistic History," in Yairah Amit, Ehud Ben Zvi, Israel Finkelstein, and Oded Lipschits (eds), *Essays on Ancient Israel in Its Near Eastern Context* (Winona Lake, IN: Eisenbrauns, 2006), 234.
25 Knoppers, "Yhwh's Rejection of the House Built for His Name," 234.
26 For an exhaustive survey including contrasts with other ANE and GR societies, see Markus Barth and Helmut Blanke, *The Letter to Philemon*, Critical Eerdman's Commentary (Grand Rapids, MI: Eerdmans, 2000), Chapter 1, "The Social Background: Slavery at Paul's Time." With specific regard to 1 Kings, see also Provan, *1 and 2 Kings*.
27 For an extensive literary analysis of this motif in 1 Kings 1–14, see Amos Frisch, "The Exodus Motif in 1 Kings 1–14," *Journal for the Study of the Old Testament* 25, no. 87 (2000): 3–21.
28 Amos Frisch, "Structure and Its Significance: The Narrative of Solomon's Reign (1 Kings 1–12:24)," *Journal for the Study of the Old Testament* 16, no. 51 (1991): 3–14.
29 Provan, *1 and 2 Kings*, 84.

78 *Moral Making*

30 I alluded to the collusion between these two in my analysis of the Tabernacle, Chapter 1. It is worth noting that Leithart reads Solomon's interaction with Hiram of Tyre as one of outreach: "1 Kgs. 4 shows again that Solomon is also a greater Adam. Beyond Adam, he eats from the tree of wisdom and demonstrates his wisdom by organizing the kingdom, in his relations with Hiram of Tyre, and in building the Temple (Exod 31:3). All these displays of wisdom bring him glory beyond the glory of any kings of his time, a partial restoration of the bright radiance of Eden." Leithart, *1 & 2 Kings*, 49.
31 See Mordechai Cogan, *1 Kings: A New Translation with Introduction and Commentary*, AYB 10 (New York, NY: Doubleday, 2001).
32 Cf. 1 Kings 6:20–2, 28, 30, 32, 35, and 7:49–51.
33 Jackson, "Enjoying the Fruit of One's Labor," 311.
34 For a detailed literature survey on the subject, see Edward Granter, *Critical Social Theory and the End of Work* (Farnham: Ashgate, 2009). Rifkin also provides an evocative summary of "end of work" utopias of the nineteenth- and twentieth century in literature: *The End of Work: The Decline of the Global Labor Force and the Dawn of the Post-market Era* (New York, NY: Jeremy P. Tarcher/Penguin, 2004), 45–9.
35 Richard Sennett provides a poignant example of this transformation and its consequences in *The Corrosion of Character* (New York, NY; London: Norton & Company, 1999).
36 Michael S. Northcott, "Concept Art, Clones, and Co-creators: The Theology of Making Modern Theology," *Modern Theology* 21, no. 2 (2005): 221.
37 Northcott, "Concept Art, Clones, and Co-creators," 222. See also Sennett, *The Craftsman*, 65–74.
38 James P. Womack, *The Machine That Changed the World: Based on the Massachusetts Institute of Technology 5-million Dollar 5-year Study on the Future of the Automobile*, ed. Daniel T. Jones and Daniel Roos (New York, NY: Rawson Associates, 1990), 13.
39 Womack, *The Machine That Changed the World*, 14.
40 Robert Jones, James Latham, and Michela Betta, "Creating the Illusion of Employee Empowerment: Lean Production in the International Automobile Industry," *International Journal of Human Resource Management* 24, no. 8 (2013): 1629–45.
41 Cited in Jones, Latham, and Betta, "Creating the Illusion of Employee Empowerment," 1630.
42 Cited in Jones, Latham, and Betta, "Creating the Illusion of Employee Empowerment," 1630.
43 Sennett, *The Craftsman*, 73. Though lamentably Sennett does not engage with the literature in craft scholarship, these insights can be linked to a number of scholars: see critique and literature survey in Paul Greenhalgh, "Words in the World of the Lesser: Recent Publications on the Crafts," *Journal of Design History* 22, no. 4 (2009): 401–11.
44 Sennett, *The Craftsman*, 73.
45 Though the Solomonic authorship of Proverbs is hotly disputed, it is worth noting that this is the traditional position, supporting the Canonical scope in which Proverbs occurs.
46 Provan, *1 and 2 Kings*, 46.
47 Leithart, *1 & 2 Kings*, 20.
48 Provan, *1 and 2 Kings*, 85.

49 Provan, *1 and 2 Kings*, 87.
50 Exod 25:5, 10, 13, 23, 28; 26:15, 26; 27:1, 6; 30:1, 5; 31:5; 35:7, 24, 33; 36:20, 31; 37:1, 4, 10, 15, 25, 28; 38:1, 6.
51 1 Kings 6:9–10, 15–16, 18, 20, 36.
52 For a summary of research on the buildings in Solomon's palace complex, see Simon John de Vries, *1 Kings*, WBC 12 (Waco, TX: Word Books, 1985), 102.
53 I examine the significance of materials in the construction account in 1 Chronicles in Chapter 3, "Reframing Abundance and Inclusiveness in 1–2 Chronicles."
54 See "Flora," *AYBD*, 2:805.
55 Lev 1:7–8, 12, 17; 3:5; 4:12; 6:12; 11:32.
56 Lev 14:4, 6, 49, 51–2; Num 19:6.
57 "Flora," *AYBD*, 2:805.
58 Bruno Latour, *Reassembling the Social: An Introduction to Actor-network-theory* (Oxford: Oxford University Press, 2005), 73.
59 Latour, *Reassembling the Social*, 72. See also Bruno Latour, *Politics of Nature: How to Bring the Sciences into Democracy* (Cambridge, MA: Harvard University Press, 2004), 75–7.
60 Latour, *Reassembling the Social*, 78. Two other recent studies that follow similar lines are Jane Bennett, *Vibrant Matter: A Political Ecology of Things* (Durham, NC: Duke University Press, 2009); Tim Ingold, "Toward an Ecology of Materials," *Annual Review of Anthropology* 41, no. 1 (2012): 427–42.
61 Donella H. Meadows et al., *The Limits to Growth: A Report for the Club of Rome's Project on the Predicament of Mankind* (New York, NY: Universe Books, 1972).
62 Richard Heinberg, *Peak Everything: Waking Up to the Century of Declines* (Gabriola, BC: New Society Publishers, 2007). Cf. also Meadows et al., *The Limits to Growth*, 54–69.
63 Jørgen Nørgaard, Kristín Vala Ragnarsdóttir, and John Peet, "The History of the Limits to Growth," *Solutions Journal: For a sustainable and desirable future* 1, no. 2 (2010): 59–63; Charles A. S. Hall and W. W. John, "Revisiting the Limits to Growth after Peak Oil," *American Scientist* 97, no. 3 (2009): 230–7; Graham Turner, *A Comparison of the Limits to Growth with Thirty Years of Reality* (Canberra: CSIRO Sustainable Ecosystems, 2008); Donella H. Meadows, Dennis L. Meadows, and Jørgen Randers, *Limits to Growth: The 30-year Update* (White River, VT: Chelsea Green Publishers, 2004).
64 Johan Rockström et al., "A Safe Operating Space for Humanity," *Nature* 461, no. 7263 (2009): 472–5.
65 McDonough and Braungart, *Cradle to Cradle*, 25.
66 McDonough and Braungart, *Cradle to Cradle*, 27.
67 Cf. Slade, *Made to Break*.
68 Crawford, *Shop Class as Soulcraft*, 2.
69 Richard Sennett, *The Culture of the New Capitalism* (London: Yale University Press, 2006), 104.
70 Harper, *Working Knowledge*, 21.
71 McDonough and Braungart, *Cradle to Cradle*, 123.
72 Gorringe, *A Theology of the Built Environment*, 92.
73 Gorringe, *A Theology of the Built Environment*, 107.
74 For the classic study on Solomon's palace, see Walter Brueggeman, *The Prophetic Imagination* (Minneapolis, MN: Fortress Press, 2001).

75 The LXX renders this with second-person pronouns, significantly changing the meaning, thus NET: "long ago you threw off my authority and refused to be subject to me." But as Craigie *et al.* note in the WBC, "The reading is possible, but the first-person form suits the context." Peter C. Craigie, Page H. Kelley, and Joel F. Drinkard, *Jeremiah 1–25*, WBC 26 (Dallas, TX: Word Books, 1991), 35. This textual issue does not undermine the broader point I am making here regarding the role of theme of free labour inverting into slavery in the judgement oracles of Jeremiah, but rather impinges on my usage of this specific text. For more relevant analysis of this specific text, see Craigie, Kelley, and Drinkard, *Jeremiah*, 36–7.

76 Cf. "Topheth (Place)," *AYBD*, 6:601.

77 See Craigie, Kelley, and Drinkard, 264ff, for further detail on the literary connection between these passages.

78 "You shall not oppress a hired servant who is poor and needy, whether he is one of your brothers or one of the sojourners who are in your land within your towns. You shall give him his wages on the same day, before the sun sets (for he is poor and counts on it), lest he cry against you to the LORD, and you be guilty of sin" (Deut 24:14–15 ESV).

79 John A. Thompson, *The Book of Jeremiah*, NICOT 24 (Grand Rapids, MI: Eerdmans, 1980), 479.

3 The Temple Not Made With Hands
Reconceptualising the Temple

> For David said, 'The Lord, the God of Israel, has given rest to his people; and he resides in Jerusalem forever. And so the Levites no longer need to carry the Tabernacle or any of the things for its service.' (1 Chr 23:25–6)

In this chapter, I approach several texts in Christian Scripture where Temple construction is narrated in a substantially different way, as the construction of the Temple forms the basis for a metaphor with distinctly eschatological clothing. As I shall suggest, for all of these texts, the Tabernacle narrative in Exodus serves as the point of reference and thus our study of these later Temple texts in Isa 60, Zech 14, 1 Chr 22, and 2 Chr 1–9 provides further opportunity – particularly in light of the counter-narrative found in 1 Kings and Jeremiah – to develop and texture the account of valorous craft work that I have already proposed. As the title for this chapter (drawn from Mark 14:58) suggests, this study also serves as a preparation for my concluding chapter in Part II, which traces all these themes into the NT. The gospels are not the first time that the reader of Christian Scripture encounters a radical revision of the Temple, and it is helpful to explore the eschatological usage of Temple construction in the Hebrew Scriptures in order to underline the conceptual points of continuity with the NT. Before I proceed to exegesis of these Hebrew texts, however, some comments are in order regarding the use of eschatology in reflection on the theology of work. As with the wisdom of Solomon, a number of scholars have recently and somewhat eclectically made generic use of eschatological theology for reflection in the theology of work; and this will serve to explain the differences between those and my more textually and thematically focused inquiry here.

Is Eschatology the Appropriate Site for a Theology of Work?

Several contemporary accounts in the theology of work focus foremost around eschatological themes.[1] Most prominent among these is Miroslav Volf, with his early monograph *Work in the Spirit*.[2] As I have noted briefly, Volf addresses the

interconnections between eschatology (of the *transformatio mundi* variety) and work, and by implication pneumatology, drawing especially (though briefly) on Paul's theology of charisms as a useful resource for reflection on work. Aside from this synthetic dimension, Volf also suggests that a theology of charisms is less "open to ideological misuse" as the charismatic relation to work is not merely evaluative, but transformative, as it will be subject to God's judgement.[3] It is on this last point that one arrives at the specifics of his deployment of an eschatological payload for the theology of work. Volf argues, we must "pattern our work according to the values of the new creation, so we also have to criticize it in the light of the eschatological judgment."[4] In this way, Volf means to address some of the shortcomings of early-twentieth-century co-creation accounts: "Elevating work to cooperation with God in the pneumatological understanding of work implies an obligation to overcome alienation because the individual gifts of the person need to be taken seriously. The point is not simply to interpret work religiously as cooperation with God and thereby glorify it ideologically, but to transform work into a charismatic cooperation with God on the 'project' of the new creation."[5] In *A Theology of Work: Work and the New Creation*, Darrell Cosden offers an account of work that he suggests is "quite similar" to Volf's, which he uses as "both an orientation point and a point of departure."[6] His account is noteworthy in that his focus on eschatology as the conceptual site for the theology of work is comprehensive. Following Moltmann's emphasis on Gestalt,[7] Cosden suggests:

> we as persons will be saved in eternal life, but that so too will eternal life (in some way) be extended to the things that we love, the objects of our concern, including our projects. This must be the case for if it were not, we as persons would be so abstracted out of our life's contexts and thus so divorced from our Gestalts that in our disorientation and dislocation our very identities (stemming from our concerns, our loves and interests) would be lost even as they were supposedly being saved.[8]

Common to these works is a twofold emphasis on (1) an attempt to benefit from the twentieth-century rehabilitation of eschatology, paradigmatically expressed in Moltmann's theology of hope, and (2) the need to augment this use of eschatology with other dogmatic themes. For Volf this augmentation is pneumatic and for Cosden it is somewhat more eclectic. Particularly in Cosden's account, one finds a striking subordination of broader theological reflection to the author's attempt to provide a theology of work and the kind of therapeutic emphasis I noted in my Introduction. The eschaton, in Cosden's way of thinking, simply *must* include our work because we cannot imagine it to be otherwise. To leave the matter ambiguous or, worse still, partially discontinuous, would risk jeopardising an attempt to provide a therapeutic account of

work for alienated workers. The hope of heaven is mobilised here in order to soothe worker *anomie*. Such a therapeutic interest surely has a place, but when mobilised so comprehensively, it blunts the precision of the moral account that follows. Further, this intense focus on a realisable final state represents a significantly circumscribed eschatology and all these authors fail (perhaps as a consequence of their recourse to freestanding dogmatic themes) to note any specific contour in canonical Christian Scripture in which this restoration of hope is located. As Oliver O'Donovan observes, regardless of whether we want it to be the case, Christian moral epistemology cannot rely so closely on knowledge of the end of history. In fact, an ethic that arises from the Christologically conditioned understanding of resurrection prevents such an approach:

> What then, must such knowledge of created order be, if it is really to be available to us? It must be an apprehensive knowledge of the whole of things, yet which does not pretend to a transcendence over the whole universe, but reaches out to understand the whole from a central point within it. It must be a human knowledge that is coordinated with the true performance of the human task in worship of God and obedience to the moral law. It must be a knowledge that is vindicated by God's revelatory work that the created good and man's knowledge of it is not to be overthrown in history. Such knowledge, according to the Christian gospel, is given to us as we participate in the life of Jesus Christ.[9]

I shall follow O'Donovan's cues here in seeking to anchor my reflection on the moral impact of eschatological accounts of Temple construction for the theology of work, not with an unsustainable fascination with the final state, but rather on our present life in Christ with an ecclesial foundation. I consider the extrication of the theology of work from its miring in final-state-obsessed eschatological speculation to be a crucial task, particularly if it is to avoid being beholden to modern narratives of hope *in* progress. A more carefully situated approach to these eschatological texts may illuminate our understanding of the ethics of work and free up the theology of work to serve its prophetic task as well, in addition to a therapeutic one. As Moltmann himself argues, our task must not be primarily therapy, but to pursue discernment that is nourished by hope. Moltmann defends such an approach in his most recent book, *The Ethics of Hope*. According to Moltmann, an Ethics of Hope is one that remains open to change, particularly away from destructive patterns, which may seem to possess an unstoppable cultural inertia:

> We become active in so far as we hope. We hope in so far as we can see into the sphere of future possibilities. We undertake what we think is possible. If, for example, we hope that the world will continue to be as it is now, we

shall keep things as they are. If we hope for an alternative future, we shall already change things now as far as possible in accord with that. If the future is closed, then nothing more is possible; we cannot do anything more.[10]

Moltmann also proposes here a balanced appropriation of hope: "if our actions were directed only to the future, we should fall victim to utopias; if they were related only to the present, we should miss our chances."[11] In this way of thinking, hope is construed as something that replaces fear. A coherent moral vision is not one that flees disaster, but one that can be drawn towards a positive portrayal of the good:

> The endtime is simultaneously the new-time. In the perils of time it lives from hope for the coming of God. It mobilized energies out of surmounted fears. It holds instructions for resistance against the old world in anticipation of the new one. It presupposes a transformative eschatology and, correspondingly, is itself transforming action.[12]

Keeping this chastened and realistic pursuit of hope in mind, I proceed with my analysis towards eschatologically inflected accounts of Temple construction, where we find further texturing of the model that I have sketched out above.

New Temple Construction in Isaiah 60

A study of Isaiah 60 offers a useful point of entry into the eschatological use of Temple imagery in the Hebrew Scriptures, as the author of Isaiah picks up on several images present in the narrative of 1 Kings that are redeployed in later eschatological visions.[13] In seeking to elaborate the relationship between the construction imagery in 1 Kings and Isaiah, I shall begin by examining three interrelated images that arise in 1 Kings and are recast in an eschatological context in Isaiah. These are the ships of Tarshish,[14] the "wealth of nations,"[15] and the foreign kings who march in after their offering.[16]

The first of these three – the ships of Tarshish – is used in significant and complex reference in both 1 Kings and Isaiah. In 1 Kgs 10:22, one reads, "the king had a Tarshish fleet on the sea, along with Hiram's fleet. Once every three years, the Tarshish fleet came in, bearing gold and silver, ivory, apes, and peacocks" (1 Kgs 10:22 JPS). Commentators suggest that this particular text is meant to draw attention to the vast scale and economic prowess of Solomon's kingdom as he was able to draw exotic and extravagant imports. In this way of thinking, the greatness of a King is represented not only in power and wealth, but also in the ability to attract trans-national merchants who connect the kingdom to other cultures, bringing sophistication and slaves.[17] As the text that follows directly

in 1 Kings summarises: "Thus King Solomon excelled all the kings of the earth in riches and in wisdom" (1 Kgs 10:23 ESV). This is the final affirmation of Solomon in the text before we read of his great fall, which is narrated in Chapter 11. It is perhaps also a final dark commentary on Solomon's status when this later metaphorical use of the ships of Tarshish includes no direct reference to Solomon. In this way, the ships become a freestanding metaphor. Later kings unsuccessfully attempt to preserve the trading fleet, as with Jehoshaphat who conspired with Ahaziah (1 Kgs 22:41–50 and 2 Chr 20:31–21:1), but their destruction (described in 1 Kgs 22:48 and 2 Chr 20:36–7) is immediate and this destructive end is affirmed as God's good judgement of an unrighteous monarchy in Ps 48:8[7],[18] Isa 23 (vv. 1, 14), Ezek 27:25–7, and possibly also Rev 18:11–17.

The other two images also occur as a composite in 1 Kings, though somewhat more indirectly. In 1 Kgs 10:1–15 there is a vision of the extravagant offerings that is distilled later in Isaiah as the wealth of nations coming from a procession of kings. These include: a procession led by the Queen of Sheba with "camels bearing spices, a great quantity of gold, and precious stones" (1 Kgs 10:2, JPS; cf. 10:10); King Hiram, who brings "gold from Ophir . . . a huge quantity of almug wood and precious stones" (10:11); and others who brought tribute or taxes, such that "[a]ll the world came to pay homage to Solomon and to listen to the wisdom with which God had endowed him; and each one would bring his tribute – silver and gold objects, robes, weapons and spices, horses and mules – in the amount due each year" (1 Kgs 10:24–5 JPS).

In Isa 60 these three images combine to convey an image of the eschatological New Jerusalem that is a true fulfilment of the Mosaic promise proclaimed in Exod 19: "you shall be My treasured possession among all the peoples. Indeed, all the earth is Mine, but you shall be to Me a kingdom of priests and a holy nation" (Exod 19:5–6 JPS). The writer of Isaiah includes the ships of Tarshish in his eschatological vision of the new kingdom: "Behold, the coastlands await me, With ships of Tarshish in the lead, To bring your sons from afar, And their silver and gold as well – For the name of the LORD your God, For the Holy One of Israel, who has glorified you" (Isa 60:9 JPS). One might initially think that these later references shine positively, free of any divine judgement of an unrighteous monarchy. However, Isaiah has already narrated the destruction of the contemporary ships in Isa 23:1–14, and the human cargo of these new merchants, rather than slaves, are the sons of Israel, "brought . . . from afar." In spite of the seemingly straightforward status of Israel's trading efforts in eschatological reference, there remains a memory of the unrighteous conduct of Israel's kings. The rendering of the "wealth of nations" here is with respect to the radiance of the New Jerusalem. Consequently, Isa 60:5 relates: "your heart shall thrill and exult, because the abundance of the sea shall be turned to you,

the wealth of the nations shall come to you" (ESV). In this way, the approach of foreign kings marks an eschatological ascendancy of Israel of which Solomon's wise rule represents a failed prototype. This theme is repeated across much of the Prophetic literature.[19]

In making an attempt to grasp at the significance of these three images and their journey across the text, I begin by noting that it is likely not an accident that Adam Smith chose to use this potent eschatological image of "the Wealth of Nations" for the title of his now-famous work on political and economic theory.[20] However, what Smith's appropriation and subsequent uses of this text seem to miss is the way in which this eschatological image is mediated in the context of the wider canonical text of Scripture. So what are we to make of Isaiah 60 and its imagery for a contemporary context? In seeking to offer an answer to this question, I should first note that this inclusion of "exotic" products and culture in the eschatological economy does not underwrite a programme of undiscerning appropriation. One might want to suggest that this globalised vision in Isaiah 60 presents a tension with the kind of bioregionally attentive craft work I have highlighted in Exodus, but I do not think this is actually the case. In the first instance, this image of the "wealth of nations" in Isaiah – which does function as a metaphor for the task of sourcing materials for work – is not just eschatological, but is also doxological. In the subsequent chapter, a priestly identity is associated with this "wealth of the nations": "While you shall be called 'Priests of the LORD,' and termed 'Servants of our God.' You shall enjoy the wealth of nations and revel in their riches" (Isa 61:6 JPS). This explicitly economic activity is to be entertained not by more generic economic agents, or even by a new King, but represents an egalitarian participation in the act of worship. Without the theologically particular social context in which worship is offered, our present context and the New Jerusalem as imagined by Isaiah lose their authentic point of reference. In this way, these three images serve to convey a theologically construed relationship between good work and "culture." The aforementioned destruction of ships serves to remind the reader that this procession does not represent the same kind of cedar-plunder that Solomon prosecutes (I take up this issue further below). Rather, if this eschatologised Temple serves as a kind of focal point for the craft work of God's people, we might say that this is a truly democratic celebration of vernacular building.

Building on this, the text of Isaiah 60 also adds a new emphasis on the aesthetic dimension of work. While the beauty of Tabernacle and Temple are certainly implicit in the narratives that I have discussed above – with the description of material excellence, particularly fine timber and precious metals – compared to the description of the Temple in Isa 60 these previous instances are quite muted. The text of Isa 60 (and indeed the broader text of Isaiah) is replete with visual aesthetic vocabulary. In particular, the writer of Isa 60 maintains a strong

rhetorical recourse to the language of bestowed divine beauty using *p'r*.[21] This link may be lost on contemporary readers, with the frequent rendering of *p'r* using the English "glory" as the Hebrew term carries an inherent aesthetic connotation that has faded in English usage. In contrast, Exodus has only three instances of *p'r* (all in nominal form), which refer exclusively to the priestly garments in Exod 28:2, 28:40, and 39:28; and the term is not used in 1 Kings at all. In fact, the sole aesthetic use of the language of beauty refers to Abishag, who is *yph* ["fair" or "beautiful"] in 1 Kgs 1:3.

It is important to note that beauty is granted to the newly constituted Temple in Isaiah by divine bestowal. This aspect is set early in the text, suggesting in Isa 4:2, "In that day, The radiance of the LORD Will lend beauty and glory, And the splendor of the land [Will give] dignity and majesty, To the survivors of Israel." In a similar way, the opening of Isa 60 establishes the aesthetic dimension of the New Jerusalem: "Arise, shine, for your light has dawned; The Presence of the LORD has shone upon you!" (Isa 60:1 JPS). This city presents not only a glorious beauty, but one that is illuminative – leading to the frequent visual imagery of brightness, shining, and light that is a result of the beauty of this new installation: "And nations shall walk by your light, Kings, by your shining radiance" (Isa 60:3 JPS).[22] However, this vocabulary is not deployed with regard to the work of the people, but rather to the divine work, i.e., the people themselves. In this way, in contrast to the emphasis in 1 Kings on the designs of Solomon (cf. 1 Kgs 7:8, 17, 19, 22, 26, 28–9, 31, 33; and Jeroboam in 16:7), this text speaks of divine "handiwork in which I glory" (Isa 60:21 JPS), which *is* God's people. This theme is inverted in Jeremiah's satirical poem about a goldsmith in Jer 10 (repeated briefly in 51:17). As Jeremiah reminds his readers, juxtaposing the wise and the "good" work they purchase made by *ḥrš* ["engravers"] and *ṣwrp* ["goldsmiths"] with that of the maker who creates and bestows wisdom, "among all the wise of the nations and among all their royalty there is none like You. But they are both dull and foolish" (Jer 10:7–8 JPS). In Isa 60, one finds the same theme repeated in a positive frame. Righteous people are even described as the result of (albeit painful and redemptively destructive) smith-work echoing with the metalwork examined in previous chapters: "It is I who created the smith to fan the charcoal fire and produce the tools for his work; So it is I who create The instruments of havoc" (Isa 54:16 JPS).[23] Also relevant is the perhaps more gentle occurrence later of the metaphor of the potter working clay: "But now, O LORD, You are our Father; We are the clay, and You are the Potter, We are all the work of Your hands" (Isa 64:7 JPS). In this way, the beauty of the Temple serves to emphasise the point I have made above: because the artisan of this new Temple is God, the result of this craftsmanship is not merely a physical installation for the site of worship, but it includes the making of the people that constitute it. This is craftsmanship on a cosmological scale.

Nevertheless, in noting the emphasis given to divine agency in the bestowal of beauty in Isaiah, it is important to observe how divine possession of beauty is also magnanimous. This bestowal is not exclusive, but rather, as the language of illumination emphasises, it overflows from YHWH to his creatures. Affirming this suggestion, in verse 5, Isaiah suggests, *tr'y wnhrṭ* ["you shall see and be radiant"]. Most importantly, however, Isaiah conveys a relationship between shining radiant beauty and holy righteousness. Verse 21 suggests, "Your people shall all be righteous . . . the work of my hands, that I might be glorified" (Isa 60:21 ESV). As above, "glorified" in verse 21 is an English rendering of the Hebrew verb *p'r* in the *hitpael*, which has a reflexive meaning. In this way, the possibility of beauty in God's work is not set in opposition to the possible beauty of the good work done by righteous humans, because this beauty inheres in the new "built" Temple and radiates outwards. If this light, bestowed by the Creator, were not possessed in some sense as their own, how could these people be described as "your people, all of them righteous" (Isa 60:21 JPS)? Though Isa 60 does portray the activity of building with a limited cast, namely with just one divine builder, ascription of this sort to the divine Creator is substantially different from focused ascription to Solomon. One is exclusive and the other is naturally inclusive, indeed as the pattern of the text is to provide a model of the moral importance of beauty not just for the exiled people of Israel but also for foreign kings and their culture. This beautifying procession provides a paradigm that is presented in several later more compressed eschatological accounts, including Hag 2:6–9 and Rev 21:23–35.

Beauty and Work

A crucial point to be drawn from this exegesis of Isaiah is that beauty is not merely a functional (or "ornamental") aspect of work. Instead, the ability to apprehend and produce beauty is an intrinsic feature of good human work, which is executed in conformity with the pattern offered by the divine Creator God. Beauty has its own place as an aspect of good work. This suggestion stands in contrast to a good deal of contemporary design theory with its strong emphasis on functionalism typified in Louis Sullivan's adage, "Form ever follows function."[24] In contrast, this narrative in Isaiah 60 resonates with the account of design offered by design theorist David Pye, who argues that beauty ought not be given a subordinate role in the process of making. Pye argues instead for a relativisation of "function," which he suggests is a fantasy: "most of the nonsense probably starts at the point where people begin talking about function as though it were something objective: something of which it could be said that it belonged to a thing."[25] He prefers to define function as "what someone has provisionally decided that a device may reasonably be expected to do at present."[26]

His point is that workers often discover function along the way as they make things and that the process of work cannot be slavishly devoted to utility. Consequently function ought not be afforded exclusive teleological primacy in work: "any concept such as 'function' which includes the idea of purpose is bound to be an unsafe foundation; for purpose leaves commonplace factual affairs like results far behind."[27] In purposeful repudiation of Engels's utilitarianism, Pye goes on to argue for a model of design and workmanship that he calls "useless work."[28] Moral work that ought to result in beauty involves much "useless" activity: exploration, play, and experimentation, and this commitment to the beautiful, as Isaiah construes it, is a recapitulation of divine Creative activity.

Rowan Williams provides a theological account of beauty, presenting a similar argument against idealistic conceptions of beauty that subordinate aesthetics to rational comprehension. Drawing on Maritain's suggestion (which in turn is drawn from Aquinas) that art is a "value of the practical intellect," he suggests:

> Beauty is not, therefore, a single transcendent object or source of radiance. It is a kind of good, but not a kind of truth – that is, it provides satisfaction, joy, for the human subject, but does not in itself *tell* you anything. . . . Beauty, we might paraphrase, is a relation between work and observer in which the observer's will as well as intellect is engaged, a relation in which what is present to the mind is sensed as desirable, as a source of pleasure.[29]

In this conception, the aspect of beauty in work cannot be rationalistically reduced to a property that is intellectually apprehensible or that can be subsumed within a generic moral scheme. Instead, this is a more focused consideration of the moral aspect of work. As Williams argues, "art is not about the will . . . nor does it aim to produce good dispositions of the will. It does not aim at delight or the desire of the good. It seeks the good of *this* bit of work. And the artist as artist is not called on to love God or the world or humanity, but to love what he or she is doing."[30] Robustly moral work that seeks to produce beauty ought to be intensely focused on excellence in the peculiar work itself, yet beauty is not apprehended prior to the act of work. In this conception, work defies the requirements of utility. As Pye suggests, if one does not pursue the beauty-less "workmanship of certainty," one must pursue a "workmanship of risk."[31] The worker seeking beauty must open themselves to contingency (in this case, the guarantee that something they produce may be beautiful). Furthermore, as I have argued above, this contingency also works itself out on a social axis with other workers and with non-human creatures. We do not only accept that the outcomes of our work may be unexpected, but must also open ourselves up to the possibility that the others we invite in may make demands upon us that do not easily accommodate rationalistic forms of production.

Taking on risk through accepting contingency in the way that I have just outlined, stands in stark contrast to the modern obsession with psychological "risk" and "flexible capitalism" in business, which Richard Sennett argues are an internalisation of postmodern narrative. In Sennett's account, as workers pursue "short-term work experience, flexible institutions, and constant risk-taking," they embody the conviction that "history is just an assemblage of fragments."[32] In contrast, as Williams suggests, the pursuit of beauty in work does not entail the solipsistic retreat of a fragmented ego. Instead, Aquinas' account of *splendor formae* involves an "'overflow' of presence. . . . This object is there *for me*, for my delight; but it is so because it is not there *solely* for me."[33] In a sense, beauty is communally and experientially substantiated. If we accept this conclusion, those forms of work that are rationally designed in abstraction (using CAD etc.) and then mass-produced "without hands" may be simply incapable of expressing the same kinds of beauty because they lack intimate human somatic involvement and the forms of contingency that are entailed there.

However, getting "hands on" may not be enough to sustain forms of work that may produce beautiful things. Bernard Leach offers a similar critique to the one Williams draws from Maritain, yet he nuances this with further attention to the sociality of beautiful work – the second form of contingency I have outlined above. Leach does not dismiss the more rationalistic work of an engineer – he acknowledges that each form may have its own "aesthetic significance."[34] But he upholds the argument that the intimacy of human somatic involvement can provide an unmediated kind of perfection: "good hand craftsmanship is directly subject to the prime source of human activity, whereas machine crafts, even at their best, are activated at one remove – by the intellect."[35] It is important to note that the concern for Leach (and for me) is a more complex one than just machine-critique. In his conception, the problem is not simply that machine-made work may replace handmade products and that they may thus replace beauty in human material experience with serviceability (as his allowance for machine-made excellence attests), but that hand-work at its best is an embodied engagement *and* a communal enterprise that is sustained by a living tradition. If hand-work becomes an exclusive and lonely outpost of "artists," this tradition, which takes centuries to develop, is at risk of being lost. To this end, he suggests:

> The necessity for a psychological and aesthetic common foundation in any workshop group of craftsmen cannot be exaggerated, if the resulting crafts are to have any vitality. That vitality is the expression of the spirit and culture of the workers. In factories the principle objectives are bound to be sales and dividends and aesthetic considerations must remain secondary. The class of goods may be high, and the management considerate and even humanitarian, but neither the creative side of the lives of the workers

nor the character of their products as human expression can be given the same degree of freedom which we rightly expect in hand work. The essential activity in a factory is the mass-production of the sheer necessities of life and the function of the hand worker on the other hand is more generally human.[36]

In this account, the sociality of work and the production of beauty are inextricably intertwined and both are required for truly *human* work. These are all synthesised, for Leach, in arguing that a properly human account of work is one that may sustain and be shaped in turn by a living tradition. Seen in this way, this secular account by Leach can be seen as deeply resonant with other theological accounts of work that situate meaningful human experience within the midst of a living tradition.[37]

This way of thinking about work as a series of layered contingencies (i.e., as "craft") offers some useful direction in seeking a rehabilitation of the concept of work for the modern context. As I have already noted above, machine-work with its natural instrumentality can encourage a reductive account of work. Work may be reduced to a series of repeatable actions without any necessary recourse to human knowledge as it is accreted in tradition.[38] This thicker account of beautiful work is also particularly useful for the contemporary work context as the rhetoric of beauty has recently become quite popular in selling mass-produced consumer goods. As Wallace and Press observe, "beauty is the new black."[39] One finds frequent recourse to the rhetoric of "beauty" in the marketing of devices such as iPhones. Yet this is a thin instrumentalised account of beauty, which is subordinated to utility. In their critique of the use of "beauty" by producers of consumer goods, Wallace and Press argue, "Industrial design can employ the illusion of beauty to temper the beast of technology by providing a veneer of desire, seduction and usability."[40] This deceptive "beautifying" is a problem not only for the consumer, but also for the worker, as suggested by the outbreak of suicides at the Foxconn manufacturing facility where these supposedly "beautiful" devices are made in China (Apple's primary outsourcer). Such thin accounts of beauty do not draw upon those robust forms of work that can in turn sustain and develop work-traditions in human communities.[41] Rather, they may actually accelerate their dissolution. To come back around to the account in Isaiah 60, we can see how desperately our contemporary workplaces need this more carefully construed account of beauty as one finds in the biblical account of moral work.

Work Materials in Isaiah 60

Returning to Isa 60, it is important to note a second point upon which Isaiah might be mistakenly seen to be resonant with the Solomonic account. In this

case, the trouble is with materials – more specifically, with regard to the timber on display that Solomon harvested with such conspicuous extravagance for the Temple. In Isaiah, the new Temple is indeed constructed using some of the timbers of Lebanon in addition to the cypress [*brwś*], pine or elm [*tdhr*], and boxtree [*wt'śwr*] that the foreign kings bring: "The majesty of Lebanon shall come to you. . . . To adorn the site of My Sanctuary, To glorify the place where My feet rest" (Isa 60:13 JPS). Yet this display is not one of conspicuous extravagance, but rather of a properly proportional beauty. In making this point, it is crucial to note an exceptional text earlier in Isaiah's vision, where he speaks of the restoration of Israel as consisting in the planting of trees:

> The poor and the needy Seek water, and there is none; Their tongue is parched with thirst. I the LORD will respond to them. I, the God of Israel, will not forsake them. I will open up streams on the bare hills And fountains amid the valleys; I will turn the desert into ponds, The arid land into springs of water. *I will plant cedars in the wilderness*, Acacias and myrtles and oleasters; I will set cypresses in the desert, Box trees and elms as well – That men may see and know, Consider and comprehend That the LORD's hand has done this, That the Holy One of Israel has wrought it. (Isa 41:17–20 JPS, *emphasis* mine)

Isaiah 41 presents a startling and straightforward account of reforestation and ecological restoration as part of the Isaianic vision of broader creational restoration. In this way, the planting of trees is an extension of God's re-bestowal of beauty to the land, as the text from Isa 4:2, noted above, suggests. The verse "*bayyôm hahû' yihyeh ṣemaḥ yhwh liṣbî ûl^ekāḇôd*" may be rendered literally as "in that day, the vegetation (*ṣemaḥ*) of the Lord shall become beauty and glory and the fruit of the land majesty and beauty to the remnant of Israel." In this light, we may read the presence of trees and exuberant appreciation of timber as standing in contrast to Solomon's approach to raw materials and the beauty of the Temple. Precious timber in this eschatological sense is portrayed not as a resource to be expropriated, but as a plant to be tended and renewed.

As this explication of materials and kingly processions in Isa 60 makes clear, the content of these construction narratives in biblical prophetic writings has been eschatologically redeployed such that the construction of the Temple experiences a transition in meaning for the moral topology of Israel. Many images from 1 Kings reappear, but in this new appropriation the new Kingdom is not a mere recapitulation of the events of 1 Kings in a new age. Rather, this transformation is far more significant, granting a new conception of kingship and a recomposition of construction of the place of worship. We find a similar – though more conspicuously eschatological – reweaving of the moral fabric in

which the places and products of worship and work are so intimately related with a study of the rehabilitation of holiness in the domestic context as narrated in Zechariah, to which I now turn.

New Temple Construction in Zechariah 14

In seeking to flesh out my appreciation of Temple theology in the later Hebrew Scriptures, I turn next to Zechariah as a complementary example. Before I proceed to close analysis of the closing verses of this book, it may be helpful to set the narrative context in which this eschatological vision appears. After a brief and violent description of the tribulation that the people of Israel will endure in 14:1–4, the writer notes, "Then the LORD my God will come, and all the holy ones with him" (Zech 14:5 ESV). From 14:6 onwards, one finds what is by some descriptions an "apocalyptic" description of the eschaton. In some contrast to the peaceful kingdom shown in Isaiah, Zechariah's new kingdom occurs as a sort of impenetrable bulwark in the midst of violent conflict and collapsing political order.[42]

In approaching Zech 14:20, several parallels with regard to the themes treated above in Isaiah should be noted. First, materials are gathered from the nations in this description, though not explicitly by sea: "And the wealth of all the surrounding nations shall be collected, gold, silver, and garments in great abundance" (14:14 ESV). Second, it is clear that this text offers another eschatological procession for the purposes of worship. At verse 16, a stillness settles over the scene and the instruction is delivered, "everyone who survives of all the nations that have come against Jerusalem shall go up year after year to worship the King, the LORD of hosts, and to keep the Feast of Booths" (14:16 ESV). Noteworthy is the fact that Zechariah maintains the transformation of monarchy into a divine (and less explicitly Solomonic) office, as I have noted above with regard to Isaiah. Also relevant is the mention of a "Feast of Booths" in 14:16. Though I shall turn my analysis in later chapters to more specific analysis of the moral significance of the feasts that punctuated the worship of Israel, for our purposes here it will suffice to note that this text describes the final annual feast, which was liturgically associated with harvest (also described as the "feast of ingathering" or "feast of Tabernacles"). This is a liturgical situation in which the notion of deliverance is brought into a theological relationship with the agricultural harvest. This establishes a clear liturgical setting for the procession described in Chapter 14 and one that, even in the eschatological domain, draws in the ordinary work of the people. In resonance with Isaiah, it is clear that this wealth is being brought for the purpose of worship, but, as Smith notes, explicit Temple language has almost completed receded into the background in Zechariah.[43] As I have already suggested, this need not necessarily be seen

as a counter-Temple ideology in competition with other prophetic writers but rather as a different level of appropriation of the complex theological abstraction of the garden–Temple–city metaphor complex.[44]

Having picked up resonances along the way, Zechariah builds to a crescendo in 14:20–1 and here the writer further develops the vision presented in Isaiah. Verse 20 offers the strongest association of work and worship in the eschatological context yet presented:

> And on that day there shall be inscribed on the bells of the horses, 'Holy to the LORD.' And the pots in the house of the LORD shall be as the bowls before the altar. (ESV)

The vision narrated in this text is that of an all-pervasive holiness. Two images that occur in Exodus and echo across the Hebrew Scriptures – a horse's bells and pots – are related here to metaphorically rich counterparts. This is not a random selection, as Meyers notes: "These two objects have symbolic value relating to warfare and subsistence, the two major themes of this chapter."[45] Regarding the metaphorical association of these two images, for the horse's bells, the inscription "Holy to the Lord" invokes the garments of the Aaronic high priest and sole entrant into the holy of holies in the Tabernacle liturgy (cf. Exod 28:36, 39:30). While formerly the priest plays a representative role, bearing this inscription in affirmation of their holiness, now even those domestic animals, horses, which had formerly functioned as ANE war machines (cf. Isa 2:7, Deut 17:16, Ezek 38:4) can bear the same insignia. As J. M. Smith suggests, "The horse is holy because he brings, not a warrior, to kill and waste, but a pilgrim to worship at the Temple of Yahweh."[46] Along similar lines, Carol Meyers notes, "The horse, the symbol for political power and military might, and of all that interferes with the peace and harmony that are to prevail in the eschatological age, will bear a holy insignia."[47]

In the second instance, the association is more obvious, even given the somewhat opaque reference in 14:20b to *mzrqym lpny hmzbḥ* ["the basin before the altar"], which has been variously translated.[48] It is clear that this reference is meant to describe a consecrated vessel involved in Israel's worship, which is described in the first half of verse 21 as equivalent to "every metal pot in Jerusalem and in Judah" (JPS). Again, the more domestic implement is declared "holy to the LORD of Hosts." As the pilgrims begin their holy festival that draws in the work of agriculture, so too worship here will draw in and consecrate one of the most basic domestic implements: the cooking bowls. Carol Meyers explicates the significance of this consecratory inclusion and her commentary bears quoting at length:

> As cooking vessels, they touch the lives of all; food prepared in them is consumed by people throughout the land. Thus by their very ordinariness they

bespeak inclusivity. The language used for food preparation – 'sacrifice' and 'cook' – merges the processes involved in preparing sacral and secular repasts. Thus the inclusivity of a mundane vessel becomes combined with a procedure, actually a reversal of a procedure, that implies sanctity for everything prepared in such a vessel. In addition to the fact that the processing of food involves the sanctification of all food, and thus of all who eat, i.e., everyone, the pots themselves signify the irrevocable crossing, and thus the obviating, of traditional boundaries between the sacred and the mundane. For the comparison of cooking pots to altar basins means likening them to vessels that, in the cultic scheme of Israel's Torah literature, are the only items that can move from an outer realm of Temple sanctity to an inner one. They are unparalleled in their ability to reach a higher degree of sanctity. Thus they signify a pervasive and vast intensification, even within the holy Jerusalem Temple, of sanctity.[49]

This universalisation of holiness that Myers describes is a recurring theme in Zechariah. This text speaks of redemptive transformation as well: "And I will put this third into the fire, and refine them as one refines silver, and test them as gold is tested. They will call upon my name, and I will answer them. I will say, 'They are my people'; and they will say, 'The LORD is my God'" (Zech 13:9 ESV). It is important to note that, even amidst all the language of beauty, the true significance of the eschatological transformation of work in the portrayal of Zechariah is the association of work and holiness. The special status of the products and rituals of worship provides a template for the rehabilitation of quotidian work.

Reading the Theology of Work in Zechariah After Social Theory

Given the strong association of work and holiness that I have highlighted in these prophetic texts, it is important to note that associating ordinary things with holiness goes against the scholarly grain, particularly within the space of twentieth-century social science, which has largely tended to contrast holiness and the quotidian. It is my contention that this tendency to dichotomise has obscured this text, and inhibited its use for moral reflection. One influential example can be found in *The Idea of the Holy*, written in 1917 by Rudolf Otto.[50] In his work, Otto meant to distinguish himself from "the tendency of our time towards an extravagant and fantastic 'irrationalism'"; and so he sought, like William James, to root the study of religion in a non-rationalistic way in *experience*.[51] His study was concerned specifically with the idea of the holy because of its enmeshment with morality: "this 'holy' then represents the gradual shaping and filling in with ethical meaning, or what we shall call the 'schematization,' of what was a unique original feeling-response, which can be in itself ethically

neutral and claims consideration in its own right."[52] This kind of schematisation is precisely the sort of rationalising of religion that Otto wants to resist and on this point I would agree with him. However, in order to advance this agenda, Otto seeks, in typical Enlightenment fashion, to identify that aspect of holiness which takes the believer out of themselves. Tim Gorringe summarises the Enlightenment move in this way: "the root of religion to the 'numinous' . . . broke in on the believer and left her trembling in awe and fear. This experience was marked off as sharply as possible from the everyday."[53] Relying in large part on Otto's approach, Mircea Eliade makes a similar suggestion: "man becomes aware of the sacred because it manifests itself, shows itself, as something wholly different from the profane."[54] In this way, holiness is a property that is wholly extrinsic from objective perceptible reality: "The sacred tree, the sacred stone are not adored as stone or tree; they are worshipped precisely because they are *hierophanies*, because they show something that is no longer stone or tree but the *sacred*, the *ganz andere*."[55] As I shall go on to suggest, this estrangement of materiality from holiness, ironically inhibits a moral deployment of these categories into our quotidian contexts. Following Otto and Eliade, Carol Meyers demonstrates the persistence of this paradigm in her introductory comments to the text in Zech 14 about what is "Holy to Yahweh." She suggests: "The distinction between that which is holy, i.e., that which is associated with the realm of the divine, and that which is mundane or profane, part of everyday life, is fundamental to ancient Israelite thought as to many other religious systems."[56] But the trouble with these dichotomies is the thickness of the curtain that separates holy and profane. As I have already noted above, "holy" exists in one sphere of life, while the "profane" exists in another. But as I have been attempting to highlight with my reading of these texts, one cannot help but notice the points of theological continuity between the apocalyptic vision on display in Zechariah and what I have argued is a morally normative vision deployed through the worship of Israel as elucidated in Exodus and reaffirmed in subsequent construction narratives.

Another brief example serves to demonstrate the persistence of this "replacement" model whereby interpreters assume that what we find in the canonical narrative is the construction of a temporary *liturgical* vision that exists to be "cast off" in favour of a more dynamic model that suits the apocalyptic vision. A similar prejudice is on display, as Ralph L. Smith suggests in his commentary, in the horse's bells and pots in Zech 14: "There could not be more shocking words for an OT priest than those in vv 19–20."[57] But, as I have been arguing here, such a priest who held to a permanent sacred/profane distinction would be a forgetful priest indeed. After all, several features of the apocalyptic on display here, most notably the egalitarian aspect stand in strong continuity with the normative (and post-lapsarian) vision proposed in Exodus. Zechariah here is

not proposing a novel order, but rather envisioning the realisation of that which the wider text of the Hebrew Scriptures has been building explicitly towards from the beginning. The apocalyptic account of the feast of Tabernacles found in the first half of this pericope (14:16–19) provides a further link to Exodus, demonstrating that this is not a novel order on display here.

In seeking to move past the dichotomies that we have inherited from these early-twentieth-century (Romantic) social-scientific models, I would suggest that the moral vision on display in Zechariah actually affirms and elaborates on the materially embedded moral vision found in Exodus. I shall mark out these themes briefly here in order to recall their resonance with Zechariah's theological vision. First, this is a vision of work that displaces Israelite war and monarchy. Human work thrives in an egalitarian system where the volition of workers is free and this aspect is crucial to the construction of the place of worship. Unhindered by monarchical subversion, the labour of Israel on their place of worship is also free to have a particular social aspect. In this way, we should expect those who labour together to cultivate a polity in which they can work together and best express the holiness to which they are jointly called. Second, even in this new eschatological vision not all things are holy, for, if this were the case, the category would no longer be useful in narrative description. In the eschatological transformation of Israel, the category of holiness is not abolished; instead, it ripples outwards to draw in more and more domestic activities and tools. Leading up to this text, one finds that it is actually in the abolition of unholy things that all things may be properly consecrated. Thirdly, the eschatological vision portrayed in the two texts I have analysed here expresses an ethics that can be realistically shaped by the eschatological vision. One cannot read the intertextual resonances between Zechariah and earlier texts and maintain a strong discontinuity between these two visions. In this way, *eschatological* text impinges on *present* practice.

There are a number of other Temple texts that affirm this vision of work. In the rebuilding narratives in Haggai 1–2 and Ezra 3–6, one finds a renewed emphasis, again harkening back to the Tabernacle, on the free and willing participation of all Israel. Along with these texts we find similar, if terse, treatment in Ezekiel and in the NT, in Revelation of the building of a Temple that is "not built with hands" yet still speaks to the intended moral unity for the people of Israel in their worship. In concluding this study of the Hebrew Scriptures, I turn from these apocalyptic visions to yet another deployment of Temple construction that can be found in Chronicles. This text offers us the longest sustained re-narration of Temple construction "with human hands" in the Hebrew Scriptures aside from Exodus and 1 Kings. Also significant for my argument here, it provides a subtle but significant recasting of the terms of holy work, redeploying themes that are notably taken up by NT writers. It is here that we find the

final exhortation towards the recovery of moral order in the rehabilitation of worship.

The Reconceptualised Temple in Chronicles

In the traditional arrangement of the Hebrew Scriptures, Chronicles stands as the final text. Given this terminal placement, it is particularly significant for my argument in this book that Chronicles carries a strong literary and typological relationship back to the Tabernacle-construction narrative in Exodus. There is good reason to think that the Chronicler offers a recapitulation (or in several cases, redeployment) of the work themes that I have drawn from Exodus and traced across other Temple-construction narratives in the Hebrew Scriptures. Affirming how the Chronicler consolidates this moral account of work also grants additional weight to the ethic that I have outlined thus far. However, substantiating this claim requires careful reading of Temple-construction texts in Chronicles, as a number of the details of the work that I have highlighted as problematic in the Solomonic narrative in 1 Kings are also preserved in the text of Chronicles, albeit with modifications. In what follows, I shall argue that the moral account of building conveyed by the Chronicler resonates with the account of valorous work in Exodus, in part (and perhaps surprisingly) because the Chronicler has deliberately revalorised Solomon and his work. However, there is an additional nuance to this resonance between Exodus and Chronicles, and appreciating this may best be facilitated with an awareness of the eschatological aspect of Chronicles.

In his recent book, Steven James Schweitzer has argued – convincingly, I think – that it might be helpful to read Chronicles through the lens of contemporary Utopian theory. In outlining his approach, Schweitzer suggests:

> The importance of social critique in utopian literature is emphasized in recent critical theory as a means of reading such works not as *blueprints* for ideal societies, but rather as *revolutionary texts* designed to challenge the *status quo* and question the way things presently are being done. Thus, utopias depict the world 'as it should be' *not* 'why it is the way it is.' In other words, *utopias are not works of legitimation* (providing a grounding for the present reality), *but works of innovation* (suggesting a reality that could be, if its parameters were accepted).[58]

This approach to "innovation" in Chronicles also provides a helpful frame for an ethical reading of Chronicles. I shall read the points of contrast in the text of Chronicles not with suspicion of a historicist agenda, but attentively, looking for tension with the present. As Schweitzer suggests, tensions between Chronicles

and Kings need not be read merely as "projections of Second Temple practice back into the pre-exilic period for the sake of legitimation"; rather, one may find that through a utopian reading these tensions offer a purposeful depiction of society that is "in tension with historical reality."[59] In this way, the Chronicler's re-appropriation of Israel's history offers a twofold prophetic witness: "Chronicles is, on the one hand, an interpretation of ancient prophecy and, on the other hand, a reflection of post-exilic prophecy itself."[60]

Turning to the Chronicler's account of David and Solomon, recourse to a "utopian genre" may also promote a more nuanced reading of these two monarchs. One can view, in Schweitzer's reading, the Chronicler's account of David as a "utopian view of this monarch – a better alternative picture without being perfect."[61] As Schweitzer observes, "Chronicles does not remove all of David's flaws (1 Chr 13:7–13; 15:11–15; 22:8; 28:3), nor is he sinless (1 Chr 21:1–22:1), nor does he rule 'all Israel' without elements of internal dissent (1 Chr 12:30 [v. 29 Eng.]; 15:29)."[62] Instead, such a reading of Chronicles raises the possibility that the purpose in Chronicles is not to launch a full defence of the Davidic monarchy, but rather to recast David and Solomon's work as a rehabilitation of Israel's worship, including the Temple. In this section, I shall consider the ways in which such reframing functions in 1 Chr 22, 28, and 2 Chr 2 in order to assess how these texts might serve to consolidate the account that I have developed above of egalitarian worker agency and working wisdom. Before proceeding to the text, however, it may be helpful to note how this textual strategy and my reading of Chronicles also implicate ethical considerations of intergenerational agency and responsibility.

The Sociality of Work and Intergenerational Ethics

One specific feature of my account of the ethics of work here has been an affirmation that a moral account of work sustains a dialectic between the agency of individual and collective workers. A further aspect to this dialectic is the affirmation that truly moral work takes into account not only the status of other living workers, but also carries an intergenerational concern – considering how good or evil acts might persist or dissipate across generations. I have argued positively above that this sort of concern requires attending to the tradition in which craft knowledge is developed and sustained. Conversely, neglect of the intergenerational implications of bad work is a very live concern given how the products of modern work and the consequences of their manufacture often span multiple generations. Particularly in ecological ethics, scholars have recently brought forth a sustained attempt to counteract the atomised account of moral agency latent in modern utilitarian moral philosophy. This takes intergenerational responsibility seriously, given the penchant of modern people to

discount the consequences and effects of bad work, leaving future generations to suffer the consequences of accumulated carbon, pollution, and waste generated by our economic activity.

The theological perspective offered by the Chronicler offers a challenge to mono-generational ethics using what has been described by a number of scholars as a theology of immediate retribution.[63] Sara Japhet summarises this as a theological programme in which God grants a person punishment or reward with "no postponement of recompense; there is no accumulated sin and no accumulated merit."[64] In this quasi-judicial procedure, after each action persons are offered a chance to repent (if necessary) and then divine response is "mandatory, immediate and individual."[65] Dillard highlights the rhetorical immediacy of this theological programme, which is notably presented in many of the passages apparently unique to the Chronicler including 2 Chr 7:14, 12:5, 15:2, and 20:20.[66] Inasmuch as it presents a more individually conceived moral engagement with God, immediate retribution may seem to present something of a challenge to an intergenerational ethic. Yet, upon closer inspection, this theological notion of "immediate retribution" actually offers a helpful corrective to simplistic radical agendas where political change is conceived of as sudden and effective. Just as one can ignore the intergenerational impact of immoral acts, one can also over-construe the *determination* of moral or immoral action by previous generations. In some sense, the Chronicler addresses the present generation with a challenge: the sins of previous generations – whether in the reckless extraction and consumption of fossil-fuels, the generation of unnecessary waste and pollution, or simply in squandering the opportunity to make things that are beautiful and promote the flourishing of all God's creation – need not prevent contemporary workers from the pursuit of well-measured moral work. With this understanding of the moral role of immediate retribution in mind, I turn now to the account of Temple construction in Chronicles to see how a reading of this text may add further nuance to this understanding of good work.

Reframing Abundance and Inclusiveness in 1–2 Chronicles

I begin with 1 Chr 22, where David provides an extended speech to his son Solomon and provides a number of important details regarding his expectations for Temple construction. Here amidst David's speech one finds that the significance of materials used in the Temple has been reframed. In particular, "abundance" has taken on a new intensity. In spite of the appropriation of narrative material from 1 Kings, it is important to note that there are also substantial parallels that have been drawn in here with the Tabernacle-construction account in Exodus. Much like Moses' speech in Exod 25, the speech by David in 1 Chr 22 serves to provide a theological frame for the Temple-construction account

that is to follow and this provides an appropriate place to begin this assessment of the construction narrative in Chronicles. Before giving the pithy instruction to Solomon *qwm w'śh* ["arise and work!"] in this unique non-synoptic portion of 1 Chr 22, David delivers a speech to Solomon that describes the provision of materials for the Temple:

> David gave orders to assemble the aliens living in the land of Israel, and assigned them to be hewers, to quarry and dress stones for building the House of God. Much iron for nails for the doors of the gates and for clasps did David lay aside, and so much copper it could not be weighed, and cedar logs without number – for the Sidonians and the Tyrians brought many cedar logs to David. . . . See, by denying myself, I have laid aside for the House of the LORD one hundred thousand talents of gold and one million talents of silver, and so much copper and iron it cannot be weighed; I have also laid aside wood and stone, and you shall add to them. An abundance of workmen is at your disposal – hewers, workers in stone and wood, and every kind of craftsman in every kind of material – gold, silver, copper, and iron without limit. Go and do it, and may the LORD be with you. (1 Chr 22:2–4, 22:14–16 JPS)

This provision by David of materials for the Temple underlines the Chronicler's suggestion regarding the unity of their two monarchies. Particularly, the note at the end of verse 14, *'lyhm twsyp* ["and upon these you will add"] connects this list with Solomon's efforts that the Chronicler revisits in 2 Chr 1. A further aspect of David's description that sets this account in some contrast to 1 Kings is the hyperbole in his speech.[67] Literary reference to abundant materials is found in Exod 25 and 35–6 and in 1 Kgs 6. Yet it is important to note that the rhetoric of abundance performs a different function in each instance. The account of materials here is different enough from the previous two to justify an attempt to offer a third theological framing for material abundance. In Exodus, the participation of the people is highlighted, whereas in 1 Kings, Solomon is given prominence in what I have negatively described as a solipsistic narrative where the abundance of material serves to highlight the danger hanging over Solomon's monarchy. Arriving at 1 Chronicles, we find that the author has taken the trajectory set by 1 Kings to a new extreme. In 1 Kings, as I have noted, the account of the gold provision may be considered *believable* as an outcome of military conquest and taxation. In contrast, as Klein observes, in Chronicles "the amount of gold is enormous and unrealistic: roughly 6,730,000 pounds or 3,365 tons. At four hundred dollars an ounce, that much gold today would amount to more than forty-three billion dollars."[68] Similarly, the extravagant import cedar is now the only timber specifically mentioned in David's list of provisions (accounting

for the use of the more generic *ṣym* ["timber"] in 22:14). It is also worth noting that the ascription we find in 1 Kings, *byt yʿr hlbnwn* ["Lebanon Forest House"], is omitted from 1 Chr 22 and instead appears later in 2 Chr 9:16, 20, further distancing this account from the parallel in 1 Kgs 10:17, 21. While the presence of hyperbole makes it clear that Chronicles is not a "realistic" narrative, precisely how we might locate the writer's construal of the relationship between the text and political–economic reality is a more complicated affair. Schweitzer's use of utopian criticism may be helpful here, as one may read the dissonance generated by the hyperbole I have noted in 1 Chr 22 as a utopian feature. Seen in this way, the author narrates an alternative world that can challenge the current one, both with respect to the "current" world of the author and the present-day one, which bears uncomfortable similarities. Specific analysis of David's account of materials in 1 Chronicles provides a basis upon which to assess the moral force of Chronicles with regard to craft.

First, in spite of the obvious connotation that cedar would have been an imported timber and gold would have been gathered from conquest, David's wording in the speech presents an account of materials that have been *conserved*. On the face of things, this seems ironic, yet 1 Chr 22:5 provides a theological interpretation of David's stockpiling of materials: "My son Solomon is an untried youth, and the House to be built for the LORD is to be made exceedingly great to win fame and glory throughout all the lands; let me then lay aside material for him" (JPS). In this way, the "conservative" nature of this stockpiling is underlined by David as his speech to Solomon continues with the statement in verse 14: "*whnh bʿnyy hkynwty lbyt-yhwh*."[69] Though David's halting of the Temple-building project has been at the Lord's command (vv. 8–9) it has still been an affliction (*ʿny*) that he has taken on in submission to the divine plan under which this project was reserved for the "*ʾyś mnwḥh*" ["man of rest"] under whose reign the Lord shall confer peace and quiet, or *šlwm* and *šqṭ* (v. 9). The Chronicler has attenuated (though not completely eliminated, as I have noted above) the negative aspects of David's reign, and this enables a more roundly positive portrayal of Solomon, his son, as a prince of peace. In addition, the Chronicler has used this new account of David's passing of materials on to Solomon to replace the account in 1 Kings of the Queen of Sheba's contribution to the Temple materials that arrive from "outside" Israel. With this in mind, one may read this account of materials in the way that I have read Isa 60 in the commentary above, where the emphasis is not on the status conferred on the materials by their giver, but on the status provided by the recipient, namely Solomon. Strangely, as it might seem amidst this account of material extravagance, there is a resonance here with the wilderness austerity of Israel that prepared them for the building of the Tabernacle. Just as the Tabernacle was built with gold drawn from the "stripping of the Egyptians" (cf. Exod 3:22, 11:2, 12:35) the previous

mention of gold in Chronicles is 1 Chr 18, particularly "the other silver and gold that he had taken from all the nations: from Edom, Moab, and Ammon; from the Philistines and the Amalekites" (1 Chr 18:11 JPS). Even though the status of the gold may be tainted by association with David's war campaigns (cf. the remark by David in 1 Chr 28:3), the Chronicler suggests to their readers that this status is *not persistent*. Consequently, these statements by David provide a different framing to the materiality of the Temple and the pedigree of its construction. Temple construction is no longer problematised, but is instead offered as a sign of hope. Thus 1–2 Chronicles presents the act of Temple construction as the realisation of a promise of peace and rest for the people of Israel, while also reaffirming a "conservative" account of work materiality.

The Chronicler takes up the question of "why costly cedars, luxurious materials and grandeur?" later in 2 Chr 2:4–6 as well.[70] Here Solomon's boast, "The House that I intend to build will be great," may seem to revisit the narcissistic King portrayed in 1 Kings. Yet in 2 Chr 2:4[5], the purpose behind this greatness is explicitly evangelical: *gdwl 'lhynw mkl-h'lhym* ["our God is greater than all gods"]. This justification, given in the context of Solomon's actual building process, resonates with David's justification in Chapter 22. In this way, the Temple fulfils a doxological purpose, such that the material beauty and abundance in construction that the text later narrates is meant to sustain sensually rich *worship*. To draw this narrative to a more explicit point, one might say that the Chronicler argues, if the work of construction is to properly express the doxological element and glorify God, then excellence and beauty in craft form an intrinsic requirement. God provides material abundance and humans recapitulate this in worship by recourse to beauty and lavishness.

There are also parallels in David's speech with the use of "design" language I highlighted in Exodus. As was the case with Moses in Exod 25, Solomon is given an extensively narrated *tbnyt* for the Temple and its functioning. Though this plan is proxied by David (28:11–18), the narrative concludes with an emphasis on the divine provenance of the design. Just as David notes in verse 5 that the selection of Solomon is divinely mandated, in verse 19 the plan he outlines briefly in Chapter 28 for Temple construction is also ascribed directly to a divine hand: "All this that the LORD made me understand by His hand on me, I give you in writing – the plan of all the works" (JPS). Just as fidelity was a central theme in Tabernacle construction, as noted above (particularly with regard to Exod 25:9), in 1 Chr 28 we find affirmation that Temple construction is performed with fidelity to the Mosaic pattern (cf. also 1 Chr 15:15). This affirms the centrality of the Exodus account of Tabernacle work and the link that I have argued for above between the building of worship space in Exodus and Chronicles. Along these lines, Selman affirms, "The Davidic monarchy continues the work that God began under Moses, and is required to maintain

the same standards. The message seems to be that if Israel seeks hope for the future, it must continue in the same tradition."[71] This pattern is taken up visually over the course of 1 Chr 13–16 as the Ark makes a gradual journey into the heart of the Temple. The remnant of Tabernacle worship noted in Exodus provides the kernel of the Temple as construction ensues.

More specifically, and also in parallel with Exodus, this account of pattern and design is rooted in *theologically construed* conformity. The emphasis that David places on the importance of fidelity to the law (28:3–4) as a precondition for the proper and holistic function of Israel's worship serves to affirm a link between Temple design and the moral architecture of Israel. Consequently, David's invocation in Chapter 22, *qwm wʿśh* ["arise and work"], becomes an exhortation *ḥzq wʿśh* ["be strong and work"] in 28:10, which is then intensified in 28:20 with the addition of *ʾmṣ* ["be strong *and courageous* and work"]. Just as was the case in Exodus, this Temple building is also to be constructed by following a plan carrying specifications that are not technically exhaustive, but morally delimited. The way in which Hebrew accounts of design infer *conformity* is underlined by the use of another Hebrew design word, "*yṣr*," in 1 Chr 28:9. In underlining his exhortation to Solomon, David suggests that "the LORD searches all minds and discerns the design (*yṣr*) of every thought" (JPS). Here one finds resonance with a host of fidelity and infidelity texts juxtaposing evil human designs[72] with designs that are conceived in conformity to the divine design.[73] Isaiah explicates this rhetorical and conceptual connection between human and divine design in Isa 29:16: "How perverse of you! Should the potter (*yṣr*) be accounted as the clay? Should what is made (*yṣr*) say of its Maker, 'He did not make me,' And what is formed say of Him who formed it, 'He did not understand?'"[74] Similarly, the Psalmist notes, "He knows how we are formed (*yṣr*)" (Ps 103:14 JPS). Just as in Exodus, the very fact that a plan for the Temple can exist is contingent upon an affirmation that all creation is formed according to a divine plan. In the same way that successful musical harmony requires a natural agreement of vibrations, the calibration of rationality, beauty, and wisdom in design rely upon harmony with the basic pattern of work that has been modelled by YHWH.

The account of Temple work in Chronicles is also notably more *social* than in 1 Kings, drawing further resonance with the Exodus account. David's speech in 1 Chr 28 is enclosed by a broadening of address. The text begins by attending to a wider audience, namely the host of Israelite officials listed in verse 1, and in the final verse (21) David draws Solomon's attention to invite what Braun describes as "the active involvement of the people in the work with Solomon."[75] This includes "priests and Levites for all kinds of service of the House of God, and with you in all the work are willing men, skilled in all sorts of tasks; also the officers and all the people are at your command" (1 Chr 28:21 JPS).

This is emphasised with the more oblique, but nonetheless positive reference to workers in 1 Chr 22:15, with David's bestowal of every artisan [*kl-ḥkm*] and all materials [*kl-mlʾkh*].[76] The use of the Hebrew *kl* continues in 1 Chr 28 and this rhetorically signals the encompassing nature of the work to be undertaken: 28:1 is a long sequence of nouns in construct form, begun with *kl-śry yśrʾl* ["all the officers of Israel"], which goes on to include the whole political and economic strength of Israel: "tribal officers, the divisional officers who served the king, the captains of thousands and the captains of hundreds, and the stewards of all the property and cattle of the king and his sons, with the eunuchs and the warriors" (JPS).[77] *All* the *śry* ["princes" or "leaders"] of Israel who were summoned in 1 Chr 22:17 are again addressed in 1 Chr 28:1. Without denying the legitimacy of monarchy, there is an egalitarian aspect to the language of David's speech, as Selman argues: "David's unusual form of address, my brothers and my people (v. 2), identifies the king with his people, with the king like everyone else under divine orders (cf. vv. 7–10; Deut 17:18–20)."[78] Though the liturgical personnel are not mentioned explicitly here, they come up later in the chapter, and as Japhet suggests, "the absence of special reference to the priests and Levites is only apparent. The particular point of view of this pericope makes such a reference unnecessary: the priests and Levites, like everyone else, are represented by their 'tribal leader,' by any 'officers' appointed from their number, and by their 'men of substance.'"[79] Echoing verse 12, verse 21 closes this discourse on a note of even further expansiveness with David's presentation to Solomon: "Here are the divisions of the priests and the Levites for all the service of the house of God; and with you in all the work will be every volunteer who has skill for any kind of service; also the officers and all the people will be wholly at your command" (NRSV). The force of this speech affirms in a strong rhetorical way the inclusiveness of the work-project that is to follow.

Finally, in addition to this inclusive vision of Temple-construction work, we find a reaffirmation of the spirit-filled wisdom involved in the work to come. The Chronicler's conception of the building process is portrayed in continuity with the Tabernacle account and in direct contrast to the building account in Kings. While, as I have noted above, the construction account in Kings ascribes wisdom only to Solomon, here we find the reappearance of *ḥkm* to describe skilled work using the exact same Hebrew phrase as was used in Exod 28:3, 31:6, 35:10, and 36. The ascription of wisdom here in the final verse of Chapter 28 is brief, but we find further occurrences of "working wisdom" with the introduction of Huram of Tyre in 2 Chr 2. The literary position of this introduction emphasises parallels between the two. While in Kings, Solomon calls upon Huram late in the description, here he is introduced early in Chapter 2. Just as in Exodus, "preparation of the necessary materials (35:4–29) is immediately followed by the introduction of artisans (35:30–36:1)."[80] One also finds in 2

Chronicles an account of the widely distributed bestowal of wisdom for work. This is the case with the description of Bezalel's parallel Huram-ab in 2 Chr 2:

> Now I have sent a skilled man (*'yś ḥkm*), who has understanding. . . . He is trained to work in gold, silver, bronze, iron, stone, and wood, and in purple, blue, and crimson fabrics and fine linen, and to do all sorts of engraving and execute any design that may be assigned him, with your craftsmen (*ḥkmy*), the craftsmen of my lord, David your father. (2 Chr 2:13–14 ESV)

It is interesting to note that, while one finds use of "wisdom" language in association with mechanical skill in 1–2 Chronicles (cf. 1 Chr 22:15; 2 Chr 2:6, 2:11–13), there is not a similar use of spirit-filling language accompanying the empowerment of workers. In fact, the first mention of *rwḥ* ["spirit"] does not come until 2 Chr 15 with the mention of Azariah the son of Oded. There are later mentions of the spirit in 2 Chronicles, but the function of the spirit is quite different here, being an agent of judgement (2 Chr 18:18–25) and inspiring prophetic speech (2 Chr 20:14, 24:20) even in the mouth of foreign kings (2 Chr 36:22).[81] One possible way to account for this difference lies in noting that spirit-language is used in different ways with late-biblical Hebrew texts such as Chronicles and Ezekiel. Seen in this way, as Schniedewind argues, the use of spirit-possession and inspiration language in Chronicles "is a development of the type of spirit inspiration in Ezekiel."[82] If this is the case, spirit language is missing from 2 Chr 2–9, not as a deliberate omission, but rather because the presence of the spirit plays a significantly different role in the narrative.[83]

Freewill Offerings: Workers and Freedom

In addition to the inclusiveness of the Chronistic narrative and the return of wisdom language to describe those who assist in the work, the aspect of volition is also theologically highlighted in Chronicles. This occurs at a number of junctures, and stands out in sharp relief when viewed against the narrative in Kings. One finds this, for example, in the first chapter of 2 Chronicles. As Japhet notes, "the king does not 'assemble' the people; rather, he only proposes the idea . . . the people's consent and co-operation are expressed in action. . . . Popular participation in the major innovation is the Chronicler's view of the event."[84] This is also the case in 2 Chronicles, Chapter 2, where we find that the episode with Huram of Tyre has been shortened and reworked. The King only receives brief mention: "And Huram king of Tyre sent messengers to David, and cedar trees, also masons and carpenters to build a house for him. And David knew that the LORD had established him as king over Israel, and that his kingdom was highly exalted for the sake of his people Israel."[85] Noteworthy here is the fact

that Huram is not summoned by Solomon, but rather he takes the initiative in approaching Solomon.[86] In a sense, one finds here a thorough deployment of the eschatological metaphor noted above in Isa 60, where this king comes "marching in."

The account of worker agency I have suggested above stands in some tension with the account of slave labour presented in 2 Chr 2:17–18; and this is perhaps the most crucial text to understand with regard to the sort of work on display in Temple construction in Chronicles. Again, one may better understand the purpose of the Chronicler by examining the contrast with Kings. As Jarick notes:

> The Annalists [author(s) of Chronicles] seem to have no embarrassment in portraying an invidious policy of slave labour under which some of the enslaved are placed in charge of enforcing the enslavement, and they make it explicit in numerical terms that every single one of the non-enfranchised residents of the kingdom [is] rounded up for the building work . . . the assertion in the Annals [Chronicles] that the Temple builders are the entire resident alien population of Solomon's kingdom, and nothing but the resident aliens, is a startling picture.[87]

Jarick ascribes this move to a purposeful inversion of the Exodus and notes that the whole Temple project seems to be based on the expropriation of resources and labour leading to a happy outcome "in the Annalist's story-world. . . . Solomon's marshalling of an alien army of slaves led to the erection of a grand edifice that required no drop of Israelite sweat or blood in its construction."[88] One way to read this contrast, as Jarick argues, is to note the disinvolvement of Israel in the labour of the building process: this is a Temple built without Israelite hands. Yet there may also be a positive theological intention on behalf of the Chronicler here, as my nod in the title of this chapter to Mark 14:58, where Jesus refers to a rebuilt Temple that is "not made with hands," suggests. I have already noted how the narrative style in Chronicles stands in some significant contrast to those earlier building accounts that carry a more varied cast of characters with more literal reference to their work. Might one read here a recalibration of building back towards the protological building account in Genesis, where the divine person acts exclusively upon inert matter and brings things into being? The Chronicler's account of slave labour sits uneasily within the middle of Christian Scripture, and the dissonance created by the writer's apparently casual attitude towards it cannot, I think, be fully resolved or easily dismissed. For my purposes here, it may help to note that this construction account by the Chronicler participates in a broader transition towards an eschatological reformulation of construction narratives that is more explicitly exhibited in the apocalyptic texts in the Hebrew Scriptures and NT. This reading is vindicated, I think, when one

turns to look for similar themes of worker agency in the related text in Ezra, where the account of worker agency is more straightforward. I turn now to a brief examination of this parallel text in Ezra before turning to the Chronicler's typological description of Solomon that is picked up in the NT.

Inclusiveness of Israel is strongly emphasised in Ezra by the use, again, of an Exodus typology from the start of the text: Cyrus himself is said to initiate a gathering of materials much like the stripping of the Egyptians in Ezra 1:4 – "And let each survivor, in whatever place he sojourns, be assisted by the men of his place with silver and gold, with goods and with beasts, besides freewill offerings for the house of God that is in Jerusalem" (Ezra 1:4 ESV).[89] As one might expect of a *ndbh* ["free will offering"], these materials are said to be *htndb* [same root in a verbal form, thus "freely offered"]. As Williamson notes, the intended similarity with Exodus in the offering of materials is underlined by the specific reference to *kly* ["vessels of silver and gold"].[90] This resonance is unique among the various Exodus typologies.[91] The second point of emphasis regarding the personnel of work described in Ezra is embedded in the structural choice to precede the Temple construction narrative by an extended account of the return of exiled Israelites in Chapter 2. This too makes typological reference to Exodus, in that the author stresses how "those returning were representative of Israel in its full extent."[92] Even the king returns the Temple vessels, which have been so contentiously harboured amidst idols in Nebuchadnezzar's Temple (cf. 1:7) in a reference back to the tools narrated in Exodus. This narrative of gathering culminates in a moment where personnel are recruited by the motion of the spirit of God: "Then rose up the heads of the fathers' houses of Judah and Benjamin, and the priests and the Levites, everyone whose spirit God had stirred to go up to rebuild the house of the LORD that is in Jerusalem" (Ezra 1:5 ESV). This account of spirit-stirred work, which opens Ezra, parallels the account in Exodus, where participation in the project of (re)construction is free and abundant. When read alongside the Chronicler's more muted account in 1 Chr, Ezra may also be seen to complement the more complex rendering of the same themes that I have examined above in Chronicles.

Temple Construction and the New King

I suggested at the outset of this section my conviction that the Chronicler may be trying to recast David and particularly Solomon as the agents for God's work in rehabilitating the worship of Israel. In seeking to demonstrate that there is a more thorough eschatological aspect in Chronicles than simply the resonances with Isaiah I have observed thus far, it is important to note the strong emphasis in Chronicles on the inauguration of a project of peace. One finds this in reading David's speech in 1 Chr 28, where the King commissions

the building of the Temple with an exhortation to the people to observe YHWH's law so that they might receive of the promise of ʾrṣ ṭwbh ["good land"] in verse 8. This reference also deploys a Deuteronomic theme, which is the only occurrence of this phrase outside the Deuteronomic texts.[93] However, Chronicles departs from Deuteronomy in offering a shift in context for monarchy, as Japhet notes:

> In Deuteronomy these formulas are all relevant to the context of the conquest, which was to follow the unsettled period of wandering in the wilderness. Here, by contrast, at the end of David's reign and on the threshold of Solomon's, war is a thing of the past. At this point, the idea of 'possession' and 'inheritance,' as the ultimate aim and hope for the people, is seen as a permanent task confronting each generation.[94]

This emphasis on peaceable inhabitation of good land is augmented with a related emphasis on "rest." As Kreitzer observes, a substantial and telling innovation by the Chronicler is: "To [drop] both references to God's 'rest' in his parallels to the passages in 2 Sam 7:1, 11, both of which speak of Yahweh giving *David* rest from his enemies. Yet David's rest is only the beginning, as in David's speech to Solomon, there is a rhetorical word-play in the Hebrew text which affirms the transition underway with the accession of Solomon by connecting Solomon (šlmh) with Sabbath (šlwm)."[95] Solomon is, according to David's earlier description in 1 Chr 22:6–16, "a man of peace/rest." The uniqueness of this phrase should be noted, as Kreitzer observes that this is the only occurrence of the phrase in the MT.[96] This modification fits within a broader canonical transition, as Gerhard Von Rad observes: "the concept of rest heads off in a new direction within the thought of the Chronicler who moves the focus away from God giving 'rest' to the people of Israel, to God enjoying rest among the people of Israel as he settles in Jerusalem among them."[97] In this way, one may read the construction of the Temple in Chronicles as being recast by the Chronicler as a work *by God through his agent Solomon*. This refocusing marks a change in perspective on the same narrative as it has been presented in 1 Kings, from the ground-level human perspective, to a divine one such that the reader of Chronicles is invited to watch Temple construction from this divine perspective. As I have already argued above, this kind of change in perspective need not imply that human agency is displaced. Instead, the focus here is on a thicker and more vivid description of the divine agency to which human work is subordinate and among which (as I have discussed in relation to Exodus) it is given meaning. This account of "perspective" is helpful in providing a basis for understanding the nature of work involved in the eschatological portrayal of Temple construction in Chronicles. Building on this account, I turn next to look at ways in

which one finds a similar re-appropriation of the Temple-construction work in the gospels, this time by the messianic man of peace: Jesus.

A Moral Reading of Tabernacle/Temple Construction

Given the range of Hebrew texts that I have explored in this chapter, it is worth pausing to survey this account of "good work" in Temple construction before proceeding further. I began in Chapter 1 by arguing that the guidelines outlined for making the Tabernacle and the ensuing details of its construction (and commentary regarding the builders' fidelity to these instructions) provide a number of details regarding the shape of moral work. First, fidelity to the pattern set by divine work is emphasised. One of the best ways of expressing this conformity to the work and pattern set by the divine creator lies in affirming human creaturely contingency through an "ecological" account of work. Here, against minimal work accounts driven either by a "naturalist" desire to minimise human engagement with the creation (and thereby lessen negative impact) or by an economically construed pursuit of absolute leisure, I affirmed that humans are made for work, at least when executed within the proper boundaries. Given these boundaries, it should not be surprising that we find that, in spite of this strong account of human technicality, the affirmation of human work in Exodus emphasises the need for morally circumscribed boundaries. No work is value neutral; and discernment with regard to the conformity of human work to the work of YHWH is a constant task.

Exodus provides an account of wisdom that *arises from* work and not merely a work-epistemology that *looks over* work. This is a pneumatically conceived affirmation, bringing together ability, intelligence, and knowledge in a unity of wisdom that is an intrinsic aspect of work and arises out of it. It is also important to note, particularly in light of other literature on the theology of work, that in Exodus this uniquely pneumatic account, though relevant to the ordinary quotidian work of Israel, is mediated through a social context. The account in Exodus also suggests that truly wise work does not find expression in solitude, as with the Romantic hero, but rather it is sustained by a measure of sociality. This in turn, is the basis for a strong account of work that emphasises the preservation of worker agency while affirming theologically construed limitations and contingency. In Exodus, Tabernacle-construction work is inherently social in that the act of Tabernacle construction is inclusive of all Israel and their participation is not demanded, but freely given. This freedom is expressed with exuberant giving, and exuberance is balanced by an awareness of sufficiency. Finally, this coming together of many gifts also provides an opportunity to appreciate a model of work that is alternately dynamic and specialised. In this way Exodus does not therapeutically revalorise specific (or all) occupations, but

rather affirms a range of occupations without reifying any specific one. I argued that the underlying account of agency in Exodus might best be described as the maintenance of two dialectics, with one concerning the balance of agency among workers, and the second concerning the balance of agency between the worker and their material or, to put it another way, between the worker and the other-than-human creatures that are implicated in their work.

On the most basic level, this account is meant to substantiate the claim that there exists a relationship between worship and work that is most powerfully expressed in the Hebrew Scriptures in the account of Tabernacle construction in the latter half of Exodus. Subsequent Temple-construction narratives serve to reinforce and in some cases intensify this account. In particular, in Solomon's Temple construction narrated in 1 Kings, one finds an inversion of both the free volition of workers in Exodus and a solipsistic account of the work agency involved. One consequence of this inversion is that the account of building in Exodus, which I have described as "ecological," is inverted into a destructive and self-serving enterprise. Jeremiah provides a resonant critique of the unrighteous home of Jehoiachim. Here too we find a king who engages in immoral work: building a home that is structurally unrighteous. In Jeremiah, the recourse to slave labour and material excess provides clear resonances with the account in 1 Kings. The account by Jeremiah narrates a moral relationship between worship and work as the Temple – meant to function as a place where the people of Israel could regularly engage in practices that promoted a moral synthesis of worship and work – is dismantled.

Subsequent Temple treatments are situated in a new eschatological context, and re-appropriate the Temple narratives with various modes of metaphor. Perhaps the most crucial aspect in understanding this re-appropriation is the change in perspective that is at work across the succession of these narratives. These are Temples "not made with hands," at least not in the same literal way that is narrated in Exodus and 1 Kings. I have drawn attention to the ways in which these narratives emphasise their continuity with the moral aspects that I presented in the first half of this chapter. Nonetheless, there are also some new features as well, which complement the moral account I am developing here. Particularly, Isaiah 60 engages this discussion of work with a theology of culture, with the description of the "Ships of Tarshish" and the "wealth of the nations." Seen in this way, the indictment of monarchy seen in Kings and Jeremiah need not serve as wholesale indictment of work that transgresses "national" boundaries and identity; and Isaiah celebrates the ways in which a diversity of work-forms (vernacular) and materials can contribute to an eschatologically persistent beauty. In a similar way, one finds that the ecological indictment of wealth and extravagance that I have observed at length in these construction accounts need not lapse into an anti-aesthetic rule for work. This dialectic, which was present in a

more muted sense in Exodus, comes to shine vividly amidst Isaiah's apocalyptic vision. Moreover, Zechariah's apocalyptic vision forcefully redeploys a liturgical metaphor from Exodus, namely the suggestion in Exod 19:6, "you shall be for me a priestly kingdom and a holy nation."[98] Worship images and concepts are deployed in Zechariah as a metaphorical collage to suggest that the work and domestic life of Israel might be drawn into an all-pervasive holiness. What we find in this vision of Zechariah is not airtight containers that separate "holy" liturgical work and "profane" domestic work, but instead a porous state where the two exist in a dynamic relationship. These eschatological visions set the terms for those entanglements of worship and work that we find in subsequent texts, particularly Chronicles and in the NT.

The Chronicler provides a consolidation of these work themes and draws them into the orbit of the eschatological vision inaugurated in Isaiah and Zechariah. In particular, here one finds that the material culture of the Temple is highlighted. Material beauty and abundance in Temple construction are recast in light of a more exclusively theological purpose – that is, to sustain a sensually rich worship. In some sense, this draws the whole people of God – bodies included – into the worship of YHWH. It follows that work with a doxological aspect will intrinsically include excellence and beauty in craft. Thus in Chronicles, we find a new iteration of this ecological vision: God provides the material abundance and humans respond to this gift in worship by similar recourse to beauty and lavishness. The details of human involvement in the construction are attenuated in Chronicles, but this is not a matter of de-emphasis; rather, it is a change in perspective as the reader gains an opportunity to gaze at the work of Temple construction from above. With this brief recapitulation in mind, I turn next to a treatment of Temple building in the New Testament.

Notes

1 See Jürgen Moltmann, *Theology of Play*, trans. Reinhard Ulrich (New York, NY: Harper & Row, 1972); Jürgen Moltmann, *On Human Dignity: Political Theology and Ethics*, trans. M. Douglas Meeks (Philadelphia, PA: Fortress Press, 1984); Jürgen Moltmann, *Theology of Hope: On the Ground and the Implications of a Christian Eschatology* (Minneapolis, MN: Fortress Press, 1993). For another account that is indebted to Moltmann, see M. Douglas Meeks, *God the Economist: The Doctrine of God and Political Economy* (Minneapolis, MN: Fortress Press, 1989).
2 This work seeks to counteract theological Reformation models of work as "vocation," which Volf describes as a "dead hand." Volf, *Work in the Spirit*, 103–10, vii.
3 Volf, *Work in the Spirit*, 116.
4 Volf, *Work in the Spirit*, 120.
5 Volf, *Work in the Spirit*, 116. He elaborates later (119): "Revelation of the future glory in the realm of grace is the measure by which events in the realm of nature must be judged. To the extent that non-Christians are open to the prompting of the

Spirit, their work, too, is the cooperation with God in anticipation of the eschatological transformation of the world, even though they may not be aware of it."
6 Darrell Cosden, *A Theology of Work: Work and the New Creation* (Carlisle: Paternoster Press, 2004), 6.
7 Cf. Jürgen Moltmann, *The Way of Jesus Christ: Christology in Messianic Dimensions*, trans. Margaret Kohl (London: SCM, 1993), 256; Jürgen Moltmann, *God in Creation: An Ecological Doctrine of Creation*, trans. Margaret Kohl (London: SCM, 1997), 259. See also the extended analysis in Stuart Weir, "The Good Work of 'Non-Christians,' Empowerment, and the New Creation," PhD Diss., University of Edinburgh (2012).
8 Cosden, *A Theology of Work*, 152.
9 O'Donovan, *Resurrection and Moral Order*, 95.
10 Jürgen Moltmann, *Ethics of Hope* (Minneapolis, MN: Fortress Press, 2012), 3.
11 Moltmann, *Ethics of Hope*, 3.
12 Moltmann, *Ethics of Hope*, 5.
13 I am grateful for Richard J. Mouw's study *When the Kings Come Marching In*, which first drew my attention to this text and several of the images I am examining here.
14 *'nywt tršyš*, referenced in 1 Kgs 10:22 and Isa 60:9. Though it will fall outside the scope of this study to examine the phrase exhaustively, references to the ships also appear in 1 Kgs 22:49; Isa 2:16, 23:1, 23:14; and Ezek 27:25.
15 *ḥyl gwym*, mentioned in Isa 60:5, 60:11, and 61:6
16 *mlkyhm nhwgym*, referenced in Isa 60:11.
17 On all these, see Ezek 27–8.
18 Here and where relevant below, I shall provide verse numbering as per the MT, enclosing alternate numbering in brackets when appropriate.
19 In addition to my discussion of Isaiah 60 here, see also Isa 2:2–4, 49:22–3; Mic 4:1–4, 7:17; Hag 2:6–8; and Zech 14 (discussed further below).
20 It is unclear as to whether Smith was aware of the direct source of his allusion. "Wealth of nations" is the literal rendering in the KJV, so such an expectation is not anachronistic, but a search of Smith's whole corpus and a survey of secondary literature on Smith locate no references to Isaiah whatsoever.
21 As Oswalt observes, "The root of *beautify*, *p'r*, is frequent in the book, occurring a total of 31 times, 9 times in verbal forms and 22 times in noun forms. Fourteen of these occurrences are grouped in chs. 60–4, where God declares the fulfilment of the promises of 4:2 and 28:5." John N. Oswalt, *The Book of Isaiah*, NICOT 23a (Grand Rapids, MI: Eerdmans, 1986), 542.
22 Cf. verse 1: "Arise, shine, for your light has dawned; The Presence of the LORD has shone upon you!" (Isaiah 60:1 JPS). This light is derivative of the divine light, as verse 19 reminds the reader.
23 This theme is inverted in the satirical poem about the goldsmith in Jeremiah 10, repeated briefly in 51:17.
24 Louis H. Sullivan, "The Tall Office Building Artistically Considered," *Lippincott's Magazine* 57 (1896): 403–9.
25 David Pye, *The Nature and Aesthetics of Design* (London: Barrie & Jenkins Ltd., 1978), 11.
26 Pye, *The Nature and Aesthetics of Design*, 14.
27 Pye, *The Nature and Aesthetics of Design*, 16.
28 Pye, *The Nature and Aesthetics of Design*, 77–80.

29 Rowan Williams, *Grace and Necessity: Reflections on Art and Love* (Harrisburg, PA: Morehouse, 2005), 10, 12.
30 Williams, *Grace and Necessity*, 15.
31 David Pye, *The Nature and Art of Workmanship* (Cambridge: Cambridge University Press, 1968).
32 Sennett, *The Corrosion of Character*, 133.
33 Williams, *Grace and Necessity*, 13.
34 Bernard Leach, *A Potter's Book* (London: Faber and Faber Limited, 1945), 2.
35 Leach, *A Potter's Book*, 2.
36 Leach, *A Potter's Book*, 11.
37 For a theological example, see Oliver O'Donovan's reference to two "transcendental representations," the "narration of history" and "art," in *Common Objects of Love: Moral Reflection and the Shaping of Community: The 2001 Stob Lectures* (Grand Rapids, MI: William B. Eerdmans Publishing, 2002), 33–4.
38 We find an example of this relegation of work to a subordinate political status in Hannah Arendt's otherwise tremendously insightful account, *The Human Condition*.
39 Jayne Wallace and Mike Press, "All This Useless Beauty: The Case for Craft Practice in Design for a Digital Age," *The Design Journal* 7, no. 2 (2004): 42–53.
40 Wallace and Press, "All This Useless Beauty," 43.
41 Malcolm Moore, "'Mass suicide' protest at Apple manufacturer Foxconn factory," *The Telegraph*, 11 January 2012.
42 In spite of this difference, the imagery of Zech 14 is nonetheless deeply resonant with Isaiah. Along these lines, see Elizabeth Rice Achtemeier, *Nahum–Malachi* (Atlanta, GA: John Knox Press, 1986), 166.
43 Ralph L. Smith, *Micah–Malachi*, WBC 32 (Dallas, TX: Word Publishing, 1984), 291.
44 Zech 6:12–14 also more explicitly presents the suggestion that the task being pursued is, in some form, the rebuilding of the Temple, which is described in concrete but eschatological language.
45 Carol L. Meyers and Eric M. Meyers, *Zechariah 9–14: A New Translation with Introduction and Commentary* (New York, NY: Doubleday, 1993), 481.
46 *A Critical and Exegetical Commentary on Haggai, Zechariah, Malachi and Jonah*, ed. J.M. Powis Smith and Julius A. Bewer (New York, NY: C. Scribner's Sons, 1912), 356.
47 Meyers and Meyers, *Zechariah 9–14*, 507.
48 Possible reference to Exodus might include the pots (*mzrq*) at the altar described in Exod 38:3 and Num 4:14, or more indirectly the kneading bowls that the Israelites were said to bring with them in their flight from Egypt in Exod 12:34. One also finds specific mention of bowls in the Temple in Ezek 46:21–4.
49 Meyers and Meyers, *Zechariah 9–14*, 507.
50 Rudolf Otto and John W. Harvey, *The Idea of the Holy: An Inquiry into the Nonrational Factor in the Idea of the Divine and Its Relation to the Rational I by Rudolf Otto* (London: Oxford University Press, 1925).
51 Otto and Harvey, *The Idea of the Holy*, vii.
52 Otto and Harvey, *The Idea of the Holy*, 6.
53 Gorringe, *A Theology of the Built Environment*, 11n36.

54 Mircea Eliade, *The Sacred and the Profane: The Nature of Religion*, trans. Willard R. Trask (New York, NY: Harcourt, Brace, 1968), 11. It is worth noting that Otto's original German term "*heilig*," which has been translated as "holy" in English, could just as easily have been rendered "sacred."
55 Eliade, *The Sacred and the Profane*, 12. See Latour, *On the Modern Cult of the Factish Gods*, for a fascinating critique of this modern prejudice.
56 Meyers and Meyers, *Zechariah 9–14*, 479.
57 Smith, *Micah–Malachi*, 293.
58 Steven James Schweitzer, *Reading Utopia in Chronicles*, Library of Hebrew Bible/Old Testament Studies (London: T&T Clark, 2009), 18.
59 Schweitzer, *Reading Utopia in Chronicles*, 30.
60 Schniedewind, *The Word of God in Transition*, 22.
61 Schweitzer, *Reading Utopia in Chronicles*, 79.
62 Schweitzer, *Reading Utopia in Chronicles*, 79.
63 Raymond B. Dillard, *2 Chronicles*, WBC 15 (Waco, TX: Word Books, 1987), 76.
64 Sara Japhet, *I & II Chronicles: A Commentary*, Old Testament Library (Louisville, KY: Westminster John Knox Press, 1993), 44.
65 Japhet, *I & II Chronicles*, 44.
66 Dillard, *2 Chronicles*, 77.
67 Allen "calls these figures 'rhetorical mathematics,' and compares them to common expressions like 'thanks a million' or 'a thousand pardons.'" Cited in Ralph W. Klein, *1 Chronicles: A Commentary*, ed. Thomas Krüger, Hermeneia (Minneapolis, MN: Fortress Press, 2006), 440.
68 Klein, *1 Chronicles*, 440.
69 Translation: "Look, by denying myself [LXX and Vulg = 'in my poverty'], I have prepared for the house of the Lord."
70 Japhet, *I & II Chronicles*, 540.
71 Martin J. Selman, *1 Chronicles: An Introduction and Commentary*, TOTC (Nottingham: InterVarsity Press, 1994), 32.
72 The classic example begins the Noah narrative: "The LORD saw how great was man's wickedness on earth, and how every plan (*yēṣer*) *devised by his mind* was nothing but evil all the time" (Gen 6:5 JPS). See also Gen 8:21; Deut 31:21.
73 "The confident mind (*yēṣer*) You guard in safety, In safety because it trusts in You." Isa 26:3 JPS.
74 This reading is further affirmed by the inversion of Isaiah's statement in Hab 2:18.
75 Roddy L. Braun, *1 Chronicles*, WBC 14 (Waco, TX: Word Books, 1982), 268.
76 "*wkl ḥkm bkl ml'kh*" (lit. "all the wise in all work").
77 Cf. commentary in Japhet, *I & II Chronicles*, 485.
78 Selman, *1 Chronicles*, 260. This is emphasised, as Japhet observes, by the fourfold repetition of the fact of Solomon's *divine* election in 1 Chr 28:5, 28:6, 28:10, and 29:1. See Japhet, *I & II Chronicles*, 488.
79 Japhet, *I & II Chronicles*, 486.
80 Japhet, *I & II Chronicles*, 541.
81 For a detailed examination of spirit-language and prophetic empowerment in Chronicles, see Schniedewind, *The Word of God in Transition*, 55ff.
82 Schniedewind, *The Word of God in Transition*, 72. Also noteworthy is his argument that spirit-inspiration in Chronicles contrasts with that of ecstatic possession

116 *Moral Making*

described outside the Hebrew Scriptures, such that the volition of prophets is not violated.
83 Cf. Japhet, *I & II Chronicles*, 25.
84 Japhet, *I & II Chronicles*, 529.
85 1 Chronicles 14:1–2 ESV.
86 Cf. Japhet, *I & II Chronicles*, 537.
87 John Jarick, "The Temple of David in the Book of Chronicles," in John Day (ed.), *Temple and Worship in Biblical Israel*, Library of Hebrew Bible/Old Testament Studies (London: T&T Clark, 2007), 376.
88 Jarick, "The Temple of David in the Book of Chronicles," 379.
89 Cf. Exod 3:21–2, 11:2, 12:35–6; Ps 105:37.
90 "That he did so is confirmed by another slight change between the wording of the decree and its fulfilment, namely the addition of the word *kly* 'vessels.' 'Vessels of silver and vessels of gold' are referred to specifically in each of the three Exodus passages listed above." H. G. M. Williamson, *Ezra–Nehemiah*, WBC 16 (Waco, TX: Word Books, 1985), 16.
91 Williamson, *Ezra–Nehemiah*, 16.
92 Williamson, *Ezra–Nehemiah*, 32.
93 Cf. Deut 1:35, 3:25, 4:21–2, 6:18, 8:10, 9:6, 11:17; Josh 23:16.
94 Japhet, *I & II Chronicles*, 491.
95 Larry Kreitzer, "The Messianic Man of Peace as Temple Builder: Solomonic Imagery in Ephesians 2:13–22," in Day (ed.), *Temple and Worship in Biblical Israel*, 498.
96 Kreitzer, "The Messianic Man of Peace as Temple Builder," 489.
97 Gerhard Von Rad, "There Remains Still a Rest for the People of God," *The Problem of the Hexateuch and Other Essays*, trans. E. W. Trueman Dicken (New York, NY: McGraw-Hill, 1966), 97–9.
98 NRSV.

4 Jesus the Temple
Temple Construction in the New Testament

> I saw no Temple in the city, for its Temple is the Lord God the Almighty and the Lamb.... The nations will walk by its light, and the kings of the earth will bring their glory into it. Its gates will never be shut by day – and there will be no night there. People will bring into it the glory and the honour of the nations. (Rev 21:22–6)

Not Built With Hands? Mediating the Temple Concept in the Gospels

In this chapter, I turn my attention towards the New Testament in order to trace the way Temple-construction themes I have developed in the first three chapters are iterated in the NT and how this may further flesh out the theological account of work that I am developing more broadly in this book. A number of scholars have recently affirmed the importance of the Temple to Second-Temple Jewish perspectives and the influence these have, in turn, on the writers of the NT. As N. T. Wright suggests, "the Temple was the focal point of every aspect of Jewish national life.... Its importance at every level can hardly be overestimated."[1] However, it is important to note at the outset that Wright makes this point precisely because so many generations of biblical scholars have dismissed the Temple and the wider complex that attended it. To be fair, a number of texts – such as the Rev 21 passage that I have included at the beginning of this chapter – seem to subsume or contest the Temple; and more broadly, a high level of controversy was generated by the Temple as it was. Keeping this in mind, I must spend some time in this chapter addressing those statements appearing to imply that the Temple is not theologically significant for the NT and others, as this seems to indicate a radical break from those construction narratives I have read closely in earlier chapters. This is particularly the case with the emphasis that this temple is not built with hands, which might seem, on the face of things, to undermine the emphasis I draw from craft theory on work that is somatically implicating. As the reader may already suspect, I have also attempted to anticipate these issues, particularly in the preceding chapter with my treatment

of Chronicles; and so I begin here by connecting some of these dots between the eschatological temple in the Hebrew Scriptures and what we find in the NT. For this argument, it is highly significant to note that this transition I have observed, from narratives about Temple construction (i.e., Exodus and 1 Kings) to eschatological narratives about Temple *re-construction*, remained unresolved in the Second-Temple period into the first century CE. In many ways, the details of Temple construction became far more contentious.[2] After all, this Temple had been built by Herod, whom almost no first-century Jew would claim to be the "true King," and the Hasmonean priestly administration, which continued under Roman rule, was not necessarily popular.[3] In broad brushstrokes, I would argue that attitudes towards the Temple are composite: an abstractly conceived Temple remains a vital part of Jewish theology, while the concrete form of the Temple in the first century is the ground for great controversy, and this context forms the backdrop for the NT writers.

The contested status of the Temple is highlighted in the brief but provocative allusion by Jesus to Temple construction in Matt 26:61, Mark 14:58, and John 2:19–21.[4] In Mark 14:58, set in the trial before the Sanhedrin, Jesus' accusers relate: "We heard him say, 'I will destroy this Temple that is made with hands, and in three days I will build another, not made with hands.'" This accusation in Mark combines two motifs of destruction and rebuilding (with implicit reference to the resurrection of Jesus) that are also combined in the similar texts in Matthew and Luke.[5] There is disagreement in these three texts in the first motif as to the agent of the Temple's destruction: one may assume there is an implicit reference to "the Jews" in John 2:18–19, while Jesus is only described as "able" [*dynamai katalysai*] in Matt 26:61. Mark 14:58 gives us the straightforward statement "*egō katalysō ton naon*" ["I will destroy this Temple"], though this statement is still ambiguous, as these are, after all, not the words of Jesus, but those of his accusers before the Jewish authorities. The details of the rebuilding in the second motif are similarly opaque in Mark and Matthew, but in contrast to the messianic secrecy of Matthew that culminates in Matt 26, the gospel of John is more clear-cut. Here Jesus is not described as rebuilding "the Temple" in a strictly literal reference, but rather in John 2:19 he suggests, "Destroy this Temple, and in three days *I will raise it up* (*egero*)." In verse 21, the gospel writer provides even further clarification by way of a gloss: "*keinos de elegen peri tou naou tou sōmatos autou*" ["he was speaking about the Temple of his body"]. The text from John intensifies a theme that is common to the synoptic gospels, namely that the Temple with all its symbolic and practical significance is replaced by the body of Christ.

There is a range of perspectives on the meaning of Jesus' action in the Temple. Chris Rowland interprets Jesus' words at the Temple cleansing as a work of reform and not a programme of replacement.[6] Defending Jesus' action as

following a reformist agenda is not critical for my argument here, however, as the reference point for a newly rebuilt Temple would have been fidelity to the same original pattern and its paradigms established in the Pentateuch. Nevertheless, it would be hard to defend an eschatological vision that is Temple free. E. P. Sanders makes this point forcefully, suggesting, "On what conceivable grounds could Jesus have undertaken to attack – and symbolize the destruction of – what was ordained by God? The obvious answer is that destruction, in turn, looks towards restoration."[7] Though he prefers a less literal understanding of the meaning of "rebuilding" for Jesus than Sanders, N. T. Wright concurs, "Jesus' action fitted into a programme of eschatological expectation, not reform."[8] He goes on to suggest, "I also agree, of course, that Jesus, like Jeremiah, regarded the Temple as God-given; there is no question of his suggesting that it should never have been built in the first place, or that worshipping in it was inherently wrong."[9]

As I noted at the outset, it is also important to assess the usage of *acheiropoiētos* ["not made with hands"] to determine what kind of contrast is being drawn with the Temple that is *cheiropoiētos* ["made with hands"]. This point is a particularly crucial one in the first century, as – with only a few Stoic and Cynic exceptions – the educated classes in Greek and Roman society had a widely held disdain for physically involving occupations (or "hand-work"). Disdain for non-agricultural work as an "illiberal" or *banausic* art can be found across non-Christian classical thought.[10] A good example of this attitude can be found in Xenophon's (ca. 430–354 BCE) reproduction of a dialogue by Socrates:

> The illiberal arts, as they are called, are spoken against, and are, naturally enough, held in utter disdain in our states. For they spoil the bodies of the workmen and the foremen, forcing them to sit still and live indoors, and in some cases to spend the day at the fire. The softening of the body involves a serious weakening of the mind. Moreover, these so-called illiberal arts leave no spare time for attention to one's friends and city, so that those who follow them are reputed bad at dealing with friends and bad defenders of their country. In fact, in some of the states, and especially in those reputed warlike, it is not even lawful for any of the citizens to work at illiberal arts.[11]

This description highlights several issues of Greek (and Hellenistic) concern regarding manual labourers. First, by their toil, they exact a "softening" on the physical body that Socrates (via Xenophon and Plato) suggests carries a corresponding effect on the mind. Further, they take away from leisure time, lessening the opportunity for participation in the political life of the polis, and thus undermining citizen loyalty to that polis. Even more moderate Classical accounts, such as that of Plato, tend to place various forms of work in a

hierarchical order. At the top of the work hierarchy, according to Plato, are the forms of work that make one learned or wise, and at the bottom are the *banausic* arts, which are antithetical to wisdom. Plato lays out this vision in his *Phaedrus*, where, in the context of his explanation about which souls are the best and as a result "follow after God" in their reincarnation, Plato provides a hierarchy of vocations, with "a craftsman" nearly at the bottom in the seventh of nine positions.[12] One might try to rescue Plato here with the suggestion that by placing the artisan in the seventh position Plato merely leaves their status under benign neglect. But it is important to note that this seventh position is sandwiched in between two categories consisting of middling prophets and poets (who earlier in the *Phaedrus* are described as the recipients of mystical divine revelation) and Plato's archenemies, the sophists and tyrants. This passage also provides a clear indication of Plato's dualism in action. Both the gymnast (number four) and the artisan (seven) work hard, but the gymnast works with material "properly," in the manner of Plato's metaphorical charioteer who wrestles the body into submission, while the artisan simply wallows in material stuff and thus has a status barely above the despised sophists.

Even should a workman produce something of appreciable beauty, this was still not grounds for appreciation of the virtues of the workman, as Plutarch suggests: "Nay, many times, on the contrary, while we delight in the work, we despise the workman. . . . Labour with one's own hands on lowly tasks gives witness, in the toil thus expended on useless things, to one's own indifference to higher things . . . it does not of necessity follow that, if the work delights you with its grace, the one who wrought it is worthy of your esteem."[13] This is not surprising, as both Plato and Plutarch are working within an idealist aesthetic wherein the idea that guides the artist or artisan in making an object is wholly extrinsic to them and their success can only be judged on their ability to accurately replicate the *ideal* form or "higher things" in some material form. Along these lines, Plato suggests, "it is the user of an object, not its maker, who possesses knowledge of it."[14] Accordingly, this Greek disdain leaves us with the pejorative term "banausic arts," also called "illiberal arts."

Given this well-developed juxtaposition in Classical philosophy, there is some urgency behind my argument that the juxtaposition between the physically involved work and non-involved work I have noted in the gospels is of a different character from the classical and anti-fabricative equivalent. Where there are juxtapositions in Scripture between *acheiropoiētos* and *cheiropoiētos*, the contrast is between work that is exercised directly by divine "handless" agency (or under divine superintendence) and human craft that is exercised in isolation from any theological guidance. Without exception, appearance of *cheiropoiētos* in the LXX is made in reference to idols and their fabrication.[15] Further, *acheiropoiētos* does not occur in the LXX.[16] Finally, underlining the uniqueness (and thus

theologically novel) nature of the distinction marked by *acheiropoiētos* in the NT, in Classical usage, the actual opposite of *acheiropoiētos* is *autophuēs* ["natural"].[17] It is important to affirm, then, that the true juxtaposition in the NT is between work that results in the making of idols and work that can reconstruct God's Temple. Only the latter may be recognised as good – in other words, exercised under divine superintendence.

My reading of a more subtle reformist agenda – at least with regard to the possibility of Temple worship – in these gospel passages is further vindicated when one considers the intertextual backdrop suggested by the quotations from Scripture provided in the gospel texts, Isa 56:7, Jer 7:11, and implicitly Zech 14:21. These texts provide some clues as to the nature of the reforming (or rebuilding) agenda. Turning to Isa 56, which portrays the "full return from exile," what stands out is the democratisation of worship with the "ingathering of the Gentiles."[18] Isaiah 56:7 provides the strongest example: "make them joyful in my house of prayer; their burnt offerings and their sacrifices will be accepted on my altar; for my house shall be called a house of prayer for all peoples." In contrast, the quoted text from Jeremiah "forms part of the great sermon denouncing the Temple and warning against unthinking trust in it."[19] Jeremiah's prophetic critique is about false worship and the subversion of worship that can occur there, as he outlines a few verses earlier in 7:4: "Don't put your trust in illusions and say, 'The Temple of the LORD, the Temple of the LORD, the Temple of the LORD are these [buildings]'" (Jer 7:4). In verse 11, Jeremiah asks rhetorically, "Do you consider this House, which bears My name, to be a den of thieves?," and warns of impending judgement: "As for Me, I have been watching – declares the LORD." Here is a similar critique of the dissolution and incoherence of worship found in Jer 22, which I assessed earlier. The people have "set up their abominations in the House which is called by My name, and they have defiled it" (Jer 7:30).

In attempting to challenge the suggestion that NT writers are dismissing the concept of Temple altogether, it is important to acknowledge that there is a trajectory in Christian reflection that does take a strong stance towards the path of discontinuity. One might take the words of Jesus here to affirm discontinuity, particularly keeping in mind the trajectory of the gospel narrative with Jesus' "prophecy of doom" in Luke 19:47 and the climactic moment of judgement marked by the rending of the Temple veil (Matt 27:51, Mark 15:38, Luke 23:45).[20] Rowland argues that this trajectory is joined by Stephen's speech in Acts, given his quotation of Isa 66:1 in Acts 7:49, which "suggests that Solomon's building of a house for God marked a departure from the divine intention."[21] This is picked up in the Christian tradition in the *Epistle of Barnabas*, which is strongly dismissive of the Jewish cult: "I discover, therefore, that there is in fact a Temple. How, then, will it be built in the name of the Lord? Learn!

Before we believed in God, our heart's dwelling place was corrupt and weak, truly a Temple built by human hands, because it was full of idolatry and was the home of demons, for we did whatever was contrary to God."[22] Yet one must take care before adopting the posture expressed here, as this trajectory is also often not far from anti-Jewish polemic in early Christian writing.[23]

It is one thing to presume that a Temple is to be rebuilt, but one may still go on to argue that the worship offered there was to be reconstituted in contradistinction to what came before. To argue a position of absolute discontinuity would require that one assume the declaration by Jesus that the new Temple would not be built by human hands, meant by extension that the work inaugurated at Jesus' resurrection would not involve human participants. But this is obviously not the case – Jesus' resurrection spurred human participants to intensify their involvement in ministry, often resulting in their persecution and death. To this end, it is helpful to keep a reading of Christological rhetoric in context and consider how properly accounting for the doctrine of the ascension (e.g., John 14:12) may provide further theological support for the Temple-ethics that I am arguing for here, albeit with a broader and more democratised context. In short, ethics may benefit from not only a robust doctrine of the resurrection, but also one of the ascension (as a number of other recent theologians have also argued).[24] This appreciation of ascension opens up the possibility that we may view the conduct of those Christian worshippers who continue to worship in the Temple in the first century and who appear to be appropriating such Jewish concepts as "firstfruits" in the fourth century (which I shall treat at greater length in a subsequent chapter) as theologically continuous with early Christianity and not a departure from a supposedly more authentic early Christian anti-nomianism. Clearly, there is a more complicated dynamic here than a mere dismissal of Jewish practice, and I shall argue that a more theologically sophisticated account can be made of the transition of the meaning of the Temple. In seeking to defend this claim, I shall begin in the material that follows, by attempting to provide some account of how this new Temple "not built with hands" nonetheless involves a great deal of handiwork. This provides a point of continuity for the moral world of the Tabernacle and its inclusion within Christian thought.

The New Ecclesial Temple and Moral Work in the New Testament

A full survey of the use by NT writers of temple imagery lies far beyond the scope of this study. However, there are two points upon which the NT texts have direct relevance to my broader moral argument. First, it is important to affirm that the concept of the Temple persists into the NT and is not merely discarded or replaced. Second, it is also important to note how these NT accounts of the

new temple impinge upon the concept of "work" and might further texture the moral argument I am making more broadly in this book. I shall focus this study on the gospels and Pauline epistles, but some brief comments are also in order with regard to two heavily temple-centric texts: Hebrews and Revelation.

The writer of the Epistle to the Hebrews – who offers what Rowland describes as "the most extended exposition of Christ's relationship to the cultic institutions of the Torah"[25] – focuses not on the Temple, but on the Tabernacle. However, this literature, Rowland claims, is "unequivocal that the religion of the Tabernacle (and by implication the Temple also, according to Heb. 9.9) is redundant, made obsolete by a sacrifice which offers access to the very presence of God."[26] In a similar way, John's Revelation also draws upon the Tabernacle account in portraying a Tabernacle/Temple that is co-extensive with the new creation.[27] Yet there is another way of viewing the meaning of replacement, having accepted that this new sanctuary not made with human hands "replaces" the former institution. As Gregory Beale notes, "this is not so much a fading away of the former Temple institution but a fulfilment of all to which it pointed."[28] As I hope to demonstrate in the subsequent material, fulfilment need not imply discarding, but can also imply conceptual absorption. In this way, the moral logic that I have drawn from the Hebrew Scriptures may be seen as continuing to function in a concrete way. However, given my focus on Temple-*construction* narratives rather than the various descriptions of a finished Temple one finds in the NT, the more obvious Temple texts of the NT will not quite suffice. For instance, though the account in Revelation vindicates my argument that the Temple imagery of Exodus may provide an apt starting point for a normative ethics of work, and further may provide the basis for the hope that may energise and form our moral imagination, the details of its construction are completely omitted from the narrative. In seeking a post-ascension basis for moral work through reading Temple construction, I turn instead to the gospels and epistles, where one finds terse, but nonetheless more explicit, detail.

To set the stage, the gospel texts I analyse below hint at a Christological and ecclesial reconstitution of the Temple. While there are no obvious textual parallels to the construction accounts in the Hebrew Scriptures I surveyed earlier, there are clear references in the gospels to a building work that is undertaken by Jesus, the messianic man of peace. Here one finds an account of construction of a new *ecclesial* Temple that carries forward hints at a shared coherence between the work being done by the disciples and by the ordinary work of the people.

Temple Building in the Gospels

Scholarly studies of work in Christian Scripture often assume that Jesus' attitude towards work was one of absolute renunciation, given his cessation of work as a

124 *Moral Making*

carpenter at the outset of his public ministry. In Miroslav Volf's influential book on the theology of work, he suggests, "We search in vain in the NT for a cultural mandate, let alone for the 'gospel of work.' Jesus left carpenter's tools when he started public ministry, and he called his disciples away from their occupations."[29] One can find a similar sentiment, ironically, in John Howard Yoder's critique of revolutionary zeal, *The Original Revolution*. Yoder suggests, "But Jesus, although his home was a village, found no hearing there, and left village life behind him. He forsook his own handicraft and called his disciples away from their nets and their plows. He set out quite openly and consciously for the city and the conflict which was sure to encounter him there."[30] These readings assume that Jesus' cessation from work was a renunciation and carries the risk of estranging Jesus' perspective from the roundly positive affirmation of work by the apostle Paul (which I shall discuss further below). As a consequence, we are left with a serious discontinuity between Jesus' and Paul's social visions. Paul's words on work are seen as his own ministerial innovation, or as passively inherited from his Jewish or GR training, but certainly not drawing from the resurrected person who met Paul on the road to Tarsus. Yet even in Pauline studies, one finds scepticism about the concern for work. In one dissertation on work in Paul's epistles, Edwin Jackson Wood (1995) provides an example of this divorce between Jesus' and Paul's work ethic. After observing Paul's tendency to describe ministry as work, Wood notes: "It is not obvious why Paul would describe missionary activity in these terms [of manual work]. Typical missionary activities like preaching, teaching, or distributing benevolences are not physically strenuous . . . the Gospel's use of the metaphor is limited and from an agricultural context. It is not an adequate background for Paul."[31] As I have already argued in this and previous chapters, metaphors relating to temple construction are often to be found intertwined with appropriations of the language and concepts of work. Outside the occurrences that I noted at the outset of this chapter, there are no explicit references to temple building in the gospels. However, one finds regular reference by Jesus to the language and experience of construction work to speak about the task of "temple building" to his apostles. To highlight this connection, I shall focus on two examples – first Jesus' use of harvest metaphors and second the Parable of the Builders – in order to explicate the relationship between the ministerial work of the disciples and craftsmanship.

Jesus frequently describes his own ministry with the language of "work," as when he suggests, "My Father is still working (*ergazetai*), and I also am working (*ergazomai*)."[32] Even more striking along these lines is Jesus' self-identification as a slave, a class in the GR world that existed in order to free the slave-owners from the regular requirements of manual labour. Mark reports Jesus' saying to this end, which is straightforward: "For the Son of Man came not to be served but to serve (*diakonēsai*), and to give his life a ransom for many."[33] In this way,

Jesus' self-identity is offered as a model for his disciples, as the foot-washing episode in John 13:14–16 suggests:

> So if I, your Lord and Teacher, have washed your feet, you also ought to wash one another's feet. For I have set you an example, that you also should do as I have done to you. Very truly, I tell you, servants are not greater than their master, nor are messengers greater than the one who sent them. (NRSV)

The model of ministry as service-work is offered by example by Jesus, a model that he expects the disciples to imitate. The suggestion that service is predicated on servant-hood or, stated more strongly, slavery, deserves close attention. This same theme is also utilised in Matt 20:25–7, 23:10–12 and Mark 9:34–5, 10:42–4 as a model for discipleship. In these texts, there is little ambiguity about the fact that Jesus is identifying himself as "master" and the disciples as "servants," but his characterisation of these roles undermines their typically hierarchical nature. Jesus' self-identification further undermines the notion that a "master" would not participate in labour, rather serving as the ultimate example of one who labours.

The Disciples' Task as Ergatai: Luke 10 and Harvest Work

Jesus' extended description of the disciples' task as becoming "workmen" [*ergatai*] in Luke 10 offers one of the most explicit descriptions of discipleship as labour and offers a particularly useful focal point for this discussion. First, the introduction offers an agricultural metaphor at the outset as Jesus uses agricultural labour to describe the disciples' task: "He said to them, 'The harvest is plentiful, but the labourers are few; therefore ask the Lord of the harvest to send out labourers into his harvest'" (NRSV).[34] Given the urban context of many modern biblical readers and the advent of machinery changing the form of agriculture for those still in rural occupations, an agrarian reading that arises out of a thick understanding of the nature of the first-century harvest may help illuminate the rhetorical force of God's sending out "labourers into his harvest."

The process of harvesting in Iron Age Palestine involves several stages and multiple work-roles in what is a complex process. Further, most crops (especially grain) ripen later in the agricultural year, and thus, as Borowski relates, "harvesting was done in the summer, when the temperature is very high."[35] The extremes of heat in harvest time are underlined by Prov 25:13: "Like the cold of snow in the time of harvest are faithful messengers to those who send them; they refresh the spirit of their masters."[36] The process begins with reaping, in which the grain was severed from stalks by iron or flint sickles. Given the nature of iron and flint

tools, even preparation for reaping was a labour-intensive process, as related by an Ancient Egyptian text advocating for the leisurely vocation of the scribe:

> Let me also expound to you the situation of the peasant, that other tough occupation . . . he attends to his equipment. By day he cuts his farming tools; by night he twists rope. Even his midday hour he spends on farm labor. He equips himself to go to the field as if he were a warrior. The dried field lies before him; he goes out to get his team.[37]

Once the tools are sharpened and reapers have completed their work, harvested stalks lying on the ground are bound into sheaves by binders. Sheaves are carried and put into piles, after which they are transported to the threshing floor. Borowski observes that the timing is not flexible for threshing: "threshing had to be done immediately after the harvest to free the farmer for his next task – picking grapes. In a good year, when the yield was great, threshing and grape picking overlapped."[38] Threshing involves very work-intensive crushing of the grain kernels. In the case of very small batches or certain tender crops, threshing was performed by beating it with a stick, but in the case of larger-scale harvesting, animals tread the grain, in some cases with a dragged sledge operated by humans. Part of the reason behind the time-consuming move of the grain sheaves for threshing is that the next process of winnowing relied on wind-energy. The material is thrown into the air with a winnowing fork, and the various components of the grain kernel settle in different places on the ground because of their diverse densities. Final cleaning of the grain is performed using a wooden shovel, which gathers the grain into a heap; it is sieved coarsely, then finely. The final product of this is termed *bœr* or "clean grain."[39]

Unpacking this process offers several elucidations of the Lukan text. First, the task of harvest tended to involve a high degree of specialised workers with different tasks, drawing in the resources of the whole rural community. This may be why in Luke the harvest metaphor is reserved for the description of discipleship given to the seventy in Luke 10, rather than the otherwise similar description of the smaller group of disciples in Luke 9:1–6. This inherently social agricultural enterprise resonates with the sociality I have underlined in the Tabernacle- and Temple-building process above. Furthermore, the task of harvest represents intense sustained labour during the hottest time of the year. One might find a faint resonance of this reality in the harvest metaphors in the Hebrew Scriptures, which, in some contrast to the NT, are often used in describing God's acts of judgement as sifting the righteous and unrighteous.[40] As I have indicated in my analysis above, it is appropriate to read this passage as containing an eschatological message, but this need not imply only judgement. Rather, eschatology in the case of the harvest here seems to imply empowerment by the Spirit for the

purpose of completing the work that God has already begun, a point emphasised already in Luke 9:1 and also assumed in this passage. In marked contrast to planting (which included ploughing and sowing), which could be a time of tenuous hope for agricultural labourers (given that yields varied widely from year to year), harvest was a time of realised joy as the literal fruits of a person's labour were gathered. In some sense, planting is the risky work (cf. Luke 8:5), while in contrast harvest is backbreaking but comes with guaranteed reward. Though I have only detailed the process of the grain harvest here, harvest season would actually occupy a full month; it included a variety of carefully timed enterprises, such as the picking and pressing of olives and grapes, and ended with the community-wide measuring of grain for tithes.

Dwelling on the notion of harvest labourers also offers another reading of Jesus' subsequent statements in Luke 10.[41] Just after his description of the labourers being sent into the Lord's harvest, he suggests, "Go on your way. See, I am sending you out like lambs into the midst of wolves." There are a number of speculations as to what Jesus meant by "lambs" and "wolves" in this text, but one possibility in this image of innocence being sent into danger might be Jesus' sending inexperienced apprentices into their first effort. They have been trained but not tested for the labour that faces them; and consequently Jesus' exhortation to them contains warnings of possible strife they may face, both in terms of austere circumstances (v. 4: "carry no purse, no bag, no sandals") and potential danger (v. 10: "whenever you enter a town and they do not welcome you . . ."). This is, in a very real sense, a labour of "risk." Also of some interest in establishing the status of labour in this passage is Jesus' suggestion that the "labourer deserves his wages."[42] Jesus' use of the labourer by analogy here vindicates the literal hard work of labourers in general. Further, in the context of this address, Jesus affirms that the vocation of ministry and teaching into which he sends his disciples is not meant to be a substitute for manual labour, but rather manual labour of a different sort and for a specific period of time.

Discipleship as Harvest Labour (John 4)

A similar example of this use of labour to describe the discipling craft can be found in John's gospel. After Jesus addresses the Samaritan crowd, he exhorts his apostles to act as successors (using an agricultural metaphor) to a long line of spiritual labourers in John 4:31–8. This is an important text in John, and focusing on the harvest/reaper metaphor is helpful for understanding John's conception of mission, as suggested by Teresa Okure: "In the Johannine conception, every missionary endeavour of every age means essentially and fundamentally a harvesting, a reaping of the fruit of the work of salvation accomplished definitively by Jesus and the Father."[43] Some of this text is similar enough to the

parallel synoptic harvest passage in Luke 10, described above, to forego close analysis. This is particularly the case with Jesus' suggestion in verses 35–6, where he says,

> Do you not say, 'Four months more, then comes the harvest'? But I tell you, look around you, and see how the fields are ripe for harvesting. The reaper is already receiving wages and is gathering fruit for eternal life, so that sower and reaper may rejoice together. (NRSV)

Here we find the now-familiar offering of harvest as a metaphor for "the gathering of people into the kingdom of God."[44] The agency is somewhat less clear-cut in the Johannine passage, as harvest appears to be already ongoing: "the reaper is already receiving wages" (v. 36a).[45] However, even though the harvest has already been initiated, it is clear in Jesus' words that the disciples are still called to participate in this process. This is a difference of emphasis and not of kind, as the Lukan text hardly defines their apostolic harvest purely in terms of the work of the seventy. Jesus' involvement in the harvest of Luke 10 is also clear: they are "*apostello... pro prosopou autou*" ["apostles... [sent on] ahead of him"]. Further, Jesus depicts the act of harvest gathering even more concretely as a joy-filled vindication of sowing, "so that the sower and reaper may rejoice together" (v. 36b). If anything, the Johannine passage is more inclusive as to the involvement of the disciples in Jesus' work. This suggestion brings me to analysis of a unique feature of this text in verses 37–8, which further elaborates Jesus' use of the language of labour. In Jesus' use of the harvest metaphor here in John 4, the disciples are depicted as participating in an intergenerational enterprise, or a legacy of labour: "For here the saying holds true, 'One sows and another reaps.' I sent you to reap that for which you did not labor. Others have laboured, and you have entered into their labor." In this passage, John provides a more explicit affirmation of harvest as a communal enterprise. My exposition of harvest in Luke above contradicts the suggestion that the disciples are being told they need not strive, which is suggested by Brown's overdrawn translation: "What I sent you to reap was not something you worked for. Others have done the hard work, and you have come in for the fruit of their work."[46] This is not quite right, as the work has not already all been done. Reaping and harvest themselves imply months' worth of hard work. In some ways, a reading of this passage presuming that the labour of "others" would displace the labour required of the disciples, misses the point. Instead, I would argue, the point of the passage centres on the location of risk in the agricultural enterprise. The sowers have done the fraught work of preparing the ground and casting seeds without knowing which, if any, would germinate and grow. Precisely because of this, as Ps 126 suggests, the activities of sowing and reaping (harvesting) are associated with different psychological

states: "May those who sow in tears reap with shouts of joy. Those who go out weeping, bearing the seed for sowing, shall come home with shouts of joy, carrying their sheaves."[47] Even if the reaping is finished, the next task, threshing, is itself backbreaking work. Consequently, when one enters "into their labor" (v. 38) one is still expected to work. The point is not whether work is involved, but whether one is involved in the beginning or at the end of the process.

There is also possibly an eschatological element to this passage, the examination of which identifies other biblical resonances relevant to the status of labour in this text. The phrase "one sows and the other reaps" is the object of wide-ranging conjecture as to possible literary parallels. Many of these (Deut 20:6, 28:30; Eccl 2:18–21; Job 31:5–8; Mic 6:15), however, carry negative connotations, as Brown notes: "the reference there is a pessimistic one, namely, that a catastrophe intervenes to prevent a man from reaping what he has sown."[48] Michaels draws attention to the possible shared imagery here of "messianic abundance," found earlier in the text of John 2, with Jesus' manufacture of a great abundance of vintage wine at the Cana wedding.[49] Of particular interest here are resonances with the eschatological vision found in Amos 9:13:

> The time is surely coming, says the LORD, when the one who plows shall overtake the one who reaps, and the treader of grapes the one who sows the seed; the mountains shall drip sweet wine, and all the hills shall flow with it.[50]

To read the mention in verse 35 – "Four months more, then comes the harvest" – as a reference to an eschatological superabundance, as Michaels does, stretches the text here. However, as he points out, one can find signs elsewhere in the pericope to justify such a reading, as with the promised "spring of water gushing up to eternal life" in verse 14 and the mutual joy described in verse 36. This mention of eschatology also draws attention to Jesus' allegorical use of "by," through which he pits *his* "food" [*brosin*] against the ordinary food [*trophas*] that the disciples have purchased in the city (John 4:8). His food is not literal bread, but rather it is "to do the will of him who sent me and to complete his work." This use of allegory parallels Jesus' characterisation earlier in the same chapter (with the woman at the well) of his living water [*hydōr zōn*] over against the ordinary water she is asked to give him to drink. This sort of dialogue occurs in several other places in John; and as Morris observes, "the disciples misunderstand Jesus by taking his words in a literal and material fashion."[51] I bring attention to this allegorical use of "bread" and "water" by Jesus in order to emphasise how the purpose here in John 4 is not to offer a Platonic exaltation of spiritual over against ordinary materiality, but rather to use allegory to draw attention to an eschatological reality. Jesus' logic, expressed here by allegory, is

perhaps best explained by Deut 8:3, which is likely behind his "you do not know about" statements about work and food (John 4:32).[52] The Deuteronomy passage opens with a reminder of the wilderness economy: "He humbled you by letting you hunger, then by feeding you with manna, with which neither you nor your ancestors were acquainted, in order to make you understand that one does not live by bread alone, but by every word that comes from the mouth of the LORD." An eschatological reading of this allegory that grapples with the reality of Deut 8 and Amos 9 enables the reader to avoid what Haenchen rightly describes as a docetic reading.[53] Instead, one finds Jesus' discourse on harvest in John to emphasise not the work-free "leisure" of the new life, but rather the proper role of divine initiation (sowing) and joy-filled participation by the disciples as part of a long line of disciple-making labourers.

Discipleship and Ancient Near-Eastern Homebuilding in Luke 6

Another example of construction labour offered by metaphor as a model for obedience to God can be found in Jesus' Parable of the Builders in Luke 6. In this case, Jesus makes use of an explicit description of building to refer, at least obliquely, to the disciple-making task. Jesus opens this parable by setting exactly this connection to labour: "I will show you what someone is like who comes to me, hears my words, and acts on them. That one is like a man building a house."[54] As is often the case with the parables, Jesus' introduction is compact and terse. With the advent of modern labour-saving machinery and the dichotomisation of the homebuilding enterprise into design (i.e., by architects) and construction (i.e., by skilled labourers), some of the force of the metaphor being employed may be obscured for the contemporary reader. Bailey cites a source that provides helpful illumination of the context:

> The enormous effort required to build a house in the ancient world was more perfectly understood by Ibn al-Tayyib who began his reflections on this parable by saying, 'Every Christian knows that building a house is not an easy endeavor. Rather it involves exhausting and frightening efforts, strenuous hardships, along with continuous and life threatening struggles.'[55]

Vindicating Ibn al-Tayyib's suggestion, this parable quickly turns to crisis, "when a flood arose" (v. 48); and, as Bailey's analysis demonstrates, this was a regular and geologically determined reality for Palestinian homebuilders. A home had to be completed in the "dry, warm days suitable for building houses" in the summer.[56] This is because, during the excessively rainy winter, "the ground begins to turn into the consistency of chocolate pudding" and consequently if a house is not built "on the underlying rock, it will last only as long as the ground under it

remains dry and prevents settling."[57] This provides a thicker context for reading the parable, as Bailey relates:

> It is easy to imagine a builder in summer, with little imagination or wisdom thinking that he can build an adequate one-level house on hard clay. With his pick he tries digging and finds the ground is indeed 'like bronze.' The walls will not be more than seven feet high. It is hot. The idea of long days of backbreaking work under a hot, cloudless sky does not appeal to him. He opts to build his simple one- or two-room home on the hardened clay. The underlying rock is down there somewhere – it will all work out! He constructs a roof with a reasonable overhand and is pleased that he has managed to finish before the onset of the rains.[58]

As this analysis, and indeed a plain reading, reveals, this parable is about foundations. However tempting it may be for an interpreter to immediately turn to the *theological* referent that Jesus intends the parable to describe, remaining on the literal level reveals that this parable is also about the determined effort wrought by a builder who is a true artisan. Reaching deep bedrock can be a backbreaking task and consequently there can be a temptation to cut corners. The target here is likely not just a foolish decision, or lack of forethought by the person who built their house "on the ground without a foundation," but the deliberate avoidance of hard labour.[59] This offers a stringent rejoinder to the Classical disdain towards labour outlined above. An interesting rhetorical inversion of this passage is the mention of workers of lawlessness in Matt 7:23.[60] The disciples' work is depicted as building that notably involves *striving*, and their hard work is not set in opposition to their adversaries, but rather is called for in light of the hard work being done on behalf of evil. In similar ways to the harvest metaphor described above, the "building" work of Jesus' followers is described with explicit reference to craftsmanship. While contemporary conceptions of craft often emphasise design, the labourers and craftspeople on which Jesus draws are physically implicated in their work, and consequently the reference to labour in these cases implies work that is not only carefully conceived but also physically strenuous, occupying their attention for an extended period of time.

Labour in Paul's Epistles

The following study of construction metaphors in Paul's writing is not merely a parallel study to the preceding one, but a complementary one too. Here one finds that some of the implicit work references in the gospels are developed in similar ways by Paul as he also explicates a relation between Christian worship and work. The Pauline material that I shall go on to analyse – seen in light of

my affirmation that the Temple is reconstituted in the person of Christ and his disciples – consolidates this new account of Temple construction.

One can hardly overstate the impact of Paul's reference to his work as a *skēnopoios* [literally "tent-maker," also translated "leather-worker"] for early Christians.[61] Also, in some contrast to gospel studies, the relationship of Paul's labour to his ministry has been the subject of much discussion among modern Pauline scholars. While there remains disagreement among scholars about some of the particulars, Still is able to observe with some confidence, "Contemporary interpreters of Paul concur that the apostle worked as an artisan in conjunction with his mission. They are also agreed that his toil as a tentmaker marked not only his missionary activity but also his apostolic self-understanding."[62]

Paul does not actually mention explicitly in his own writings that he is a tent-maker, only generically that he does manual labour for the purpose of supporting himself. However, one finds specific mention of his trade in Acts 18:1–3, which, presuming the account presented there is reliable, introduces Paul's move to Corinth and describes the logistics of his stay there: "Paul went to see them [Priscilla and Aquila], and, because he was of the same trade, he stayed with them, and they worked together – by trade they were tentmakers."[63] This detail, as Thiselton puts it, "coheres with the greeting in [1 Cor] 16:19, namely, that Paul stayed for 18 months in Corinth in the home of Aquila and Prisca."[64] There is no textual uncertainty or historical reason to doubt these details, and it seems right to assume that Paul was a tentmaker by trade and that he practised it particularly during his stay in Corinth as suggested in 1 Cor 4:12, "we toil, working with our own hands."

Paul's statements in 1–2 Thessalonians also indicate that he prides himself on the practice of this trade as a means of self-support.[65] This pride in self-support is echoed in his speech as preserved in Acts 20:32–5, and this further seems to suggest that this bi-vocational life may have been Paul's preferred pattern throughout much of his ministry. Studies of 1 Corinthians have also illuminated how this choice of tentmaking work was deliberate and not because Paul was without other options. As Thiselton relates, "many at Corinth who became Christian believers would have liked Paul to turn 'professional'; to be like 'the sophists, those "visiting professional preachers" who relied upon . . . admirers, all expert talkers. . .' (like the chat-show hosts or media figures of the present day)."[66] Thiselton notes also:

> In a city where social climbing was a major preoccupation, Paul's deliberate stepping down in apparent status would have been seen by many as disturbing, disgusting, and even provocative. This comes to a head partly in definitions of 'apostle' but more especially in Paul's 'foregoing his right' to receive

maintenance (and hence patronage and reciprocal obligations) as a genuine professional in the sphere of religion and rhetoric.[67]

Given the degree to which the problems of the Corinthian church may have been intertwined with a "high-status culture," as Thiselton suggests, choosing to continue in his work as a tentmaker may have been a deliberate choice for the purpose of enabling a ministry to the Corinthians that targeted those issues of "boasting" that were intrinsic to the problems with their church.[68]

This integration of work and ministry may also have been expressed in the location of Paul's ministry. Hock suggests that Paul's various workshops functioned as a social setting for Paul's missionary preaching, alongside synagogues (Acts 9:20, 9:29, etc.), homes (Acts 16:15, 18:7, etc.), and the occasional public *stoa* (Acts 17).[69] Along similar lines, Wood conjectures that Paul may have preached in the "meeting hall of a trade association."[70] Hock provides a vivid reconstruction of this workshop ministry as follows:

> During the long hours at his workbench cutting and sewing leather to make tents, Paul would not only have been supporting himself, but he would also have had opportunities to carry on missionary activity (see 1 Thess 2:9). Sitting in the workshop would have been his fellow-workers and perhaps one or more visitors, perhaps customers or perhaps someone who has heard of this tentmaker–'philosopher' newly arrived in the city. In any case, they would have been listening to, or debating with, Paul, who had raised the topic of the gods and was exhorting them to turn from idols and to serve the living God (1:9–10). Some of those who listened – a fellow-worker, a customer, an aristocratic youth, or even a Cynic philosopher – would want to know more about Paul, about his churches, about his Lord and would return for individual exhortation (2:11–12). From these workshop conversations some would eventually accept Paul's word as the word of God (2:13).[71]

As Hock suggests, it seems reasonable to take Paul's comments in 1 Thess 2:9 seriously, that "we worked night and day."[72] Building on this, one may assume that, in addition to his preaching after hours in various locations, Paul may well have had less formal conversations about his faith with interested customers in the context of his workshop. Studies of similar workshops in the GR context elaborate the likely physical circumstances of Paul's workshop. Hock affirms that his workshop was probably quiet enough – with only the noise of stitching – to allow for conversation.[73] Further, Hock affirms that the work of tentmaking was itself physically demanding, contrary to suggestions that Paul's might have been a "soft" trade.[74]

As this brief survey has indicated, Paul's ministry was intertwined with his practice of manual labour. This led him to commend self-support (to the Thessalonian church especially) and likely also to use his workplace as a site for preaching and ministry. I would affirm that Paul considered his manual work to be important and that he conceived of it as being related to his apostolic ministry. In defending this suggestion, it is helpful to note the extensive degree to which Paul's statements on work and ministry and their interrelation are treated normatively in patristic and later monastic writing.

Ministry and Craft in Paul's Epistles

Above, I focused particular attention on Jesus' use of harvest metaphors and the Parable of the Builders as examples of a deployment of the language and wisdom of manual labour in describing the Christian life. It is noteworthy that Paul echoes both these metaphors in his description of ministry in 1 Cor 3. It is to this passage that I shall first direct my attention before turning to Eph 5 in order to explicate another use of the language and logic of work in ways that are in continuity with the gospel descriptions examined above.

In 1 Cor 3:5–4:21, Paul offers an application of the principles he has outlined earlier in the letter.[75] In the preceding materials, Paul deploys, as Thiselton puts it, a "corrective redefinition of 'spirituality' at Corinth" such that spiritual maturity and wisdom are to be understood by "Christological criteria."[76] The behaviour of the Corinthian Christians has been "as infants in Christ" (3:1) and "merely human" (3:4); and after a call for a new wisdom that maintains the cross as its central paradigm (1 Cor 1:17, 19–22, 24–5, 30; 2:1, 4–7, 13) Paul offers an application to ministers and their ministry by way of three "explanatory images": God's Field [*theou geōrgion*], God's Building [*theou oikodomē*], and, in an image most directly resonant with the Temple, God's Holy Shrine [*naos theou*].[77]

With the first image, "God's Field," Paul casts the agricultural metaphor in a slightly different form than is the case in Luke 10 and John 4, examined above. Paul's primary purpose is to emphasise God's role in the successful growth of a church over against any human leadership. So he suggests, "I planted, Apollos watered, *but God gave the growth*. So neither the one who plants nor the one who waters is anything, *but only God who gives the growth*" (4:6–7).[78] Having firmly established the priority of divine agency in this process, Paul goes on to relativise the significance of individual human contributions: "It is all one who does the planting and who does the watering" (4:8a, NJB).[79] One result of this relativisation of contribution by Paul is to undermine social hierarchy in which leaders in his audience may be manoeuvring for position.[80] However, this relativisation does not subsume their contributions, as Paul suggests "each will receive

wages according to the labour of each" (4:8b). This commendation about wages echoes Jesus' statement in Luke 10:7 examined above and infers similarly that the work described is not fundamentally insignificant.[81] Attempting to identify a concrete referent for Paul's use of *misthos* [usually translated "pay," "reward," or "wages"] is complex, as demonstrated by the diversity in commentators' conclusions. However, one can make several affirmations with confidence. The mention of *misthos* is deployed in order to affirm that their pay is from God; and in this way, as Thiselton suggests, "the image of pay or reward serves primarily to intensify the point that Paul and Apollos are responsible to God, their employer, for judgments about their success or failure, not the community.... Stipends accorded by the church do not indicate this worth, against the assumptions of a consumer-driven world."[82] There is also likely an indication here of the reward and punishment due ministers, which is (again) bestowed by God alone.[83] The REB rendering of verse 9, "We are fellow-workers in God's service," captures the sense in the wider passage that what is at stake for the Corinthians is peer-comparison and thus that ministers carry an equal status in their participation. Nonetheless, Paul's closing comment in verse 9 emphasises the nature of ministry as labour: "After all, we do share in God's work; *you are God's farm, God's building*" (NJB). There is good reason for the more generic use of "field" or "farm" here rather than "vineyard," as "the imagery carries with it the themes of (i) belonging to God; (ii) inviting growth and fruitfulness; (iii) needing the nurture and care of those who have been assigned to this task by the owner. The metaphor excludes self-sufficiency, mechanistic routinization, and stasis."[84] The Corinthian church is identified here by Paul as both the focal point of God's labours and a field from which some are plucked to be labourers.

These themes are recapitulated and intensified in the next image: God's building. Paul's content in this second image is more similar than the previous to its gospel parallel. As in Jesus' Parable of the Builders, Paul is principally speaking about the endurance of Christian ministry. Accordingly, Paul analogises his ministry in the language of craftsmanship: "By the grace of God which was given to me, I laid the foundations like a trained master-builder (*sophos architektōn*)." Though Paul may have laid the foundation (Christ), he is not the only builder working and so even when the work is handed on to an apprentice or a co-worker ("someone else is building on them"), "each one must be careful how he does the building" (v. 1 Cor 3:10, NJB).[85] One important element in this process of ministerial building is, according to Paul, a properly identified foundation. He points to the bedrock of "Jesus Christ" (3:11) upon which all, master-builders and lesser ones, must build. Shanor's analysis of Paul's self-identifying language of *architektōn* alongside other ANE literary parallels offers some illuminating context.[86] He confirms my suggestion that the material circumstances of the labour of building are relevant to understanding this

136 *Moral Making*

passage by Paul, observing, "the building or repair of a temple involved a number of individual builders, each under separate contract to complete a defined portion of the total project... the general supervision of day-to-day work fell to the *architektōn*."[87] Regarding the suitability of Temple-construction contracts as suitable for understanding Paul's language here, Shanor suggests, "To those who lived constantly in the shadow of both ancient and recently completed (or yet uncompleted) temples, the reference to a recognised class of temple-builders would have been absolutely clear."[88]

At 1 Cor 3:12, Paul's language takes on a decidedly eschatological tone, and, as I have demonstrated above with Jesus' language, it is important to observe that an eschatological meaning need not exclude a domestic one. The two can be, as is the case here, mutually informative. Thiselton argues that Paul's language in verse 12 is "apocalyptic epiphany: a universal disclosure in which all hitherto protective veils of ambiguity and hoping-for-the-best (or, equally, fearing-for-the-worst) are removed in a definitive, cosmic act in the public domain."[89] In this way, Paul's ambiguity about the outcome of hard work in ministry is not due to some intrinsic deficit within work itself, but rather because it has yet to be tested "by fire" as the day of judgement has not yet come.[90] The process of discerning building quality is, in both the eschatological and realistic senses, opaque and for similar reasons. Of further note for the task of this book is the fact that this eschatological fire [*pyr*] does not obliterate the work of the artisan but rather serves to reveal in an apocalyptic sense [*apokalyptō*] the purity of work. In this way, Paul's imagery of burning in this passage does not undermine but rather intensifies the force of his metaphor as drawn from labour. Inferior work, signified by "wood, hay, straw" (1 Cor 3:12), will perish at the last judgement, while superior work, signified by "gold, silver, precious stones" will μένω [*meno* = "abide" or "survive"].[91] Discernment, seen in this way, parallels the work of an artisan engaged in craft work, but this is subordinate to the eschatological context that undergirds Paul's message in 1 Cor Shanor affirms the reliability of this reading with regard to parallel GR literature:

> The strength of his [Paul's] appeal for quality rests upon his certainty that both the manner of approach to the work (*pos*) and the durability of the materials will be subjected to final examination. This again closely parallels the secular tradition, since final payment for nearly all public, private and sacred construction was withheld pending final inspection, i.e., until the commissioners and their approved inspector were satisfied that the work had been done according to the terms stated in the contract.[92]

Paul is specifically urging the Corinthians here to forego attempts to discern superior ministerial craftsmanship (gold) from inferior work (hay), as this

process of discernment can only be coherent at the completion of the building process (the last judgement) and consequently only open to judgement by God. What one finds in Paul's argument here is an account of craft strikingly resonant with the aesthetic outlined by Rowan Williams that I summarise in Chapter 3. Paul's desire is to refocus the energy of the Corinthians such that *they participate* as co-workers (and not audience members or mere critics) striving to produce superior work for which one can expect wages [*misthon* in 1 Cor 3:14] and by which the builder will "be saved" (1 Cor 3:15).

The third image, "God's Holy Shrine," is deployed by Paul in continuity with the preceding two images. As Thiselton relates, "*naos* denotes the temple building itself. Hence it carries forward the previous image, but in a specific way which narrows its focus to the issue of holiness and to God's sanctifying indwelling."[93] While it may be tempting to think of the introduction of language of "holiness" at this juncture as discontinuous with the more mundane circumstances and work of building from which Paul is drawing the metaphor in all three images, I would suggest that if one follows the trajectory of Paul's usage the conclusion is precisely the opposite. Here Paul's description of excellence in building as a metaphor for Christian community implicates the normal act of building in the Christian life. The very act of using manual work as material for a metaphor implicates it on a literal level in the same economy that Paul describes here. Paul confirms this in the wider contour of the epistle by using his suggestion, "For God's temple is holy, and you are that temple" (1 Cor 3:17), as a launchpad for the more specific later discussion of the ethics and conduct of the Corinthian church. In a sense continuous with the Hebrew materials surveyed above, the work that is the activity of a holy people is deployed by Paul in verses 16–17 as a driving force in the Christian ethical life. Because the Corinthian church community (and by extension the individual members) are consecrated as God's *naos*, "sinning against 'consecrated persons' who are corporately God's temple . . . defiles the joint sharing in the Spirit who consecrates the temple (*koinonia*)."[94]

With this examination of Paul's use of construction analogies in 1 Corinthians 3, I have drawn out the resonance between the presentations that have been examined here of priesthood, discipleship, and apostleship; and I have noted how each is understood through the lens of craft. Though one finds both continuity and change with regard to the relationship between work and priesthood in the Hebrew and Christian conception, there is a theologically construed agreement across the canonical text that worship and work exist in a mutually informing relationship. I have drawn attention to the ways in which both the call to ministry and subsequent worship by believers, draws in and implicates a moral account of work. Just as YHWH's call to the people of Israel to be his holy people implicates work and its products, so too Jesus' call to his disciples

and Paul's epistles use work as a metaphor for the task of ministry to which they are called.

There is an emphasis in 1 Corinthians on human participation in work that ultimately has divine agency, yet one finds a continued affirmation of the importance and coherence of individual human contributions set amidst what is a communal effort. As Lanci argues, "Paul encourages the Corinthians to understand themselves as people ... coming together with many different skills to construct a building which will serve as a Temple of God."[95] This cooperative vision of church-building work is described paradigmatically in Paul's statement: "I planted, Apollos watered, *but God gave the growth*. So neither the one who plants nor the one who waters is anything, *but only God who gives the growth*" (1 Cor 3:16–17).[96] This relativisation of individual contributions is accompanied by a relativisation of expectations with regard to outcomes. The process of discerning building quality is opaque and thus the ultimate act of judgement is reserved by Paul for God. Yet, as Paul suggests, one may still expect that the Corinthian community might be expected to – guided by the spirit – derive their judgements of this work. Discernment of craftsmanship in building is not discarded, but rather it is now seen through an eschatological lens and granted an intergenerational duration. Given all this emphasis on the building work of Jesus' disciples who join in his ministry, it makes sense to find Paul's argument in 1 Cor 3 situated within explicit Temple theology.

Several additional Pauline Temple texts recapitulate the themes that I have treated above, and also make clear that for Paul, the Christian task of Temple construction is a social or *ecclesial* task.[97] Even the personal tone granted by the "body" language in 1 Cor 3:16–17 and 6:19, is attended by exclusively plural second-person pronouns: "Do *you* not know that *you* are God's Temple and that God's Spirit dwells in *you*? If anyone destroys God's Temple, God will destroy him. For God's Temple is holy, and *you* are that Temple" (1 Cor 3:16–17). A similar appropriation of ecclesial Temple building can be found in Eph 2:19–22:

> So then you are no longer strangers and aliens, but you are fellow citizens with the saints and members of the household of God, built on the foundation of the apostles and prophets, Christ Jesus himself being the cornerstone, in whom the whole structure, being joined together, grows into a holy Temple in the Lord. In him you also are being built together into a dwelling place for God by the Spirit. (ESV)

Here also one finds a Temple that is not static but constantly growing.[98] As Beale describes it, this Temple is made for expansion, meant to concentrically expand to include the whole cosmos. The Greek term used to describe growth here *auxei* (in v. 21) carries a number of senses, as Günther relates: "The thought

here is not solely of numerical increase, but also of maturity and the consolidation of the community in Christ from which good works naturally grow."[99] This multilayered notion of growth is described using an agricultural analogy later in 2 Corinthians: "whoever sows sparingly will also reap sparingly, and whoever sows bountifully will also reap bountifully. . . . He who supplies seed to the sower and bread for food will supply and multiply your seed for sowing and increase the harvest of your righteousness. You will be enriched in every way to be generous in every way, which through us will produce thanksgiving to God" (2 Cor 9:6–11). Further, given this democratisation of worship and the grafting of Gentiles into worship at Israel's new Temple, in some sense, the task of Temple construction no longer has a readily perceptible terminus. Temple construction, at least on this side of the eschaton, has become an indefinitely ongoing project. Both the corporate and ecclesial aspects of this task of construction that I am describing here have clear resonances with my argument above that the work of Temple construction is an inherently social and democratic task. Further, church building in Paul's account is intertwined with moral theology. Here, particularly in Ephesians, we find an explicit defence of the idea that the act of constructing the "place for worship" is meant to be a morally formative task, tied to the increasing adornment of holiness as "the whole structure . . . grows into a holy Temple" (2:21), which is pneumatically sustained.

The building stones and foundations of this building, as described in Ephesians, connote that this new structure is a hybrid, drawing in both Jew and Gentile, prophets and apostles. The wider context behind the Temple text in Eph 2:19–22 also affirms this point, as the text is rich with the language of mutuality and reconciliation. Jew and Gentile are alike in being "dead in our trespasses" and in being "made . . . alive together with Christ" (v. 5). In verse 16, Paul goes on to suggest that Christ's redeeming work "might reconcile us both to God in one body through the cross." The consequence of this, as Peterson puts it, is that "new Temple imagery implies the renewal of worship for Israel as well as the inclusion of Gentiles in God's house."[100] It is important to avoid being unduly distracted from this basic premise by the much-contested description by Paul in verse 15 of the way in which Christ's work of peace abolishes *ton nomon tōn entolōn en dogmasin* ["the law with its commands and dogmas"]. What one finds here is an abolition of *whatever ordinances* [Gk: *dogma*] *served to create hostility and undermine Christ's reconciling work of peace between Jew and Gentile*.[101] It is important to understand how Paul's description of abolition is subordinate to the broader purpose he is describing here, as one could construe (wrongly, I think) Paul's ethic here as being accommodationist. Keeping in mind the Temple imagery, it seems more appropriate to assume that he means for the reader to focus not on the pursuit of the experience of peace, but rather on the conditions for reconciliation, which are – in the sense of Temple theology – eschatological.

To this end, Peterson argues that the church as described in Ephesians is to be viewed eschatologically, "as already existing in Christ but moving towards the final revelation and enjoyment of what is now true through faith in him."[102] What one finds here, then, is an account of ecclesiality that is inflected by an eschatological vision. As I have argued above, the purpose of eschatology considered within the context of the theology of work is not to provide a context for inclusion that can function as a therapeutic balm.[103] Indeed, the purpose is far richer. Human work can be motivated and shaped by a vision for the future, but this vision for the future is not unmediated. Instead, it is the very act of becoming "fellow citizens with the saints and members of the household of God" (as Paul suggests in Eph 2:19) who worship together "addressing one another in psalms and hymns and spiritual songs, singing and making melody to the Lord with your heart" (Eph 5:19) that persons can deploy this future vision and find it comprehensible.[104] This moral vision that I have explicated with regard to its purchase on the work of the people, is sustained through this hybrid ecclesial community. In this way my argument – that Temple and church "construction" portray a form of work that is inherently a social and egalitarian task, invoking the work of the Spirit and remaining contingent upon the agency of the Creator God – is not a freestanding moral account, rather it is embedded and sustained in an ecclesial place. There is, then, a particular and essential relationship between the moral vision of work portrayed in Christian Scripture and the act of worship. On this basis, I turn now in Part II of this study to examine the specific content of the practices of worship in seeking a doxological point of synthesis for this moral vision.

Notes

1 N. T. Wright, *New Testament and the People of God*, Christian Origins and the Question of God (Minneapolis, MN: Fortress Press, 1992), 224.
2 For a survey of anti-Temple movements and their relation to the New Testament, see Nicholas Perrin, *Jesus the Temple* (Grand Rapids, MI: Baker Academic, 2010).
3 Cf. Josephus, *Antiquities*, 15.380–425 and Wright, *New Testament and the People of God*, 225–6.
4 Though Luke does not provide a direct parallel in his narrative, there is an implicit relation between these texts and Jesus' comment in Luke 21:5–36.
5 Donald A. Hagner, *Matthew 14–28*, WBC 33a (Dallas, TX: Word Books, 1995), 799.
6 Chris Rowland, "The Temple in the New Testament," in Day (ed.), *Temple and Worship in Biblical Israel*, 470. For an alternate perspective and engagement with contemporary NT scholarship on the meaning of this pericope, see N. T. Wright, *Jesus and the Victory of God*, Christian Origins and the Question of God (Minneapolis, MN: Fortress Press, 1996), 405–28 particularly 413–15.
7 E. P. Sanders, *Jesus and Judaism* (Philadelphia, PA: Fortress Press, 1985), 71. Cited in Wright, *Jesus and the Victory of God*, 425.

8 Wright, *Jesus and the Victory of God*, 426.
9 Wright, *Jesus and the Victory of God*, 426. In a footnote to this statement, Wright observes: "Hence, the early Christians went on worshipping in the Temple (e.g., Luke 24:45)."
10 Of particular relevance is the middle-Platonist Plutarch, who was alive at the same time as the Apostles (c. 46–120 CE). See note 13 on page 141 below. See also the earlier writers including Plato, *Resp.* 495e; Xenophon, *Oec.* 4.2; Aristotle, *Pol.* 8.2, 1337b; Cicero, *Off.* 1.42; Dionysius of Halicarnassus, *Roman Antiquities*, 9.25; Livy, 8.20.3.
11 Xenophon, *Oec.* 4.2. Cf. the parallel text in Plato, *Resp.* 495e and Xen. *Oec.* 6.5. Aristotle also makes almost exactly the same point in *Pol.* 8.2, 1337b.
12 Plato, *Phdr.* 248a–e.
13 Plutarch, *Pericles*, 1.4, 2.1–2. For this lumping together of craft and art under "productive arts," see also Aristotle, *Metaphysics*, 11.7, 1064a.
14 Plato, *Gorgias*, 491a.
15 Cf. Lev 26:1, 26:30; Jdt 8:18; Wis 14:8; Isa 2:18, 10:11, 16:12, 19:1, 21:9, 31:7, 46:6; Dan 5:4, 5:23, 6:28. The Greek most often is a rendering of the Hebrew term אליל ("idol"), cf. *TDNT* 9:436. For instances in patristic Greek, see *LPGL*, 280, 1522.
16 This is also the case for pseudepigraphal literature. We find instances of χειροποίητος, cf. *Sib. Or.* 3:606, 3:618, 3:722, 4:28, 14:62, 23:29; *Liv. Pro.* 2:7, but not ἀχειροποίητος.
17 Cf. *LSJ*, 1985. See also *TDNT* 9:436.
18 Wright, *Jesus and the Victory of God*, 418.
19 Wright, *Jesus and the Victory of God*, 418.
20 Rowland, "The Temple in the New Testament," 470.
21 Rowland, "The Temple in the New Testament," 474.
22 Translation from J. B. Lightfoot and J. R. Harmer (eds and trans), *The Apostolic Fathers: Greek Texts and English Translations of Their Writings*, 3rd edn, ed. and rev. Michael W. Holmes (Grand Rapids, MI: Baker Academic, 2007).
23 Oliver O'Donovan raises precisely this point, specifically with regard to the *Epistle of Barnabas*, in *The Desire of the Nations: Rediscovering the Roots of Political Theology* (Cambridge: Cambridge University Press, 1996), 130–1.
24 This point is made well in O'Donovan, *Desire of the Nations*, 144–6, 161. See also Douglas Farrow, *Ascension and Ecclesia: On the Significance of the Doctrine of the Ascension for Ecclesiology and Christian Cosmology* (Grand Rapids, MI: Eerdmans, 1999). An appreciation of ascension is also significant in Luke Bretherton's *Hospitality as Holiness*.
25 Rowland, "The Temple in the New Testament," 475.
26 Rowland, "The Temple in the New Testament," 477. N. T. Wright agrees with this position, arguing that there is a link with Jesus' quotation of Hosea 6:6 – see Wright, *Jesus and the Victory of God*, 426.
27 For a summary of the significant number of allusions between Revelation and Exodus, see Gregory K. Beale, *The Temple and the Church's Mission: A Biblical Theology of the Dwelling Place of God* (Downers Grove, IL: InterVarsity Press, 2004).
28 Beale, *The Temple and the Church's Mission*, 371.
29 Volf, *Work in the Spirit*, 93.
30 John Howard Yoder, *The Original Revolution* (Scottdale, PA: Herald Press, 1971), 173.

142 *Moral Making*

31 Edwin Jackson Wood, "The Social World of the Ancient Craftsmen as a Model for Understanding Paul's Mission," PhD Diss., Southwestern Baptist Theological Seminary (1995), 162–3.
32 John 5:17. The physical toll of Jesus' ministry is further implied in John 4:6.
33 Mark 10:45.
34 Luke 10:2.
35 Oded Borowski, *Agriculture in Iron Age Israel* (Winona Lake, IN: Eisenbrauns, 1987), 61.
36 Cf. Isa 18:4; Prov 26:1; Ruth 2:9. Further examination of agricultural metaphors and similes can be found in Ferdinand Deist, *The Material Culture of the Bible: An Introduction*, ed. Robert P. Carroll (Sheffield: Sheffield Academic Press, 2000), 153–5.
37 Instruction in letter-writing made by the royal scribe Nebmare-nakht. See Miriam Lichtheim, *Ancient Egyptian Literature: Volume 2* (Berkeley, CA: University of California Press, 2006), 170.
38 Borowski, *Agriculture in Iron Age Israel*, 62.
39 Cf. Jer 23:28; Joel 2:24.
40 Joseph A. Fitzmyer, *The Gospel According to Luke 10–24: Introduction, Translation, and Notes*, AYB 28b (New Haven, CT; London: Yale University Press, 1985), 846.
41 It is also noteworthy that the synoptic parallel for this text in Luke is Mark 6:7–11, the third of the three significant call narratives in Mark (1:16–20; 3:13–19; 6:7–13); the first, in Chapter 1, is analysed above.
42 Luke 10:7, NJB.
43 Teresa Okure, *The Johannine Approach to Mission: A Contextual Study of John 4:1–42* (Tubingen: Mohr-Siebeck, 1988), 164. Cited in Charles H. Talbert, *Reading John: A Literary and Theological Commentary on the Fourth Gospel and the Johannine Epistles* (Macon, GA: Smyth & Helwys Publishing, 2005), 123.
44 George R. Beasley-Murray, *John*, 2nd edn, WBC 36 (Waco, TX: Word Books, 1987), 63.
45 Cf. Talbert, *Reading John*, 123.
46 Raymond E. Brown, *The Gospel According to John 1–12*, AYB 29a (New Haven, CT; London: Yale University Press, 1995), 168.
47 Ps 126:5–6.
48 Brown, *The Gospel According to John 1–12*, 168.
49 J. Ramsey Michaels, *John*, NIBC, ed. W. Ward Gasque (Peabody, MA: Hendrickson Publishers, 1989), 74. Cf. John 2:1–11. See above also for my fuller treatment of this theme in Luke.
50 For a helpful elaboration on the meaning of this passage, see Douglas K. Stuart, *Hosea–Jonah*, WBC 31 (Dallas, TX: Word Publishing, 1989), 398–9.
51 Leon Morris, *The Gospel According to John*, NICNT (Grand Rapids, MI: Eerdmans, 1995), 245.
52 Deut 8:3 is mentioned directly in both Matt 4:4 and Luke 4:4 (see also 12:29–30).
53 Ernst Haenchen, *John: A Commentary on the Gospel of John*, ed. Ulrich Busse and Robert Walter Funk, trans. Robert Walter Funk, Hermenaeia (Philadelphia, PA: Fortress Press, 1984), 259.
54 Luke 6:47–8a. Cf. Matt 7:24–6.
55 Ibn al-Tayyib, *Tafsir al-Mashriqi*, ed. Yusif Manqariyos, 2 vols (Egypt: Al-Tawfiq Press, 1907), 2:118, cited in Kenneth E. Bailey, *Jesus through Middle Eastern Eyes: Cultural Studies in the Gospels* (Downers Grove, IL: InterVarsity Press, 2008), 323.

56 Bailey, *Jesus through Middle Eastern Eyes*, 323.
57 Bailey, *Jesus through Middle Eastern Eyes*, 323–4.
58 Bailey, *Jesus through Middle Eastern Eyes*, 323.
59 This interpretation is reaffirmed with similar use of building as a metaphor for ministry in Matt 21:28 and 25:16.
60 The literal Greek phrase "ἐργαζόμενοι τὴν ἀνομίαν" [*ergazomenoi tēn anomian*], is translated opaquely as "evildoers" in the NRSV. See also Matt 13:27 and the "two masters" that are served in Luke 16:13.
61 See Geoghegan, *The Attitude towards Labor*, for an extended survey; and also my article on "Labour," in Pollmann and Otten (eds), *The Oxford Guide to the Historical Reception of Augustine*, 3:1268–73.
62 Todd D. Still, "Did Paul Loathe Manual Labor? Revisiting the Work of Ronald F. Hock on the Apostle's Tentmaking and Social Class," *Journal of Biblical Literature* 125, no. 4 (2006): 781–95. For other summaries of this consensus, see also Justin J. Meggitt, *Paul, Poverty and Survival*, Studies of the New Testament and its World (Edinburgh: T&T Clark, 1998), 75–7, and Anthony C. Thiselton, *The First Epistle to the Corinthians: A Commentary on the Greek Text*, NIGTC (Grand Rapids, MI: Eerdmans, 2000), 23. Major scholarly disagreements include: (1) the precise materials with which Paul made tents and thus the nature of his work, given the sparse attestation of "*skēnopoioi*" – as with the title given to Jesus' vocation, "*tektōn*" – and historical distance from the practice of these occupations, see Holger Szesnat, "What Did the Skēnopoios Paul Produce?," *Neotestamentica* 27 (1993): 391–402, and Still, "Did Paul Loathe Manual Labor?," 781, in addition to Wood, "The Social World of the Ancient Craftsmen as a Model for Understanding Paul's Mission," 117–24 for a summary of relevant studies; (2) Paul's attitude towards the status of his own work, see Still, Wood, *contra* Ronald F. Hock, *The Social Context of Paul's Ministry: Tentmaking and Apostleship* (Philadelphia, PA: Fortress Press, 1980); (3) Paul's social status, see John Barclay, "Poverty in Pauline Studies: A Response to Steven Friesen," *Journal for the Study of the New Testament* 26, no. 3 (2004): 363–6, also Hock, *The Social Context of Paul's Ministry*, *contra* Steven J. Friesen, "Poverty in Pauline Studies: Beyond the So-called New Consensus," *Journal for the Study of the New Testament* 26, no. 3 (2004): 323–61, and Meggitt, *Paul, Poverty and Survival*; and (4) when/where Paul learned and took up his trade, see Still, "Did Paul Loathe Manual Labor?," 785, for a summary of the options. It is interesting to note that Chrysostom's reading of this passage was that Paul made tents from animal hides, cf. *Hom. 1 Cor.* 5.5.
63 Acts 18:2–3. Accordingly, Luke mentions Paul as having worked both in Corinth and Ephesus.
64 Thiselton, *The First Epistle to the Corinthians*, 23.
65 Thess 4:10–12, 2 Thess 3:7–12, also suggested in 1 Cor 9:15–18 and indirectly in Eph 4:28. See also the mention of Barnabas engaging in the same practice in 1 Cor 9:6.
66 Thiselton, *The First Epistle to the Corinthians*, 24, citing Stephen M. Pogoloff, *Logos and Sophia: The Rhetorical Situation of 1 Corinthians*, SBL Dissertation Series 134 (Atlanta, GA: Scholars Press, 1992), 191 and 203.
67 Thiselton, *The First Epistle to the Corinthians*, 13.
68 This theme of status inconsistency is developed at some length by Thiselton in his commentary on 1 Corinthians. See Thiselton, *The First Epistle to the Corinthians*, 40; also Dale B. Martin, "Tongues of Angels and Other Status Indicators," *Journal of the American Academy of Religion* 59, no. 3 (1991): 547–89.

69 Ronald F. Hock, "The Workshop as a Social Setting for Paul's Missionary Preaching," *Catholic Biblical Quarterly* 41, no. 3 (1979): 438–50.
70 Wood, "The Social World of the Ancient Craftsmen as a Model for Understanding Paul's Mission," 141ff.
71 Hock, "The Workshop as a Social Setting for Paul's Missionary Preaching," 449–50. See also Hock, *The Social Context of Paul's Ministry*, 60–2, for a fuller description of the physical conditions of this workshop.
72 Hock, *The Social Context of Paul's Ministry*, 32.
73 Hock, *The Social Context of Paul's Ministry*, 32.
74 Hock, *The Social Context of Paul's Ministry*, 32.
75 Cf. Thiselton, *The First Epistle to the Corinthians*, 296.
76 Thiselton, *The First Epistle to the Corinthians*, 252.
77 These images are explicitly referenced in verses 9 and 16 respectively. Thiselton, *The First Epistle to the Corinthians*, 295, 147ff.
78 *Emphasis* mine.
79 I have purposefully chosen the opaque use of pronouns in the NJB as this seems a helpful rendering of the ambiguity in Paul's Greek here.
80 Thiselton, *The First Epistle to the Corinthians*, 303. Cf. Paul's recapitulation of this relativising theme in the well-known body metaphor in 1 Cor 12.
81 See also the parable in Matt 20:1–16, though it is worth noting that wages are relativised in a different way in this passage.
82 Thiselton, *The First Epistle to the Corinthians*, 304.
83 See esp. David Kuck, "Paul and Pastoral Ambition: A Reflection on 1 Cor 3–4," *Currents in the Theology of Missions* 19 (1992): 174–83. Kuck identifies several instances of eschatological "rewards" in the NT: Matt 5:12, 6:1, 10:41–2; Mark 9:41; Luke 6:35; Rev 11:18, 22:12.
84 Thiselton, *The First Epistle to the Corinthians*, 306.
85 Wood provides some reflection on the possible range of meanings associated with Paul's use of companion language indigenous to the crafts and trades of his day, including "synergos" in "The Social World of the Ancient Craftsmen as a Model for Understanding Paul's Mission," 165–70.
86 Jay Shanor, "Paul as Master Builder: Construction Terms in First Corinthians," *New Testament Studies* 34, no. 3 (1988): 461–71.
87 Shanor, "Paul as Master Builder," 465.
88 Shanor, "Paul as Master Builder," 466.
89 Thiselton, *The First Epistle to the Corinthians*, 312.
90 Thiselton, *The First Epistle to the Corinthians*, 312.
91 I read this analogy with Thiselton, Shanor, and Gale as a "broad image" and not a "point-by-point allegory." See Thiselton, *The First Epistle to the Corinthians*, 308, 312; Shanor, "Paul as Master Builder," 466–8; Herbert M. Gale, *The Use of Analogy in the Letters of Paul* (Philadelphia, PA: Westminster John Knox Press, 1964), 79–90.
92 Shanor, "Paul as Master Builder," 468.
93 Thiselton, *The First Epistle to the Corinthians*, 314.
94 Thiselton, *The First Epistle to the Corinthians*, 315.
95 John R. Lanci, *A New Temple for Corinth: Rhetorical and Archaeological Approaches to Pauline Imagery* (New York, NY: P. Lang, 1997), 60.
96 *Emphasis* mine.

97 This conclusion is defended at length with regard to the Corinthian correspondence in Lanci, *A New Temple for Corinth*.
98 This theme is developed extensively across Scripture by Beale in *The Temple and the Church's Mission*.
99 "αὔξω," *NIDNTT*, 2:129.
100 David Peterson, "The New Temple: Christology and Ecclesiology in Ephesians and 1 Peter," in T. Desmond Alexander and Simon Gathercole (eds), *Heaven on Earth* (Waynesboro, GA: Paternoster Press, 2004), 170.
101 For an extended survey of the various options for "fence" and "ordinances," see Ernest Best, *A Critical and Exegetical Commentary on Ephesians* (Edinburgh: T&T Clark International, 1998), 250–69. See also Markus Barth, *Ephesians*, AYB 34 (New York, NY: Doubleday, 1974), 283–91. The argument here also resonates with Paul's argument in Rom 3:31.
102 Peterson, "The New Temple," 172.
103 See Chapter 3, "Is Eschatology the Appropriate Site for a Theology of Work?"
104 It is, as Bernd Wannenwetsch suggests, in worship that "the congregation experiences the reconciliation of antitheses which had hitherto been deemed irreconcilable." Bernd Wannenwetsch, *Political Worship: Ethics for Christian Citizens* (Oxford: Oxford University Press, 2004), 146.

Part II
Moral Maintenance
Sustaining Work Ethics in Christian Worship

Introduction to Part II

In her recent volume on the theology of work, Esther Reed argues, "the meaning and ethics of work is learned, at least in part, from the Church's practice of worship."[1] I am highly sympathetic to Reed's argument; and in the chapters that follow I take up an exegetical line of inquiry that complements her attempt to trace connections between well-practised contemporary liturgy *and* good work. Indeed, one may hope that authentic contemporary worship practice and the exegesis of Scriptural instruction regarding worship might both be brought cooperatively to bear on the human moral life. In this sense, these three domains (exegesis of worship texts, interpretation of the experience of worship, and the form of our work) might be seen as complementary. Of course, in practice this is often not the case: worship practice can seem perfunctory rather than vital, and habit-led rather than habit-shaping; biblical worship texts can seem too remote from contemporary practice to be relevant; and work may seem most of all to be something quite distant from worship.

In attempting to stitch these three back together in Part II of this book, I follow a trajectory that arose from my exegesis in Part I: turning from Tabernacle to Eucharist. Of course, attempting an excavation of this kind with all the biblical precursors and expositions of Eucharistic practice would exceed the scope of this study by many volumes. With this in mind, I shall focus my inquiry more narrowly towards the ethics that lie latently in one component of Eucharistic practice, the offertory rite. In explaining the justification for this choice, I would suggest that offertory may well be the most diminished aspect of contemporary Eucharistic practice. A brief example will serve to demonstrate my point. In my own weekly worship, drawn from the Scottish Episcopal prayerbook, the congregation speaks the words, "we bring these gifts."[2] Yet an attentive outsider observing might find this claim to be somewhat incongruous. What exactly have those gathered in the place of worship brought? In practice, the offertory overlaps with the presentation of the table (where the bread and wine are prepared for serving) in many liturgies and so this reference to what "we bring" may be taken to refer to the monetary offerings made by

the congregants *or* the presentation of bread and wine. Yet there is a problem with either of these instances. In the first, many parishes now encourage those few members who do bring tithes to do so electronically by direct debit in order to ease the tasks of bookkeeping and administration. The offering plate passes along empty, while banks facilitate an electronic transfer of digitally recorded currency at a precise and regular interval. Practised in this way, the "bringing" of money seems to widen the distance in the liturgy between what is spoken and what is happening materially. Can one really be said to "bring" such a thing? One problem raised by contemporary economists, particularly those following the economic historian Karl Polanyi, relates to the way in which the monetisation of value and wealth serve to cut human transactions loose from material or bioregional contexts in which they might otherwise be embedded. Further, such a mode of bringing (i.e., the electronic transaction) involves so little phenomenally perceptible personal investment, that it stretches the limits of the meaning of the word "gift." One might say that they have brought some things, or some money, but certainly not a gift. In the latter case, where "gifts" might be taken as a reference to bread and wine, the experience stretches reality still further. Except in rare circumstances, no one will have brought bread or wine that they themselves have made, and even if a parish might be so lucky as to have a dedicated baker and vintner, it is unlikely (indeed almost ecologically impossible in the case of grapes) that these people would have grown the grain or grapes themselves. This incongruity between the language of "gift" and the things being presented is exacerbated with the intensified material sensibility carried by the 1975 and 2000 Roman Catholic liturgies and the Anglican *Common Worship* (which follows the former closely on offertory language). At the presentation of the gifts, the priest says, "Through your goodness we have this bread to offer, *which earth has given and human hands have made*. It will become for us the bread of life.... Through your goodness we have this wine to offer, fruit of the vine *and work of human hands*. It will become our spiritual drink."[3] Yet, once one becomes acquainted with the practices by which the bread and wine have been manufactured, it may be more difficult to proclaim them "good." As Michael Northcott notes, the modern loaf of bread stands as a profound example of "industrial food's fossil-fuel dependence" because it is enmeshed in a system of production that produces massive pollution and waste and expends an extraordinary amount of fossil fuels.[4] Extending this critique, in his work-manifesto *Shaping Things*, Bruce Sterling notes how the modern bottle of wine has been technologically rendered such that it is a "gizmo":

> Socrates (who was a Hunter-Farmer from a world of Artifacts) was drinking local wine from a Greek vineyard in a handmade clay krater.... I am

drinking from a machine-labeled, mass-produced bottle of industrial glass, with a barcode and legalistic health warnings, which exists in many hundreds of identical copies, and was shipped from Italy to California and offered for sale in a vast supermarket. And yes, this bottle of wine has a Webpage.[5]

The collusion of these two once-basic foodstuffs in industrial and technological forms of making can hardly be overstated. However, contemporary liturgical practice often carries little formal recognition of these quandaries. In particular, it is difficult to know whether "the good of all his Church" is served by the processes by which wine and bread are now made.

A final possibility is that the gift that has been brought is the body of those worshipping: congregants bring their bodies and make a spiritual sacrifice following the pattern of Christ's self-sacrifice on behalf of the whole creation. The Scottish prayer book to which I refer above actually suggests this very scenario explicitly in some of the Eucharistic prayers (I and V), by the corporate statement, "we bring ourselves."[6] In contrast to those options I outlined earlier, this final suggestion seems at least plausible in the midst of contemporary practice, as worshippers have (perhaps) a greater control over the collusion of their own bodies in acts of pollution and extrication. Yet I have saved this most obvious possibility for last, as, seen in light of these other denied possibilities of meaning, the affirmation of an exclusively spiritual offering relies upon a troubling dichotomisation of personal and material investment in the liturgy and a sad reduction of the liturgy to a mere monetary collection.

In contrast, as I go on to argue here, Christian Scripture narrates a dynamic complex of offertory liturgies. In the chapters that follow, I revisit the themes I have developed in the previous chapters in light of those practices that are prescribed in Christian Scripture.[7] The critical concern that occupies the latter half of this book regards the way in which the work of the people is drawn in by their worship and given moral coherence. As I argue, the Hebrew Scriptures portray a rich tradition that was taken up in creative and compelling ways by the early Christian writers, standing as an indictment of contemporary practice in which work and worship are left unrelated in so many ways.

Before I begin the task of close study of offertory instructions in the Hebrew Scriptures, one may ask why this Jewish account of offertory has not had a more substantial influence on contemporary worship practice. In seeking to explain the possible cause of this dramatic attenuation of "Jewish" offertory towards the more materially thin practices in contemporary worship and theology, a number of contemporary scholars, including John Milbank, argue that the continued influence of modern structuralist models of sacrifice have had a narrowing influence on the modern study of religion and biblical-critical study. Along

these lines, Detienne and Vernant offer a forceful critique of the naive structuralism driving contemporary models of "sacrifice":

> Today ... it seems important to say that the notion of sacrifice is indeed a category of the thought of yesterday, conceived of as arbitrarily as totemism – decried earlier by Levi-Strauss – both because it gathers into one artificial type elements taken from here and there in the symbolic fabric of societies and because it reveals the surprising power of annexation that Christianity still subtly exercises on the thought of these historians and sociologists who were convinced they were inventing a new science.[8]

As Milbank argues, there are also reasons for theologians – in seeking a way to best explain the theological coherence of the rituals described in the Hebrew Scriptures – to distance themselves from this popular trope of "sacrifice." If we dispel the social-scientific fog, Milbank suggests, sacrifice no longer seems the most fitting metaphor to describe what one finds in a specific reading of Christian Scripture. Instead, the structural accounts offered by sacrifice theorists such as René Girard and Georges Bataille abandon the "radical specificity of a Jewish/Christian construal of sacrifice."[9] At their core, Milbank argues, these accounts of sacrifice convey an ironically limited asceticism rather than "a genuine religious sacrifice of everything for the sake of its return (repetition, mimesis) as same but different."[10] In response, Milbank argues that a more appropriate conceptual frame for this discussion is that of gift. In my exegesis, I follow this helpful refocusing around "gift," though I maintain use of the more liturgically specific term "offering" in seeking a way out of the modern Marcionism that too often pits Old Testament "sacrifice" against NT "freedom." The exegesis is structured (but not limited to) a reading of the offerings detailed in the first three chapters of Leviticus. By letting that ancient liturgical guide stand as our structuring medium, I mean to demonstrate how this liturgical system nurtured a far more comprehensive notion of offertory and, in turn, sustained a more robust liturgical politics than many modern readers have supposed.

Having noted my suspicion of modern positivism, there is a second and perhaps deeper problem to be addressed here. This is, as I have already noted at the outset, the disassociation of *sign* from *reality*, or – to borrow a title from John Milbank – a liturgical "[t]heology without substance." In one resonant account, media theorist Jean Baudrillard argues that communication that lives on in spite of being severed from its material referent is not merely benignly confusing but in fact profoundly destructive. In *The Mirror of Production*, Baudrillard argues that signs, detached from any real material referent, may take on their own political economy wherein this "age of signs" resembles the monetised abstraction that is a consequence of capitalism.[11] In introducing the content of this chapter,

I want to raise the question as to whether contemporary offertory liturgies risk functioning in a similar "age of signs," such that they collude with rather than challenge or illuminate contemporary capitalist narratives. Perhaps worse still, it may be that contemporary offertory and tithing practice is so theologically thin that the practice reifies the contemporary denial of the non-human material world that goes on outside cathedrals and churches by abstracting value, meaning, and agency from its embedding in the world.[12] In this case, tithing in its present form is not Christian, but rather has assimilated the logic and practices of the competing liturgy of market capitalism. What little vestiges might have remained of ancient practices in tithing, have been traded for an invisible transaction with no material content or referent. It is my hope that a closer, theologically attentive look at the descriptions of offerings in Hebrew and Christian Scripture may offer a theologically thick affirmation of good work and true value in the material order.

Finally, it is important to note that I do not think that the moral account of work that I elucidate in the preceding chapters can function in a freestanding way. In other words, I do not mean to extract the "moral logic" contained in these texts so that these extracted insights can be appropriated in a secular context. As I have already hinted above, Christian Scripture seems to command an account of "holy work" that is mediated through theologically peculiar and ecclesially structured worship. It is my contention that the most morally robust appreciation of the holiness of things and the work that produces them is enabled not (at least primarily) by an unmediated personal contemplation of beauty or the goodness of "ideas in things" (to quote the American poet William Carlos Williams), but rather by their entanglement in a very concrete act of worship. This entanglement of the ordinary in the exceptional moments and acts of worship grants one's apprehension a particular moral shape and a template that may grant moral coherence to work *within* this activity of worship. In this way, the crucial question is not merely about how much money or even what sorts of things we bring, but about how the specific practices that go on in Christian worship might carry forward into our daily work. This hope that worship might provide paradigms and practices for the work we do "outside the Temple" provides the impetus for my discussion in Part II of this book of "moral maintenance."

Before I proceed, some final comments are in order regarding the way in which I intend to construe the relationship between worship practice and Christian Scripture. After all, a problem faces any scholar who hopes to find an uninterrupted narrative of practice in Christian Scripture, since, in contrast to the richly detailed liturgies presented in the Hebrew Scriptures, the NT references to practices are terse, lacking the same detailed level of ritual instruction. This problem was highlighted with a particular intensity when early Protestant

scholastic theologians attempted to constrain worship practice to explicit biblical instruction, a practice that was formalised as the so-called "regulative principle." Yet, centuries after the altars had been "stripped" (to quote Eamon Duffy's famous study of Protestant iconoclasm), the regulative principle shows signs of abandonment by all but the most determined Protestant theologians.[13] I would argue that what is called for is a more dynamic account of the relationship between worship and the reading of Scripture than a reductive expression such as the "regulative principle." One such dynamic attempt has been offered in Bernd Wannenwetsch's account of Political Worship, where he suggests, "canon is to worship as a grammar is to a form of life. In both cases the *telos* of the first is at home in the second."[14] In Wannenwetsch's account, as I have hinted with reference to Esther Reed's work at the start of this section, the moral life emerges out of an "interaction" between the two: "ethics has its foundation neither in worship nor in the canon, but it begins in the relation between canon and worship perceived in the interaction of the two: in political worship."[15] In Part I of this book, I illuminated the *telos* that Christian Scripture narrates for moral work. It remains now to demonstrate how this *telos* is taken up in Christian worship. To this end, I shall seek to account for some of the interaction that has occurred between Scripture and practice in early Christian practice. Against the tragically limited expression that one often finds with contemporary tithes and offerings, both Christian Scripture and the Tradition of the Church offer a rich tapestry in which work is woven into worship in specific and substantial ways. In the three chapters that follow, I shall explore how Christian Scripture preserves a rich account of offertory practice and how those various strands have been taken up over the ages. Keeping in mind that the living tradition of Christian worship carries the same precious fragility as the craft wisdom that Bernard Leach worried over, I offer these examples as a limited exhibition of possibilities through which contemporary Christians may begin the work of drawing work back into worship, mending this moral tapestry.

I shall take up the three offerings described in Leviticus 1–3 as a trope to organise my analysis of offertory practice narrated in Christian Scripture. My study will not be limited to analysis of these three chapters of Leviticus and I do not mean to falsely reify the offertory categories described there. Instead, as this survey will reveal, the various offerings described in the Hebrew bible overlap and combine in a variety of ways. I shall rely upon the description of the three offerings described there, specifically the "burnt offering," the "cereal offering," and the "peace offering," as a trope that may draw out more specific details emerging from the dynamic I am arguing for here, in which work is "drawn into" worship. Thus each of these three offerings proves suggestive in a different way for contemporary offertory practice. The burnt offering draws in work and relativises its economic measurement (or productivity); the firstfruits

offering (a specific example of the cereal offering I shall highlight) provides a way of affirming excellence and quality in drawing in a specific portion of the work of the people; and finally, the peace offering draws the work of the people into an unavoidably social and festal context. All three offerings also highlight the various aspects of "good work" I have developed above, including agency, sociality, and wisdom, and I shall engage with NT texts and practices in the pre-modern church that resonate with this liturgical "drawing in" of the work of Israel. What this investigation reveals, I hope, is that, when the three offerings are taken as a whole, one finds a form of worship expressed (or in some cases prepared for) in Christian Scripture that can challenge the pragmatism of contemporary offertory practice; and this in turn can offer a theologically rich mechanism for the implication of the work of the people of God in their worship.

Notes

1 Esther Reed, *Good Work: Christian Ethics in the Workplace* (Waco, TX: Baylor University Press, 2010), 35.
2 In the Anglican rite (2000), the "Prayers at the Preparation of the Table" are a mixture of references to Eucharistic elements (prayers 4–7, some of which make explicit reference to "good" agriculture) and monetary offerings (prayers 2–3). Invitation to communion includes the blessing of the elements, with, "God's holy gifts for God's holy people." The 1669 Book of Common Prayer offertory and preparation have little verbal acknowledgement of the bread and wine – a number of biblical texts are recited while a basin is passed, and then the priest says, "We humbly beseech thee most mercifully to accept our alms and oblations."
3 *Emphasis* mine. The Anglican rite (2000) has a very similar phrasing: "Blessed are you, Lord God of all creation: through your goodness we have this bread to set before you, which earth has given and human hands have made. It will become for us the bread of life." The Roman Catholic Order of Mass 2010 has been modified slightly from the 1973 Missal, using, "for through your goodness we have received the bread we offer you: fruit of the earth and work of human hands, it will become for us the bread of life." The 1973 Missal has, "through your goodness we have this bread to offer, which earth has given and human hands have made. It will become the bread of life."
4 Northcott, *Moral Climate*, 245–6.
5 Bruce Sterling, *Shaping Things* (Cambridge, MA: MIT Press, 2005), 15–16.
6 The same meaning comes through in the Roman rite. Benedict XVI emphasises this point in *Sacramentum Caritatis*: "This humble and simple gesture is actually very significant: in the bread and wine that we bring to the altar, all creation is taken up by Christ the Redeemer to be transformed and presented to the Father" (47, 2007).
7 This has been undertaken, for example, in recent work by Esther Reed. In Reed, *Good Work*, Chapter 3, "Resurrection and Liturgical Moral Reasoning," Reed traces the moral inflection of specific Eucharistic acts.
8 Marcel Detienne and Jean Pierre Vernant, *The Cuisine of Sacrifice among the Greeks* (Chicago, IL: University of Chicago Press, 1989), 20. See also Jean Soler,

"Sémiotique de la Nourriture dans la Bible," *Annales Histoire, Sciences Sociales* 28, no. 4 (1973): 943–55.

9 John Milbank, "Stories of Sacrifice: From Wellhausen to Girard," *Theory, Culture & Society* 12, no. 4 (1995): 40.

10 "Stories of Sacrifice," 41. Milbank's polemic here is targeted particularly at moral accounts that emphasise absolute self-sacrifice, as he notes in his "The Midwinter Sacrifice: A Sequel to 'Can Morality Be Christian?,'" *Studies in Christian Ethics* 10, no. 2 (1997): 13–38. See also John Milbank, "The Ethics of Self-Sacrifice," *First Things: A Monthly Journal of Religion & Public Life* 91 (1999): 33–8.

11 Jean Baudrillard, *Jean Baudrillard: Selected Writings*, ed. Mark Poster (Cambridge: Polity, 2001).

12 Regarding cash as abstractive and disembedding, see Northcott, *The Environment and Christian Ethics*, 77–85. See also Anthony Giddens, *The Consequences of Modernity* (Stanford, CA: Stanford University Press, 1990) and Georg Simmel, *The Philosophy of Money* (New York, NY: Routledge, 2004).

13 For a survey of recent Protestant approaches to "biblical worship," see Michael A. Farley, "What is "Biblical" Worship? Biblical Hermeneutics and Evangelical Theologies of Worship," *Journal of the Evangelical Theological Society* 51, no. 3 (2008): 591–613.

14 Wannenwetsch, *Political Worship*, 35.

15 Wannenwetsch, *Political Worship*, 36.

5 Burnt Offerings
Challenging Modern Work Efficiency

There is perhaps no act of Christian worship that is stranger to the modern context than the burnt offering. As I shall argue below, such a brazenly inefficient act poses a direct challenge to a number of aspects of modern work, particularly to the modern attempt to exert absolute control over the processes and outcomes of work. In this way, the burnt offering provides "wasteful" paradigms for political economy that resonate deeply with similar challenges issued by modern craft-workers. I begin this chapter by setting the context through a survey of the whole complex of offertory practice in Scripture. This context provides the basis for a series of more focused readings of the burnt offering in this chapter and the firstfruits and eaten offerings in subsequent chapters. Though biblical instruction on worship may be opaque, whether through authorial intention or the cultural distance between our modern world and the ANE, I contend that one may still benefit by grasping towards the moral logic that undergirds these offertory practices. In the case of this chapter with the burnt offering, I argue that this offering renders notions of human ownership, efficiency, and control unstable in the act of worshipping a God who has made and owns all things. As I shall go on to argue, this is conveyed forcefully in early Christian notions of charity, but not exclusively in the ways that have been conventionally understood.

Setting the Stage: Offerings in Christian Scripture

It is important to begin by noting that the formal expressions of offerings that I shall spend most of my time examining in these chapters (particularly in Leviticus and later in the Hebrew Scriptures) are preceded by a rich narrative of offertory practice that is less formally precise and in this way provides introductory paradigms for the more specific details of offertory practice. The first account of human offering to God appears in Gen 4:4, where "Cain brought some of the produce of the soil as an offering for Yahweh, while Abel brought the firstborn (*bkrwt*) and fattest of his flock." Interpreters are divided in trying to parse

out how to read the action in the text subsequent to the two offerings. The Hebrew text of Gen 4:4–5 is terse, with a literal rendering being something like the following: "YHWH had regard towards (*yšʿ*) Abel and his offering, and did not have regard towards Cain and his offering." There is no direct indication in the text as to why regard is offered and this opaque beginning provides an important cue for reading later accounts of offerings in Christian Scripture. Von Rad and Westermann suggest that this text is the first in a line of many that demonstrate how "God's motives are inscrutable."[1] However, Wenham suggests that one should be cautious about rendering God's activity opaque in an absolute way: "this type of explanation should only be resorted to if the text gives no other motives for divine action."[2] Other more theologically motivated interpreters follow the lead of the Epistle to the Hebrews 11:4, which locates God's response in God's assessment of Cain and Abel's inner motives, judging the latter to have "by faith offered to God a more acceptable sacrifice than Cain's."[3] A third possible reading draws attention to the notable textual difference between the two offerings, the emphasis on Abel's bringing the first and fattest. Most interpreters agree that God's dissatisfaction does not stem from a preference for horticulture, but rather because God demands proper deference, which is satisfied by Abel's bringing the first and best. The impact of this is doubled by the irony (represented by chiasm in the text) that Eve's firstborn does not bring his firstfruits.[4] Given this diversity of readings, it is fair to say that this interpretive ambiguity is not one that can be easily settled here. With this in mind, I would suggest that these options need not be made mutually exclusive. Genesis highlights several features that are intrinsic to the dynamic of human offerings: the response of God, the notion of faith, and some attention to the material significance of an offering. This first account of offerings also serves to highlight the way in which offertory themes overlap, as I shall note below at greater length.

It is important to note that intertextual study on the topic of sacrifice is made more complex by the way the varied and technical Hebrew vocabulary of sacrifice is rendered generically in Greek, in particular, with fewer terms, which results in a blurring of categories in contrast to the varied technical vocabulary used in Hebrew description. While the details in the Hebrew Scriptures involve an extensive vocabulary of terms and more discrete (though overlapping) categories, the LXX and NT often refer merely to *prosphora* ["offerings"] or *thysia* ["sacrifice"].[5] This is also the case where, as I shall note below, the various Hebrew terms for firstfruit offerings are flattened under a single Greek term *aparche*. However, it would also be a mistake to assume that the presence of specific instructions and named offerings in the Hebrew Scriptures indicates that the various genres of offerings are discrete in an absolute sense. As I shall go on to suggest, the attributes of Hebrew categories such as "burnt offering," "tithes,"

"firstfruits," and "eaten offerings" overlap and blend together, leaving it difficult to set a strict typology.

Also of preliminary interest is the genre of Leviticus. As I have suggested earlier in the case of the Tabernacle, a closer look at the first several chapters of Leviticus forces one to reconsider the nature of the text. Though it seems to be a stripped-down version of instructions for Israelite ritual, in fact a number of crucial details are missing, which might cause problems if one were to attempt to use this text for a reconstruction.[6] Also of interest is the accreting nature of details provided in the text. Leviticus 1 provides a terse account of the burnt offering, but procedural details pertinent to this ritual are added at various points in the first several chapters (take, for example, the description of priestly procedure in Lev 6 and of the prebend in Lev 7). This is not, in my reading, a matter of disagreement, but rather of a text in which the author has chosen to allow details to accumulate along the way. One reaches the fullest understanding of the ritual details only after reading the entire Pentateuch, and this drives the intertextual approach I take in this chapter to offertory ritual. Keeping this in mind, I shall hold to ritual categories lightly, placing emphasis on the overall tradition-complex of offerings, and I shall seek to abstract the attributes of rightly practised offerings from the Pentateuch, while maintaining a sense of the narrative place of these offerings.

The descriptions of offerings in Genesis and Exodus are terse, with oblique references without procedural detail to "burnt offerings" and "peace offerings," and the limited instructions regarding "hewn stones" and "steps." One must turn to Leviticus for fuller explication of the practice of worship. While this study will not focus exclusively on Leviticus – indeed, in examining the various iterations of offerings below, I shall range both canonically backwards and forwards – I rest upon the categories that Leviticus initiates to frame my presentation. Specifically, I shall make use of those offerings presented in the first three chapters of Leviticus that are not exclusively expiatory. Here one finds several different forms of offering outlined, in which each has a separate (though often overlapping and repeated) set of instructions and at least partially unique purposes. These are, as Milgrom translates them, (1) the ʿlh ["burnt offering" or "whole offering"], (2) the mnḥh ["cereal offering"], and (3) the zbḥ šlmym ["well-being offering(s)"].[7] In seeking to justify my emphasis on these non-expiatory offertory liturgies, I note that contemporary research by Christian theologians drawing upon Leviticus has tended to focus almost exclusively on the expiatory aspect of the cultus described in Leviticus. Writing in the NT and contemporary systematic descriptions of atonement theory have, in particular, provided a narrow filter for those seeking to explore the theological meaning of Leviticus. In a similar way, research in Temple theology has tended to focus on the "Holy of Holies" to the exclusion of the outer court.[8] I do not mean to

deny the important and substantial place occupied by atonement-related metaphors and texts in the Hebrew Scriptures; rather, I hope to expand the current picture to include some further details that have been unnoticed amidst this theological focus. This expanded picture, I hope, may prove particularly helpful in reinvigorating the relationship between Christian worship and biblical ethics. Similarly, I do not mean to deny the phenomenal significance of those rituals that took place with respect to the holy of holies, but, again, I mean to draw attention to the implications for the moral life of Israel of the considerably more regular activity that took place in the court outside. As I have suggested with the Tabernacle text in Exodus analysed earlier, the offertory rituals in Leviticus present another text of the bible that has been significantly neglected by modern biblical scholarship. This bears out in moral use of the bible, as Christian ethicists only occasionally refer to Lev 19 or 22.[9] No contemporary study of work in biblical ethics (or indeed, perhaps, within the whole genre of biblical ethics) offers a substantial treatment of the material presented in the first half of Leviticus. This neglect of the start of Leviticus is lamentable, as like overly enthusiastic readers of a novel skipping to the final chapter, contemporary readers seek to understand only the material that comes in the latter portion of the book. Keeping this in mind, I proceed with the more specific details of this investigation, seeking to recover something of the political and economic significance of the patterns of worship expressed in offertory rituals as they have been appropriated in both Hebrew and Christian practice.

A Social Offering

Burnt offerings provide a fitting place to start this inquiry, in part because they are the first to be presented in the offertory instructions in Leviticus. The *ʿlh* is introduced in Lev 1:3 and is, as Hartley suggests, "the main sacrifice of the Israelite cult."[10] In attesting to this primacy, Milgrom suggests, "The fact that the burnt offering answers every conceivable emotional and psychological need leads to the inference that it may originally have been the only sacrifice offered except *šĕlāmîn*, which provided meat for the table."[11] It is also important to note that, by the time the reader arrives at Lev 1, burnt offerings have already been described variously including formal practice at solitary altars.[12] One also finds surprising references to the reinstitution of burnt offerings, as in Ps 51. Here the Psalmist opens in a way that seems to dismiss sacrifice: "O LORD, open my lips, and let my mouth declare Your praise. You do not want me to bring sacrifices; You do not desire burnt offerings; True sacrifice to God is a contrite spirit; God, You will not despise a contrite and crushed heart" (Ps 51:17–19 JPS). Yet the verses that follow do not continue the repudiation of burnt offerings, but rather imagine its reinstitution as a worship practice in more righteous times: "May it

please You to make Zion prosper; rebuild the walls of Jerusalem. Then You will want sacrifices offered in righteousness, burnt and whole offerings; then bulls will be offered on Your altar" (Ps 51:20–1 JPS). As I shall go on to suggest further below, burnt offerings also persist in Christian practice, though with some reconceptualisation.

In accounting for the ethical implications of this ritual, one must first contend with the influence on modern exegetes of the Romantic conception of the heroic individual who faces his sin before God with an expiatory offering. Such reconsideration is commended in the first case because a close reading of Leviticus reveals that the function of the burnt offering is not strictly expiatory. This claim requires some nuance and justification, as Lev 1:4 does suggest: "He shall lay his hand upon the head of the burnt offering, that it may be acceptable in his behalf, in expiation for him" (Lev 1:4 JPS). Milgrom is helpful here, as he notes – after an extensive survey of the explanations accompanying expiatory burnt offerings in ANE ritual systems, Rabbinic literature, and other liturgical systems in the Hebrew Bible – that the primary purpose of the burnt offering is explained most clearly in 1 Sam 13:12 as *entreaty*:

> But entreaty covers a wide range of motives: homage, thanksgiving, appeasement, expiation.... Appeasement was certainly the goal of Samuel's sacrifice at Mizpah.... The Tanna, R. Simeon, asks: 'why does the purification offering precede the burnt offering (in the sacrificial order)? It is comparable to an attorney who comes to appease. Having made his (plea of) appeasement, the gift (of appeasement) follows' (t. Para 1:1; b. Zebah. 7b [Bar.]). The burnt offering then is a gift, with any number of goals in mind, one of which – the one singled out in this chapter – is expiation.[13]

Keeping this in mind, one can outline the logic of the expiatory aspect of the burnt offering in the following way: it is expiatory *because* expiation functions as a subset of a broader dynamic. The expiatory function of this offering exists inasmuch as the ʿlh functions as part of a holistic ritual system wherein ritual acts are rarely discrete; instead, they often overlap and exist in composite expression.[14] As Gordon Wenham suggests, "the burnt offering does not remove sin or change man's sinful nature, but it makes fellowship between sinful man and a holy God possible."[15] This suggestion is affirmed when we look outside the spare prose of Leviticus and note, as Milgrom does, "when the cultic texts (outside of P) actually specify a motive for the burnt offering, it is an occasion of joy, such as the fulfilment of a vow or a freewill offering (22:17–19; Num 15:3)."[16]

In contrast, in an influential reading by Wellhausen, the so-called "Priestly" texts (such as Lev 1) are used to underwrite a dichotomy between the rituals described in P and the more "dynamic" and primitive festival practices in

non-Priestly sources. As Knohl argues, in Wellhausen's prolegomena, "The Priestly Code ... is a 'late' development that has lost this natural and agricultural character and replaced it with detailed specific ritual prescriptions of public sacrifices that were to be offered at fixed times during the year. The awareness of nature was exchanged for historical discussions that explained the festivals as reflecting events of national history."[17] Though Knohl does not suggest this, it is clear from his distillation that Wellhausen's interpretive matrix has been set by the agenda of late-modern German Romanticism, where the institutional expression of worship is juxtaposed with spontaneous (and free or "liberal") expression.[18] Aside from offering a radically anti-canonical approach to the text of Leviticus, Wellhausen's approach is unwarranted, as Knohl suggests, based on both archaeological and textual grounds.[19] I have already noted above the consequences that these projections of "nature" and "freedom" carry for an ethics of work, particularly in undermining the basis for human action that engages with the natural world. At this juncture, I note also the ways in which the anti-institutional Romantic construal of moral agency (as being aloof from a political context) may estrange ritual practice from its social setting. By resisting this reductive approach, I hope to take a more authentic account of the dynamic represented in Leviticus rather than allowing Enlightenment categories to dominate a conception of liturgical sociality.[20]

A close look at the dynamics of the burnt offering also reveals that this broader psychological spectrum is matched by a more complexly interrelated social dynamic than Wellhausen and his intellectual progeny have expected from these texts. It may help to begin by sketching out the basic procedural details described in Lev 1 regarding the burnt offering. The description of the ceremony, which was likely practised on a daily basis, begins with Lev 1:3, where one reads that the offerer is meant to bring a male animal without blemish (*zkr tmym*). The animal is to be brought before the entrance of the Tent of Meeting, in the courtyard of the Tabernacle complex (1:4) where, in cooperation with the sons of Aaron, the animal is slaughtered. Milgrom summarises the procedure in this way:

> After the offerer has performed the hand-leaning rite and slaughtered his animal, the officiating priest dashes the animal's blood – collected by his fellow priest(s) – upon all the sides of the altar, while the offerer skins and quarters the animal and washes its entrails and skins. Once the priests have stoked the altar fire, laid new wood upon it, and then laid the animal parts, the officiating priest supervises the incineration of the sacrifice.[21]

Though, particularly when seen in descriptive detail, this ritual may seem obscure to the modern reader, I think Milgrom is right to suggest, "behind the

seemingly arcane rituals lies a system of meaning that we can draw into our own modern lives."[22] I shall take up this assertion later in this chapter. In preparing the way for a consideration of the modern implications of this ritual practice, I offer some synthetic analysis of several specific details of the ceremony.

First, it is important to note the personnel involved. This is not priestly action that excludes the worshipper, but a ritual drama that is performed cooperatively by celebrant and officiant and one that emphasises the relationship between these two persons and the animal involved. This is a socially inclusive act and, rather than merely commodify the animal involved, it emphasises the relation among all three individuals.[23] Wenham puts this in particularly vivid (if slightly conjectural) terms: "The ancient worshipper did not just listen to the minister and sing a few hymns. He was actively involved in the worship. He had to choose an unblemished animal from his own flock, bring it to the sanctuary, kill it and dismember it with his own hands, then watch it go up in smoke before his very eyes."[24] In addition to the personal participation of the worshipper, the liturgy as described in Leviticus is deliberately told from the perspective of both the worshipper (1:1–17) and the priest (6:8–13). The choreography of the ritual also emphasises this closeness. This is the case with the instruction in verse 4, "He shall lean his hand (*smk ydecca*) upon the head of the burnt offering." As Milgrom notes, "sāmak implies pressure."[25] Just as the selection process connotes intimate relationship (as the animal is drawn from one's own flock), so too the ritual itself emphasises the shared space between the worshipper and the sacrificial animal being offered. This intimacy is underlined by the act of prayer that is implied with the laying on of hands.[26] This liturgical practice is preserved in the Psalter, where a number of Psalms set their prayers in relation to the burnt offering.[27]

More Than Money

In addition to functioning in a robustly social way, there are important ethical implications of the fact that the offering is "incinerated." This is a straightforward translation of the Hebrew verb *qtr*, which in the *hifil* suggests, "make go up in smoke." The scope of incineration is emphasised in verse 9 with *kl* ["all of it"]. As Milgrom notes, "The unique distinction of the burnt offering in the sacrificial system is that all of it, except for the skin, is consumed on the altar."[28] It is worth noting that the writer of Leviticus makes use of a different Hebrew verb to connote non-sacrificial incineration, *srp*.[29] The contrast here seems to be that this incineration is not meant to be simply destructive. Instead, with *hqtyr*, "the offering is not destroyed but transformed, sublimated, etherealized, so that it can ascend in smoke to the heaven above, the dwelling-place of God."[30] This represents what is the most direct material transference of the offering to

YHWH at the front end of a series of other offerings (which I shall address in subsequent chapters) that involve different appropriations of economic value. The burnt offering stands in distinct contrast to those later offerings, like tithes, that are deployed into practical contexts such that the offering served either to provide for the sustenance or salaries of priestly personnel and Temple maintenance or to supply a meal for the worshippers. While I shall go on to discuss the second and third categories of economic appropriation, it is crucial to note the relativisation that occurs with this first and perhaps most frequent of the offerings. Underlining the centrality of this offertory act, Levine suggests that the purpose behind the laying of hands was not "the transferal of impurity or guilt to the victim," but rather to provide assurance that "sacrifices intended for specific rites would be used solely for that purpose. Once assigned in this way, the offering was sacred and belonged to God."[31] In this way, the burnt-offering ritual may be thought of as the bringing of a gift to God in a way that affirms how possession by the human giver was only ever provisional.[32]

Though the burnt offering relativises monetary value in a certain sense, this does not prevent the ceremony from including an accommodation of means. There are three different variations provided on this offering, the first a bull (1:3–9), the second a male sheep or goat (1:10–13), and third, a turtledove or pigeon (1:14–17). While the ritual procedure for all three is relatively similar, the obvious difference is the contrast in the value of offerings. Milgrom draws on Rabbinical sources in seeking to understand the purpose behind this three-tiered ritual procedure, particularly Midr. Lev. Rab. 3:5. The Midrash bears repeating:

> King Agrippa [probably Agrippa I, 41–44 CE] wished to offer up a thousand burnt offerings in one day. He sent to tell the high priest, 'Let no man other than myself offer sacrifices today!' There came a poor man with two turtledoves in his hand, and he said to the high priest, 'Sacrifice these.' Said he: 'The king commanded me, saying, "Let no man other than myself offer sacrifices this day."' Said he: 'My Lord the high priest, I catch four [doves] every day: two I offer up, and with the other two I sustain myself. If you do not offer them up, you cut off my means of sustenance.' The priest took them and offered them up. In a dream it was revealed to Agrippa: 'The sacrifice of a poor man preceded yours.' So he went to the high priest saying: 'Did I not command you thus: "Let no one but me offer sacrifices this day"?' Said [the high priest] to him: 'Your Majesty, a poor man came with two turtledoves in his hand, and said to me: "I catch four birds every day; I sacrifice two, and from the other two I support myself. If you will not offer them up you will cut off my means of sustenance." Should I not have offered them up?' Said [King Agrippa] to him: 'You were right in doing as you did.'[33]

Particularly given the regular occasion for burnt offerings, the purpose of this tiering (as this parable suggests) is to provide different modes of this offering that are economically accessible to those with less disposable capital.[34] This attempt to make the ritual participation accessible to people of all economic strata also carries forward into other rituals described later in Leviticus.[35] Taken in combination with my suggestion that this offering marks an incineration of wealth, like the tithe, this is meant to be a scaled offering that relativises *personal wealth*. It would be shameful for a rich man to bring a bird, whereas it would also be unnecessary for a poor man to bring a goat. The effect is a levelling of the economic impact for those whose work provides extravagant or modest means. The rhythm of this offering does not make for a grand periodic act, but rather a regularly recurring devotion of personal income exclusively to YHWH. Thus Samuel, as described in 1 Sam 7:9, brings a lamb and not a bull.

The contemporary reader can only conjecture regarding the psychological experience of specific participants, but I do not think that a modern experience of the burnt offering would be categorically different with regard to the *economic* and *work* implications of this rite. A reconstruction of the rite might go as follows. Depending on their ability, some spontaneous occurrence prompted the worshipper to bring an offering to the outer court where the altar fires were kept continually burning to meet the needs of occasion. Along with the priest, they would have helped to hold and butcher the sacrifice (and in the case of a bull, likely with the help of others given the weight of the carcass),[36] they would have watched the life-blood – God's absolute possession – be drained from the animal and scattered. Then, they would have watched as the offering was incinerated, with choice (and expensive) cuts of meat being burned down to ashes, consumed by no person. In some cases, though definitely not all, this animal would have represented a prolonged investment of time and nurture, and, in the case of the first two categories, a choice unblemished male animal. This signified a significant expense, publicly offered, for no purpose other than to offer praise and entreaty to YHWH.

Burnt Offerings in New Testament Perspective

As I suggested in the previous chapter, I am strongly against a supersessionist reading of these Hebrew liturgical texts particularly in light of the dismissal of their moral vision that follows from such an approach. Nevertheless, one needs to contend with the relativisation of sacrifice as "spiritual" in the NT. First, it is important to keep in mind that this description of sacrifice as "spiritual" parallels the reforms already prescribed in the exilic and post-exilic literature in the HB. Further, these reforms are not a straightforward dismissal or condemnation of sacrificial practice. Instead, as Jacob Milgrom notes, "the prophets uniformly

affirmed the indispensability of the Temple ... they only remonstrated against the blind belief in its efficacy without affecting the moral behavior of its adherents."[37] The point to be taken from the many reforming texts in both the latter HB and NT is that *right* sacrifice cements reconciliation between God and humans and wrong practice may be worse than no practice at all.[38] Keeping this more nuanced portrait of HB prophetic critique of sacrificial practice in mind, it becomes clear that NT critique of Hebrew ritual is also, as Averbeck additionally suggests, "in continuity with the OT prophetic critique of the cult."[39] The instruction by Jesus in the Sermon on the Mount that one must be reconciled with one's brother (Matt 5:23–4) before (rather than instead of) bringing an offering underlines this reading. Further, it is interesting to observe that both Jesus and Paul provided burnt offerings (among others) and as practising Jews they would have had an intimate knowledge of first-century Jewish ritual practice.[40] It is undeniable that a significant procedural transformation occurs in the NT, but adjectives fall short in seeking to provide an exhaustive description of this transformation. I would like to argue that the freight of meaning conveyed by the sacrificial system is brought forward metaphorically into human practice, but this metaphor is a complex composite that requires careful reading of the Hebrew Scriptures. If this is correct, then any contemporary metaphorical appropriation that is not founded upon a thorough understanding of Hebrew worship practice risks incoherence. This reading is supported by several key NT texts that draw upon the Israelite cultus to provide a metaphorical bridge for the content I have developed here into Christian doctrine and practice.

I have already noted at length in the previous chapter how the concept of the Temple is, in the NT, cast in an eschatological light, which in turn provides a crucial part of the NT narration of the shape of the Christian moral life. This appropriation of "Temple" also involves appropriation of the ritual action that goes on at the Temple. There are a number of NT texts that can serve as examples of this dynamic. Christians are described in Rom 12:1 as *thysian zosan* ["living sacrifice"] (Rom 12:1). In a similar way in Eph 5:1, Paul exhorts the church to "be imitators of God" and in the subsequent verse he makes use of these two sacrificial terms, "*prosphoran kai thysian tǭ theǭ*" ["an offering and sacrifice to God"], and appends to that the modifying phrase "*eis osmēn euōdias*" ["as a smell of fragrance" or "fragrant burnt offering"]. Here, Paul uses the burnt offering in an explicit way as a metaphor for the "sacrifice" of oneself. Elsewhere the actions of Christians are said to constitute the offering, as is the case in Phil 4:18 where Paul makes reference to literal (and not "spiritualised") gift received from Epaphroditus as "*osmēn euōdias, thysian dektēn, euareston tǭ theǭ*" ["a sacrifice acceptable and pleasing to God"].[41] In a similar way, the writer of Hebrews provides an extended account of this spiritual redefinition of sacrifice in Chapter 10, and then concludes the letter by saying, "Through him then let

us continually offer up a sacrifice of praise to God, that is, the fruit of lips that acknowledge his name. Do not neglect to do good and to share what you have, for such sacrifices are pleasing to God" (Heb 13:15–16 ESV). Finally, one finds in 1 Pet 2:5 perhaps the most explicit layering of Temple images to describe the Christian moral life. In this text, the author describes his audience as *lithoi zōntes* ["living stones"] *oikodomeisthe oikos pneumatikos* ["built up as a spiritual house"] *hierateuma hagion* ["to be a holy priesthood"] for the purpose of offering *pneumatikas thysias* ["spiritual sacrifices"]. These appropriations affirm the ethical dimensions of offerings that I have explicated from the Hebrew Scriptures above: this sacrifice is freely given and serves to emphasise the relatedness of both human creatures and their Creator.

Romans 12 offers several opportunities for closer study as Paul's use of the participle *zōsan* ["living"] might seem to undermine the suggestion that this is drawn in relation to the burnt offering (which is certainly not living after the ceremony). Further, Paul describes such an act as not merely worship, but *logikēn latreian*, which a number of contemporary translators render as "spiritual worship." That Paul is trying to underline a point of departure for Christian worship from the Jewish cultus is unmistakable. However, the precise nature of this difference is somewhat more complex, I think, than many commentators have suggested. As might be expected, this text often serves as a popular location for antinomian speculation. In attempting to refute such a tendency, James Dunn argues, "[Paul] takes up cultic terms in order to redefine them too. . . . The boundary of cultic ritual is transposed from actual cultic practices to the life of every day and transformed into nonritual expression, into the much more demanding work of human relationships in an everyday world."[42] While I agree with Dunn's broader argument that Paul is trying to displace the national aspect of Jewish self-understanding in redefining ritual action, his juxtapositions here are striking: "actual cultic practices" are set in opposition to "the life of everyday" and the "much more demanding work of human relationships." Dunn goes on to argue:

> The emphasis on a spiritual sacrifice was of course not new, but in Paul's case and that of the early Christian congregations, it was not a matter of 'both . . . and' (observe the sacrificial system, but recognize that God wants something more), but rather of encouraging the idea of a different kind of community, marked by self-giving *without* an accompanying sacrificial cult. At the same time Paul's insistence that such sacrifice must take concrete bodily expression prevents his thought degenerating into a mere unworldly pietism or enthusiastic dualism.[43]

In contrast to Dunn's reading, as I shall continue to argue in this chapter, the original set of rituals to which Paul is obliquely referring was itself marked by self-giving, infused with hospitality (as I shall argue in a later section), and does not neglect human relationship. Rather than argue that Paul's only options are radical redefinition or "both . . . and," it seems reasonable to modify Dunn's approach to suggest that Paul's redefinition draws upon the moral coherence that is already present in Hebrew ritual.

Translation of the term Paul uses to specify the form of worship, *logikēn*, as "spiritual" may also be misleading if one is not aware of the link between spirit and reason in the classical meaning of the term. *Logos* was popular with Stoic thinkers, as the adjectival form of the word connotes, "the ordered and teleologically oriented nature of the cosmos."[44] Thus *logiken* implies "rational," inasmuch as rationality is not mere thought, but a grasping at the intelligibility and coherence of things. Keeping this in mind, a more accurate translation for the text in Romans might be (as suggested in *BDAG*) "a thoughtful service (in a dedicated spiritual sense)."[45] It cannot be denied that what Paul is referring to is sacrifice that occurs outside the Temple and also excludes the external creature. This is internalised, yet while the person lives on, something is surely relinquished: one's autonomy and agency are the "burnt offering" here offered in grateful thanksgiving to God. This Christian modification is not unique, as Jewish writers provide a similar modification, which Paul refers to earlier in Rom 2:29. Literature, such as the Testament of Levi and Philo, offers similar modification "in echo of the prophetic demand of Ps. 51:16."[46] Seen in this way, the reader can appreciate how the unique feature of Paul's approach is not his "spiritualising," but rather his emphasis on the mediation of the moral norms of *logiken latreian* through the spirit of Jesus Christ.

Early Christian Charity as a Burnt Offering

I turn now to early Christian literature in seeking to vindicate the reading of offertory practice in Scripture that I have provided above. Yet it is important to note that early Christian literature can be quite terse with regard to the procedural details or "lived" dimensions of Christian worship. As Margaret Barker relates, a wide array of early Christian writers go so far as to refer to a "secret tradition" (cf. John 16:12) that, she argues, concerns Christian liturgy.[47] This tradition is noted by Clement, Ignatius, Irenaeus, Origen, and Basil, with Basil leaving the intriguing suggestion that there were certain practices "handed down to us in a mystery from the tradition of the apostles" that concerned "liturgical customs, prayers and rites of the sacraments and other Christian universal customs . . . [and] the theological doctrines implied in the liturgical rites and prayers."[48] Nonetheless, there are suggestions that the ethical features of burnt

offerings that I have highlighted throughout the study above persisted in Christian worship with very practical effects.

One of the best places to find validation of this claim is in Ancient Church Order documents, which sought to provide a manual of right Christian practice, and this genre of Christian literature is functionally similar to Leviticus. In these documents, one finds that early Christian practice took seriously the transition that had occurred in the meaning of temple I have explored above, such that they thought of themselves, following Rom 12, as *thysian zōsan* ["living sacrifice"], or as an *osmēn euōdias* ["fragrant burnt offering"], as Paul puts it in Eph 5:2. One can find this suggestion in Chapter 14 of the *Didache*, where the author describes Christian worship: "On the Lord's own day gather together and break bread and give thanks, having first confessed your sins so that your sacrifice may be pure (*hopōs kathara hē thysia hymōn*)." This sacrifice is worked out in very practical, if radical, terms earlier, in *Didache* 4:5–8:

> Do not be one who stretches out the hands to receive but withdraws them when it comes to giving. If you earn something by working with your hands, you shall give a ransom for your sins. You shall not hesitate to give, nor shall you grumble when giving, for you will know who is the good paymaster of the reward. You shall not turn away from someone in need, but shall share everything with your brother or sister, and do not claim that anything is your own. For if you are sharers in what is imperishable, how much more so in perishable things![49]

The outworking of this spiritual sacrifice described in *Didache* §14 is the argument for charity norms provided in *Didache* §4. In this way, the language in the *Didache* resonates with various NT texts (also pertaining to charity norms), particularly Matt 19:21; Luke 14:33; Acts 2:44, 4:32; Gal 6:6; and Rom 15:27.[50] It is also significant to note that, as Del Verme argues, these charity norms resonate in significant ways with first-century Jewish practice.[51] There is more to be said about the charity commended in the *Didache* and other Ancient Church Order documents, but I shall attend to this further below. Suffice it to say for now, this metaphor of self-sacrifice and relinquishment persists such that the practice of burnt offerings is not discarded by Christians but intensified, such that two centuries later Gregory Nazianzus can suggest, quoting Rom 12:1, "let us become reason endowed whole burnt offerings."[52]

A number of scholars have noted that the call to charity and radical divestiture that these early Christian writers commend has direct implications for modern conceptions of political economy. Spiritual sacrifice entails a relinquishment of the income that arises from one's productive occupation and a commitment to continue work as a means of self-support and charity.[53] However, I would like to

argue that the implication of such a model of recurring charity (just as with the recurring nature of the burnt offering) exceeds the scope of individual benevolent acts. Perhaps even more importantly, an economically implicating sacrifice that is also rhythmic and repeated (such as the burnt offering) provides the possibility of a reconfigured relationship towards income, money, and work. Much has been written with regard to the first two of these three, but far less has been noted about the ways in which one might experience a reconfigured relationship to work that extends beyond money; and this is where my particular interest lies. I would argue that exposition of early Christian social ethics may help one to better understand some of the ways in which one's relationship with work could be rehabilitated by the practice of offerings I have noted above. I bring some voices from recent craft scholarship alongside my discussion to note how this rehabilitation might also be conceived of as a theology of craft. This in turn provides the basis for broadening our understanding of the possible meaning of "spiritual sacrifice" in the context of modern work.

This relinquishment of control over one's vocation may be represented not merely in giving away possessions, but also in reconceptualising the activity and basis of work. Perhaps the most basic implication of treating one's orientation towards work as a "spiritual sacrifice" is towards one's choice of vocation. Against the modern therapeutic narrative that poses the choice of vocation as an exercise in self-actualisation, the early Christian account offers a radically social vision. The writer of the later church order document, the *Apostolic Constitutions* (likely written in the fourth century), makes this point at length, describing extensively those vocations that persons must renounce if they are to be baptised. In §16.1, the confessor is charged with the task of inquiring with the person who wishes to be baptised "about the crafts and work of those who will be brought in to be catechised as to what they are." Collusion with paganism is not to be tolerated (i.e., the idol maker, priests of idols, etc.), nor are occupations that engage in violence (the brothel keeper, gladiators, charioteers, soldiers, etc.). Similar arguments are offered by Augustine, who is critical of those trades that are inherently oriented towards vice. In his letters, he advises against participation in moneylending or the mercantile trade, given their propensity towards the distortion of value. He also expands on this list of unacceptable occupations elsewhere in his commentaries on the Psalms. In his pastoral advice, Augustine argues that thieving, prostitution, pimping, and sorcery cannot be justified even if income from such activity staves off financial hardship or provides a basis for charitable giving.[54] By extension, fundraising for charity cannot be an absolute good; rather, it is kept subordinate to other goods including the just treatment of workers and the preservation of material value. In this way, a Christian theology of craft should seek to balance the dialectics of work agency I introduced in the first chapter between individual and corporate

work. The crucial concern for a theology of craft is not merely with "my" work, but with balancing the work of individual persons against that of the greater human community of workers.[55]

Aside from one's choice of vocation, there are two other modern idols in work practice that a theology of craft may further challenge. These are a focus on work efficiency and the ownership of work-products. As regards the first, one may see how an emphasis on work efficiency is the outcome of a modern emphasis on control through technological mastery. Inasmuch as workers and managers aim to ensure that the outcomes of our work are predictable and regular, they seek to exert control over the process of work. While some degree of control is natural, I would argue that it is equally important to appreciate how work represents a negotiation of contingencies, whether these are presented in the formal limits of material or in the requirements of one's customer. The problem that I am describing here arises when this concern for a measure of control devolves into a quest for total control, such that efficiency becomes the *primary* purpose of work.

It is worth pausing my exposition here to note several ways in which an account of work as craft resonates with the work-aesthetics of the burnt offering that I have outlined above, inasmuch as one finds an emphasis on the relinquishment of control and a wider perspective on the role of "efficiency." First, as David Pye suggests in his account of the "workmanship of risk," true craft cannot be oriented exclusively towards utility and function, but must also attend to what he polemically terms "wasteful beauty."[56] The conception of gratuitous generosity that I outlined above regarding the burnt offering also aligns well with a reconfigured attitude towards the effort invested in a craft product. In a similar account, *Thinking through Craft*, Glenn Adamson argues that a core aspect of craft involves the inclusion of forms of work that are supplemental. Adamson uses "supplemental" in the sense described by Derrida in *On Grammatology*, to describe a form of work that "provides something necessary to another, 'original' entity, but which is nonetheless considered to be extraneous to that original."[57] He sets this contingency of craft in deliberate contrast to the supposed autonomy of modernist art (and perhaps also the industrial designer). In Adamson's description, craft work "is always essential to the end in view, but in the process of achieving that end, it disappears... proper craftsmanship draws no attention to itself; it lies beneath notice, allowing other qualities to assert themselves in their fullness."[58] This way of conceiving craft work defies the tendency in the contemporary *avant garde* towards personality cult that is paralleled in the flashy CEO keynote presentations in design industries that have now become commonplace. In Adamson's contrasting account, one contributes work-excellence with the knowledge that such investment will not be transparently apparent to the beholder of one's work. This way of conceiving

craft work also undermines an emphasis on work efficiency, as craft work may involve effort that does not directly relate to the enhancement of the price of a product. Instead, beneath the domestic context and functionality of the product of craft work lies hidden a gratuitously invested sum of work and part of the constitution of craft practice speaks to a denial that craft can be accounted for in the finished product in a concrete (or marketable) way. Thus, as Carla Needleman argues, craft work also eschews predictable results. Rather than making a thousand pots – by the use of industrially designed processes – that one can guarantee will be passable but not *excellent*, Needleman notes how the process of craft is experimental. This challenges our "need to know, right away, whether they are good or bad" against the contemporary craving for certainty.[59] In this way, craft tends to push up against the requirements of efficiency by extending work-time rather than closing it down into predictable containers.

The kind of relinquishment that lies at the heart of craft work I am describing here may also be found in early Christian social ethics, with John Chrysostom's account of "intellectual property." In order to understand what Chrysostom is getting at (and avoid anachronism), it is important to first situate his account within his broader ethic with regard to wealth and possessions. As is well known among patristic scholars, Chrysostom presents a sustained argument against personal wealth, which we find in clearest expression in his Homilies on 1 Timothy. Against overly enthusiastic readings of Chrysostom's seemingly radical objection, Oliver O'Donovan presents a helpful frame for the ascetic discipline he is prescribing:

> It would be a misunderstanding to read it as an attack on material goods as such, nor do we ever find in John the suspicion that ownership by communities could be as greedy as ownership by individuals. Separating resources from the common stock and keeping them in private hands is the root offense; anything that perpetuates the result of that offense perpetuates its guild. The moral worth of charitable giving is to reverse it; in passing to others the resources that they need, the giver reasserts the original community of Goods.[60]

This approach to the community of goods, emphasising the relative nature of property ownership, persists across the Christian tradition.[61] A number of recent accounts in the theology of work, particularly those by John Paul II, Miroslav Volf, and John Hughes note how conceptions of property relate to the treatment of workers and these writers have advanced the discussion on the philosophy of work through a critical Christian assessment of the dominant Marxist critique. What is interesting for our purposes here is how these craft writers broaden out this discussion – like Max Weber with his "spirit of

Capitalism" – to note how conceptions of property and ownership affect not just the configuration of labour and capital, but also the very constitution of work practice. It is precisely this kind of practice-focused theological account that Chrysostom provides. Just as material goods are owned by God, Chrysostom argues, so too is skill and knowledge. He suggests this in a sermon on spiritual gifts, inspired by 1 Cor 14:3. He notes that Paul's underlying point in 1 Cor 14 is to "[give] the higher honor to that which tends to the profit of the many."[62] In his homily on 1 Cor 3:18–19, Chrysostom lays out his perspective on property. The trouble lies, he suggests, not in the possession of wealth, but in the spending of it:

> the things which are not thine own become thine, if thou spend them upon others: but if thou spend on thyself unsparingly, thine own things become no longer thine. For since thou usest them cruelly, and sayest, 'That my own things should be altogether spent on my own enjoyment is fair': therefore I call them not thine own. For they are common to thee and thy fellow-servants; just as the sun is common, the air, the earth, and all the rest.... So also in regard of wealth. If you enjoy it alone, you too have lost it: for you will not reap its reward. But if you possess it jointly with the rest, then will it be more your own, and then will you reap the benefit of it.[63]

Among Chrysostom's many comments across his sermons there is an abundance of comments on wealth. I have chosen this homily in particular as here Chrysostom goes on to extend this notion of *common property* to a form of intellectual property: one's cultivated skill. After describing a biological analogy, he moves on to the trades:

> For the smith also, if he chose to impart of his craft to no one, ruins both himself and all other crafts. Likewise the cordwainer, the husbandman, the baker, and everyone of those who pursue any necessary calling; if he chose not to communicate to anyone of the results of his art, will ruin not the others only but himself also with them.[64]

As expected, Chrysostom inflects this lesson with some sense of class consciousness, but the crucial difference in his account is that agricultural workers must share their skill by the very nature of those professions. If the gardener chooses to hoard his seeds without planting them, he will bring famine, just as, if the tiller of the soil refuses to share the "labour of his hands," he will starve. It is a unique privilege of classical "white-collar" workers that they may, by benefit of accumulated (or inherited) income, choose to withhold their skill. But this is, according to Chrysostom, a grave mistake: "For in every thing to give and

receive is the principle of numerous blessings: in seeds, in scholars, in arts. For if any one desire to keep his art to himself, he subverts both himself and the whole course of things."[65] Here one finds a convergence of Chrysostom's attitude towards property and sloth. What we do not find is an explicit parsing out of the logistics of how this might function. Did Chrysostom expect doctors and lawyers to provide free services? Exclusively? We aren't given a specific rule; rather, the litmus by which such charity should be practised is an evangelistic principle. On this basis, the lack of rule is itself instructive as Chrysostom is after a more dynamic approach. He goes on in the 1 Corinthians homily to explain how such an attitude of willing sacrifice might serve as a form of witness much grander than the disbursement of wealth:

> Therefore as teachers, however many scholars they have, impart some of their lore unto each; so let thy possession be, many to whom thou hast done good. And let all say, such an one he freed from poverty, such an one from dangers. Such an one would have perished, had he not, next to the grace of God, enjoyed thy patronage. This man's disease thou didst cure, another thou didst rid of false accusation, another being a stranger you took in, another being naked you clothed. Wealth inexhaustible and many treasures are not so good as such sayings. They draw all men's gaze more powerfully than your golden vestments, and horses, and slaves.[66]

Rather than provide a procedurally specific account of charity, Chrysostom's patristic ethic provides contemporary workers with a challenging application of this notion of one's self and work as a spiritual sacrifice, given as a burnt offering. In his account, the focus is not on wealth accumulation as primary motivator, even if it is accumulated for good purposes. Rather, his analogical use of the burnt offering extends this analogical appropriation of burnt offerings that one finds in the NT and latter HB. Such a sacrifice is offered to the glory of God, freely, and with a joyful heart. Work that brings wealth is not ruled out in practice, but rather the crucial concern for these early Christian writers concerns the disposition of a worker towards their craft, and the way in which they appropriate the goods which result from their diligence in work.

Notes

1 The range of options is summarised in Gordon J. Wenham, *Genesis 1–15*, WBC 1 (Waco, TX: Word Books, 1987), 104.
2 Wenham, *Genesis 1–15*, 104.
3 NRSV.
4 Wenham, *Genesis 1–15*, 103.

5 This is also the case with economic terms, such that the LXX and GNT use *dōron* to render a variety of Hebrew terms.
6 Missing details are noted by Mary Douglas throughout her book *Leviticus as Literature*. See also Rolf Rendtorff and Robert A. Kugler, *The Book of Leviticus: Composition and Reception* (Atlanta, GA: SBL, 2006), 103, and James W. Watts, *Ritual and Rhetoric in Leviticus: From Sacrifice to Scripture* (Cambridge: Cambridge University Press, 2007).
7 While I shall not do this here, one could also choose to organise this type of presentation based on the slightly different (but complementary) categories in Deut 12:6.
8 One example of this is the insightful study by Greg Beale, who nevertheless presents a thesis where "the Old Testament Tabernacle and Temples were symbolically designed to point to the cosmic eschatological reality that God's tabernacling presence, formerly limited to the holy of holies, was to be extended throughout the whole earth." *The Temple and the Church's Mission*, 25.
9 Cf. Witherington, *Work*, 93; Reed, *Good Work*, 12, 16, 47, 65, 107.
10 John E. Hartley, *Leviticus*, WBC 4 (Waco, TX: Word Books, 1992), 17.
11 Jacob Milgrom, *Leviticus 1–16: A New Translation with Introduction and Commentary*, AYB 3a (New York, NY: Doubleday, 1991), 176.
12 Averbeck, "עלה," *NIDOTTE*, 3:406.
13 Milgrom, *Leviticus 1–16*, 175–6.
14 See Richard E. Averbeck, "'olâ, Burnt Offering," *NIDOTTE*, 1:407.
15 Gordon J. Wenham, *The Book of Leviticus*, NICOT 3 (Grand Rapids, MI: Eerdmans, 1979), 57.
16 Milgrom, *Leviticus 1–16*, 175.
17 Israel Knohl, *The Sanctuary of Silence: The Priestly Torah and the Holiness School* (Winona Lake, IN: Eisenbrauns, 2007), 40.
18 To this effect, see Wellhausen, *Prolegomena*, 11.2.2.
19 Knohl, *The Sanctuary of Silence*, 40.
20 It bears mention that a number of modern biblical scholars have also argued, from a similar basis, that Israelite rituals were not constructed for faith in YHWH, but rather in a struggle to resist other ANE ritual systems. See, for example, Gerhard von Rad, *Old Testament Theology*, I (Atlanta, GA: Westminster John Knox Press, 2001), 252. While I do not think this needs to be a zero-sum argument, i.e., that Israel's cultus is wholly original, one need not assume that Hebrew worship was merely a passive receptacle for other ANE ritual. It is hard to decisively refute a reconstruction, but what we have in Leviticus, it seems to me, is far too robust and interesting for this to be the case. That the cultus lacks straightforward "rationalistically" conceived coherence, seems grounds for a critique of Enlightenment bias in biblical-critical scholarship rather than dismissal of their content. For more along these lines, see Colin Brown, *NIDNTT*, 3:418ff.
21 Jacob Milgrom, *Leviticus: A Book of Ritual and Ethics*, Continental Commentaries 3 (Minneapolis, MN: Fortress Press, 2004), 21.
22 Milgrom, *Leviticus*, 18.
23 I take my cues for this ecological reading of Leviticus from Jonathan D. Morgan, who provides this account in "Sacrifice in Leviticus: Eco-friendly Ritual or Unholy Waste?," in David G. Horrell, Cherryl Hunt, Christopher Southgate, and Francesca Stavrakopoulou (eds), *Ecological Hermeneutics: Biblical, Historical, and Theological*

Perspectives (Edinburgh: T&T Clark, 2010), 32–45. Morgan develops this argument at length in his dissertation, "Land, Rest & Sacrifice."
24 Wenham, *The Book of Leviticus*, 55.
25 Milgrom, *Leviticus 1–16*, 150.
26 Wenham, *The Book of Leviticus*, 61.
27 Cf. Psalm 20, 40, 50, 51, 66, and possibly also 4–5.
28 Milgrom, *Leviticus 1–16*, 161. This act of complete incineration is also emphasised in the priestly instructions later in Lev 6:2: "The burnt offering itself shall remain where it is burned upon the altar all night until morning, while the fire on the altar is kept going on it" (JPS). Lev 7:8 describes a priestly prebend of the animal's hide, which is the one exception to this practice. For more on the meaning of this term, see Baruch A. Levine, *Leviticus*, JPSTC 3 (Philadelphia, PA: Jewish Publication Society, 1989), 5–6, and Milgrom, *Leviticus 1–16*, 172ff.
29 Cf. Lev 4:12, 4:21, 10:16, 16:27–8. See also Num 19:5, 19:6, 19:8.
30 F. C. N. Hicks, *The Fullness of Sacrifice* (London: SPCK, 1953), 15. Cited in Milgrom, *Leviticus 1–16*, 161.
31 Levine, *Leviticus*, 6.
32 Milgrom, *Leviticus 1–16*, 176.
33 Midr. Lev. Rab. 3:5 cited in Milgrom, *Leviticus 1–16*, 166–7.
34 Keil and Delitzsch corroborate this suggestion: "There are also turtle-doves and wild pigeons in Palestine in such abundance, that they could easily furnish the ordinary animal food of the poorer classes, and serve as sacrifices in the place of the larger animals." *Commentary on the Old Testament*, 10 vols (Peabody, MA: Hendrickson Publishers, 1996), 2:289.
35 Milgrom notes a similar "explicit purpose of special allowances for birds in other sacrifices: the scaled purification offering (5:7–10) and the offerings of the parturient (12:8) and the healed *mĕṣōrāʿ* (14:21–2). The same motivation applies to the cereal offering (chap. 2; cf. esp. 5:11–13)." Milgrom, *Leviticus 1–16*, 167.
36 See Wenham, *The Book of Leviticus*, 54.
37 Milgrom, *Leviticus 1–16*, 482.
38 Cf. Isa 1:10–15; Jer 7:21–6; Hos 6:6; Amos 5:21–6; and Mic 6:1–8.
39 Cf. Averbeck, *NIDOTTE*, 3:1015–16.
40 For examples, see Matt 8:4; Mark 1:44; Luke 5:14, 17:14; Acts 21:23–6. Cf. Averbeck, *NIDOTTE*, 3:1015–17.
41 "[A] fragrant offering, a sacrifice acceptable and pleasing to God" (ESV).
42 James D. G. Dunn, *Romans 9–16*, WBC 38B (Waco, TX: Word Books, 1988), 717.
43 Dunn, *Romans 9–16*, 717.
44 *TDNT* 4:85.
45 *BDAG*, 598.
46 Cf. *TDNT* 4:143ff.
47 See, for example, Margaret Barker, *The Great High Priest: The Temple Roots of Christian Liturgy* (London; New York, NY: T&T Clark, 2003), 2–33.
48 Translation from Barker, *The Great High Priest*, 11.
49 Cf. also *Didache* §13, which I discuss further below. Translation from *The Apostolic Fathers*, ed. and trans. Lightfoot and Harmer, ed. and rev. Holmes.
50 Some datings of the *Didache* make this problematic; for more on NT citations, see Christopher M. Tuckett, "Synoptic Tradition in the Didache," in J.-M. Sevrin (ed.), *The New Testament in Early Christianity. La Réception des Écrits Neotestamentaires*

dans le Christianisme Primitif, BEThL 86 (Leuven: Leuven University Press, 1989), 197–230. For a rigorous survey of New Testament charity norms in Luke, see Christopher M. Hays, *Luke's Wealth Ethics: A Study in Their Coherence and Character* (Tübingen: Mohr Siebeck, 2010). Hays also provides an erudite survey of second- to third-century wealth ethics in "Resumptions of Radicalism: Christian Wealth Ethics in the Second and Third Centuries," *Zeitschrift fur die Neutestamentliche Wissenschaft und Kunde der Alteren Kirche* 102, no. 2 (2011): 261–82. Of note is his suggestion that divestiture and sharing, while rigorously commended by Clement, Cyprian, and several other contemporary traditions, is meant to be voluntary and for the good of the Christian community.

51 Marcello Del Verme, *Didache and Judaism: Jewish Roots of an Ancient Christian–Jewish Work* (New York, NY: T&T Clark International, 2004), Chapter 2.
52 *Oration* 40.40, translation from Nonna Verna Harrison, *Festal Orations: Saint Gregory of Nanzianus* (Crestwood, NY: St. Vladimir's Seminary Press, 2005), 136.
53 For more along these lines, see my article on "Work," in *The Oxford Guide to the Historical Reception of Augustine*, ed. Pollmann and Otten.
54 Cf. Augustine, *en. Ps.* 128.6; cf. *en Ps.* 36.6.c. This and subsequent translations of Augustine's works are from *Works of Saint Augustine*, ed. Boniface Ramsey, 50 vols (Hyde Park, NY: New City Press, 1990–).
55 Jeff Van Duzer makes a similar point in his book *Why Business Matters to God* (Grand Rapids, MI: InterVarsity Press, 2010). See especially Chapter 8.
56 Cf. Pye, *The Nature and Aesthetics of Design*.
57 *Thinking through Craft* (New York, NY: Berg, 2007), 11.
58 *Thinking through Craft*, 13.
59 *The Work of Craft: An Inquiry into the Nature of Crafts and Craftsmanship* (London: Arkana, 1986), 3.
60 Joan Lockwood O'Donovan and Oliver O'Donovan, *From Irenaeus to Grotius: A Sourcebook in Christian Political Thought 100–1625* (Grand Rapids, MI: Eerdmans, 1999), 91.
61 Hughes, *The End of Work*, 21, 66.
62 *Hom. in I Cor.*, 35. Cf. also *Hom. in Matt.*, 77.3 and *Hom. in 2 Cor.* 17.3. This and subsequent translations of Chrysostom are from *The Nicene and Post-Nicene Fathers* 1, ed. Philip Schaff, 14 vols (Peabody, MA: Hendrickson [1886–89], repr. 1994).
63 *Hom. in I Cor.*, 10.7.
64 *Hom. in I Cor.*, 10.7.
65 *Hom. in I Cor.*, 10.7.
66 *Hom. in I Cor.*, 10.8.

6 Firstfruits and the Consecrating Relation

> Honour the Lord with all your wealth, and with the firstfruits of all your harvest – your income – and your barns will be filled with grain, your vats will burst with new wine. (Prov 3:9–10)

In some contrast to the burnt offering, which offered a relativising of ownership and a related subordination of one's work to divinely reckoned purposes, the offering described in Leviticus Chapter 2 – the *mnḥh*, or cereal offering – provides the setting for a liturgical consideration of work quality and excellence. It does, of course, remain intimately related to the burnt offering.[1] However, the cereal offering also differs procedurally in several respects. As I shall go on to suggest, these differences provide the basis for a consecratory experience that is also deeply useful for a theology of work and resonant with the accounts of work as craft I have been exploring along the way.

The first distinction regarding the cereal offering relates to the quantity involved: only a representative portion, literally a "handful," is incinerated. The rest of the offering provides the basis for a consecrated meal to be eaten by priests on the Tabernacle grounds. Regarding this first portion, the first half of verse 2 instructs the priest to "scoop out of it a handful of its choice flour and oil" (JPS). In the second half of the verse, we read that he is to take this incinerated handful and "turn [it] into smoke on the altar, as an offering by fire, of pleasing odour to the LORD" (JPS). This portion is described using a term unique to Leviticus, *'zkrh*, which is usually translated as a "token" portion. However, many lexicographers tend to rely upon a definition by derivation, arguing that it likely derives from the root *zkr* ("to remember").[2] This provides the basis for the suggestion that the offering is a "memorial portion" (cf. ESV, NJB *contra* NRSV "token"). Another feature of the cereal offering that sets it apart from the burnt offering is its designation as *qdš qdšym* ["most holy"] in Lev 2:3, 2:10, 6:10–11, and 6:18. Perhaps contrary to what one might expect, this designation is applied to the portion that is eaten.[3] This need not imply, as Milgrom suggests, that the category does not apply to the incinerated portion, but for my

argument here, it is important to underline the importance of Levitical assignment of holiness to the non-memorial portion. Related to this is a third and final noteworthy difference from the previous offering: with the cereal offering, there is a connotation that the aspect of this offering was to be joyful.[4] In slight contrast to the previous offering, which carried aspects of expiation and entreaty, the cereal offering is meant to be propitiatory. Milgrom follows Driver in suggesting, "The most likely definition for biblical mnḥh is 'a present made to secure or retain good will.'"[5]

The cereal offering provides a particularly intense emphasis on the freshness and excellence of the offering in question. The materials for the cereal offering are repeatedly described in Lev 2 (vv. 1–2, 4–5, 7 – also in 5:11, 6:8, 6:13, 7:12, 14:10, 14:21, 23:13, 23:16–17, 24:5) as using "choice flour" [slṭ], which was, as Wegner observes, "significantly more expensive than barley (2 Kgs 7:1, 16, 18) and was used in fine cuisine (Ezek 16:13), proper for entertaining guests (Gen 18:6)."[6] The specific elevation offering described in Lev 23:17 is a festal variation on this cereal offering. In this case, the firstness is even more underlined: it is to be a new grain offering [literally "offering of the new," Heb. mnḥh ḥdšh] brought in the form of two loaves baked with leaven (Lev 23:16).

This is a very brief survey of the cereal offering, as there are numerous instructions on how to perform the cereal offering scattered across the biblical text (especially the HB). In seeking to focus this explication, I have chosen to focus the remainder of this chapter on one specific instance of the cereal offering, described in Lev 23:17 and the end of Lev 2 (vv. 14–16). This offering, the bkwrym or firstfruits offering, is particularly appropriate for study because (as I shall go on to note) it is taken up in significant ways both in the NT and in early Christian literature. With this in mind, I proceed to look at the ways in which firstfruits offerings provide an example of the offertory emphasis on quality and set up a consecratory dynamic where work and worship are brought into a unique relationship. Making these two things clear does require some untangling, however, as interpreters of these texts have tended to assume that the involvement of work products in these acts of worship was superficial. As I have already suggested elsewhere, I believe that awareness of the specifics of agrarian work can helpfully illuminate these texts and highlight ways in which the involvement of work in worship was far from superficial.

Cereal Offerings in Context: Bringing Firstfruits

Taking firstfruits in the widest perspective, in the Hebrew Bible bkwrym is a relatively narrow liturgical term, referring to an offering that is often in close association with the second of the three great pilgrimage harvest festivals. This second festival is given several names: Feast of Harvest [ḥg qṣyr] (found

in Exod 23:16), Feast of Weeks [*ḥg šbʿt*] (found in Exod 34:22, Deut 16:10, 16:16; Ezek 45:21; 2 Chr 8:13), and the most obvious "day of firstfruits" [*ywm bkwrym*] found in Num 28:26. As with burnt offerings, firstfruits offerings do not begin or end with Leviticus. There are a number of consecratory offerings in the Pentateuch that surround firstfruits and the feasts that parallel them.[7] As I have already hinted, some contemporary readers proceed from the designation of firstfruits as a "token offering" to a presumption that the use of a representative portion might permit a detachment of the meaning of firstfruits from an agricultural context. Given my overarching argument here that the complex of offerings "draws in" the work of Israel, I would question whether this accurately represents the full force of the term and conversely whether "firstfruits" may have – as with the "unblemished" status of the burnt offering – invoked ancient notions of productive excellence. Given the brevity of the accounts that concern firstfruits, I shall also make references to some semantic relationships that can help illuminate a reading.

The emphasis on the importance of offerings to YHWH in the form of firstfruits surfaces with explicit force in the Mosaic Law in Exodus. Notable here is the inversion of context. While the language of firsts occurs frequently in the first 13 chapters of Exodus, 16 out of 18 of these early occurrences concern the infanticide perpetrated by Pharaoh and the final reciprocal plague against the oppressive and hard-hearted monarchy of Egypt with the death of all firstborn Egyptians (Exod 11:5, 12:29). This appreciation of "firstfruits" also highlights the faithfulness of the two midwives, Shiphrah and Puah, in defying the Pharaonic orders to commit genocide in Exod 1:17. In the first text using this language in the context of worship (shortly following the report of the final plague and preceding the capitulation of Pharaoh) the Israelites are instructed, "Consecrate all the first-born to me, the first birth from every womb, among the Israelites" (13:2 NJB). The Exod 13 text codifies the requirement of offerings that are firstfruits or first born. The text also offers a further clarification to their status: they are to be consecrated. This instruction to consecrate or make holy, a rendering of the Hebrew "*qdš*," harkens back to God's work in Gen 2:3, where "God blessed the seventh day and made it holy." With regard to the children implicated in Exodus, I would suggest that this consecration may be read as an aetiological remembrance of the Exodus deliverance of the Israelite first born, and thus a sort of dedication for service.[8] This association between firstfruits and offerings is explicated and reaffirmed in the formal covenant law at Sinai (Exod 22:28–30, 23:16, 23:19) and stressed further in the reiteration of instructions given after Israelite idolatry (34:19–20, 34:22, 34:26) alongside passover and sabbath observance.[9] The importance of these firstfruit instructions is underlined by their location within those laws that, as Durham notes, "set Israel apart from all other peoples as Yahweh's own unique

and loyal people."[10] As I shall explore further below, the specific act of consecration as associated with the firstfruits offering is also formalised in the later Pentateuchal texts.[11] It is important to reiterate that one may best understand these offerings not as pure categories, but rather as formal liturgical acts that exist within a tradition-complex of other offerings. In this way, the cereal offering (and the more specific expression in the form of a firstfruits offering) ought to be situated within a tradition-complex of "first-offerings," which is initiated in Genesis. Keeping this in mind, I shall note some of the differences between the various accounts of firstfruits, but also probe these texts for points of convergence concerning this concept of firstfruits.

Distinguishing Firstness: Chronology and Quality

The first crucial question with regard to an offering of *first*ness relates to the meaning of this act of selection. In keeping with my suggestion at the outset that these cereal offerings are concerned with excellence, it is important to sort out the ways in which first relates to the fineness of the offering and the ways in which it is merely a chronological designation – or indeed if these two can be distinguished in such airtight ways. Turning from Genesis to Exodus, one can see how the firstfruits offering expands the dedication (or consecration) of firstborn children into the domain of horticulture and agriculture – and here we arrive at the "cereal" form of the gift brought. This agricultural form comes into sharpest relief when one turns to the aspect of selection that precedes the bringing of this offering. As regards the question of quality, one may prefer not to say that the firstborn (male) child was the most valuable or best in an absolute sense, but they surely provided a function within Israelite society that was of particular importance. Further, to simply state the obvious, when the firstborn was dedicated, they were often a family's *only* child.

As we shall see, the notion of firstness in agricultural offerings is to a certain extent bifurcated in the HB. It is important to note that there are two different Hebrew liturgical terms that are both often translated into English and Greek as firstfruits: *bkwrym* and *rʾšyt*. Milgrom, in particular, suggests that there is a status distinction (conceived within a reconstructed strand of "priestly" texts) to be drawn based on the former being "raw" and the latter "processed." In his words, "*Bikkurim* refers to 'the first ripe,' and *reʾshit* to 'the first processed.'"[12] After some wrestling with his approach, I have accepted Milgrom's proposition with some reservations. This suggestion that the two words represent different designations is well supported by Rabbinic materials, particularly *Mishna Bikkurim* and *Mishna Terumah*, and is affirmed by similar usage in the Qumran materials as well.[13] Firstfruits are, at least whenever a distinction is made, specifically taken from newly ripened produce (Exod 23:16, 23:19, 34:22; Num

13:20; Neh 10:37).[14] There is a direct correlation here between the first born and the first grown such that plucking the first head of ripe grain and dedicating it to God matches the consecration of the promise that the firstborn child represents. Yet it should be noted that this unity of distinction relies on a strong separation of priestly and non-priestly literature, and there is little internal warrant in the *bkwrym* texts of Exodus for such a specific reading. Finally, while Milgrom's distinction is absolute with regard to *bkwrym*, he is less sure with *r'šyt*: "Outside of P, *re'shit* has two other meanings: Either it is equivalent to *bkwrym*, 'first ripe' (e.g., Deut 26:2, 10; Jer 2:3), or it means 'the best' (e.g., 1 Sam 2:29b; 15:21; possibly Exod 23:19; 34:26)."[15]

Though a full treatment of *r'šyt* lies outside the scope of this study, some comments are in order regarding the relation between these two offerings, lest the reader come away with a dichotomy rather than a differentiation. Both offerings function within what I termed earlier a tradition-complex of "first-offerings," and it is important to note that both also serve a purpose that is closely related to the burnt offering, namely to subordinate the economic activity of Israel to worship of YHWH. This convergence of first-offerings is actualised in the LXX, where different Hebrew terms are flattened in their translation into the Greek *aparchē*. The Greek rendering, while blurring these aforementioned distinctions, does not distort the more fundamental purpose of these liturgical acts. In this way, the consecratory activities of the two offerings can be seen as complementary. With *bkwrym*, one offers up the first moment of promise in the harvest. With *r'šyt* and the other firstfruit offerings, this act of dedication evolves into one of selection, where discernment is engaged in a particular way.

In the context of the Feast of Harvest or Feast of Weeks, the firstfruits offering is specifically one of wheat or baked loaves of wheat-bread (generic in Exod 23:16; wheat in Exod 34:22; grits in Lev 2:14; oil, wine, and grain in Num 18:12), but later developments indicate that firstfruits come to involve all of the seven Rabbi-approved agricultural products.[16] As "first" can indicate a spectrum of produce, it should be noted that this is nonetheless first-*ripe*, such that all of the products, though unprocessed, were edible. Further, the first-ripening of these products can extend from April to May for barley and wheat and into September to November for olives. The use of wheat for the firstfruits offering in the context of the festival of weeks is a perfectly sensible one, as this is the chronologically first of the first-ripe.[17] The inclusion of other products indicates that firstfruit offerings extended well beyond the liturgical confines of the Feast of Weeks, and this fact should prevent one from assigning too narrow a provenance to the practice. Thus, the dual practices of *bkwrym* and *r'šyt* offer a double-weaving of Israel's worship through their work. First, as anyone who has planted a garden can attest, the discovery of the first piece of ripe produce is a moment rife with excitement. As an Israelite farmer first beheld a bit of ripe

grain, their practice would have been to cut it off to save for a *bkwrym* offering. Work was woven into worship a second time at harvest, after one had, most likely in cooperation with one's wider community, gathered, picked, harvested, threshed, and ground the various "fruits" into their final products. As a group of labourers beheld the final harvest, whether bounteous or sparse, there would be a moment in which the *r'šyt* offering was set aside as a sample of the finest from among the various products. For oil, it was the first skimming of the first pressing (labelled as "first cold press" on our olive oil bottles now); with wheat it was the finest of the grain.

This relationship between the two firstfruit offerings is reinforced in several *bkwrym* texts by proximity: when one finds a dedicatory *bkwrym* offering, another involving selection is almost certainly nearby. This is the case with Exod 22:28 and 23:16. While 23:16 provides the terser instruction concerning the liturgical calendar, 22:28 involves refined produce. Regrettably, English translations do not always render the possible force of the vocabulary in 22:28 regarding the quality of the offering requested. The NAB offers the flat rendering, "the offering of your harvest and your press," while the REB offers, "first of your harvest, whether grain or wine," which still leaves the force of "first" ambivalent. Durham recommends a more vivid rendering, based on the LXX: "You are not to hold back your bumper crop and your vintage wine and richest oil."[18] Even though he relies on the more elaborate LXX text of 22:28, Durham's more vivid rendering does also seem to capture the uniquely agrarian aspect of the text in the MT.[19] This first-skimming belongs to the "first-processed" category, and some more vivid language is certainly called for.

This relation between firstfruits and quality is also represented in Numbers by a resonance between *bkwrym* and *r'šyt*. The context of Chapter 18 is a working out of the priestly prebend taken from this offering, as described tersely in Lev 2:3, 2:9, and 6:7–23. To this end, Num 18:12 offers a string of nouns in construct, which the JPS aptly translates as, "All the best of the new oil, wine, and grain – the choice parts that they present to the LORD – I give to you." Verse 13 uses *bkwrym* in a way parallel to *r'šyt* in the former: "The first fruits of everything in their land, that they bring to the LORD, shall be yours" (Num 18:13 JPS).[20] In a less obvious way, Num 15:20–1 seems to make this sort of association: "as the first yield of your baking, you shall set aside a loaf as a gift; you shall set it aside as a gift like the gift from the threshing floor. You shall make a gift to the LORD from the first yield of your baking, throughout the ages" (JPS). This suggestion becomes all the more important when one notes how, in the text of Deuteronomy, mention of *bkwrym* is completely absent. Here the firstfruits ceremony is not absent, but is described, as in Exodus, without detail (Deut 16:10, 16:16). There is more elaborate description of *r'šyt* offerings, particularly in their social dimension, to be found in Deut 26. Tigay, in

his JPS commentary, suggests that the instructions here merely elaborate on the firstfruits Temple offerings (Exod 23:19, 34:26; Num 18:12–13; Deut 12:6, 14:28–9, 18:4). This concurrence in Deuteronomy between firstfruits and a liturgical feast leads me to my next point of emphasis regarding the social aspect of these offerings.

Distinguishing Wafers From Handfuls: "Token" and "Representative"

One can find reference to the persistence of the firstfruits feast in the life of Israel in several apocryphal and NT texts, under a new name: Pentecost.[21] In Tobit 2, Pentecost is described as the occasion for a great meal at home and the occasion for hospitality.[22] The instructions in Deuteronomy regarding the festival note that the Israelites are literally to offer their firstfruits as a gesture of deference to God and this occurs in the context of a great feast, as the instruction in Deut 16:11 to "party" implies (described as a "holy convocation," *mqr'-qdš*, in Lev 23:21 and Num 28:26). "Party" is my (admittedly casual) rendering of *śāmaḥtā*, which is often rendered with the now stale-sounding "rejoice" in many popular translations (TNIV, ESV, JPS, NRSV). The writers of the NAB, perhaps actually having attended a party once or twice, themselves opt for "make merry."[23] Given my contention above that all the produce was likely meant to be of the highest quality, this may have been quite a significant event. It is also significant to note how, in Deuteronomy, 26:1–11, the firstfruits festival is placed as one of the two liturgies (the other being tithes, described in 26:12–15) to be practised in the newly inhabited Promised Land. By this measure, this is a liturgy of renewal and crucial formation.

This "holy convocation" was likely also a glad day for priests who were entitled, given the Levitical instructions assigning it as a prebend, to consume the bread made with this fine flour and the two sheep brought by the congregant ("they shall be holy to the LORD, for the priest," Lev 23:20 JPS). Similar but terser instructions for the same feast are found in Num 28:26–31 and Deut 16:9–12. The specific instructions provided might seem to affirm the fact that this offering is to be a token offering, as it is only one loaf and two sheep. However, as Durham notes, in commenting on the occurrence of firstfruits in Exodus, the command regarding firstfruits is intended to underline how "an appropriate respect for YHWH also requires priority for him in the matter of offerings."[24] As I have suggested above with regard to the cereal offering, this deference need not be austere, as the prohibition provided in Exod 22:28–30 sets the tone: this prohibition "is against a token offering from a bounteous crop, a legalistic expression of the obligation as opposed to a joyous offering in thanksgiving."[25] In this way, the offering is not to be a token offering without resemblance to the material of the harvest

and one's hard work, as in the case of the tasteless machine-made communion wafers that are so often used in contemporary liturgies around the world. This is a *representative* portion that is drawn into worship in a materially coherent sense.

This case for firstfruits is not of purely technical interest, but serves as a way of properly deploying the moral force of these worship instructions. Consecration as a theological category is associated in a crucial way with excellence in the work that is brought. For an age in which workers are increasingly alienated from their work, such a link commends the importance of affirming the goodness of the ordinary agricultural work of Israel and provides some ritual context for the further affirmation of excellence. Seen in this way, the offering of firstfruits also has a certain unity, providing Israel with an opportunity to affirm their holiness as a people by consecrating their best to YHWH. In this way, the firstborn child and the pinnacle of Israelite agriculture and horticulture are set apart for a similar purpose and "consecrated to Me" (Exod 22:31, NRSV). Just as the people of Israel are set apart from the nations with a special status as God's firstborn son(s) (Exod 4:22) and consecrated by their worship, so too the inner pattern of this worship involves the consecration of first-things back to YHWH. This consecration of the agricultural and horticultural firstfruits of Israel's work also parallels the contribution of artisans to the consecrated place, the Tabernacle, as described above. Indeed, the Hebrew verb for consecration, *qdš*, in nominal form translates as "sanctuary."

I have established that the bringing of firstfruits implicated the work of Israel in a direct way in their worship and provided a reminder in practical form that one's daily work was to be inextricably involved in one's worship. Notably, this involvement was not blind, but rather carried a qualificatory aspect such that excellence in agricultural craft was observed and celebrated in the process of selection. Bringing the first and best portion to God concurrently celebrated craftsmanship and relativised the place of wealth (even the product of one's own labour). This relativisation also works itself out in the communal aspect, as the firstfruits festival is wrapped closely in humanitarian service. The ingathering that led to the firstfruits marked the beginning of the gleaning season in Israel. Any person who had observed or participated in the feast would have known that there was an aspect of justice that accompanied the offering of the most excellent portion of the harvest. There is further strong warrant to believe that marginalised persons were meant to be invited to the feast to enjoy the freewill (and gourmet!) offering. Along these lines, Carl Armerding observes:

> For the well off to rejoice without considering the widow, the orphan and the alien would have been unthinkable and a denial of all that covenant blessing involved. In Deuteronomy 16 (cf. Deut 26:1–15) the emphasis

on giving back is even stronger. The worshiper brought a freewill offering (literally, 'the sufficiency of what your hand can afford') according to the measure of God's blessing. He rejoiced before Yahweh, together with all his extended family, sons and daughters, male servants and female servants, the Levite (to whom no inheritance of land had been given), the resident alien, the orphan and the widow.[26]

In particular, in the context of what Von Rad suggests may be one of the earliest recognisable creeds of Israel, at the climax of Deuteronomy in 26:11 we find a stipulation that this feast is to be enjoyed "together with the Levite and the stranger in your midst" (JPS). I shall extend this discussion of the social aspect of these offerings with my analysis in the next section of the *zbḥ šlmym* offerings. First, however, I turn to the NT in order to provide a closer look at the appropriation of this consecratory logic and liturgical celebration of excellence.

Firstfruits in New Testament Perspective

Cereal offerings are not mentioned explicitly in the NT. However, as I have hinted above, there are a number of changes in liturgical lexicon that occur in the (pre-NT) transition from a range of more specific Hebrew liturgical terminology to a more limited set of Greek words. Thus, "grain offering" is an English rendering of several Hebrew nouns presented in construct, *qrbn mnḥḥ* [literally: "offering of [a] grain-gift"], which the LXX translates, using more generic terms, as *dōron thysian* ["gift sacrifice"]. Among the various mentions of *thysian* in the NT, none of these refers explicitly to cereal offerings, but this does not mean this meaning cannot be implied. As Averbeck notes, "the NT recognized the distinction between the religious and secular usages of the Heb. Term . . . more readily than the distinction between any offering, and specifically a grain offering."[27] In consequence, while there are a number of instances of either *dōron* or *thysian* in the NT, the meaning is almost always intended generically, i.e., regarding "sacrifice."[28] The Hebrew term for firstfruits, *bkwrym*, is translated in the LXX in two ways. First, there is *archēn therismou* [literally "first of the harvest," as in Exod 34:22]; these two words do not occur together in the NT. The second rendering, which does appear in Paul's epistles, is a modification of *archē*: *aparchē*. In the LXX, *aparchē* is used in almost exclusively liturgical contexts (the one exception is in 2 Sam 1:21 in Samuel's reference to "bounteous fields"). The explicit liturgical nature of the term here should not be surprising, given the extensive GR usage also in a ritual context.[29] It also bears mention, as I have already noted in the previous section, that *aparchē* is utilised more broadly in the LXX than merely in translation of the Hebrew *bkwrym*, referring in some cases to other offerings that also occur within a ritual context.

Given the apparent absence of any reference to cereal offerings in the NT, one can find a more robust basis for comparison in seeking to demonstrate the canonical persistence (albeit in a metaphorical context) of *aparchē*.[30] For this comparison, I shall maintain an awareness of the meaning and use of this concept as I have detailed above as a backdrop for an analysis of Paul's use of "firstfruits." Recent research in biblical studies has highlighted Paul's use of liturgical metaphors and it is my hope that this study can further emphasise both the scholarly neglect of Pauline liturgical metaphor and the "fruits" that can come from close scrutiny of them.[31]

It is important to note a few caveats at the outset of this treatment of firstfruits in Paul's epistles. The scope of this chapter (or indeed, perhaps even an encyclopaedia) does not permit treatment of the vast and growing literature concerning Paul's knowledge of and relationship to GR culture and/or Hebrew culture or this relationship to a reconstructed audience for each epistle. However, a couple of observations along these lines are in order.

First, there is a well-attested GR *aparchē* festival and liturgy. There is no contemporary study of the firstfruits festival in GR context, or more particularly Paul's relation to it, and this would be a valuable line of inquiry one may hope will be taken up in NT scholarship. One need not presume, though, that the GR firstfruits festival was at odds with the Hebrew one. The most important point of distinction for my analysis of Paul's theology here is with respect to the person being worshipped; and along these lines, it may be fair to consider Paul as thinking in greater continuity with Hebrew than with GR religion.

Secondly, along similar lines, I shall bracket out considerations in my discussion of Pauline audience. These considerations are no doubt of value, but reconstructions of the Pauline audience are sufficiently complex that space does not permit critical interrogation of these reconstructions in parallel with my more conceptually focused analysis; and the broader purposes of this study would be only tenuously edified by such an undertaking. My purpose with regard to these Pauline references to "firstfruits" is relatively constrained: to explore the ways in which Paul's use of the liturgical language of firstfruits might be conceptually coherent across his epistles and test the hypothesis that he may be operating with a thick understanding of Hebrew liturgy that maintains an awareness of the aspect of quality and excellence that I have noted above. Though one cannot deny that Paul's usage may be deployed with reference to a Hebrew or GR liturgical context, I shall assume that it is a mistake to attempt to dichotomise Paul's Jewish context and the thought-world that nourished it and his experience of the GR world; and that the audience for his epistles may well have had experience of both as well.[32] As I have argued above, it may be best to situate the Hebrew concept of firstfruits in a tradition-complex of "first-offerings." This wider liturgical perspective extends beyond exclusively Temple-focused liturgy

188 *Moral Maintenance*

and allows for the possibility that ANE persons with more moderate exposure to Jewish practice would still have had some exposure to the unique inflections of Hebrew firstfruits liturgy. Neither of these assumptions is radical, but, as I hope to demonstrate, considering Hebrew liturgy does provide interesting illuminations of Paul's often thickly metaphorical and terse prose. Paul's use of metaphor does not simplistically deploy merely the form of this liturgical concept; rather, his use betrays an awareness of the meaning embodied by the full ritual practice of the firstfruits offering.

Firstfruits in Paul's Epistles

With the stage set, I proceed now to analysis of three different Pauline epistles where the concept of firstfruits is deployed in order to better understand Paul's metaphorical use of these liturgical concepts: 2 Thessalonians (2:13), 1 Corinthians (15:20, 15:23, 16:15), and Romans (8:23, 11:16, 16:5). The first Pauline usage of this term comes in 2 Thess 2:13 near the end of his exhortation to the Thessalonian church, where Paul resumes his thanksgiving offered in his introduction (1:3) and just before his prayer in 2:16–17. Paul suggests: "But we ought always to give thanks to God for you, brothers beloved by the Lord, because God chose you as the firstfruits to be saved, through sanctification by the Spirit and belief in the truth" (2 Thess 2:13 ESV). One may wonder why Paul did not simply use the more generic non-liturgical term *archē* ["first"].[33] There are several reasons why Paul's use of the liturgically oriented term might be appropriate here in 2 Thess. First, the broader theological context of 2 Thess 2:13 is soteriological, namely God's choice of the Thessalonian brothers to be saved. In this sense, by recourse to liturgy, Paul reverses the expected doxological context: God brings a firstfruits offering to the broader church and it is constituted by the faithful Thessalonians. Perhaps further undermining a more generic meaning, the sense here cannot logically be chronological either, as F. F. Bruce suggests: "the Thessalonian believers could not be called the firstfruits of Macedonia, for the Philippian church was established before theirs."[34]

Paul's second usage of *aparchē* occurs in a Christological context in 1 Cor 15:20 and 15:23: "Christ has been raised from the dead, as the first-fruits of all who have fallen asleep" and "but all of them in their proper order: Christ the first-fruits, and next, at his coming, those who belong to him" (NJB). These texts occur in the midst of Paul's larger argument for the significance of Christ's bodily resurrection. One might think the usage here to be substantially different from 2 Thessalonians, except that Paul reverts to a similar example later in 16:15: "You know how Stephanas' [household] have been the first-fruits of Achaia and have devoted themselves to the service of God's holy people" (1 Cor 16:15 NJB). In this sense, the members of the house of Stephanas have made of

themselves a firstfruits offering, again to serve the broader community. There is a tension with an exclusively chronological reading of firstfruits here, as with 2 Thessalonians above, as Acts 17:34 seems to indicate that the Athenians were converted before Paul had been to Corinth.[35] A final similar usage of the term can be found in Rom 16:5, where Paul makes more straightforward reference to another firstfruit Christian, Epaenetus, the first Christian convert of the Asian province with Ephesus as its capital. While nearly all of Paul's uses of firstfruits are in reference to particular persons, there are two remaining instances of *aparchē* in Romans that implicate a more complex group of agents; to these I turn now.

The occurrence in Rom 8:23 brings firstfruits into a third pneumatological domain (in addition to the human and specifically Christological dimensions described above). In this instance, it is not the persons who *are* the firstfruits of God's work; rather, Paul notes, "we ... have the firstfruits of the spirit" [*tēn aparchēn tou pneumatos*]. So what is it that possession represents? It is important to first note that possessing here is incomplete, realised fully only in eschatological perspective. Paul has already suggested at this point that both the creation (v. 22) and "we ourselves" (v. 23) are groaning [*stenazomen*] under the weight of suffering as all anticipate their final redemption where, by the prototypical firstborn Christ, we will be firstborn [*prōtotokos*] among many brothers (v. 29). With this limit in mind, one can read Paul's reference to *prōtotokos* in verse 29 as referring to the ministerial work of his audience. The same language is employed in the LXX description of Abel's offering, which was "the firstborn of his flock" (Gen 4:4), and in the dedication of firstborn sons (Exod 22:29, 34:19; Num 3:12–13). This NT usage is similar to that in the Hebrew Scriptures, inasmuch as there is an aspect of *dedication*, but the NT usage also adds a newly eschatological dimension. Those Christians who have the firstfruits of the spirit are to endure the sufferings that come from being a committed minority in lieu of the larger brotherhood that is to follow in the newly constituted Kingdom of God.[36]

This brings me to the final instance of the firstfruits in Paul's writing that can be found in Rom 11. This instance draws on the most explicitly agricultural dimension of firstfruits and it is this usage that I find to have the most unexplored theological consequences. In this instance, I would argue, Paul deploys logic that is intrinsic to the practice of the Jewish pilgrimage feast and firstfruits offerings. In Rom 11:16, Paul makes a rhetorical suggestion that functions as part of a much larger argument in Rom 11. Paul suggests: "If the dough offered as firstfruits is holy, so is the whole lump, and if the root is holy, so are the branches" (ESV). By way of this rapid procession of metaphors in Rom 11, Paul offers an argument for the place of Israel (and by extension the cultus) in God's salvific work now displayed with fullness in the resurrection

of Christ and the meaning of (at least some of) Israel's rejection of that good news.[37] But for my purposes here, it is important to note that these metaphors are meant to provide some clarification as to the nature of inclusion in God's salvific work (cf. Rom 11:13–15).[38] In verse 16 one finds Paul's very brief use of firstfruits followed by another metaphor (using roots and branches) in rapid succession that further affirms his point regarding holiness and inclusion (11:16). Paul elaborates on the meaning of his second metaphor in verses 17–24, but he does not return to explicit mention of *aparchē* here. This usage is what I would describe as a more specific sense of the dedicatory consecration described earlier in this chapter. One need not assume that Paul's brevity with regard to the firstfruits analogy is because the details behind the metaphor are insignificant, as it is just as plausible that the rich ritual context already provides a narrow meaning for his statement: here Paul situates the notion of firstfruits within a broader consecratory logic.[39] In this way of thinking, we bring firstfruits to God as an act of offering or dedication and this act consecrates the remainder that has not been brought. In the logic of Paul's argument, the offering of firstfruits does not grant it a separate and unique status from the rest of the economy that produced it. To the contrary, it draws the entire batch into an act of consecration, marking it all holy. Cranfield argues along similar lines:

> The OT nowhere says that this offering hallows the rest of the dough: its purpose seems rather to have been to free the rest of the dough for general consumption (cf. Lev 23:14). But a comparison of Lev 19:23–25, according to which the fruits of the trees are to be regarded as 'uncircumcised' until an offering has been made to God from them, suggests that it would be quite natural for the Jew to think of the offering of the first-fruit cake as purifying the rest of his dough.[40]

I would like to argue that Paul's use of the firstfruits offering concept by way of metaphor in Romans establishes a point of logical continuity between the Jewish and early Christian understanding of firstfruits and offerings. Accepting this suggestion has several consequences, one of which might be to temper a reading of Paul's exhortation in Gal 4:10 regarding feast days. On this basis, one might argue that his overall intention is subtler than to merely dismiss the liturgical function of feasts wholesale. In a similar eschatological sense, in Col 2:16, these days are described as "a shadow of the things to come" (v. 17); and indeed, though the calendar is practised by pretentious persons and commended by Judaisers for righteousness (both postures that Paul resists, cf. Gal 4:10), they have a glorious function in the age to come. While Paul may dismiss practice for the sake of a rhetorically laden theological argument, I would argue here that

the moral logic undergirding the notion of firstfruits has a persistent place in Pauline theology.

This is also emphasised in the text of Galatians by the turn to a metaphor regarding dough. Many commentators treat this as a reference to a generic and as of yet undiscovered GR proverb; and yet the imagery of *phyrama* is parallel in many ways to that used in Rom 11. Here Paul omits the obvious reference to *aparchē* and the context is inverted (namely that unholiness can corrupt an entire batch). In his study of yeast or leaven [*zymē*] in the *TDNT*, Hans Windisch considers whether Paul's usage in 1 Cor 5:6 / Gal 5:9 might be resonant with a Jewish festival, but his inquiry is with exclusive regard to the feast of unleavened bread. He concludes that Paul "goes rather beyond the thought and usage of the Jewish festival."[41] Yet Windisch's primary reason for assigning the source of this saying by Paul to a GR context is the negative aspect of the statement: "In spite of all the various analogies, the parable bears the stamp of originality. In contrast to the Plutarch tradition Jesus views the process of leavening as something healthy."[42] As I have suggested above, there seems to be reasonable warrant to ask whether there may also be a Jewish liturgical context for understanding Paul's statement in Galatians.

This survey of Pauline use of firstfruits reveals that, though it may have been treated as perfunctory or empty by celebrants, the practice of the festival of harvest offered a yearly celebration that could be theologically and morally laden with meaningful ritual actions providing a practical elaboration of Israel's convictions regarding the interrelation of good work, proper worship, and justice. Along these lines, one may attempt a provisional synthesis of Paul's use of this term presuming a Jewish context. Put briefly, here is how I think Paul's use of the metaphor might overlay onto a summary of the literal details of the ritual practice. As in the Hebrew Scriptures, where the firstfruits offering consists of the people of God bringing a token representation of the first and/or very best results of their labour for worship, Paul suggests that Christians may offer themselves in an even more direct way. The connotation, particularly in 2 Thessalonians, is that these human-firstfruits, particularly the protological and superlative firstfruit, the person of Christ, are the products of a labouring Creator God. These persons are not merely chronologically first, but their firstness betrays an aspect of quality: they are the best produce amidst the early harvest of God's cultivation among the gentiles, pre-eminent, in the case of Christ. Finally, these firstfruit-persons are brought not exclusively before God, but in a striking (and I daresay Christological) inversion they are brought before the unholy people. As with the Hebrew festival, these firstfruits are offered benevolently not just for gleaning but for a great feast of the people that foreshadows the great and intimate banquet to come. Nijay Gupta vindicates the argument I am making here, in providing a more general basis for such a reading. In surveying Paul's use

of holiness language more generally, he argues, "language of holiness suggests a cultic interpretation at the most general level."[43] Looking specifically at the "wish prayer" in 1 Thess 5:23 (and 3:13), Gupta argues that Paul's imagery "is further enhanced by the similar adjectives of 'complete' or 'perfect' – a descriptive category prominent in the Jewish conceptions of purity."[44] Thus, "It is possible that Paul's thinking is similar – just as the regulatory sacrifices are required to be holy and impeccable, so the offerer – even the person-as-offering – must surely meet that same standard in regard to character."[45] On the basis of this interpretation, taking as given a theological continuity between Lev 2 (and the other firstfruits texts in the Hebrew Scriptures) and their metaphorical deployment in the NT, I turn now to some analysis of the appearance of this term in early Christian practice. It may surprise some readers to find that the language of firstfruits recurs with an even more explicitly liturgical tone.

"Firstfruits" in Christian Practice

An indication of the importance of "firstfruits" in offertory practice for Christians may be found in the Italian Basilica di Aquileia. The current cathedral was built in the eleventh century, on top of a much more ancient basilica, preserving a mosaic floor beneath that was likely built between 313 and 333 CE, just after the conversion of Constantine. What we find in these mosaic tiles is an astonishing testimony to offertory practice in the late antique church. Peter Brown aptly summarises the scene:

> The mosaics in the middle of the nave made plain what the inscription meant. Wealth had flowed into the church. Octagonal panels of mosaic showed chubby servants in late Roman dress as they gathered the good things of the earth. Their busy activity evoked the many scenes of bucolic, innocent prosperity that were places on the mosaics of contemporary villas. At the center, a winged Victory, with a laurel crown on her head and a palm in her hand, stood above two full baskets. These were the 'first fruits' offered by the laity to the church.[46]

One of the patrons of basilica construction explains the warrant behind his endowment to the church in another part of the mosaic where he left an inscription. The text indicates that this gift was given "*Dei dono*" or "from the gift of God." As Peter Brown relates,

> This succinct phrase echoed the solemn prayer of King David, when he endowed the first Temple of Jerusalem: *For all things come from Thee, and of Thine own have we given Thee* (1 Chron. 29:14). This was a votive formula

shared by Jews and Christians. It also occurred in Jewish synagogues.... As in the synagogue, wealthy Christian donors claimed that by contributing to the church, they were giving back to God a little of the wealth He had showered upon them.[47]

Brown's emphasis on the element of generosity that lay behind this early Christian practice demonstrates a connection back to what I suggested at the end of the previous chapter. These gifts were brought in such a way that they upheld the rich early Christian practice of charity. I want to suggest further that this act of giving in early Christianity was multidimensional, and one of these dimensions carried a *qualitative* aspect. Another way of putting this is that those persons who brought firstfruits also brought their best.

The best place to find mention of firstfruits offerings in early Christianity is in a literature generally referred to as Ancient Church Order documents. These texts, the most famous of which is probably the *didache*, contain an array of instructions for behaviour in early Christians and include a range of practices that includes hospitality, baptism, teaching, and offerings. The practice of bringing firstfruits offerings finds explicit mention – alongside tithes and charitable free-will offerings – in almost all Ancient Church Order documents, starting with the *Didache*, and this is an appropriate place to begin in seeking to clarify early Christian "firstfruits" practice. It is also worth noting that Jews continued in the practice of bringing firstfruits into the first century and this charitable giving continued to evolve as early Christian practice developed. We have good reason to believe that Jewish practice retained the recognition of quality in firstfruits offerings, as in first-century Jewish practice "[f]irst fruits of doubtful origin were not accepted as offerings" and were liable to be refused.[48] In his extended study on the *Didache*, Del Verme argues that particularly those passages referring to a firstfruits offering in the *Didache* "seem to reflect an ongoing process of interaction with Judaism and Jewish institutions, pointing to the existence of a Jewish Christianity which existed within the bounds of the 'Great Church,' and which had not yet manifested any of those traits of belief or practice which subsequently led to its marginalisation."[49] This suggestion seems appropriate given the points of resonance between the Hebrew offertory I have explicated above and the standard for bringing firstfruits that is presented in *Didache* §13. In this passage, the author proposes a mode of support for itinerant preachers who have become sedentary:

> Take, therefore, all the first fruits (*pasan oun aparchēn*) of the produce of the wine press and threshing floor (*gennēmatōn lēnou kai halōnos*), and of the cattle and sheep, and give these first fruits to the prophets, for they are your high priests. But if you have no prophet, give them to the poor. If you

make bread, take the first fruit and give in accordance with the commandment. Similarly, when you open a jar of wine or oil, take the first fruit and give it to the prophets. As for money and clothes and any other possessions (*pantos ktēmatos*), take the first fruit that seems right to you and give in accordance with the commandment (*entolēn*).[50]

The language of this *Didache* passage is notably resonant with Hebrew offertory instruction, made most obvious by the two references to *entolē* ["commandment"] (*Didache* 13:5, 7) but also present in the mention of "threshing floor" and "winepress," which together resonate with the firstfruits texts in Num 15:20, 18:27, and 18:30, which use the same nouns, "*halǭs*" and "*lēnos*." Further, the *Didache* refers to these firstfruits as priestly prebends, resonating with the firstfruits instructions in Lev 23:20.[51] Yet in spite of these similarities, the author of the *Didache* intensifies the offering, extending both the scope of generosity – not merely to priests, but also to the poor – and the pool of goods that are eligible as such firstfruits to include any "*ktēma*" ["possessions"]. It is also interesting to note that the second "command" is not actually provided in the Hebrew Scriptures, i.e., giving from among one's possessions more generally. It may be more likely that the writer of the Didache is making reference to the complex of charitable giving that had arisen in both Christian and contemporary Jewish practice.[52]

While this intensification takes place with regard to the generosity of the offering, there is simply not enough detail to decisively affirm that the qualitative aspect of the offering persists in early Christian practice. Del Verme argues, as I have above, that the Greek usage of these Hebrew terms betrays a merging of categories: "The fact that the same term *aparche* . . . can represent two separate terms in Hebrew, is itself an indication that the terms *rʾšyṭ* and *trwma* were not always strictly differentiated in Hebrew or at least in the way the Hebrew was understood by the translators."[53] This "semantic bi-valency" parallels the LXX usage; and consequently he argues that it is better to read the use of firstfruits as operating in a "comprehensive sense," including the whole variety of possible emphases that I have outlined above in my study of firstfruits. Based on this conclusion, Del Verme proposes an English translation of *Didache* 13:3 in a way that preserves an emphasis on quality: "Therefore take all the best of the products from the winepress and threshing floor, from the cattle and sheep, and give them to the prophets, because they constitute your high priests."[54]

Several later Church Order documents make use of the *Didache* as a primary source and preserve reference to a specific firstfruits offering. The *Didascalia Apostolorum* expands on the *Didache* instructions in §2.25.7 and §2.25.9: "set apart special offerings and tithes and first fruits for Christ the true high-priest, and for his ministers, as tithes of salvation."[55] Further, the *Apostolic Tradition* of

Pseudo-Hippolytus provides an extended prayer for firstfruits offerings in §31 that indicates they are still offered *in kind*. In fact, some of the Latin renderings of this section can be even more explicit in their designation, as they make use of the more explicit phrase "*primitias fructuum prima gamina* – which can be translated 'the best of the fruits' or simply 'the firstfruits of the growth.'"[56] In the *Apostolic Constitutions*, reference to firstfruits (§7.29.1–3) continues to operate with a comprehensive sense of possible meanings, including qualitative understandings of the offering, and its designation for sacerdotal and charitable purposes.[57]

The landscape of Europe provides a challenging testimony to any person who might want to suggest that these ancient practices lacked continuity into modern practice. In fact, the variety of tithe barns scattered across Europe demonstrates how offertory practice continued to be brought *in kind* until very recently, in some cases into the twentieth century. Even in late modern practice, agricultural workers often brought their tithes in the form of produce and such qualitative concern would have been unavoidable. These ancient references to firstfruits offerings in both Christian Scripture and early Christian practice preserve a legacy of material engagement that has recently been picked back up, particularly in recent movements of liturgical reform that has sought to place the sacerdotal function of offertory back in a wider context.

Rehabilitating Offertory in Contemporary Worship

Though it may be for different reasons, contemporary liturgists have also raised the issue of quality in Eucharistic practice that I have pressed above. Specifically, in light of a renewed emphasis on the doctrine of creation and related concerns for human creatureliness and embodiment, liturgical scholars have argued for amaterial re-engagement in liturgical practice. In one example, Thomas Scirghi wonders if the experience of "industrial eating" has led to a strictly pragmatic understanding of the material used in the Eucharistic feast:

> Just by the fact that most parishes use hosts – little round wafers of wheat, rather than real bread – contributes to an attitude of convenience and efficiency. The advantage to using hosts rather than bread is that they avoid the messiness of crumbs, and they are easier to store and preserve in the tabernacle. Here again we can ask, has the value of purity (efficiency) prevailed over that of unity, that is, the one bread broken for the community?[58]

Pope Benedict XVI raises a similar concern, with explicit reference to the construction of the Tabernacle. He argues (as I have above) that human participation in God's design implies that "[h]umans can only correspond to God's greatness if they also give to their response, according to the extent of their ability, the

complete dignity of the beautiful, the height of true 'art.'"[59] This suggestion is taken up in a very practical way in the General Instruction of the Roman Missal (2010), the authorised guide for priests seeking procedural instruction in administering the Eucharist.[60] In §320, the instruction suggests: "The bread for celebrating the Eucharist must be made only from wheat, must be recently made, and, according to the ancient tradition of the Latin Church, must be unleavened." Perhaps even more sharply, the document proceeds to argue the following in §321: "By reason of the sign, it is required that the material for the Eucharistic Celebration truly have the appearance of food." These are promising points of engagement with the rich Hebrew and Christian legacy of offertory practice. Yet, in practice, much contemporary worship conveys little awareness of this rich intertextual legacy and material consciousness. Aside from providing an aesthetically bare experience, such an industrial Eucharist also interrupts the process in which worship might draw in the work of worshipers. This in turn, I believe, leaves all those celebrating potentially captive to prevailing secular economic conceptions of work. I would argue that there is much to be regained by a liturgical practice that draws upon the Hebrew account and places renewed emphasis on the materials that are offered for worship. In this way, work is not drawn into worship indiscriminately, but rather worshippers are encouraged to bring their best to the offering. This in turn sustains a dynamic in which workers are not merely given therapeutic affirmation, but the real content of their work provides a backdrop for the celebration. In the chapter that follows, I take up this aspect of celebration with a closer look at the peace offering and the ethics that flows from this practice.

Notes

1 On a basic level, a cereal offering is prescribed after each burnt offering, cf. Josh 22:23, 22:29; Judg 13:19, 13:23; 1 Kgs 8:64; 2 Kgs 16:13, 16:15. Also paralleling the burnt offering, a pleasing aroma [*ryḥ nyḥḥ*] is a crucial aspect of the offering (cf. Lev 1:9, 1:13, 1:17; with 2:2, 2:9, 2:12) and it is meant to be brought willingly.
2 Cf. *HALOT* 1:269–70; *TDOT* 4:79–80. Milgrom follows G. R. Driver: "No definitive answer can be given. Provisionally, it is best to understand 'azkārâ as related to zēker 'remembrance,' referring to the fact that the entire cereal offering should really go up in smoke and that the portion that does is pars pro toto: it stands for the remainder; in other words, it is a 'token portion.'" Milgrom, *Leviticus 1–16*, 182, citing Driver, "Offer, Offering, Oblation," in J. Hastings (ed.), *Dictionary of the Bible*, vol. 3 (New York, NY: Charles Scribner's Sons, 1900), 587.
3 Milgrom, *Leviticus 1–16*, 183.
4 Anson F. Rainey, "Sacrifice and Offerings," in Merrill C. Tenney (ed.), *Zondervan Pictorial Encyclopaedia of the Bible*, 5 vols (Grand Rapids, MI: Zondervan, 1975), 5:207.
5 Milgrom, *Leviticus 1–16*, 196.

6 Paul D. Wegner, "חֵלֶס," *NIDOTTE*, 3:268.
7 Cf. Exod 23:16, 34:22; Lev 23:10; Num 28:26; Deut 16:10.
8 Cf. Durham, *Exodus*, 329.
9 Structurally both texts are set in the midst of a feast-observance command, a theologically important point that I shall address in the next section.
10 Durham, *Exodus*, 461.
11 Cf. Exod 13:2; Lev 23:20, 27:26; Num 3:13, 3:50, 8:17, 18:17, 28:26; Deut 15:19. For more on Sanctification, cf. Jacob Milgrom, *Leviticus 23–27: A New Translation with Introduction and Commentary*, AYB 3C (New York, NY: Doubleday, 2001), 2412–14.
12 Milgrom, *Leviticus 23–27*, 427.
13 For more on later Jewish adaptation of these offerings, see *Encyclopedia Judaica*, ed. Fred Skolnik, 21 vols, vol. 19 (New York, NY: Macmillan, 2007), 651–4.
14 Milgrom, *Leviticus 23–27*, 428.
15 Milgrom, *Leviticus 23–27*, 428.
16 "Wheat, barley, grapes, figs, pomegranates, olives used for oil, and dates for honey (Dt. 8:8)," described in *Mishna Bikkurim* 1:3.
17 Borowski, *Agriculture in Iron Age Israel*, 34–7.
18 Durham, *Exodus*, 309. See also Durham, 329–30. This reading of 22:28b as a qualitative rather than chronological designation is also affirmed by Houtman, who notes, "In light of 22:28b, 29 it is likely that 22:28a is about the yield of cultivated fields and in particular about the first and best part of it." Cornelis Houtman, *Exodus, Chapters 20–40*, ed. Cornelis Houtman, Gert T. M. Prinsloo, Wilfred G. E. Watson, and Al Wolters, trans. Sierd Woudstra, Historical Commentary on the Old Testament 3 (Leuven: Peeters, 2000), 233. He suggests, along with Alter, that the two terms "דִּמְעֲךָ וּמְלֵאָתְךָ" may also represent a hendiadys, i.e., "the very best of the harvest." This is also suggested by the LXX, "ἀπαρχὰς ἅλωνος καὶ ληνοῦ," in which firstfruits is more explicit.
19 Behind Durham's translation lies a decision with regard to a critical textual issue, namely the difference between the MT, which is more exclusively occupied with liquid produce, as the JPS translates it "the first yield of your vats," and the LXX, which expands the text to refer to "ἀπαρχὰς ἅλωνος καὶ ληνοῦ" ["firstfruits of your threshing floor and press"] (Exod 22:28 [22:29] NETS).
20 Cf. Baruch A. Levine, *Numbers 1–20: A New Translation with Introduction and Commentary*, ed. David Noel Freedman and William Foxwell Albright, AYB 4a (New York, NY: Doubleday, 1993), 438, and Jacob Milgrom, *Numbers, English and Hebrew: Commentary in English*, JPSTC (Philadelphia, PA: Jewish Publication Society, 1990), 427.
21 Cf. Tob 2:1; 2 Macc 12:32; Acts 2:1, 20:16; 1 Cor 16:8; 2 Chr 8:13.
22 "Then during the reign of Esar-haddon I returned home, and my wife Anna and my son Tobias were restored to me. At our festival of Pentecost, which is the sacred festival of weeks, a good dinner was prepared for me and I reclined to eat. [T]he table was set for me and an abundance of food placed before me" (Tobit 2:1–2 NRSV).
23 See especially *NIDOTTE* 3:249 and also *TWOT* 2:879.
24 Durham, *Exodus*, 329.
25 Durham, *Exodus*, 330.
26 Carl Armerding, "Feasts and Festivals," in Alexander and Baker (eds), *Dictionary of the Old Testament*, 311.

27 Averbeck, "Minhâ, Gift, Present, Grain Offering, Sacrifice," in *NIDOTTE*, 1:978.
28 Cf. Averbeck, "Minhâ, Gift, Present, Grain Offering, Sacrifice," 1:978–80.
29 Cf. Herodotus, 4.71; Plato, *Prot.* 343b.
30 I base my choice to limit this study to Pauline instances on the fact that Paul is the only New Testament writer to deploy the concept in a sustained way. There are two non-Pauline instances of *aparchē* in the NT, James 1:18 and Rev 14:4, but neither of these is substantially different from the usage by Paul that I detail here.
31 For more on the scholarly literature regarding Paul's use of non-atonement cultic metaphors, see Nijay K. Gupta, *Worship That Makes Sense to Paul: A New Approach to the Theology and Ethics of Paul's Cultic Metaphors* (Berlin: De Gruyter, 2010), 9–26.
32 For recent examples of this argument see Martin Vahrenhorst, *Kultische Sprache in Den Paulusbriefen* (Tübingen: Mohr Siebeck, 2008); Gupta, *Worship That Makes Sense to Paul*.
33 A minority of manuscripts actually revise to *ap arches*, demonstrating the valid temptation towards this option.
34 F. F. Bruce, *1 & 2 Thessalonians*, WBC 45 (Waco, TX: Word Books, 1982), 190.
35 Cf. John Gillman, "Stephanas," *AYBD*, 6:207.
36 The liturgical reading I have noted above may also be complemented by related research into Paul's reliance on GR role-ethics. See especially Reidar Aasgaard, *My Beloved Brothers and Sisters! Christian Siblingship in Paul* (London: T&T Clark, 2004), 137ff and especially 144–5. Thanks go to Ben Edsall for bringing my attention to Aasgaard's work. In this way, Paul can be referring concurrently to GR backgrounds and a specific Hebrew liturgical context as regards the dedication of the firstborn that is one thread among the tradition-complex of firstfruits offerings.
37 Cf. Romans 10:16–21.
38 Cf. Luke Timothy Johnson, *Reading Romans: A Literary and Theological Commentary* (Macon, GA: Smyth & Helwys Publishing, 2001), 180.
39 Augustine vindicates this reading in *en Ps.* 129.5–6 §7.
40 C. E. B. Cranfield, *A Critical and Exegetical Commentary on the Epistle to the Romans*, ICC 2 (London; New York, NY: T&T Clark, 2004), 563.
41 *TDNT*, 2:905.
42 *TDNT*, 2:905–6.
43 Gupta, *Worship That Makes Sense to Paul*, 57.
44 Gupta, *Worship That Makes Sense to Paul*, 57.
45 Gupta, *Worship That Makes Sense to Paul*, 58.
46 Peter Brown, *Through the Eye of a Needle: Wealth, the Fall of Rome, and the Making of Christianity in the West, 350–550 AD* (Princeton, NJ: Princeton University Press, 2012), 39.
47 Brown, *Through the Eye of a Needle*, 40.
48 Cf. *Mishna Bikkurim*, 1.1–2; Shemuel Safari, "The Temple," in Shemuel Safari and Menahem Stern (eds), *The Jewish People in the First Century*, Compendia Rerum Iadaicarum ad Novum Testamentum I/2 (Assen: Van Gorcum, 1976), 878.
49 Del Verme, *Didache and Judaism*, 189.
50 *Didache*, 13:3–7.
51 Cf. Del Verme, *Didache and Judaism*, 192.
52 First-century Jewish charity is strongly commended by the Tannaitic and Amoraic Rabbinic traditions, cf. Del Verme, *Didache and Judaism*, 195–6. See also Robert M.

Grant, *Early Christianity and Society: Seven Studies* (San Francisco, CA: Harper & Row, 1977), 125–6.
53 Del Verme, *Didache and Judaism*, 193.
54 Del Verme, *Didache and Judaism*, 208, 197.
55 Sebastian P. Brock and Michael Vasey, *The Liturgical Portions of the Didascalia* (Bramcote: Grove, 1982), 11.
56 Del Verme, *Didache and Judaism*, 208.
57 Del Verme, *Didache and Judaism*, 208.
58 Thomas J Scirghi, "This Blessed Mess," in Alex Garcia-Rivera and Thomas J Scirghi (eds), *Living Beauty: The Art of Liturgy* (Lanham, MD: Rowman & Littlefield Publishers, 2008), 27.
59 Pope Benedict XVI, *A New Song for the Lord: Faith in Christ and Liturgy Today* (New York, NY: Crossroad Publishing, 1996), 129. See also Thomas J. Scirghi, "What Is Beautiful for God? (What Does God Like?)," in Garcia-Rivera and Scirghi (eds), *Living Beauty*, 68–70.
60 United States Conference of Catholic Bishops, *General Instruction of the Roman Missal*, 3rd edn (Washington, DC: United States Conference of Catholic Bishops, 2010).

7 "Eaten" Offerings and Liturgical Sociality

As I have suggested in the preceding two chapters, the features of the various offering ritual instructions overlap and complement one another. Consequently, in arriving at the third offering to be considered in this study, the *zbḥ šlmym* ["eaten offerings" or "well-being offerings"], my treatment here will be briefer than the previous two chapters, as the task that remains is to note how this third offering consolidates and emphasises the social aspect of offertory ritual I have already noted in several instances. However, even though sociality is not a new theme, I feel we must pause and note how the eaten offerings bring the aspect of the meal – which has been present in the foregoing discussion – front and centre.[1]

I begin by noting that, as Lev 7:11–16 details, the eaten offering is "the joyous sacrifice par excellence."[2] In each of the three different categories pertaining to the occasion under which the eaten offerings might be brought, this arises in a different way. These categories include: (1) *ndbh* ["freewill"], which is a "spontaneous byproduct of one's happiness, whatsoever its cause"; (2) following a *ndr* ["vow"], as described in Gen 28:20–2; and (3) *twdh* ["thanksgiving"].[3] The joyous aspect of this offering, if somewhat muted in Lev 3, is emphasised elsewhere in the Pentateuch. For example, in Deut 27:6–7, the ritual to celebrate the entry of the people of Israel into the promised land involves an offering of well-being: "You shall offer on it burnt offerings to the LORD your God, and you shall sacrifice there offerings of well-being and eat them, rejoicing before the LORD your God" (JPS). Similarly, Num 10 describes how "your joyous occasions" involve burnt offerings and sacrifices of well-being.

The eaten offering shares several features with the offerings discussed in the previous two chapters. The offering is to be of the highest quality ("without blemish" in 3:1), while the process is an intimate one as the celebrant is to lay their hand upon the animal and assist in the slaughtering process. Blood, that life-force reserved only for YHWH, is reserved and dispersed (v. 2b), and this offering is offered upon the fire to bring a "pleasing odor to the Lord."

Particularly, one reads in verses 3–4 that certain portions of the slaughtered animal, primarily fat and kidneys, are to be incinerated. One learns more about what is to be done with the remainder of the carcass from the parallel details provided in Lev 7:15: "the flesh of his thanksgiving sacrifice of well-being shall be eaten on the day that it is offered; none of it shall be set aside until morning" (JPS). In continuity with the firstfruits festival I have highlighted above, this is to provide the basis for a great feast, particularly given the amount of meat involved. As Milgrom suggests, "Except for kings and aristocrats, meat was eaten only on rare occasions, usually surrounding a celebration. Because a whole animal was probably too much for the nuclear family, it had to be a household or clan celebration."[4] The stipulation that it must be consumed on the same day as the sacrifice intensifies this feast and also provides occasion for a large act of hospitality. Across the Hebrew Scriptures, one can find instances of this sacrifice providing the basis for a shared meal and hospitality. This includes Jacob's celebration with his kinsmen described in Gen 31:54 and the blasphemous meal shared by Israel in Exod 32:6 (to which I shall turn more fully below). Of particular note is the way that this meal offering accompanies the dedication of the place of worship. The Tabernacle altar-dedication ceremony described at length in Num 7 involved, as verse 88 summarises, a meal that resulted from 24 bulls, 60 rams, 60 goats, and 60 lambs. An even more opulent meal, hosted by Solomon at the Temple-dedication ceremony, is described in 1 Kgs 8:62–4.[5] In Isa 56:7, the prophet's description of the celebration of the new Temple on God's holy mountain involves *'lh* ["burnt offerings"] and *zbḥ* ["sacrifices"]; and Ezekiel also describes the rededication of the altar in Ezek 43:27 as involving a meal offering.

Particularly with the sacrifice described in Lev 3, this was meant to be a holy meal with YHWH as a guest. This is underlined in verses 3–5, which suggest that the priests were to incinerate the reserved organs and animal fat "as an offering by fire, of pleasing odour to the LORD."[6] It is noteworthy that, in some contrast to other ANE rituals, the deity is considered present at the meal with those worshipping. Along these lines, Milgrom notes, "in Mesopotamia, the gods did not even participate in a shared meal; a king might serve a banquet and invite the gods to it, but he would prepare a separate banquet for himself and his nobles."[7] In seeking to appreciate the full impact of this unique divine presence, it is important to avoid a crass reading of supposedly "primitive" sacrifice in this text. Indeed, the purpose described in Leviticus and elsewhere is explicitly not to provide food for YHWH, nor is it to achieve mystic union. Rather, one finds here an act of encompassing hospitality where priest, worshipper, and creator share the experience of joyful celebration.[8] As Levine suggests, this offered "[the] experience of joining together with the priests in a sacred meal at which God Himself was perceived to be the honored guest."[9] This is emphasised by the tendency by some translators to render *zbḥ šlmym* as "peace offering." As one

Rabbinic source suggests, this is because the offering "effects peace among the altar, the priests, and the offerer" (t. Zebaḥ. 11:1), for "the suet is for the altar, the thigh and breast for the priest (see 7:30–5), and the skin and meat for the offerer" (Sipra, Nedaba 16:2).[10]

Taking all these elements together, one can ascertain a moral shape to this offering, namely the redirection of the profits of one's work into an act of reconciling hospitality. For those Israelites whose work may have been solitary, this festal aspect brought the fruits of work into an explicitly social context. Against a narrow construal of worship that only imagines a single celebrant standing before the divine person, here one finds a scene where attention to God is part of a social experience of worship involving priests, the bringer of the offering, and their meal-party. I shall note further below the parallels to Eucharistic notions of work here; other scholars have drawn attention to the usefulness of the Eucharist in revealing a moral order and forming worshippers for moral interaction.[11] First, however, it is important to acknowledge the prominence of the shared meal offering in the NT.

As Luke 22 suggests, Jesus' last supper may have been a passover meal, such that the Eucharist is instituted over a *zbḥ šlmym*.[12] Shared meals are featured regularly in the subsequent witness to early Christian practice, as with the meal described in Acts 2:46–7a, which includes a number of the features I have described above as elements of the *zbḥ šlmym*. Here, the joy of those participating is foregrounded in this shared reconciling meal: "And day by day, attending the temple together and breaking bread in their homes, they received their food with glad and generous hearts, praising God and having favor with all the people" (Acts 2:46–7). In a similar way, Paul emphasises the aspect of reconciliation in his Eucharistic instructions in 1 Cor 11, which describe the Eucharist as a shared meal. In contrast to those who eat *anaxios* ["unworthily"] (1 Cor 11:27), Paul commends both equal distribution of food (so that none may come hungry to the meal, cf. 1 Cor 11:21)[13] and shared presence (so that none may eat as if alone) – "when you come together to eat, wait for one another" (1 Cor 11:33).

Several practices in early Christian Eucharistic practice further corroborate a relation to the sociality of the *zbḥ šlmym*. First, a number of early Christian writers make reference to the sending of bread, via deacons, to be given to those who are unable to attend the Eucharist.[14] This practice echoes the instruction in *Didache* §13 that I analysed above in which offerings resulted in a charitable enterprise. Bradshaw affirms this relation:

> The earliest Christian eucharistic meal ... did not merely express symbolically the love that the believers had for one another but was itself a practical

expression of that love, as those who had means fed those in the community who were hungry, sending them home with leftovers to sustain them during the week and distributing portions to those unable to be present. It was no wonder then that one of the names used to designate that meal in some Christian communities was *agape* – the Greek word for 'love.'[15]

Counterbalancing this emphasis on the gathered body across the city is a provision that arises in the fourth century and attempts to limit or even prohibit outright the celebration of the Eucharist in private houses. For example, in his shorter monastic rule (§310), Basil of Caesarea strictly "forbids celebrations in houses except in cases of extreme necessity."[16] In similar ways, several later councils, including the Council of Laodicea and the Second Council of Carthage sought to limit this practice. The significance of these limits underlined the ways in which the Eucharistic meal could provide a context for shared sustenance and shared joy while remaining tethered, as much as possible, to the act of corporate worship.

A second practice that demonstrates the sociality of the offering, though in a slightly different way, is the practice of offertory processions. Though a number of contemporary liturgical reformers have focused on the procession as a context for the affirmation of the mutuality and reciprocity among those gathered, so far as I have found, no one has noted the significance for contemporary practice of the way in which the products of work were drawn into worship. As Cabié suggests, in the early form of the Eucharist (post 2c.), "the faithful brought to the church the foods they had on their own tables at home."[17] This practice is well attested, finding affirmative reference by Cyprian and Augustine.[18] In both North Africa and Rome, this became formalised in a double procession, with offerers bringing "gifts" in a way that paralleled the communion procession.[19] With the singing of a Psalm, worshippers would file in and deposit their contribution for the elements of the Eucharist on the table. The theological implications of this act were not lost on the early theologians, as Cabié notes, Augustine affirms this procession as an example "of the 'marvelous exchange' represented by the incarnation: Christ takes our humanity in order to bestow on us his divinity."[20] Though practice varied slightly among regions, the consecrated bread, which often exceeded the need for ritual use, was distributed afterwards among the clergy and poor, in the practice I have noted in the previous chapter.

As Morrill notes, contemporary liturgical reformers have sought to revive this ancient practice as a way of emphasising "the full engagement of all in the liturgy, as enactors of the ritual symbolism, the source and summit of the people's ongoing lives as the ethical, social, interpersonal work of human sanctification,

of salvation."[21] He narrates an experience of this practice, which is helpful in underlining its promise for revitalising contemporary offertory practice:

> I . . . joined the almost entirely African–American congregation [at St Augustine's in New Orleans] for what proved an exuberant two-hour liturgy combining the Mass of Paul VI with the music, bodily and vocal prayer styles, and preaching patterns of African–American Christianity. Most arresting and memorable for me were the two processions of the entire assembly framing the liturgy of the eucharist, which began with every member – old and young, women, men and children – coming up the main aisle to deposit their donations in a large basket at the foot of the altar, singing and dancing with the choir's anthem. Bringing up the rear were elders and children bearing bread and wine. I was witnessing the type of procession about which I had read in Cabié's historical study, and I was deeply affected, especially as I experienced the impact on the second procession for communion, how much more communal and consecratory and empowering it felt because of its mirroring the first corporate movement.[22]

While Morrill focuses on the socially inclusive aspect of this practice, what strikes me is that such a practice provides an extraordinary example of the threading of worship and work together, weaving in a social aspect and tying the congregants to their very tangible offering. Though in the modern urban church this may not be possible, in an agrarian context this practice would have also included the bringing of bread that someone had themselves baked and perhaps also grown. Work was drawn into worship in a tangible and indelible way.

Tithes and Moral Work

In much contemporary practice, offertory practice has been collapsed into the Eucharistic "presentation of gifts" with a silent passing of plates, while the liturgy is spoken and music played. While it is unlikely that worshippers have brought bread and wine, it is probable that at least some will have brought tithes. Yet, as I noted at the start of Part II, the contemporary practice of tithing is often liturgically thin, stripped down to a pragmatic weekly fundraising exercise. In closing this chapter, I turn to the end of Leviticus to re-examine one final offertory practice, tithing, particularly because it has endured so persistently into modern practice. As I shall argue, in addition to the diverse yet intertwined complex of offertory practices detailed above, the details of tithing practice narrated in Christian Scripture also invoke many of the practical elements I have highlighted; and so for churches that only intermittently celebrate

the Eucharist, tithes provide to those gathered an opportunity for a similar kind of worshipful engagement with the theology of work.

An exhaustive look at the specific contours of tithing practice, set against a backdrop of broader Hebrew offertory practice, offers a striking critique of the superficial nature of modern tithing practice and an opportunity to recapitulate the various dimensions of work sociality, quality, and value I have treated. It is important to observe at the outset that tithing was not a practice exclusive to the Hebrew people. Thompson observes, "the practice of tithing, the custom of setting aside for the upkeep of the national Temples and the maintenance of the priests a portion of the annual increment of the land, was almost universal among ancient civilizations."[23] The antiquity of Hebrew tithing is affirmed by early mentions in Genesis. After Abram's military success, we read that he "gave . . . one tenth of everything" to the priest-king "Melchizedek of Salem" (Gen 14:18, 14:20). Similar mention is found in Jacob's vow, "If God will be with me, and will keep me in this way that I go . . . then the LORD shall be my God, and this stone, which I have set up for a pillar, shall be God's house; and of all that you give me *I will surely give one tenth to you*" (Gen 28:20-2). While these two texts provide little direction as to the importance of tithing in the life of Israel or its formal practice, the remainder of the Pentateuch provides more formal mention of the practice of "the tenth." This is found particularly in the Mosaic laws, where three parallel texts in Leviticus, Numbers, and Deuteronomy outline the procedural details regarding tithing. I begin with several points regarding the formal regulation of tithing in Leviticus as the terse instructions in Leviticus gain further clarity in the tithe texts in Numbers and Deuteronomy.

The Lev 27 instructions note first that – as with the *mnḥh* and firstfruits offerings (with which tithing instructions overlap) – tithing involves an act of consecration. This involves a wide range of products, as tithes are to be drawn from much of the Israelite economy, either from the land or from herd and flock. The specific instances of seed, fruit, herd, and flock in Lev 27:30-1 need not be seen as exclusive designations, as Milgrom suggests, "It seems . . . that the specification in the priestly and deuteronomic codes refers to only the most common objects of tithing in Israel."[24] It seems likely then that tithes were brought in kind, from whatever stock of goods one's work might have produced. Further underlining the consecration of these goods, both offerings are consistently described as "holy to the Lord." The Hebrew term "*qdwš*," translated as "holy," is the adjectival form of the verb *qdš* ["consecrate"]. This emphasis on holiness more generally is established early in Leviticus and also in Chapter 19. Ellen Davis builds on this suggestion, noting, "Elsewhere in Leviticus, holiness is the special characteristic of the sanctuary and the priests who attend it, but here in the Holiness Code (Chapters 17–26), that notion is democratized and vastly extended."[25] I would suggest that the language of holiness, closing every

verse in Lev 27, pervades here also in a similar vein, though this need not be seen as contrasting with other procedures detailed in Leviticus.

Another way of describing the consecration of one's work lies in thinking of tithing as a form of redemption. Redemption offers a mechanism by which one can "buy back into one's own possession something whose ownership had been in effect transferred to God."[26] While I believe the concept of "redemption" offers tremendous promise, it also created an opening for a subversion of the intended dynamic of worship practice. This arises from a stipulation that tithes can, in certain circumstances, essentially be paid in cash, with a "handling fee" of 20 per cent by which one buys back these divinely owned goods. Interpreters have engaged in some conjecture regarding the implications of this stipulation in context. Of special relevance is the actual form of the ancient money economy and the degree to which it resembled the present-day capitalist market economies.[27] Much has been written about the negative social impacts of money in contrast to gift-exchange or barter in kind on social relationships, but far less examination has been offered on the impact of a transition from in-kind to cash tithes on worship.[28] For the purposes of this study, I want to underline the possible usefulness of the framing of tithes as redemptive, particularly inasmuch as it captures the effect upon one's whole enterprise caused by the bringing of a representative portion into worship. However, it is equally important to underline how quickly such redemption can slide into a hollowed-out fiscal mechanism. As I shall demonstrate below, the more specific provisions listed in Deut 14 fill out the details of in-kind provisions and confirm that the redemption of tithes is to be the exception and not the rule of tithing.

In approaching the texts of Numbers and Deuteronomy, one finds several new themes as well as elaboration on the tithe topic. While the recipient of tithes is resoundingly affirmed as "the Lord" in Leviticus, this is expanded, or designated more specifically to the Levites, in the latter Pentateuch.[29] It is noteworthy that Num 18 is particularly concerned with the abstention from manual labour commanded for the family of Aaron and the house of Levi in exchange for the exercise of their priestly duties. They receive not only the tithes, but also the *trwma* ["offerings" or "holy things"] of which tithes are a part: "My gifts, all the sacred donations of the Israelites."[30] The tithe described in Num 18 is meant to be given in recognition of their Temple service because the family of Aaron has been set apart for priestly duties and they lack both land and time as the result of their status and priestly duties.[31] In this way, one finds the same holiness theme from Leviticus as the centre of tithing practice extended here in Numbers.

One of the most notable affirmations within the text of Deuteronomy is the festal cast given to tithing. In Deut 14:23, the tither is commended to "consume the tithes of your new grain and wine and oil, and the firstlings of your herds

and flocks, in the presence of the LORD your God, in the place where He will choose to establish His name, so that you may learn to revere the LORD your God forever" (Deut 14:23 JPS). Similarly, cash redemption of tithes is allowed for geographical challenges, so that, "should the distance be too great for you, should you be unable to transport them [tithes] . . . you may convert them into money" (Deut 14:24–5a JPS). In spite of this logistical consideration, the outcome is still a great party:

> Wrap up the money and take it with you to the place that the LORD your God has chosen, and spend the money on anything you want – cattle, sheep, wine, or other intoxicant, or anything you may desire. And you shall feast there, in the presence of the LORD your God, and rejoice with your household. (Deut 14:25b–26 JPS)

The contrast with Numbers as ascribing tithes to the Levites should not be construed too strongly, as immediately following this, the text instructs Israel not to "neglect the Levite in your community, for he has no hereditary portion as you have" (Deut 14:27, JPS) and then suggests formally,

> Every third year you shall bring out the full tithe of your yield of that year, but leave it within your settlements. Then the Levite, who has no hereditary portion as you have, and the stranger, the fatherless, and the widow in your settlements shall come and eat their fill, so that the LORD your God may bless you in all the enterprises you undertake. (Deut 14:28–9 JPS)

Here the divine blessing of manual labour is *contingent upon* the third-year tithe redirection, a command reaffirmed in Deut 26:12–15. Perhaps the more significant point to be made in terms of jurisdiction in the three texts is not to be found in their dissimilarities, but rather in their consistency: in none of these texts do tithes fall under the jurisdiction of a human monarch.

Tithes surface in various places in later OT texts, but of special relevance for this study is the apparent subversion of tithes into a royal tax. In the tragic scene presented in 1 Sam 8, part of Samuel's warning regarding the consequences of monarchy in Israel is the subversion of the tithe. He warns, "He [the king] will tithe your crops and vineyards to provide for his courtiers and his officials. . . . He will tithe your flocks, and you yourselves will become his slaves."[32] The Prophet Malachi observes the actual realisation of this warning many generations later:

> Will anyone rob God? Yet you are robbing me! But you say, 'How are we robbing you?' In your tithes and offerings! You are cursed with a curse, for you are robbing me – the whole nation of you! Bring the full tithe into the

> storehouse, so that there may be food in my house, and thus put me to the test, says the LORD of hosts; see if I will not open the windows of heaven for you and pour down for you an overflowing blessing. (Malachi 3:8–10 NRSV)

The details of Israel's decline, from faithful observance of tithing to the "robbing of God," are complicated, but several clues surface among the texts prescribing reform. In particular, the reforms of both Hezekiah and Nehemiah involve the reinstitution of tithing. Nehemiah notes his discovery of the abrogation of tithing: "I also found out that the portions of the Levites had not been given to them; so that the Levites and the singers, who had conducted the service, had gone back to their fields" (Neh 13:10, NRSV). The crucial point here is not the observation that Levites were working their fields, but the fact that they had *left* the Temple because subsistence there was impossible given the unfaithfulness of the people worshipping. Nehemiah's observation is loaded, as the Levites, according to the Pentateuchal texts examined above, rely exclusively on tithes for their livelihood. To "go back to their fields" implies not a return to some former arrangement, but a complete transformation of their vocation. In contrast, in the vision of the well-ordered community, Nehemiah suggests, "They set apart that which was for the Levites; and the Levites set apart that which was for the descendants of Aaron" (12:47b). While Nehemiah is concerned with the lapse of practice in post-exilic Judaism, one finds a similar situation earlier under the monarchy highlighted by the reforms of Hezekiah. The account describes Hezekiah's discovery and reinstitution, but implicit in this account is the fact that Israel has alongside their idolatry lapsed in its practice of tithes and offerings. Verses 4–7 of 2 Chronicles 31 relate,

> He commanded the people who lived in Jerusalem to give the portion due to the priests and the Levites, so that they might devote themselves to the law of the LORD. As soon as the word spread, the people of Israel gave in abundance the first fruits (*r'šyt*) of grain, wine, oil, honey, and of all the produce of the field; and they brought in abundantly the tithe (*m'śr*) of everything. The people of Israel and Judah who lived in the cities of Judah also brought in the tithe of cattle and sheep, and the tithe of the dedicated things (*qdśym*) that had been consecrated to the LORD their God, and laid them in heaps. In the third month they began to pile up the heaps, and finished them in the seventh month. (NRSV)

One finds in 2 Chronicles a composite of several elements found in Pentateuchal accounts of tithing; the tithe is tied to the livelihood of the priests and Levites and these tithes are affirmed as holy: the "tithe of the dedicated things."

Further, the people bring an abundance of "first fruits," and this offering even begins in the "third month," which would correspond to the feast of firstfruits. Inasmuch as Israel's later attempts to rehabilitate the practice mark an apprehension of its inner significance, both texts underline the central importance of tithing to Israel and demonstrate some of the integration of the various themes presented above with regard to offerings more generally. Support of the priests, festal celebration, ongoing affirmation of the "choicest of the first fruits," and the integration of manual labour into a worship that affirmed the respective holinesses of YHWH and the people of YHWH were not discretely separated but were intertwined. Further, these later texts demonstrate in the shape of their reforms that observance with regard to firstfruits and tithing does not become more formal and thus abstracted from their domestic roots in Israelite labour, but in fact remains close to the ground. Austerity does not replace feasting and token offerings do not replace true abundance, but rather tithes and offerings serve as an intensive affirmation of Israelite work that is radically intertwined in the worship of YHWH. This rich ritual practice elaborated for tithing that I have described here could scarcely provide a stronger contrast with much of the contemporary offertory practice that I problematised at the outset of Part II. In contrast to the instructions in Scripture regarding tithing, contemporary practice lacks social context, festivity, or explicit material reference to the work of the offerer.

Another way of framing my argument in these last several chapters is that there are certain blind spots that are more pervasive in economic contexts where non-agricultural forms of work are dominant. In these industrial or post-industrial work contexts, one finds a peculiar unawareness of the contingency of an individual worker both to the community of other human persons (their co-workers) and the wider community of other creatures – both animate and inanimate. Modern forms of work have created an ecological catastrophe on a global scale and we cannot hope to address these without reconceptualising work in light of these limits – or, to put it in a more theological way, these *relationships*. In my assessment, the Christian doctrine of creation, which is nurtured by and expressed in direct and indirect ways through these texts I have examined, portrays a unique account of the contingent human maker. This is an account of a maker who designs and makes following the pattern set by a divine maker. A consequence of this conception is that one must conceive of work through a paradoxical combination of two elements: on the one hand, an awareness of our frailty as creatures; on the other, awareness of our great power. These two are held together only inasmuch as we bear the cruciform image of the one in whom all things were made (Col 1:15–16). What these accounts of worship-entangled work suggest is that Christian theology preserves an awareness of the moral forms of making through the practice of worship.

210 *Moral Maintenance*

While I have noted a few examples of how this might look in practice (many of them from early Christianity), I have largely left the contemporary expressions of recovered worship and the forms of work it draws in for the reader to imagine. This open space betrays my greatest hope for this study, namely that its readers might find themselves encouraged to conduct their own study of these ancient texts, and rediscover the living memory of a strange worshipping world that they have upheld. I believe such an encounter might provide a context in which to sing the ethos of God for our workplaces and industries in fresh and creative ways.

Notes

1 For more on the various translations that have been pursued for *zbḥ šlmym* and some appraisal of their viability, see Milgrom, *Leviticus 1–16*, 220–1, and Levine, *Leviticus*, 15. See also Chapter 6, pp. 184–86.
2 Milgrom, *Leviticus*, 29 *contra* Wenham, to a certain degree; see 78–80.
3 Milgrom, *Leviticus 1–16*, 218–19.
4 Milgrom, *Leviticus*, 28–9.
5 See also 2 Chr 5:12–13 and my earlier analysis of Kings and Chronicles.
6 However, note Milgrom's suggestion: "According to the Priestly texts, the meat of the well-being offering could be eaten anywhere and by anyone as long as the place and person were in a state of purity (7:19–21)." Milgrom, *Leviticus 1–16*, 223.
7 Citing Charbel 1970, in Milgrom, *Leviticus 1–16*, 221.
8 Cf. commentary in Milgrom, *Leviticus 1–16*, 440.
9 Levine, *Leviticus*, 14.
10 Cited in Milgrom, *Leviticus 1–16*, 220.
11 Examples of work as Eucharistic can be found in Jensen, *Responsive Labor*; Northcott, *Moral Climate*; Reed, *Good Work*.
12 For a summary of the literature in biblical studies on this assertion, see Thiselton, *The First Epistle to the Corinthians*, 871–8.
13 Cf. Bruce B. Winter, "The Lord's Supper at Corinth: An Alternative Reconstruction," *Reformed Theological Review* 37 (1978): 73–82.
14 Cf. Justin Martyr, *Ad uxorem* 2.5, *De oratione* 19.
15 Paul F. Bradshaw, *Reconstructing Early Christian Worship* (Collegeville, MN: Liturgical Press, 2010), 23.
16 Cited in Bradshaw, *Reconstructing Early Christian Worship*, 28.
17 Robert Cabié, *The Church at Prayer: An Introduction to the Liturgy*, vol. 2: *The Eucharist*, trans. Matthew J. O'Connell (London: Geoffrey Chapman, 1986), 77.
18 Cf. Cyprian, *Liber de opere et eleemosinis*, 15; Augustine, *Conf.* 5.9.
19 Cabié, *The Church at Prayer*, 78.
20 Cabié, *The Church at Prayer*, 78.
21 Bruce T. Morrill, "Holy Communion as Public Act: Ethics and Liturgical Participation," *Studia liturgica* 41, no. 1 (2011): 39.
22 Morrill, "Holy Communion as Public Act," 39–40.
23 P. W. Thompson, *The Whole Tithe* (London; Edinburgh: Marshall, Morgan & Scott, Ltd., 1930), 3. For more on ANE parallels, see esp. Milgrom, *Leviticus 23–27*,

2396–401, 2421–34. Cormack offers several examples from Classical Literature, including Herodotus, 1.89; Xenophon, *Hellenics*, 4.3.21; Dionysius, *Archaeologia*; Cicero, *De Natura Deorum*, 3.87–8; Plutarch, *Quaestiones Romanae*, 18 cited in Alexander A. Cormack, *Teinds and Agriculture: An Historical Survey* (London: Oxford University Press, 1930), 3.

24 Milgrom, *Leviticus 23–27*, 2422.
25 Davis, *Scripture, Culture, and Agriculture*, 85.
26 Davis, *Scripture, Culture, and Agriculture*, 85.
27 See historical analysis in Morris Silver, *Prophets and Markets: The Political Economy of Ancient Israel* (Boston, MA: Kluwer-Nijhoff Publishers, 1983). For critique of Silver's account see Anne Mayhew, Walter C. Neale, and David W. Tandy, "Markets in the Ancient Near East: A Challenge to Silver's Argument and Use of Evidence," *Journal of Economic History* 45, no. 1 (1985): 127–34.
28 See discussion in Allen Morris Sievers, *Has Market Capitalism Collapsed? A Critique of Karl Polanyi's New Economics* (New York, NY: AMS Press, 1968); Eric Eustace Williams, *Capitalism & Slavery* (Kingston; Miami, FL: Ian Randle Publishers, 2005); and Northcott, *Moral Climate*, esp. 120–56. See also Santhi Hejeebu and Deirdre McCloskey, "The Reproving of Karl Polanyi," *Critical Review* 13, no. 3 (1999): 285–314 for a recent summary of scholarship on Polanyi's market-less economy thesis.
29 Whether this ascription to "the LORD" is exclusive of priestly or Levitical designation is not necessarily obvious in the text. See Levine, *Numbers 1–20*, 435.
30 Num 18:8, JPS.
31 Cf. Exod 28:1–30:38; Josh 13:14–33.
32 Samuel 8:15, 17 NJB. Strangely, many English translations fail to render "tithe" literally here, while they do so elsewhere, including the NRSV and TNIV.

Conclusion
Seeking the Craft of Worship

In the second part of this book, I have sought to highlight the intricately woven account of liturgical practices in Christian Scripture and the ways in which their performance might have proven morally formative. However, it is crucial to note in concluding this study that Scripture preserves two different accounts of the moral aspect of worship, one *positive* and the other *negative*. In the positive account – to which I have devoted most of my attention in this book – one finds specific points of contact where the ritual act of worship draws in the work of the people and grants it a specific moral contour in a dynamic I have described as consecratory.

Yet this consecratory dynamic is not automatic; it can be interrupted or subverted because it is predicated upon the activity of right worship. This may seem an obvious point, but the manifold accounts of idolatry in Scripture attest that the subversion of this consecratory dynamic is close at hand in any act of worship. The work of the people can result in the further thriving of all creation, but this can just as easily be turned – as narrated in Exod 32 – towards the use of fabrication for more sinister purposes. In the episode preserved in Exodus 32 that sits alongside the paradigmatic account of Tabernacle construction, one finds a double subversion of work and worship. First, there is an inversion of the Tabernacle-construction process that I have treated above. The work of the people employed in the fabrication of the place of worship is turned to the fabrication of an idol. Second, the right worship that I have treated above is also subverted. Bizarrely, after building a new altar for this golden calf, Aaron announces, "Tomorrow shall be a festival of the LORD!" (Exod 32:5b, JPS). It is noteworthy in the verse that follows that the Israelites perform the *same* forms of offering before this new altar: "Early next day, the people offered up burnt offerings and brought sacrifices of well-being; they sat down to eat and drink, and then rose to dance" (Exod 32:6, JPS). There is nothing categorically different about the act of worship narrated in Exod 32. All that has changed here is the object of worship. This unsettling symmetry highlights the importance of *craftsmanship*

in worship, which balances an awareness of how our work may be indeterminate (i.e., not conveying a predictable outcome based on the level of control we exert), but it also requires care and attentiveness. Also important is the point of impact: when worship is subverted, the impact is socially dispersed. This dispersal of consequence is underlined in the emphasis in Temple-reform movements on purging the sanctuary. Regarding these consequences, Jacob Milgrom notes:

> Finally, why the urgency to purge the sanctuary? The answer lies in this postulate: the God of Israel will not abide in a polluted sanctuary. The merciful God will tolerate a modicum of pollution. But there is a point of no return. If the pollution continues to accumulate, the end is inexorable: 'Then the cherubs raised their wings' (Ezek 11:22). The divine chariot flies heavenward, and the sanctuary is left to its doom. The book of Lamentations echoes this priestly theology: 'The Lord has abandoned his altar, rejected his Sanctuary. He has handed over to the foe the walls of its citadels' (Lam 2:7). That the sancta can become polluted beyond repair is demonstrated by the measures taken by both Hezekiah and Josiah to invalidate the bāmôt: Hezekiah hēsîr 'removed' them (2 Kgs 18:4); presumably he razed them to the ground.[1]

As Milgrom argues, while misbehaviour affects corporate worship first, the eventual consequence, as I have argued in my analysis of Jeremiah above, is the breaking of moral relationships in other domestic contexts, jeopardising the very basis for moral action.

I am not the first to note the way in which businesses have developed a resilient amoral self-understanding under the auspices of modern accounts of market capitalism. Thin theologies of providence deployed by late-Enlightenment thinkers left unchallenged the proclamation that the invisible hand of the market would naturally guide human economic activity towards the common good.[2] This same humanistic optimism was taken up in Taylor's scientific conception of work management. I want to suggest that these alternative "theologies" have shaped modern Christian offertory practice. As the robust drawing-in of work in worship gradually declined, various forms of work have been left to their own devices, such that even persons of Christian faith and deep piety have experienced a disconnection of piety from work. Under this condition, certain admonitions towards right moral action may have persisted, against lying to one's associates for example, but the actual practices and products of our work have been placed behind a curtain and allowed to develop such that pious Christian people lead and work for companies promoting forms of work that are grossly immoral without any sense of the dissonance between their work and faith. In the Levitical sense, God has abandoned the Temple.

However, Christian Scripture preserves an account of a more demanding worship, and I have argued that this richly textured account might provide the basis for a rehabilitation of the economic capabilities of Christian worship. Based on the account in the previous three chapters, I would suggest that such a rehabilitation might include the following. First, Hebrew offerings might begin by relativising the economic status of those who bring an offering. This is realised most profoundly in the burnt offering, where economic pragmatism is resolutely set aside in an act devoted to YHWH. These liturgies suggest that one's status and work must be, to a certain extent, relativised in worship and offered in a truly exclusive way towards the Creator God. The most obvious way by which this could be implemented in contemporary practice would be to literally incinerate the offerings brought by the people on a given Sunday. Such a practice would be, at least in the United States, an act of civil disobedience, as it is a crime to destroy legal tender. In addition to serving as a denial of the sovereignty of *mammon*, such a practice would also stand as a powerful refutation of the pragmatism that grips many contemporary Christian communities. However, as I have already noted, this is not the only means by which one can "deploy" the burnt offering. Both one's choice of vocation and posture towards the goods of one's work offer additional areas in which Christians can offer their work as a "spiritual sacrifice." The celebration of beauty, exposed as one of many basic components of moral work (as I have suggested in Chapter 3) might also prove another area where the expense of materials and the time of artisans in an expression of "useless beauty" might de-emphasise money and reorient work towards worship.

The second aspect of worship, which I have detailed in Chapter 7, stands in tension with the relativising aspect I have noted above. Here, with the cereal offering and shown in greater detail by recourse to the firstfruits offering, one finds a special emphasis on the materiality of offerings. Quality is expected, and, by extension, recognised and celebrated. In contrast to the unidirectional movement of one's work in the burnt offering, with these offerings one finds a bidirectional dynamic in which one's work is consecrated and returned: the products of work are given to God and they are returned for domestic purposes. In Lev 2, we find the happy priest enjoying a tasty snack, but this expands in Lev 3 where the offering is returned *en masse* and specific instructions drive one towards a communal feast. Here one finds in offertory practice an affirmation of the relationship between celebrant and officiant, human and non-human creature, rich and poor, and Israelite and stranger. With this third explicitly social aspect, work is inextricably woven into celebration. In tithing, one finds a consolidation of all three of these aspects such that the work of the people is similarly "drawn into" a moral context.

It is my hope that this study might provide a basic context for contemporary worshippers to consider a renewal of offertory practice. In terms of the practices of the church, this offers a promising site for a renewal of this ancient dynamic where worship is drawn into work and brought into a theologically construed moral context. Such a renewal might provide a more robust basis for contemporary Christians to resist those secular theologies that have caused modern worshippers to sustain and collude with modern forms of work and work organisation that destroy humans and other creatures, and put the whole created order at risk. It is my prayer that – as it has in past centuries – Christian work might provide a context for worship of the Creator in the promotion of convivial work communities, the making of products that promote the flourishing of life, and the retrieval of artisanal wisdom and craft traditions.

Notes

1 Milgrom, *Leviticus 1–16*, 258.
2 Cf. Matthew B. Arbo, "On the Idea of Commerce as a Natural Means of Human Improvement: Adam Smith's Theory of Progress," in Jeremy Kidwell and Sean Doherty (eds), *Theology and Economics: A Vision of the Common Good* (New York, NY: Palgrave, 2015), 93–108.

Bibliography

Aasgaard, Reidar. *My Beloved Brothers and Sisters! Christian Siblingship in Paul*. London: T&T Clark, 2004.

Achtemeier, Elizabeth Rice. *Nahum–Malachi*. Atlanta, GA: John Knox Press, 1986.

Adamson, Glenn. *Thinking through Craft*. New York, NY: Berg, 2007.

Agrell, Göran. *Work, Toil, and Sustenance: An Examination of the View of Work in the New Testament, Taking into Consideration Views Found in the Old Testament, Intertestamental, and Early Tabbinic Writings*. Translated by Stephen Westerhold. Lund: Verbum, Håkan Ohlssons, 1976.

Aitken, Jonathan. "The Market Economy and the Teachings of the Christian Gospel." *Economic Affairs* 24, no. 2 (2004): 19–21.

Albinus, Lars. "Radical Orthodoxy and Post-structuralism: An Unholy Alliance." *Neue Zeitschrift für Systematische Theologie und Religionsphilosophie* 51, no. 3 (2009): 340–54.

Arbo, Matthew B. "On the Idea of Commerce as a Natural Means of Human Improvement: Adam Smith's Theory of Progress." In *Theology and Economics: A Vision of the Common Good*. Edited by Jeremy Kidwell and Sean Doherty. New York, NY: Palgrave, 2015, 93–108.

Arendt, Hannah. *The Human Condition*. Chicago, IL: University of Chicago Press, 1998.

Armerding, Carl. "Feasts and Festivals." In *Dictionary of the Old Testament: Pentateuch*. Edited by T. Desmond Alexander and David W. Baker. Downers Grove, IL: InterVarsity Press, 2003, 300–13.

Augustine. *Works of Saint Augustine*. Edited by Boniface Ramsey. 50 vols. Hyde Park, NY: New City Press, 1990–.

Averbeck, Richard E., "The Tabernacle and Creation." In *Dictionary of the Old Testament: Pentateuch*. Edited by T. Desmond Alexander and David W. Baker. Downers Grove, IL: InterVarsity Press, 2003, 807–27.

Bailey, Kenneth E. *Jesus through Middle Eastern Eyes: Cultural Studies in the Gospels*. Downers Grove, IL: IVP Academic, 2008.

Barclay, John M. G. "Poverty in Pauline Studies: A Response to Steven Friesen." *Journal for the Study of the New Testament* 26, no. 3 (2004): 363–6.

Barker, Margaret. *Creation: A Biblical Vision for the Environment*. London; New York, NY: T&T Clark, 2010.

_____. *Temple Themes in Christian Worship*. London: T&T Clark, 2007.

_____. *The Great High Priest: The Temple Roots of Christian Liturgy*. London: T&T Clark, 2003.

Barth, Karl. *Church Dogmatics III/1*. Edited by G. W. Bromiley and T. F. Torrance. Translated by J. W. Edwards, O. Bussey, and Harold Knight. Edinburgh: T&T Clark, 1958.

Barth, Markus. *Ephesians*. 2 vols. AYB 34–34A. New York, NY: Doubleday, 1974.

_____, and Helmut Blanke. *The Letter to Philemon*. Critical Eerdman's Commentary. Grand Rapids, MI: Eerdmans, 2000.

Bartholomew, Craig G. *A Royal Priesthood? The Use of the Bible Ethically and Politically: A Dialogue with Oliver O'Donovan*. Carlisle: Paternoster Press, 2002.

Baudrillard, Jean. *Jean Baudrillard: Selected Writings*. Edited by Mark Poster. Cambridge: Polity, 2001.

Beale, Gregory K. "Eden, the Temple, and the Church's Mission in the New Creation." *Journal of the Evangelical Theological Society* 48, no. 1 (2005): 5–31.

_____. *The Temple and the Church's Mission: A Biblical Theology of the Dwelling Place of God*. Downers Grove, IL: InterVarsity Press, 2004.

Beasley-Murray, George R. *John*. 2nd edn. WBC 36. Waco, TX: Word Books, 1987.

Benedict XVI, Pope. *A New Song for the Lord: Faith in Christ and Liturgy Today*. New York, NY: Crossroad Publishing, 1996.

Bennett, Jane. *Vibrant Matter: A Political Ecology of Things*. Durham, NC: Duke University Press Books, 2009.

Best, Ernest. *A Critical and Exegetical Commentary on Ephesians*. Edinburgh: T&T Clark International, 1998.

Blenkinsopp, Joseph. *Prophecy and Canon*. Notre Dame, IN: University of Notre Dame Press, 1977.

_____. "Structure of P." *Catholic Biblical Quarterly* 38, no. 3 (1976): 275–92.

Bookchin, Murray. *Our Synthetic Environment*. New York, NY: Harper & Row, 1974.

Borowski, Oded. *Agriculture in Iron Age Israel*. Winona Lake, IN: Eisenbrauns, 1987.

Bradshaw, Paul F. *Reconstructing Early Christian Worship*. Collegeville, MN: Liturgical Press, 2010.

Brammer, S., Geoffrey Williams, and John Zinkin. "Religion and Attitudes to Corporate Social Responsibility in a Large Cross-country Sample." *Journal of Business Ethics* 71, no. 3 (2007): 229–43.

Braun, Roddy L. *1 Chronicles*. WBC 14. Waco, TX: Word Books, 1982.

Bretherton, Luke. *Hospitality as Holiness: Christian Witness amid Moral Diversity*. Aldershot: Ashgate, 2006.

Brock, Brian. *Christian Ethics in a Technological Age*. Grand Rapids, MI: Eerdmans, 2010.

_____. *Singing the Ethos of God: On the Place of Christian Ethics in Scripture*. Grand Rapids, MI: Eerdmans, 2007.

Brock, Sebastian P., and Michael Vasey. *The Liturgical Portions of the Didascalia*. Bramcote: Grove, 1982.

Brown, Peter. *Through the Eye of a Needle: Wealth, the Fall of Rome, and the Making of Christianity in the West, 350–550 AD*. Princeton, NJ: Princeton University Press, 2012.

Brown, Raymond E. *The Gospel According to John 1–12*. AYB 29a. New Haven, CT; London: Yale University Press, 1995.
Brown, William P. *The Seven Pillars of Creation: The Bible, Science, and the Ecology of Wonder*. Oxford: Oxford University Press, 2010.
Bruce, F. F. *1 & 2 Thessalonians*. WBC 45. Waco, TX: Word Books, 1982.
Brueggeman, Walter. *The Prophetic Imagination*. Minneapolis, MN: Fortress Press, 2001.
Bulgakov, Sergei. "The Significance of the Basic Economic Functions: Consumption." In *Philosophy of Economy: The World as Household*. Edited and translated by Catherine Evtuhov. New Haven, CT: Yale University Press, 2000 [1912], 95–122.
Bunting, Madeleine. *Willing Slaves: How the Overwork Culture is Ruling Our Lives*. London: Harper Perennial, 2004.
Cabié, Robert. *The Church at Prayer: An Introduction to the Liturgy*, vol. 2: *The Eucharist*. Translated by Matthew J. O'Connell. London: Geoffrey Chapman, 1986.
Calkins, Martin. "Recovering Religion's Prophetic Voice for Business Ethics." *Journal of Business Ethics* 23, no. 4 (2000): 339–52.
Carson, Rachel. *Silent Spring*. Boston, MA: Houghton Mifflin, 2002.
Cassidy, John. "Who killed the middle class?" *The New Yorker*, 16 October 1995, 113–24.
Childs, Brevard. *Introduction to the Old Testament as Scripture*. London: SCM, 1979.
Chryssides, George D. *An Introduction to Business Ethics*. Edited by John H. Kaler. London: Chapman & Hall, 1993.
Cogan, Mordechai. *1 Kings: A New Translation with Introduction and Commentary*. AYB 10. New York, NY: Doubleday, 2001.
Coleman, Roger. *The Art of Work: An Epitaph to Skill*. London: Pluto Press, 1988.
Cormack, Alexander A. *Teinds and Agriculture: An Historical Survey*. London: Oxford University Press, 1930.
Cosden, Darrell. *A Theology of Work: Work and the New Creation*. Carlisle: Paternoster Press, 2004.
Craigie, Peter C., Page H. Kelley, and Joel F. Drinkard. *Jeremiah 1–25*. WBC 26. Dallas, TX: Word Books, 1991.
Cranfield, C. E. B. *A Critical and Exegetical Commentary on the Epistle to the Romans*. ICC 2. London; New York, NY: T&T Clark, 2004.
Crawford, Matthew B. *Shop Class as Soulcraft: An Inquiry into the Value of Work*. New York, NY: Penguin Press, 2009.
Cross, Frank M. "The Tabernacle: A Study from an Archaeological and Historical Approach." *The Biblical Archaeologist* 10, no. 3 (1947): 45–68.
Davies, Eryl W. *The Immoral Bible*. London: T&T Clark, 2010.
Davis, Ellen F. *Scripture, Culture, and Agriculture: An Agrarian Reading of the Bible*. New York, NY: Cambridge University Press, 2009.
———. "The Agrarian Perspective of the Bible: A Response to James A. Nash, 'The Bible vs. Biodiversity: The Case against Moral Argument from Scripture.'" *Journal for the Study of Religion, Nature & Culture* 3, no. 2 (2009): 260–5.
———. "Slaves or Sabbath-keepers: A Biblical Perspective on Human Work." *Anglican Theological Review* 83, no. 1 (2001): 25–40.

De Graaf, John, David Wann, and Thomas H Naylor. *Affluenza: The All-Consuming Epidemic*. San Francisco, CA: Berrett-Koehler, 2005.

De Vries, Simon J. *1 and 2 Chronicles*. Grand Rapids, MI: Eerdmans, 1989.

———. *1 Kings*. WBC 12. Waco, TX: Word Books, 1985.

Deist, Ferdinand. *The Material Culture of the Bible: An Introduction*. Edited by Robert P. Carroll. Sheffield: Sheffield Academic Press, 2000.

Del Verme, Marcello. *Didache and Judaism: Jewish Roots of an Ancient Christian–Jewish Work*. New York, NY: T&T Clark International, 2004.

Despard, Tom. *The Top Line: Virtuous Companies Finish First*. Fairfax, VA: Xulon Press, 2002.

Detienne, Marcel, and Jean Pierre Vernant. *The Cuisine of Sacrifice among the Greeks*. Chicago, IL: University of Chicago Press, 1989.

Dillard, Raymond B. *2 Chronicles*. WBC 15. Waco, TX: Word Books, 1987.

Douglas, Mary. *Leviticus as Literature*. Oxford: Oxford University Press, 1999.

Dunn, James D. G. *Romans 9–16*. WBC 38B. Waco, TX: Word Books, 1988.

Durham, John I. *Exodus*. WBC 3. Waco, TX: Word Books, 1992.

Eliade, Mircea. *The Sacred and the Profane: The Nature of Religion*. Translated by Willard R. Trask. New York, NY: Harcourt, Brace, 1968.

Ellul, Jacques. *The Technological Society*. New York, NY: Vintage, 1967.

Epstein, Edwin M. "Religion and Business: The Critical Role of Religious Traditions in Management Education." *Journal of Business Ethics* 38, no. 1 (2002): 91–6.

———. "Contemporary Jewish Perspectives on Business Ethics: The Contributions of Meir Tamari and Moses L. Pava: A Review Essay." *Business Ethics Quarterly* 10, no. 2 (2000): 523–41.

Escobar, David. "Amos & Postmodernity: A Contemporary Critical & Reflective Perspective on the Interdependency of Ethics & Spirituality in the Latino-Hispanic American Reality." *Journal of Business Ethics* 103, no. 1 (2011): 59–72.

Farley, Michael A. "What is 'Biblical' Worship? Biblical Hermeneutics and Evangelical Theologies of Worship." *Journal of the Evangelical Theological Society* 51, no. 3 (2008): 591–613.

Farrow, Douglas. *Ascension and Ecclesia: On the Significance of the Doctrine of the Ascension for Ecclesiology and Christian Cosmology*. Grand Rapids, MI: Eerdmans, 1999.

Fitzmyer, Joseph A. *The Gospel According to Luke 10–24: Introduction, Translation, and Notes*. AYB 28a. New Haven, CT; London: Yale University Press, 1985.

Fowl, Stephen E., and L. Gregory Jones. *Reading in Communion: Scripture and Ethics in Christian Life*. Eugene, OR: Wipf & Stock, 1998.

Fox, Everett. *Genesis and Exodus: A New English Rendition*. New York, NY: Schoken Books, 1991.

Frank, Robert H., and Philip J. Cook. *The Winner-take-all Society: Why the Few at the Top Get So Much More Than the Rest of Us*. New York, NY: Penguin Group USA, 1995.

Friesen, Steven J. "Poverty in Pauline Studies: Beyond the So-called New Consensus." *Journal for the Study of the New Testament* 26, no. 3 (2004): 323–61.

Frisch, Amos. "The Exodus Motif in 1 Kings 1–14." *Journal for the Study of the Old Testament* 25, no. 87 (2000): 3–21.

———. "Structure and Its Significance: The Narrative of Solomon's Reign (1 Kings 1–12:24)." *Journal for the Study of the Old Testament* 16, no. 51 (1991): 3–14.

Gale, Herbert M. *The Use of Analogy in the Letters of Paul*. Philadelphia, PA: Westminster John Knox Press, 1964.

Geoghegan, Arthur Turbitt. *The Attitude towards Labor in Early Christianity and Ancient Culture*. Washington, DC: The Catholic University of America Press, 1945.

George, Mark K. *Israel's Tabernacle as Social Space*. Atlanta, GA: SBL, 2009.

Gerdmar, Anders. *Roots of Theological Anti-Semitism: German Biblical Interpretation and the Jews, From Herder and Semler to Kittel and Bultmann*. Leiden: Brill, 2009.

Giddens, Anthony. *The Consequences of Modernity*. Stanford, CA: Stanford University Press, 1990.

Gorringe, Timothy. *The Common Good and the Global Emergency: God and the Built Environment*. Cambridge: Cambridge University Press, 2011.

———. *A Theology of the Built Environment: Justice, Empowerment, Redemption*. Cambridge: Cambridge University Press, 2002.

Grant, Robert M. *Early Christianity and Society: Seven Studies*. San Francisco, CA: Harper & Row, 1977.

Granter, Edward. *Critical Social Theory and the End of Work*. Farnham: Ashgate, 2009.

Greenhalgh, Paul. "Words in the World of the Lesser: Recent Publications on the Crafts." *Journal of Design History* 22, no. 4 (2009): 401–11.

Guinagh, Kevin, and Alfred P. Dorjahn. *Latin Literature in Translation*. London: Longmans, Green and Co., 1942.

Gupta, Nijay K. *Worship That Makes Sense to Paul: A New Approach to the Theology and Ethics of Paul's Cultic Metaphors*. Berlin: De Gruyter, 2010.

Haenchen, Ernst. *John: A Commentary on the Gospel of John*. Edited by Ulrich Busse and Robert Walter Funk. Translated by Robert Walter Funk. Hermenaeia. Philadelphia, PA: Fortress Press, 1984.

Hagner, Donald A. *Matthew 14–28*. WBC 33a. Dallas, TX: Word Books, 1995.

Hall, Charles A. S., and W. W. John. "Revisiting the Limits to Growth after Peak Oil." *American Scientist* 97, no. 3 (2009): 230–7.

Hammond, Pete, R. Paul Stevens, and Todd Svanoe. *The Marketplace Annotated Bibliography: A Christian Guide to Books on Work, Business & Vocation*. Downers Grove, IL: InterVarsity Press, 2002.

Harper, Douglas A. *Working Knowledge: Skill and Community in a Small Shop*. Berkeley, CA: University of California Press, 1992.

Harper, William. "The Future of Leisure: Making Leisure Work." *Leisure Studies* 16, no. 3 (1997): 189–98.

Hartley, John E. *Leviticus*. WBC 4. Waco, TX: Word Books, 1992.

Hays, Christopher M. "Resumptions of Radicalism. Christian Wealth Ethics in the Second and Third Centuries." *Zeitschrift fur die Neutestamentliche Wissenschaft und Kunde der Alteren Kirche* 102, no. 2 (2011): 261–82.

———. *Luke's Wealth Ethics: A Study in Their Coherence and Character*. Tübingen: Mohr Siebeck, 2010.

Heidegger, Martin. "The Origin of the Work of Art." Translated by Albert Hofstadter. In *Basic Writings*. Edited by David Farrell Krell. New York, NY: HarperCollins, 1993, 139–212.

Heinberg, Richard. *Peak Everything: Waking Up to the Century of Declines*. Gabriola, BC: New Society Publishers, 2007.

Hejeebu, Santhi, and Deirdre McCloskey. "The Reproving of Karl Polanyi." *Critical Review* 13, no. 3 (1999): 285–314.

Heschel, Abraham Joshua. *The Sabbath: Its Meaning for Modern Man*. New York, NY: Farrar, Straus and Giroux, 2005.

Hillman, Os. *The 9 to 5 Window*. Ventura, CA: Regal, 2005.

Hock, Ronald F. *The Social Context of Paul's Ministry: Tentmaking and Apostleship*. Philadelphia, PA: Fortress Press, 1980.

———. "The Workshop as a Social Setting for Paul's Missionary Preaching." *Catholic Biblical Quarterly* 41, no. 3 (1979): 438–50.

Houtman, Cornelis. *Exodus, Chapters 20–40*. Edited by Cornelis Houtman, Gert T. M. Prinsloo, Wilfred G. E. Watson, and Al Wolters. Translated by Sierd Woudstra. Historical Commentary on the Old Testament 3. Leuven: Peeters, 2000.

Howard, Thomas A. *Religion and the Rise of Historicism: W.M.L. De Wette, Jacob Burckhardt, and the Theological Origins of Nineteenth-century Historical Consciousness*. Cambridge: Cambridge University Press, 2006.

Hughes, John. *The End of Work: Theological Critiques of Capitalism*. Illuminations: Theory & Religion. Malden, MA: Blackwell, 2007.

Illich, Ivan. *Tools for Conviviality*. London: Calder and Boyars, 1973.

Ingold, Tim. "Toward An Ecology of Materials." *Annual Review of Anthropology* 41, no. 1 (2012): 427–42.

Jackson, John Robert. "Enjoying the Fruit of One's Labor: Attitudes toward Male Work and Workers in the Hebrew Bible." PhD Diss., Duke University, 2005.

Japhet, Sara. *I & II Chronicles: A Commentary*. Old Testament Library. Louisville, KY: Westminster John Knox Press, 1993.

Jarick, John. "The Temple of David in the Book of Chronicles." In *Temple and Worship in Biblical Israel*. Edited by John Day. London: T&T Clark, 2007, 365–81.

Jensen, David Hadley. *Responsive Labor: A Theology of Work*. Louisville, KY: Westminster John Knox Press, 2006.

John Paul II, Pope. *Laborem Exercens*. London: Catholic Truth Society, 1981.

Johnson, Luke Timothy. *Reading Romans: A Literary and Theological Commentary*. Macon, GA: Smyth & Helwys Publishing, 2001.

Jones, Robert, James Latham, and Michela Betta. "Creating the Illusion of Employee Empowerment: Lean Production in the International Automobile Industry." *International Journal of Human Resource Management* 24, no. 8 (2013): 1629–45.

Kanigel, Robert. *The One Best Way*. New York, NY: Viking, 1997.

Kearney, Peter J. "Creation and Liturgy: The P Redaction of Ex 25–40." *Zeitschrift für die alttestamentliche Wissenschaft* 89, no. 3 (1977): 375–87.

Keil, Carl Freidrich, and Franz Julius Delitzsch. *Commentary on the Old Testament*. 10 vols. Peabody, MA: Hendrickson Publishers, 1996.

Kelsey, David H. *Eccentric Existence: A Theological Anthropology*. 2 vols. Louisville, KY: Westminster John Knox Press, 2009.

Kessler, Eric H., and James Russell Bailey, eds. *Handbook of Organizational and Managerial Wisdom*. Los Angeles, CA: Sage Publications, 2007.

Kidwell, Jeremy. "Nature and Culture in Augustine, a Patristic Spiritual Ecology?" In *Augustine and the Environment*. Edited by Teresa Delgado, John Doody, and Kim Paffenroth. Lanham, MD: Lexington Books, 2016, forthcoming.

―――. "Radical or Realist? The Ethics of Work in John Chrysostom." In *Theology and Economics: A Christian Vision of the Common Good*. Edited by Jeremy Kidwell and Sean Doherty. New York, NY: Palgrave Macmillan, 2015, 127–42.

―――. "Labour." In *The Oxford Guide to the Historical Reception of Augustine*. Edited by Karla Pollmann and Willemien Otten. 3 vols. Oxford: Oxford University Press, 2013, 3:1268–73.

Kim, David, Dan Fisher, and David McCalman. "Modernism, Christianity, and Business Ethics: A Worldview Perspective." *Journal of Business Ethics* 90, no. 1 (2009): 115–21.

Klein, Naomi. *No Logo: Taking Aim at the Brand Bullies*. New York, NY: Picador, 2000.

Klein, Ralph W. *1 Chronicles: A Commentary*. Edited by Thomas Krüger. Hermeneia. Minneapolis, MN: Fortress Press, 2006.

Knohl, Israel. *The Sanctuary of Silence: The Priestly Torah and the Holiness School*. Winona Lake, IN: Eisenbrauns, 2007.

Knoppers, Gary N. "Yhwh's Rejection of the House Built for His Name: On the Significance of Anti-temple Rhetoric in the Deuteronomistic History." In *Essays on Ancient Israel in Its Near Eastern Context*. Edited by Yairah Amit, Ehud Ben Zvi, Israel Finkelstein, and Oded Lipschits. Winona Lake, IN: Eisenbrauns, 2006, 221–38.

Kreitzer, Larry. "The Messianic Man of Peace as Temple Builder: Solomonic Imagery in Ephesians 2:13–22." In *Temple and Worship in Biblical Israel*. Edited by John Day. Library of Hebrew Bible/Old Testament Studies. London: T&T Clark, 2007, 484–512.

Kuck, David. "Paul and Pastoral Ambition: A Reflection on 1 Cor 3–4." *Currents in the Theology of Missions* 19 (1992): 174–83.

Lanci, John R. *A New Temple for Corinth: Rhetorical and Archaelogical Approaches to Pauline Imagery*. New York, NY: P. Lang, 1997.

Langston, Scott M. *Exodus through the Centuries*. Malden, MA; Oxford: Blackwell, 2006.

Larive, Armand. *After Sunday: A Theology of Work*. New York, NY: Continuum, 2004.

Latour, Bruno. *On the Modern Cult of the Factish Gods*. Durham, NC: Duke University Press, 2010.

―――. *Reassembling the Social: An Introduction to Actor-network-theory*. Oxford: Oxford University Press, 2005.

―――. *Politics of Nature: How to Bring the Sciences Into Democracy*. Cambridge, MA: Harvard University Press, 2004.

Leach, Bernard. *A Potter's Book*. 2nd edn. London: Faber and Faber Limited, 1945.

Leithart, Peter J. *1 & 2 Kings*. Brazos Theological Commentary on the Bible. Grand Rapids, MI: Brazos Press, 2006.

———. "Making and Mis-making: Poiesis in Exodus 25–40." *International Journal of Systematic Theology* 2, no. 3 (2000): 307–18.

Levenson, Jon D. *Creation and the Persistence of Evil*. Princeton, NJ: Princeton University Press, 1994.

———. *Sinai and Zion*. Minneapolis, MN: Winston Press, 1985.

Levine, Baruch A. *Leviticus*. JPSTC 3. Philadelphia, PA: Jewish Publication Society, 1989.

———. *Numbers 1–20: A New Translation with Introduction and Commentary*. Edited by David Noel Freedman and William Foxwell Albright. AYB 4A. New York, NY: Doubleday, 1993.

Lichtheim, Miriam. *Ancient Egyptian Literature: Volume 2*. Berkeley, CA: University of California Press, 2006.

Lienhard, Joseph T., and Ronnie J. Rombs. *Exodus, Leviticus, Numbers, Deuteronomy*. Ancient Christian Commentary on Scripture OT 3. Edited by Thomas C Oden. Downers Grove, IL: InterVarsity Press, 2001.

Lightfoot, J. B., and J. R. Harmer, eds and trans. *The Apostolic Fathers: Greek Texts and English Translations of Their Writings*. 3rd edn. Edited and revised by Michael W. Holmes. Grand Rapids, MI: Baker Academic, 2007.

Longacre, Robert E. "Building for the Worship of God: Exodus 25:1–30:10." In *Discourse Analysis of Biblical Literature: What It Is and What It Offers*. Edited by Walter R. Bodine. Semeia Studies. Atlanta, GA: Scholars Press, 1995, 21–39.

MacIntyre, Alasdair C. *After Virtue: A Study in Moral Theory*. 3rd edn. Notre Dame, IN: University of Notre Dame Press, 2007.

Martin, Dale B. "Tongues of Angels and Other Status Indicators." *Journal of the American Academy of Religion* 59, no. 3 (1991): 547–89.

Maxwell, John C. *The 21 Most Powerful Minutes in a Leader's Day: Revitalize Your Spirit and Empower Your Leadership*. Nashville, TN: Thomas Nelson, 2007.

Mayhew, Anne, Walter C. Neale, and David W. Tandy. "Markets in the Ancient Near East: A Challenge to Silver's Argument and Use of Evidence." *Journal of Economic History* 45, no. 1 (1985): 127–34.

McDonough, William, and Michael Braungart. *Cradle to Cradle: Remaking the Way We Make Things*. New York, NY: North Point Press, 2002.

McLemore, Clinton W. *Street-smart Ethics: Succeeding in Business Without Selling Your Soul*. Louisville, KY: Westminster John Knox Press, 2003.

McNutt, Paula M. *The Forging of Israel: Iron Technology, Symbolism and Tradition in Ancient Society*. Sheffield: Almond Press, 1990.

Meadows, Donella H., Dennis L. Meadows, and Jørgen Randers. *Limits to Growth: The 30-year Update*. White River, VT: Chelsea Green Publishers, 2004.

Meadows, Donella H., Dennis L. Meadows, Jørgen Randers, and William W. Behrens III. *The Limits to Growth: A Report for the Club of Rome's Project on the Predicament of Mankind*. New York, NY: Universe Books, 1972.

Meeks, M. Douglas. *God the Economist: The Doctrine of God and Political Economy.* Minneapolis, MN: Fortress Press, 1989.

Meggitt, Justin J. *Paul, Poverty and Survival.* Studies of the New Testament and Its World. Edinburgh: T&T Clark, 1998.

Meyers, Carol L., and Eric M. Meyers. *Zechariah 9–14: A New Translation with Introduction and Commentary.* New York, NY: Doubleday, 1993.

Michaels, J. Ramsey. *John.* NIBC. Edited by W. Ward Gasque. Peabody, MA: Hendrickson Publishers, 1989.

Milbank, John. *Beyond Secular Order: The Representation of Being and the Representation of the People.* Oxford: Wiley Blackwell, 2013.

———. *Theology and Social Theory: Beyond Secular Reason.* Oxford; Malden, MA: Blackwell, 2006.

———. "The Ethics of Self-sacrifice." *First Things: A Monthly Journal of Religion & Public Life* 91 (1999): 33–8.

———. "The Midwinter Sacrifice: A Sequel to 'Can Morality Be Christian?'" *Studies in Christian Ethics* 10, no. 2 (1997): 13–38.

———. "Stories of Sacrifice: From Wellhausen to Girard." *Theory, Culture & Society* 12, no. 4 (1995): 15–46.

———. *The Religious Dimension in the Thought of Giambattista Vico, Part 2, Language, Law and History.* Studies in the History of Philosophy 32. Lewiston, ME: Mellen, 1992.

Milgrom, Jacob. *Leviticus: A Book of Ritual and Ethics.* Continental Commentaries 3. Minneapolis, MN: Fortress Press, 2004.

———. *Leviticus 23–27: A New Translation with Introduction and Commentary.* AYB 3c. New York, NY: Doubleday, 2001.

———. *Leviticus 1–16: A New Translation with Introduction and Commentary.* AYB 3a. New York, NY: Doubleday, 1991.

———. *Numbers, English and Hebrew: Commentary in English.* JPSTC. Philadelphia, PA: Jewish Publication Society, 1990.

Miller, David W. *God at Work: The History and Promise of the Faith at Work Movement.* Oxford: Oxford University Press, 2007.

Moltmann, Jürgen. *Ethics of Hope.* Minneapolis, MN: Fortress Press, 2012.

———. *God in Creation: An Ecological Doctrine of Creation.* Translated by Margaret Kohl. London: SCM, 1997.

———. *The Way of Jesus Christ: Christology in Messianic Dimensions.* Translated by Margaret Kohl. London: SCM, 1993.

———. *Theology of Hope: On the Ground and the Implications of a Christian Eschatology.* Minneapolis, MN: Fortress Press, 1993.

———. *On Human Dignity: Political Theology and Ethics.* Translated by M. Douglas Meeks. Philadelphia, PA: Fortress Press, 1984.

———. *Theology of Play.* Translated by Reinhard Ulrich. New York, NY: Harper & Row, 1972.

Molyneaux, David. "'Blessed Are the Meek, for They Shall Inherit the Earth' – An Aspiration Applicable to Business?" *Journal of Business Ethics* 48, no. 4 (2003): 347–63.

Moore, Malcolm. "'Mass suicide' protest at Apple manufacturer Foxconn factory." *The Telegraph*, 11 January 2012.
Morgan, Jonathan D. "Land, Rest & Sacrifice: Ecological Reflections on the Book of Leviticus." PhD Diss., Exeter University, 2010.
_____, "Sacrifice in Leviticus: Eco-Friendly Ritual or Unholy Waste?" In *Ecological Hermeneutics: Biblical, Historical, and Theological Perspectives*. Edited by David G. Horrell, Cherryl Hunt, Christopher Southgate, and Francesca Stavrakopoulou. Edinburgh: T&T Clark, 2010, 32–45.
Morrill, Bruce T. "Holy Communion as Public Act: Ethics and Liturgical Participation." *Studia liturgica* 41, no. 1 (2011): 31–46.
Morris, Leon. *The Gospel According to John*. NICNT. Grand Rapids, MI: Eerdmans, 1995.
Mouw, Richard J. *When the Kings Come Marching In: Isaiah and the New Jerusalem*. Grand Rapids, MI: Eerdmans, 2002.
Needleman, Carla. *The Work of Craft: An Inquiry into the Nature of Crafts and Craftsmanship*. London: Arkana, 1986.
Northcott, Michael. "Loving Scripture and Nature." *Journal for the Study of Religion, Nature & Culture* 3, no. 2 (2009): 247–53.
Northcott, Michael S. *Moral Climate: The Ethics of Global Warming*. Maryknoll, NY: Orbis Books, 2007.
_____. "Concept Art, Clones, and Co-creators: The Theology of Making Modern Theology." *Modern Theology* 21, no. 2 (2005): 219–36.
_____. *The Environment and Christian Ethics*. Cambridge: Cambridge University Press, 1996.
Norton, Michael I., Daniel Mochon, and Dan Ariely. "The IKEA Effect: When Labor Leads to Love." *Journal of Consumer Psychology* 22, no. 3 (2012): 453–60.
Nørgaard, Jørgen, Kristín Vala Ragnarsdóttir, and John Peet. "The History of the Limits to Growth." *Solutions Journal: For a sustainable and desirable future* 1, no. 2 (2010): 59–63.
O'Donovan, Joan Lockwood, and Oliver O'Donovan. *From Irenaeus to Grotius: A Sourcebook in Christian Political Thought 100–1625*. Grand Rapids, MI: Eerdmans, 1999.
O'Donovan, Oliver. *Common Objects of Love: Moral Reflection and the Shaping of Community: The 2001 Stob Lectures*. Grand Rapids, MI: William B. Eerdmans Publishing, 2002.
_____. *The Desire of the Nations: Rediscovering the Roots of Political Theology*. Cambridge: Cambridge University Press, 1996.
_____. *Resurrection and Moral Order: An Outline for Evangelical Ethics*. 2nd edn. Leicester: Apollos, 1994.
Oswalt, John N. *The Book of Isaiah*. NICOT 23a. Grand Rapids, MI: Eerdmans, 1986.
Otto, Rudolf, and John W. Harvey. *The Idea of the Holy: An Inquiry into the Nonrational Factor in the Idea of the Divine and Its Relation to the Rational*. London: Oxford University Press, 1925.
Pava, Moses L. "The Path of Moral Growth." *Journal of Business Ethics* 38, no. 1/2 (2002): 43–54.

Perrin, Nicholas. *Jesus the Temple*. Grand Rapids, MI: Baker Academic, 2010.
Peterson, David. "The New Temple: Christology and Ecclesiology in Ephesians and 1 Peter." In *Heaven on Earth*. Edited by T. Desmond Alexander and Simon Gathercole. Waynesboro, GA: Paternoster Press, 2004, 161–76.
Pieper, Josef. *Leisure: The Basis of Culture*. San Francisco, CA: Ignatius Press, 2009.
Plato. *Plato: Complete Works*. Edited by John M. Cooper. Indianapolis, IN: Hackett Publishing Company, 1997.
Powis Smith, J. M., and Julius A. Bewer, eds. *A Critical and Exegetical Commentary on Haggai, Zechariah, Malachi and Jonah*. New York, NY: C. Scribner's Sons, 1912.
Propp, William H. C. *Exodus 19–40: A New Translation with Introduction and Commentary*. AYB 2a. New York, NY: Doubleday, 2006.
Provan, Iain William. *1 and 2 Kings*. NIBC 7. Peabody, MA: Paternoster Press, 1999.
Pye, David. *The Nature and Aesthetics of Design*. London: Barrie & Jenkins Ltd., 1978.
_____. *The Nature and Art of Workmanship*. Cambridge: Cambridge University Press, 1968.
Rae, Murray. "On Reading Scripture Theologically." *Princeton Theological Review* 14.1, no. 38 (2008), 13–26.
Rainey, Anson F. "Sacrifice and Offerings." In *Zondervan Pictorial Encyclopedia of the Bible*. Edited by Merrill C. Tenney. 5 vols. Grand Rapids, MI: Zondervan, 1975, 5:194–211.
Reed, Esther D. *Good Work: Christian Ethics in the Workplace*. Waco, TX: Baylor University Press, 2010.
Rendtorff, Rolf. "The Paradigm Is Changing: Hopes – and Fears." *Biblical Interpretation: A Journal of Contemporary Approaches* 1, no. 1 (1993): 34–53.
_____, and Robert A. Kugler. *The Book of Leviticus: Composition and Reception*. Atlanta, GA: SBL, 2006.
Rifkin, Jeremy. *The End of Work: The Decline of the Global Labor Force and the Dawn of the Post-market Era*. New York, NY: Jeremy P. Tarcher/Penguin, 2004.
Roberts, Kenneth. *Leisure in Contemporary Society*. 2nd edn. Wallingford: CABI Publishing, 2006.
Robertson, Amy H. C. "'He Kept the Measurements in His Memory As a Treasure': The Role of the Tabernacle Text in Religious Experience." PhD Diss., Emory University, 2010.
Rockström, Johan, Will Steffen, Kevin Noone, Asa Persson, F. Stuart Chapin, Eric F. Lambin, and Timothy M. Lenton. "A Safe Operating Space for Humanity." *Nature* 461, no. 7263 (2009): 472–5.
Rojek, Chris. "Did Marx have a Theory of Leisure?" *Leisure Studies* 3, no. 2 (1984): 163–74.
Rowland, Chris. "The Temple in the New Testament." In *Temple and Worship in Biblical Israel*. Edited by John Day. Library of Hebrew Bible/Old Testament Studies. London: T&T Clark, 2007.
Rush, Myron. *Management: A Biblical Approach*. Colorado Springs, CO: Victor, 2002.
Safari, Shemuel. "The Temple." In *The Jewish People in the First Century*. Edited by Shemuel Safari and Menahem Stern. Compendia Rerum Iadaicarum ad Novum Testamentum I/2. Assen: Van Gorcum, 1976, 865–907.

Sanders, E. P. *Jesus and Judaism*. Philadelphia, PA: Fortress Press, 1985.
Sarna, Nahum M. *Exodus*. JPSTC 2. Philadelphia, PA: Jewish Publication Society, 1991.
Schaff, Chrysostom. *The Nicene and Post-Nicene Fathers* 1. Edited by Philip Schaff. 14 vols. Peabody, MA: Hendrickson [1886–89], repr. 1994.
Schniedewind, William M. *The Word of God in Transition*. Sheffield: Sheffield Academic Press, 1995.
Schweitzer, Steven James. *Reading Utopia in Chronicles*. Library of Hebrew Bible/Old Testament Studies. London: T&T Clark, 2009.
Scirghi, Thomas J. "This Blessed Mess." In *Living Beauty: The Art of Liturgy*. Edited by Alex García-Rivera and Thomas J. Scirghi. Lanham, MD: Rowman & Littlefield Publishers, 2008, 19–33.
_____. "What Is Beautiful for God? (What Does God Like?)." In *Living Beauty: The Art of Liturgy*. Edited by Alex García-Rivera and Thomas J. Scirghi. Lanham, MD: Rowman & Littlefield Publishers, 2008, 63–71.
Selman, Martin J. *1 Chronicles: An Introduction and Commentary*. TOTC. Nottingham: InterVarsity Press, 1994.
Sennett, Richard. *The Craftsman*. New Haven, CT: Yale University Press, 2008.
_____. *The Culture of the New Capitalism*. London: Yale University Press, 2006.
_____. *The Corrosion of Character*. New York, NY; London: Norton & Company, 1999.
Shanor, Jay. "Paul as Master Builder: Construction Terms in First Corinthians." *New Testament Studies* 34, no. 3 (1988): 461–71.
Sievers, Allen Morris. *Has Market Capitalism Collapsed? A Critique of Karl Polanyi's New Economics*. New York, NY: AMS Press, 1968.
Silver, Morris. "Karl Polanyi and Markets in the Ancient Near East: The Challenge of the Evidence." *Journal of Economic History* 43, no. 4 (1983): 795–829.
_____. *Prophets and Markets: The Political Economy of Ancient Israel*. Boston, MA: Kluwer-Nijhoff Publishers, 1983.
Simmel, Georg. *The Philosophy of Money*. New York, NY: Routledge, 2004.
Slade, Giles. *Made to Break: Technology and Obsolescence in America*. Cambridge, MA: Harvard University Press, 2006.
Smith, Ralph L. *Micah–Malachi*. WBC 32. Dallas, TX: Word Publishing, 1984.
Soler, Jean. "Sémiotique de la Nourriture dans la Bible." *Annales Histoire, Sciences Sociales* 28, no. 4 (1973): 943–55.
Sterling, Bruce. *Shaping Things*. Cambridge, MA: MIT Press, 2005.
Stevens, R. Paul. *Doing God's Business: Meaning and Motivation for the Marketplace*. Grand Rapids, MI: Eerdmans, 2006.
_____. *The Other Six Days: Vocation, Work, and Ministry in Biblical Perspective*, repr. of *The Abolition of the Laity* (1999). Grand Rapids, MI: Eerdmans, 1999.
Still, Todd D. "Did Paul Loathe Manual Labor? Revisiting the Work of Ronald F. Hock on the Apostle's Tentmaking and Social Class." *Journal of Biblical Literature* 125, no. 4 (2006): 781–95.
Stordalen, Terje. *Echoes of Eden: Genesis 2–3 and Symbolism of the Eden Garden in Biblical Hebrew Literature*. Leuven: Peeters, 2000.

Stuart, Douglas K. *Hosea–Jonah*. WBC 31. Dallas, TX: Word Publishing, 1989.
Sullivan, Louis H. "The Tall Office Building Artistically Considered." *Lippincott's Magazine* 57 (1896): 403–9.
Szesnat, Holger. "What Did the Skēnopoios Paul Produce?" *Neotestamentica* 27 (1993): 391–402.
Talbert, Charles H. *Reading John: A Literary and Theological Commentary on the Fourth Gospel and the Johannine Epistles*. Macon, GA: Smyth & Helwys Publishing, 2005.
Tamari, Meir. "Ethical Issues in Bankruptcy: A Jewish Perspective." *Journal of Business Ethics* 9, no. 10 (1990): 785–9.
Thiselton, Anthony C. *The First Epistle to the Corinthians: A Commentary on the Greek Text*. NIGTC. Grand Rapids, MI: Eerdmans, 2000.
Thompson, John A. *The Book of Jeremiah*. NICOT 24. Grand Rapids, MI: Eerdmans, 1980.
Thompson, P. W. *The Whole Tithe*. London; Edinburgh: Marshall, Morgan & Scott, Ltd., 1930.
Tuckett, Christopher M. "Synoptic Tradition in the Didache." In *The New Testament in Early Christianity. La Réception des Écrits Neotestamentaires dans le Christianisme Primitif*. BEThL 86. Edited by J.-M. Sevrin. Leuven: Brill, 1996, 197–230.
Turner, Graham. *A Comparison of the Limits to Growth with Thirty Years of Reality*. Canberra: CSIRO Sustainable Ecosystems, 2008.
United States Conference of Catholic Bishops. *General Instruction of the Roman Missal*. 3rd edn. Washington, DC: United States Conference of Catholic Bishops, 2010.
Vahrenhorst, Martin. *Kultische Sprache in Den Paulusbriefen*. Tübingen: Mohr Siebeck, 2008.
Van Duzer, Jeff. *Why Business Matters to God*. Grand Rapids, MI: InterVarsity Press, 2010.
Volf, Miroslav. *Work in the Spirit: Toward a Theology of Work*. New York, NY: Oxford University Press, 1991.
Von Rad, Gerhard. "There Remains Still a Rest for the People of God." In *The Problem of the Hexateuch and Other Essays*. Translated by E. W. Trueman Dicken. New York, NY: McGraw-Hill, 1966, 94–102.
———. *Old Testament Theology*, vol. 1. Atlanta, GA: Westminster John Knox Press, 2001.
Wallace, Jayne, and Mike Press. "All This Useless Beauty: The Case for Craft Practice in Design for a Digital Age." *The Design Journal* 7, no. 2 (2004): 42–53.
Wannenwetsch, Bernd. *Political Worship: Ethics for Christian Citizens*. Oxford: Oxford University Press, 2004.
Watts, James W. *Ritual and Rhetoric in Leviticus: From Sacrifice to Scripture*. Cambridge: Cambridge University Press, 2007.
Weaver, Gary R., and Bradley R. Agle. "Religiosity and Ethical Behavior in Organizations: A Symbolic Interactionist Perspective." *The Academy of Management Review* 27, no. 1 (2002): 77–97.
Webster, John. "Reading Scripture Eschatologically." In *Reading Texts, Seeking Wisdom*. Edited by David F. Ford and Graham Stanton. Grand Rapids, MI: Eerdmans, 2003, 245–56.

Weir, Stuart. "The Good Work of 'Non-Christians,' Empowerment, and the New Creation." PhD Diss., University of Edinburgh, 2012.
Wenham, Gordon J. *Genesis 1–15*. WBC 1. Waco, TX: Word Books, 1987.
_____. *The Book of Leviticus*. NICOT 3. Grand Rapids, MI: Eerdmans, 1979.
Westermann, William Linn. "Between Slavery and Freedom." *The American Historical Review* 50, no. 2 (1945): 213–27.
Wevers, John William. *Notes on the Greek Text of Exodus*. Septuagint and Cognate Studies 30. Atlanta, GA: Scholars Press, 1990.
Williams, Eric Eustace. *Capitalism & Slavery*. Kingston: Ian Randle Publishers, 2005.
Williams, Rowan. *Grace and Necessity: Reflections on Art and Love*. Harrisburg, PA: Morehouse, 2005.
Williamson, H. G. M. *Ezra–Nehemiah*. WBC 16. Waco, TX: Word Books, 1985.
Winter, Bruce B. "The Lord's Supper at Corinth: An Alternative Reconstruction." *Reformed Theological Review* 37 (1978): 73–82.
Witherington, Ben. *Work: A Kingdom Perspective on Labor*. Grand Rapids, MI: Eerdmans, 2011.
Womack, James P. *The Machine That Changed the World: Based on the Massachusetts Institute of Technology 5-million Dollar 5-year Study on the Future of the Automobile*. Edited by Daniel T. Jones and Daniel Roos. New York, NY: Rawson Associates, 1990.
Wood, Edwin Jackson. "The Social World of the Ancient Craftsmen as a Model for Understanding Paul's Mission." PhD Diss., Southwestern Baptist Theological Seminary, 1995.
Wright, N. T. *Jesus and the Victory of God*. Christian Origins and the Question of God. Minneapolis, MN: Fortress Press, 1996.
_____. *New Testament and the People of God*. Christian Origins and the Question of God. Minneapolis, MN: Fortress Press, 1992.
Yoder, John Howard. *The Original Revolution*. Scottdale, PA: Herald Press, 1971.

Index of Biblical References

Genesis

1–3	29
1:1–2:3	32, 107
2:1–2	23
2:3	180
4:4	157, 158, 189
6:5	115n72
7:12	48n2
8:20	48n2
8:21	115n72
14:18	205
14:20	205
18:6	179
28:20–2	200, 205
31:54	201
41:38	35

Exodus

1:17	180
2:23	54
3:21–2	116
3:22	102
4:22	185
11:2	102, 116
11:5	180
12:29	180
12:34	114
12:35–6	116
12:35	102
13:2	180
19:5–6	85
19:6	112
20:25	28
22:28–30	180, 184
22:28	183
22:29	189
22:31	185
23:16	180–3
23:19	180–2, 184
24:18	48
25–31	31
25–40	15, 34
25	26–32, 40, 100–1, 103
25:1	32
25:2–7	40
25:2	40
25:8	45, 46
25:9	26, 31, 43, 103
25:11	38
25:12	38
25:21–2:26	
25:31	38
26:36	38
28:1–30:38	211
28:2	87
28:3	36, 105
28:11	38
28:20	38
28:28	38
28:32	38
28:36	94
28:40	87
30:11	32
30:17	32
30:22	32
30:25	38
30:34	32
31	32–9
31:1	32
31:3	51, 78
31:4	38
31:3–5	34
31:5	38, 51
31:6	36, 105
31:12	32
32–6	39–48

32–4	31
32:3	40
32:5	212
32:6	201, 212
34:22	180, 182, 186
34:26	182, 184
34:28	48
35–40	31, 45
35–6	40, 101
35	40
35:2–3	48n1
35:4–29	105
35:4–9	40
34:19–20	180
34:22	180–1
34:26	180
35:5	40, 68
35:10	45, 105
35:20–9	40
35:21–2	68
35:25–6	38
35:26	36
35:29	40, 51
35:30–36:1	105
35:30–36:7	50
35:31	51
35:33	51
35:34	36
35:35	39, 51
35:36	34, 36, 105
36:1–2	36
36:2	40
36:4	45
36:3–7	40, 41
38:3	114
38:23	36
39:3	38
39:28	87
39:30	94
39:32	23, 45
39:42–3	45
40:33	23

Leviticus

1–3	154
1:1–17	163
1:3	160, 162
1:4	161
1:7–8	69
1:12	69
1:17	69
2	178, 192
2:1–2	179
2:3	178, 183
2:4–5	179
2:7	179
2:9	183
2:10	178
2:14–16	179
2:14	182
3	200
3:3–5	201
3:5	69
4:12	69, 163
4:21	163
5:11	179
6	159
6:7–23	183
6:8–13	163
6:8	179
6:10–11	178
6:12	69
6:13	179
6:18	178
7	159
7:11–16	200
7:12	179
7:15	201
10:16	163
11:32	69
14:4	69
14:6	69
14:10	179
14:21	179
14:49	69
14:51–2	69
17–26	205
19	160, 205
19:23–5	190
22	160
23:13	179
23:14	190
23:16–17	179
23:20	184, 194
23:21	184
24:5	179
25	12
26:1	120
26:30	120
27:30–1	205

Numbers

3:12–13	189
3:13	197

Index of Biblical References

3:50 .. 197
4:14 .. 114
7 ... 201
8:17 .. 197
10 ... 200
13:20 .. 182
15:3 .. 161
15:20–1 .. 183
15:20 .. 194
18 ... 206
18:12–13 .. 184
18:12 ... 182–3
18:13 .. 183
18:17 .. 197
18:27 .. 194
18:30 .. 194
19:5 .. 176
19:6 ... 79, 176
19:8 .. 176
28:26–31 .. 184
28:26 180, 184, 197

Deuteronomy

1:35 .. 116
3:25 .. 116
4:6 ... 35
4:20 ... 27
4:21–2 .. 116
6:18 .. 116
8:3 .. 130, 142
8:10 .. 116
9:6 .. 116
11:17 .. 116
12:6 .. 175, 184
14 ... 206
14:23 .. 206
14:23 .. 207
14:23–5 .. 207
14:25–6 .. 207
14:27 .. 207
14:28–9 184, 207
15:19 .. 197
16 ... 185
16:9–12 .. 184
16:10 180, 183
16:11 .. 184
16:16 180, 183
17:14–17 .. 76
17:16 .. 94
17:18–20 .. 105
18:4 .. 184
20:6 .. 129

24:14–15 .. 75
26 ... 183
26:1–11 .. 184
26:2 .. 182
26:10 .. 182
26:12–15 .. 207
27:5 .. 28
27:6–7 .. 200
28 ... 55
28:30 .. 129
31:21 .. 115

Joshua

13:14–33 .. 211
19:51 .. 23
21:17 .. 57
22:23 .. 196
22:29 .. 196
23:16 .. 116

Judges

3:10 .. 34
8:22–3 .. 76
9:1–57 .. 76
11:29 .. 34
13:19 .. 196
13:23 .. 196
13:25 .. 34
14:6 .. 34
14:19 .. 34
15:14 .. 34

1 Samuel

1 ... 54
2:29 .. 182
7:9 .. 165
8 ... 207
8:11–17 .. 55
10:6 .. 34
11:6 .. 34
13:12 .. 161
15:21 .. 182

2 Samuel

1:21 .. 186
7:1 .. 109
7:11 .. 109

1 Kings

1–12	62
1:3	87
2:1–4	56
2:24	60
2:28–34	60
3:3–4	57
3:5–4:34	59
3:1	60
3:9	58–9
3:15	77
4	78
4:22–3	68
5–8	48
5:8	69
5:13	61
6	101
6:9–10	79
6:15–16	79
6:18	79
6:20	79
6:36	79
7:2	69
7:8	87
7:17	87
7:19	87
7:22	87
7:26	87
7:28–9	87
7:31	87
7:33	87
7:40	63
7:45	63
8:62–4	201
8:64	196
9	61, 68
9:6–7	73
9:11	69
10:1–15	85
10:1	58
10:2	85
10:17	102
10:21	102
10:22	84
10:23	85
10:24–5	85
22:41–50	85
22:48	85
22:49	113

2 Kings

7:1	179
7:16	179
7:18	179
16:13	196
16:15	196
18:4	213
23:34–24:16	74

Isaiah

1:10–15	176
2:2–4	113
2:7	94
2:16	113
2:18	141
4:2	87, 92
10:11	141
16:12	141
18:4	142
19:1	141
21:9	141
22:8	69
23:1–14	85
23:1	113
23:14	113
26:3	115
28:24–9	38
29:14	37
29:16	104
31:7	141
41:17	92
46:6	141
49:22–3	113
54:16	87
56:7	121, 201
60	81, 86, 91
60:1	87
60:3	87
60:5	85, 88, 113
60:9	85
60:11	113
60:13	92
60:21	87–8
61:6	86, 113
64:7	87
66:1	121

Jeremiah

2:3	182
2:20	74
7:4	121
7:9	74
7:11	121
7:18	74
7:21–6	176
7:30	121

Index of Biblical References

7:31 .. 74
10:7–8 ... 87
11:9–13 ... 74
19:14–15 ... 74
21:14 ... 69
22 .. 74–5, 121
22:1–7 ... 74
22:13 ... 75
22:14–15 ... 75
23:28 ... 142
36:21–6 ... 74
51:17 ... 87
52:12–13 ... 76
52:24–7 ... 76
52:28–30 ... 76

Ezekiel

11:22 ... 213
16:13 ... 179
27:25–7 ... 85
38:4 ... 94
43:27 ... 201
45:21 ... 180
46:21–4 ... 114

Hosea

6:6 ... 141

Joel

2:24 ... 142

Amos

5:21–6 ... 176
9 .. 130
9:6 ... 49
9:13 ... 129

Micah

4:1–4 ... 113
6:1–8 ... 176
6:15 ... 129
7:17 ... 113

Habakkuk

2:18 ... 115

Haggai

1–2 ... 64
2:6–9 ... 88
2:6–8 ... 113

Zechariah

6:12–14 ... 114
13:9 ... 95
14 ... 81, 93–8
14:5 ... 93
14:14 ... 93
14:16 ... 93
14:19–20 ... 96
14:20 ... 93
14:20–1 94, 121

Malachi

3:8–10 207–8
3:10 ... 41

Psalms

48:8 ... 85
20 .. 176
40 .. 176
50 .. 176
51 .. 176
51:16 ... 168
51:17–19 ... 160
51:20–1 ... 161
66 .. 176
103:14 ... 104
104:2–3 ... 49
105:37 ... 116
126 .. 128
127:1 ... 31

Proverbs

3:9–10 ... 178
9:1–6 ... 66
25:13 ... 125
26:1 ... 142
30:8 ... 68
31 .. 67

Job

31:5–8 ... 129

Ruth

2:9 ... 142

Lamentations

2:7 ... 213

Ecclesiastes

2:5 ... 34
2:18–21 .. 129

Daniel

1:17 ... 35
2:20–2 ... 37
5:4 ... 141
5:23 ... 141
6:28 ... 141

Ezra

1:4 ... 108
1:5 ... 108
3–6 ... 64, 97
7:15–16 .. 68

Nehemiah

10:37 ... 182
12:47 ... 208
13:10 ... 208

1 Chronicles

12:30 ... 99
13–16 .. 104
13:7–13 ... 99
15:11–15 ... 99
15:15 ... 103
15:29 ... 99
16:39 ... 77
18:11 ... 103
21:29 ... 77
22 81, 100–2
22:2–4 ... 101
22:5 ... 102
22:8 ... 99
22:14–16 101
22:15 ... 105–6
22:17 ... 105
23:25–6 ... 81
28 ... 108
28:1 ... 105
28:3 .. 99, 103
28:5 ... 115
28:6 ... 115
28:9 ... 104
28:10 ... 115
28:21 ... 104

2 Chronicles

1 ... 101
1:3–13 ... 77
1:3 ... 77
1:13 ... 77
2–9 ... 106
2 ... 105
2:4–6 ... 103
2:12 ... 35
2:13–14 ... 106
2:17–18 ... 107
5:12–13 ... 210
7:14 ... 100
8:13 ... 180
9:16 ... 102
9:20 ... 102
12:5 ... 100
15:2 ... 100
18:18–25 106
20:14 ... 106
20:20 ... 100
20:31–21:1 85
20:36–7 ... 85
24:20 ... 106
31:4–7 ... 208
36:22 ... 106

Matthew

4:4 ... 142
5:12 ... 144
5:23–4 ... 166
6:1 ... 144
7:23 ... 131
7:24–6 ... 142
8:4 ... 176
10:41–2 ... 144
13:27 ... 143
19:21 ... 169
21:28 ... 143
25:16 ... 143
26:61 ... 118
27:51 ... 121
20:1–6 ... 144
20:25–7 ... 125
23:10–12 125

Mark

1:44	176
6:7–11	142
9:34–5	125
9:41	144
14:58	81, 107, 118
15:38	121

Luke

1:15	34
1:41	34
1:67	34
4:4	142
5:14	176
6	130–1
6:35	144
6:47–8	142
8:5	127
9:1–6	126
10	125–7
10:7	12, 135
10:35–6	128
10:37–8	128
14:33	169
16:13	143
17:14	176
19:47	121
21:5–36	140
22	202
23:45	121
24:45	141

John

2:1–11	129
2:18–19	118
2:19–21	118
4	127–30
4:6	142
4:8	129
4:31–38	127
4:32	130
5:17	124
13:14–16	125
14:12	122
16:12	168

Acts

2:1	197
2:4	34
2:44	169
2:46–7	202
4:8	34
4:31	34
4:32	169
7:29	121
9:17	34
9:20	133
9:29	133
13:9	34
16:15	133
17	133
17:34	189
18:1–3	132
18:2–3	143
18:7	133
20:16	197
20:32–5	132
21:23–6	176

Romans

2:29	168
3:31	145
8:23	189
11:13–15	190
11:16	189–90
12	169
12:1	166
15:27	169
16:5	189

1 Corinthians

1:17	134
1:18–19	37
1:19–22	134
3:5–4:21	134
1:24–5	134
1:30	134
2:1	134
2:4–7	134
2:13	134
3:10	135
3:12	136
3:14	137
3:15	137
3:16–17	138
3:17	137
3:18–19	173
4:12	132
5:6	191
6:19	138
7:40	34

9:6 .. 143
9:15–18 ... 143
11:21 .. 202
11:27 .. 202
11:33 .. 202
12 ... 144
12:3 ... 34
14:3 ... 173
15:20 .. 188
15:23 .. 188
16:8 .. 197
16:15 .. 188
16:19 .. 132

2 Corinthians

3:3 ... 34
9:6–11 ... 139

Galatians

4:10 .. 190
5:9 .. 191
6:6 .. 169

Ephesians

2:19–22 ... 138–9
2:19 .. 140
2:21 .. 139
4:28 .. 143
5:1 .. 166
5:2 .. 169
5:19 .. 140

Philippians

3:3 ... 34
4:18 .. 166

Colossians

1:9–10 ... 35
1:15–16 ... 209
2:16 .. 190

1 Thessalonians

2:9 .. 133
3:13 .. 192
4:10–12 ... 132
5:23 .. 192

2 Thessalonians

1:3 .. 188
2:13 .. 188
2:16–17 ... 188
3:7–12 ... 132

Hebrews

9:9 .. 123
13:15–16 ... 167

James

1:18 .. 198

1 Peter

2:5 .. 167

Revelation

11:18 .. 144
14:4 .. 198
18:11–17 ... 85
21:22–6 ... 115
21:23–35 ... 88
22:12 .. 144

Index of Authors

Aristotle 41, 51, 141
Aquinas 42, 89, 90
Arendt, Hannah 42, 51, 114,
Augustine of Hippo 29, 30, 44, 50n27, 73, 170, 203, 216

Barth, Karl 19n35, 217
Basil, of Caesarea 38, 168, 192, 203
Bezalel 25, 34–9, 45–6, 48, 63, 106
Bretherton, Luke 11, 141n24, 217
Brock, Brian 8, 10, 11, 12, 18, 48, 217

Crawford, Matthew 1, 30–1, 72, 218
Chrysostom 143n62, 172–4, 227

David, King 34, 55–7, 81, 99–109, 192
Davis, Ellen 13, 24, 27, 39, 51n63, 67, 205, 218
Douglas, Mary 8–9, 28, 175

Ellul, Jacques 33–4

George, Mark K. 24–5, 27, 43
Gorringe, Tim 13, 15, 48, 73, 96
Gregory Nazianzus 169

Harper, Doug 32, 72
Heidegger 7

Jesus 16, 48, 83, 107, 110, 118–39, 166, 168, 191, 202

Latour, Bruno 52, 70
Leithart, Peter 42–3

Milbank, John 42–4, 51, 152, 156
Milgrom, Jacob 159–65, 178–9, 181–2, 201, 205, 213, 224
Moltmann, Jürgen 82–4, 112, 113
Moses 26, 35–6, 39–45, 62, 69, 100, 103

Northcott, Michael 5, 13, 14, 18n33, 64, 150, 156n12, 211n28, 225

O'Donovan, Oliver 11, 18n21, 30, 83, 114n37, 141n23–4, 172, 225

Paul, Apostle 16, 34, 124, 131–40
Pye, David 88–9, 171

Reed, Esther 2, 149, 155n7, 175n9, 210n11, 226,

Sennett, Richard 47, 51, 52, 66, 72, 78, 90
Solomon 34–5, 55–73, 78, 81, 84–8, 92, 99–111, 201

Taylor, Frederick (and "Taylorism") 4, 213; *see also Taylorism*

Volf, Miroslav 1, 6–8, 37–8, 51, 81–2, 112, 124, 172

Williams, Rowan 89–90, 137
Wellhausen, Julius 15, 161–2

Index of Subjects

ability 34–5, 59, 110, 195; *see also* skill
abundance 68, 79, 85–6, 93, 100–6, 112, 129, 173, 176, 197, 208–9
aesthetic 65, 86–7, 90, 111, 137, 171, 196; as a source for knowledge 32, 89; *see also* beauty
agency *see* work, agency
altar 28, 48, 57, 94, 95, 114, 121, 155, 160–5, 176, 178, 201–4, 212–13
apostasy 40, 57, 68
ascension 122–3
Ancient Church Order documents: *Apostolic Tradition of Pseudo-Hippolytus* 194; *Apostolic Constitutions* 170; *Didache* 169, 176n50, 193, 202; *Didascalia Apostolorum* 194
agrarian economy 28–30, 70–1, 179, 183, 204; *see also* agriculture
agriculture 8, 12–13, 28–9, 55, 93–4, 119, 124–8, 134, 139, 142, 155, 162, 173, 180–2, 185, 195, 209
animals 94, 126, 143, 162–3, 165, 176n28, 176n34, 200–1
apprenticeship 36, 45, 127, 135
art 43, 51n67, 64–5; as skill 34, 36, 89, 173; bansautic (*see* work, with hands); temple as 7; vs craft 66, 171; *see also* aesthetics; avant-garde; architecture; beauty; modernism
avant-garde 64–5, 171
atonement 159–60
architecture, architects 7, 25–6, 33, 35, 39, 73, 104, 130

Basilica di Aquileia 192
beauty 86–92, 95, 103–4, 111–12, 120, 153, 171, 196, 214

capitalism 57, 90, 152–3, 172–3, 213
charity 157, 168–74, 193–5, 202

church 15, 26, 48, 133–40, 151, 153–5, 166, 169, 188, 192, 203–4, 215
Christology 44, 83, 122–3, 134, 188–91
communion *see* Eucharist
covenant 24, 38, 180, 185
Creation 9, 14, 23–4, 32, 38, 42, 44, 47, 48, 49, 53, 73, 82, 92, 100, 104, 110, 151, 189, 195, 209, 212
creativity 31, 33, 43–4, 89, 90–1; *see also* originality

desire 40, 89, 91; *see also* volition

ecology, ecological design 5, 13–15, 42, 47, 51, 69, 71–3, 92, 99, 110–12, 209
Enlightenment hero 46–7, 64, 110, 161
Epistemology 5, 7, 19, 34–5, 43, 64, 72, 83, 110
Eschatology, new creation 11, 30, 38, 51, 53, 69, 81–8, 92–8, 107–12, 118–19, 126, 129–30, 136–40, 144, 189–90
Eucharist 149, 195–6, 202–5
evil 59, 74, 99, 104, 313; *see also* sin

firstfruits 158–9, 178–96, 205, 209, 214
freedom *see* work, agency

glory, divine 78, 87, 92, 174

hermeneutics: Agrarian 13–15, 125; Utopian 98–9
Holiness 93–8, 112, 137, 139, 153, 179, 185, 190–2, 205–6, 209
Holy Spirit 11, 34–8, 45, 51, 54, 72, 90, 105–8, 115, 125–9, 134–40, 189
hospitality 168, 184, 193, 201–2

incarnation 44, 203

Index of Subjects

joy 89, 127–30, 161, 173–4, 184, 200–3
judgement, divine 43, 69, 74, 82, 85, 121, 126, 136–7, 158; human, exercise of 3, 4, 13, 31, 58–60, 106, 120, 138
justice 13, 17, 47, 75, 185, 191

leisure 28–9, 32, 110, 119, 126, 130
love 57, 82, 99, 202–3

management 3–5, 11–12, 33–6, 39, 57–61, 63–7, 90, 171
Marcionism 152
Modernism 171

originality 46, 66, 72, 95, 171; *see also* creativity

planting *see* agriculture
politics, political 2, 4–7, 60, 62, 73, 86, 93–4, 100, 102, 105, 114, 119, 152–4, 157, 160, 169
poverty 143n62, 174
property 105, 172–4
purity 136, 164, 192, 195, 210

reconciliation 139, 145, 166, 202
redemption 87, 95, 139, 189, 206–7
resurrection 83, 118, 122, 188–9
retribution 100–1
repair 1, 31, 71–2, 136

sacrifice 8–9, 57, 69, 74, 95, 121, 123, 151–2, 156, 158–70, 174, 186, 192, 200–1, 212–14

skill 3, 30–9, 45, 47–8, 65, 72, 104–6, 138, 173; of reading scripture 10
Stoicism 28–9, 119, 168

Taylorism 39, 64
Tabernacle 23–52, 57, 62, 64, 67–8, 75, 100–5, 110–12, 123, 162, 178, 185, 195, 201, 212
Temple 7, 9, 15, 23–4, 28, 36, 53–80, 86–95, 98–112, 134, 136–40, 166–9, 192, 201–2, 205–8, 213; *see also* tabernacle
tithes *see* charity

wealth 32, 55, 58, 68, 72, 84–6, 93, 111, 113, 165, 172–4, 177–8, 185, 192–3; *see also* charity
wisdom 15, 28–9, 32–9, 45, 47, 54, 57–67, 78, 85, 87, 105–6, 110, 120, 134, 154–5, 215
work: authority, in workplace 47; agency 26–32, 40–2, 44–5, 47, 61–6, 70, 107–11, 120, 128, 138, 140, 153, 162, 168; comprehensibility of 31; fabrication 14, 27, 32, 44, 64, 120, 212; human capacity for 29; knowledge in (*see also* wisdom) 33–9; materials 28, 40–7, 55, 67–74, 86, 90, 91–3, 96–7, 100–12, 120, 135–6, 150–3, 171–3, 185, 214; products of (*see* property); sociality of 39–40, 45–8, 66, 90–1, 99–100, 110; with hands 119
workshop 47, 66, 90, 133